Simon Stafford **Nikon D300**

Magic Lantern Guides®

Nikon D300

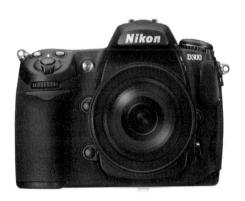

Simon Stafford

A Division of Sterling Publishing Co., Inc. New York / London Editor: Danielle Andes Book Design and Layout: Michael Robertson Cover Designer: Thom Gaines

Library of Congress Cataloging-in-Publication Data

Stafford, Simon.

Nikon D300 / Simon Stafford. -- 1st ed.

p. cm. -- (Magic lantern guides)

Includes index.

ISBN-13: 978-1-60059-325-3 (PB--trade pbk. : alk. paper)

ISBN-10: 1-60059-325-9 (PB--trade pbk. : alk. paper)

1. Nikon digital cameras--Handbooks, manuals, etc. I. Title. TR263.N557239 2008

771.3'3--dc22

2007050099

10987654321

First Edition

Published by Lark Books, A Division of Sterling Publishing Co., Inc. 387 Park Avenue South, New York, N.Y. 10016

Text © 2008, Simon Stafford Photography © 2008, Simon Stafford unless otherwise specified

Distributed in Canada by Sterling Publishing, c/o Canadian Manda Group, 165 Dufferin Street Toronto, Ontario, Canada M6K 3H6

Distributed in the United Kingdom by GMC Distribution Services, Castle Place, 166 High Street, Lewes, East Sussex, England BN7 1XU

Distributed in Australia by Capricorn Link (Australia) Pty Ltd., P.O. Box 704, Windsor, NSW 2756 Australia

The written instructions, photographs, designs, patterns, and projects in this volume are intended for the personal use of the reader and may be reproduced for that purpose only. Any other use, especially commercial use, is forbidden under law without written permission of the copyright holder.

Nikon, Nikkor, Speedlight, and other Nikon product names or terminology are trademarks of Nikon Inc. Other trademarks are recognized as belonging to their respective owners.

Every effort has been made to ensure that all the information in this book is accurate. However, due to differing conditions, tools, and individual skills, the publisher cannot be responsible for any injuries, losses, and other damages that may result from the use of the information in this book. Because specifications may be changed by manufacturers without notice, the contents of this book may not necessarily agree with software and equipment changes made after publication.

If you have questions or comments about this book, please contact: Lark Books 67 Broadway Asheville, NC 28801 (828) 253-0467

Manufactured in the USA

All rights reserved

ISBN 13: 978-1-60059-305-5

For information about custom editions, special sales, premium and corporate purchases, please contact Sterling Special Sales Department at 800-805-5489 or specialsales@sterlingpub.com.

Contents

Introduction	
Production of the Nikon D300	15
About This Book	16
Conventions Used in This Book	17
The Nikon D300	19
Design	19
Power	25
MB-D10 Battery Pack	25
Sensor	26
Built-In Sensor Cleaning	30
File Formats	32
The Viewfinder	35
The Control Panel	37
Shooting Information Display	38
Scene Recognition System	40
Automatic Focus	40
Exposure Modes	42
Exposure Control	43
3D Color Matrix Metering II	43
Center-Weighted Metering	43
Spot Metering	43
White Balance	44
Expeed Image Processing	45
Picture Control System	45
Color Space	46
The Shutter	46
Shooting Modes	4/
Self-Timer Mode	48
Live View	49
Mirror Lock-Up	50
Additional Shooting Features	50
The LCD Monitor	51
Menus	53
Built-In Speedlight	53
External Ports	55
Quick Start Guide	57
Charging/Inserting the EN-EL3e Battery	5/
Attaching the Camera Strap	58
Choosing a Language	58
0110001119 0440	

Setting the Internal Clock	59
Mounting/Removing a Lens	61
Adjusting Viewfinder Focus	63
Using Memory Cards	64
Inserting Memory Cards	6
Formatting the Memory Card	66
Formatting the Memory Card	66
Simple Photography	6
Shooting at Default Settings	60
Holding the Camera	70
Composing and Shooting	72
Basic Image Review	72
basic image keview	14
D200 Shooting Operations in Datail	_
D300 Shooting Operations in Detail	77
Power	77
Using the EN-EL3e Battery	78
The MB-D10 Battery Pack	81
External Power Supply	84
Internal Clock/Calendar Battery	86
Battery Performance	86
Battery Storage	88
White Balance	80
White Balance Options	91
Selecting a White Balance Option	96
Fine-Tuning White Balance	97
Choose Color lemp	90
Creative White Balance	99
Preset Manual White Balance	00
Copying a White Balance Value 1	00
Selecting a White Balance Preset Value	02
Attaching a Comment to a Preset Value	03
White Balance Bracketing	03
Picture Control System1	04
Selecting a Nikon Picture Control	06
Modifying a Picture Control	08
Sharponing	10
Sharpening 1	12
Contrast	13
Brightness 1	14
Saturation 1	14
Hue1	14
Monochrome – Filter Effects 1	15
Monochrome – Toning 1	15
Creating Custom Picture Controls	17
Sharing Custom Picture Controls	17
Managing Custom Picture Controls 1	18
Active D-Lighting	19

Color Space	119
Shutter Release	120
Shooting Modes	122
Single Frame	123
Continuous Low-Speed	124
Continuous High-Speed	124
Self-Timer	124
Mirror-I In	126
Live View	12/
Using a Remote Release	12/
Power Source and Frame Rate	128
Multiple Exposure	128
Interval Timer Shooting	130
Live View	133
Live View Options	134
Hand-Held Mode	135
Tripod Mode	136
Image Review Options	139
Single-Image Playback	141
Information Pages	141
Viewing Multiple Images	146
Playback Zoom	14/
Protecting Images	147
Deleting Images	148
Assessing the Histogram Display	149
Two-Button Reset	150
Exposure and the Autofocus System	153
ISO Sensitivity	133
ISO Noise	155
ISO Sensitivity Auto Control	156
TTI Metering	157
Matrix Metering	15/
Center-Weighted Metering	159
Spot Metering	160
Exposure Modes	161
Programmed Auto (P)	161
Aperture-Priority Auto (A)	162
Shutter-Priority Auto (S)	164
Manual (M)	164
Autoexposure (AE) Lock	165
Exposure Compensation	166
Bracketing Exposure	169
Bracketing Considerations	1/1
Using Non CPU-Type Lenses	172
Specifying Lens Data	173

Depth of Field	. 174
Depth-of-Field Preview	175
Depth of Field Considerations	176
Diffraction	177
Shutter Speed Considerations	170
Exposure Considerations	170
Digital Infrared and UV Photography	190
The D300 Autofocus System	190
The D300 Autofocus System The Autofocus Sensor	100
Focus Modes	101
S – Single-Servo AF	104
C – Continuous-Servo AF	104
M – Manual Focus	100
Single-Servo vs. Continuous-Servo	186
Predictive Focus Tracking	18/
Predictive Focus Tracking	188
Focus Tracking with Lock-On	189
Using Trap Focus	189
Autofocus Area Modes	190
Single-Point AF	191
Dynamic-Area AF	191
Auto-Area AF	191
Selecting an Autofocus Point	192
Focus Look	193
TOCUS LOCK	194
AF Assist Illuminator	195
Limitations of the AF System	196
The Manu System	
The Menu System	199
Accessing Menus	201
Playback Menu	202
Delete Images	202
Playback Folder	203
Hide Image	204
Display Mode	206
Image Review	208
After Delete	208
Rotate Iall	209
Slide Show	209
Print Set (DPOF)	211
shooting Menu	211
Shooting Menu Bank	211
Reset Shooting Menu	212
Active Folder	214
File Naming	216
image Quality	217
Image Size	217

	JPEG Compression	218
	NEF (RAW) Recording	218
	White Balance	218
	Set Picture Control	219
	Manage Picture Control	219
	Color Space	219
	Active D-Lighting	219
	Long Exposure Noise Reduction	220
	High ISO NR	221
	ISO Sensitivity	222
	Live View	222
	Multiple Exposure	223
	Interval Timer Shooting	223
CHE	tora Cattings Manu	113
Cus	Selecting Custom Settings Options	224
	C: Bank Select	224
	R: Menu Reset	224
	Autofocus	.227
	Metering / Exposure	233
	Timers / AE Lock	237
	Shooting / Display	239
	Bracketing / Flash	244
	Controls	250
Cati	ıp Menu	260
seu	Format Momory Card	260
	Format Memory Card LCD Brightness	261
	Clean Image Sensor	261
	Lock Mirror Up for Cleaning	261
	Video Mode	262
	HDMI	262
	World Time	263
	world time	263
	Image Comment	264
	USB	265
	USB	265
	Dust Off Reference Photo	266
	Battery Info	267
	Wireless Transmitter	268
	Image Authentication	268
	Save/Load Settings	270
	GPS	270
	Non-CPU Lens Data	270
	AF Fine Tune	270
	Firmware Version	. 2/2
Ret	ouch Menu	2/2
	Selecting Images	. 2/:
	Image Quality and Size	. 2/4

D-Lighting	274
Red-Eye Reduction	27
Irim	27!
Monochrome	276
Filter Effects	27
Color Balance	27
Image Overlay	27
Side-by-Side Comparison	2/0
My Menu	2/5
Add Menu Items	280
Delete Menu Itoms	280
Delete Menu Items	281
Reorder Menu Items	281
Image Resolution and Dresses	
Image Resolution and Processing	283
Image Storage	283
UDMA CompactFlash Memory Cards	283
wiicrourives	284
Memory Card Capacity	286
Formatting a Memory Card	286
image Quality and File Formats	288
JPEG	291
TIFF	294
NEF (RAW)	294
Compressed NEF	298
Which Format?	301
Setting Image Quality and Size	302
File Compression Options for IPEG	303
File Compression Options for NEF (RAW)	304
, , , , , , , , , , , , , , , , , , , ,	504
Nikon Flash Photography	307
The Creative Lighting System	200
Understanding Nikon Flash Terminology	308
TTL Flash Modes	212
Intelligent LLL (i-11L) Flash Control	211
Flash Output Assessment	317
Focus Information	210
The Built-in Speedlight	220
Lens Compatibility with the Built-in Speedlight	320
Using External Speedlights	222
Non-TTL Flash with the SB-800	323
Flash Synchronization	325
Flash Sync Modes	326
Flash Range, Aperture, and ISO Sensitivity	327
Slow Synchronization Flach	330
Slow Synchronization Flash	331
Rear-curtain Synchronization	332
Auto rocarriane (FF) mign-speed Sync	222

Additional Flash Features & Functions	335
Flash Compensation	335
Flash Value (FV) Lock	335
Flash Color Information	338
Wide-Area AF-Assist Illuminator	339
Using a Speedlight Off-Camera with a TTL Cord	341
Using the Built-in Speedlight in Commander Mode	344
Effective Flash Range	346
Nikon Lenses and Accessories	349
The DX-Format Sensor	349
Lens Types	352
Lens Compatibility	354
Using Nikon AF-S/AF-I Teleconverters	357
Features of Nikkor Lenses	358
Filters	360
General Nikon Accessories	363
Nikon Software	367
Resources	368
Working Digitally	371
Metadata	3/2
FXIF Data	. 372
IPTC Data – DNPR	373
XMP	. 373
Camera Connections	. 373
Video Out	. 373
Connecting via HDMI	. 375
Connecting to a Computer	. 3/5
Direct USB Connection	. 3/6
Memory Card Readers	. 377
Wireless and Ethernet Networks	. 3/8
Direct Printing	. 378
Nikon Software	. 383
Digital Workflow	. 389
Caring for Your D300	. 393
Cleaning the Low-Pass Filter	. 394
Self-Cleaning	. 395
Manual Cleaning	. 396
Troubleshooting	. 399
Frror Messages and Displays	. 403
Using a GPS Unit	. 407
Approved Memory Cards	. 408
Memory Card Capacity	. 409
Index	. 411

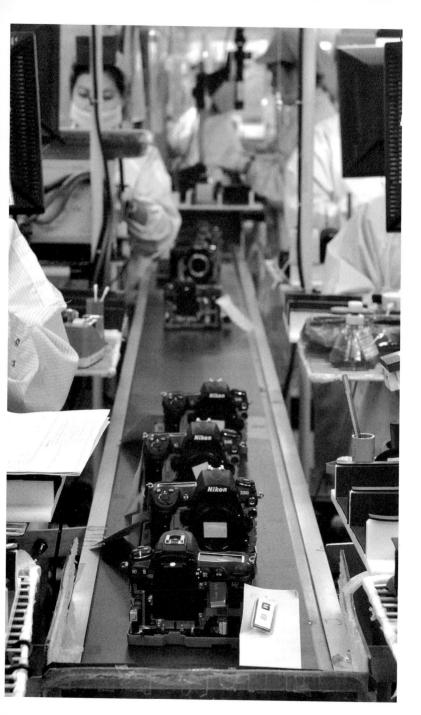

Introduction

The Nikon Corporation has accrued many years of experience building digital cameras beginning with a variety of hybrid cameras produced in collaboration with Kodak and Fuji respectively, but their breakthrough came in 1999 with the launch of the Nikon D1. This model represented their first fully independent digital SLR (D-SLR) camera design, which not only broke new ground technically, but also made high quality digital photography financially viable for many photographers.

Since Nikon has never attempted to introduce new camera models at the frequency of some of its well-known competitors, the development of Nikon D-SLRs during recent years can consequently be best described as a process of steady evolution. Nikon has unveiled a variety of models aimed at different sectors of the market, from the popular D100, launched during 2002, to the phenomenally successful D70 that arrived during 2004, and later to the mid-range D200 and D80, together with the professionally specified D2Xs. In light of this, the simultaneous announcement of the D300 and D3 models represents a positive revolution!

Coming less than two years after the introduction of the D200, the model it effectively replaces, the D300 offers specification, that surpass those of the former flagship D2Xs at less than half its cost, which in itself is an indication of how the economies of scale involved in the manufacture of digital cameras and associated technologies have changed in a short period of time.

Nikon has provided photographers with a series of indispensable photographic tools for over half a century. Here, in its factory in Thailand, Nikon's expertise in quality cameras continues with production of the Nikon D300.

It is clear that development of the D300 was closely associated with that of the D3, which at the time of writing represents the most advanced Nikon D-SLR made to date. In fact, the two new models only differ significantly in three aspects of their specification: size of sensor, ISO range, plus their respective size and weight.

The D300 has a whole raft of features available for the first time in a Nikon D-SLR camera, including:

- Nikon's exclusive Expeed processing system
- A 51-point autofocus system with a 3D focus-tracking feature
- A Live View function that enables real time viewing via the monitor screen
- The Scene Recognition System, which enhances performance of the autofocus, metering, and automatic white balance functions
- The Picture Control System that provides a very high degree of control over the way the camera records an image
- A built-in sensor cleaning mechanism to help remove dust particles from the optical low-pass filter

The D300 is a fully developed photographic tool with the flexibility to be used in either a completely automated way for point & shoot style photography, or with all its features and functions under the direct control of the user. Consequently, it is capable of meeting a broad range of requirements, from those of a dedicated enthusiast to a full-time professional photographer.

The D300 incorporates Nikon's new Live View system, enabling realtime viewing of the subject before shooting.

Production of the Nikon D300

The D300 is assembled at Nikon's wholly owned production facility, Nikon Thailand, near Ayuthaya, the old historical capital of Siam, about 50 miles (80 km) north of Bangkok. I say assembled because a number of core parts of the D300 are manufactured elsewhere, such as the camera's main printed circuit board and its associated electronic components, which are produced at the Nikon factory in Sendai, Japan. The Nikon Thailand plant has been involved in precision manufacturing for almost twenty years. Its ability to handle high-volume production in the digital era was proven by the tremendously successful D70 and D70s models, with the unprecedented demand for these cameras bringing about a significant expansion in the size of the workforce. Today the factory, which also handles production of the D40, D60, and D80 models, together with a number of lower-priced Nikkor lenses, operates around the clock.

Taking the time to become familiar with the D300 and shooting a lot of photos is the best way to become proficient in D-SLR handling. This guide is designed to make camera operation understandable, so you'll gain maximum enjoyment from your photography.

About This Book

To get the most from your D300 it is important that you understand its features so you can make informed choices about how to use them in conjunction with your style of photography. This book is designed to help you achieve this and should be seen as an adjunct to the camera's own instruction manual. Besides explaining how all the basic functions work, this book also provides useful tips on operating the D300 and maximizing its performance. The book does not have to be read from cover to cover. You can move from section to section as required, study a complete chapter, or just absorb the key features of functions you want to use.

The key to success, regardless of your level of experience, is to practice with your camera. You do not waste money on film and processing costs with a digital camera; once you have invested in a memory card it can be used over and over again. Therefore, you can shoot as many pictures as you like, review your results along with a detailed record of camera settings almost immediately and then delete your near misses but save your successes—this trial and error method is a very effective way to learn!

Conventions Used in This Book

Unless otherwise stated, when the terms "left" and "right" are used to describe the location of a camera control, it is assumed the camera is being held to the photographer's eye in the shooting position.

When referring to a specific Custom Setting, it will often be mentioned in the abbreviated form – CS xx, where xx is the identifying letter-number of the function. In describing the functionality of lenses and external flash units, it is assumed that the appropriate Nikkor lenses (generally D- or G-type Nikkor lenses to ensure full compatibility) and Nikon Speedlight units are being used. Note that lenses and flash units made by independent manufacturers may have different functionality. If you use such products, refer to the manufacturer's instruction manual to check compatibility and operation with the D300.

When referring to software, either Nikon or third-party, it is assumed that the most recent iterations of each application are used. Compatibility between image files recorded by the D300 and Nikon software will require the following, or later, versions: Nikon Transfer (version 1.0), Nikon View NX (version 1.0.3), Capture NX (version 1.3), and Nikon Camera Control Pro (version 2.0).

Simon Stafford Wiltshire, England.

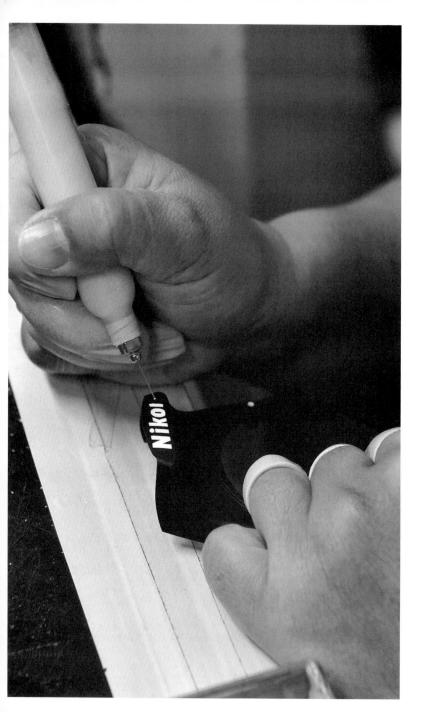

The Nikon D300

Design

Nikon has a long heritage of innovative engineering and progressive design that sets their cameras apart from the rest of the pack, and the D300 is no exception. It is clear that development of the D300 took place along near parallel paths with the flagship D3 model, which was announced at the same time. These two cameras have much in common, sharing cutting edge technology and many advanced features. As a consequence of this design philosophy, the D300 possesses a meld of qualities that allows it to be used proficiently at assorted skill levels, from the relatively inexperienced photographer who seeks nothing more than point and shoot convenience to the demanding requirements of professionals.

At first glance the D300 appears almost identical to its predecessor, the D200, as both models share virtually the same specifications in terms of size and weight: W x H x D 5.8 x 4.5 x 2.9 inches (147 x 114 x 74 mm) and approximately 29 oz (825 g) without battery or memory card. On closer inspection, the 3 inch (7.6 cm) LCD monitor that dominates the rear of the D300 and the relocation of some external control buttons hint at the significant changes that have taken place internally, including an entirely new 12.3 megapixel CMOS sensor.

Developed alongside the professional D3 camera and produced largely in Nikon's plant in Thailand, the D300 is an advanced D-SLR, offering photographers a myriad of choices from fully automated to sophisticated user-defined operation.

Nikon has long been trumpeting that image quality in the digital world rests on three pillars: optical quality of the lens, sensor technology, and internal camera processing. The D300 epitomizes this in respect of the latter two aspects, where the new sensor supports a multi-channel output to an in-built 14-bit analog-to-digital converter (ADC), thereafter all internal camera processing is handled at a 16-bit depth by a single ASIC. Nikon has dubbed this entirely new image-processing system "Expeed," and it is at the heart of the camera's ability to record, process, and output high quality images at a rapid rate. This fast data processing is combined with a completely new design of the mechanical shutter that enables the D300 to cycle at a maximum of 6 frames-persecond (fps), which can be raised to 8 fps with the addition of the MB-D10 Multi-Battery Pack; the shutter unit is tested to perform at least 150,000 actuations.

Another new aspect of the camera is its 51-point autofocus system, which is one of the numerous features and functions that mirrors very closely those available on the D3 model, along with its comprehensive menu system. The camera body is built around a sturdy magnesium alloy chassis that imparts a solid, rugged feel to the camera, as well as sealing against moisture and dust.

The D300 has a Nikon F lens mount with an automatic focusing (AF) coupling and electrical contacts, the design of which can be traced back to the Nikon F introduced during 1959. The greatest level of compatibility is achieved with either AF-D or AF-G type Nikkor lenses. Other lenses can be used but provide a variable level of compatibility: AF and Ai-P type Nikkor lenses offer a slightly reduced functionality of the camera's TTL metering system, as 3D Color Matrix is not available. Even manual focus Ai, Ai-s, Ai converted, and E-series Nikkor lenses can be used with the D300, although neither 3D Color Matrix metering, nor Programmed Auto and Shutter Priority exposure modes are supported.

For image storage, the D300 accepts CompactFlash cards—both Type I and Type II.

Nikon D300 — Front View

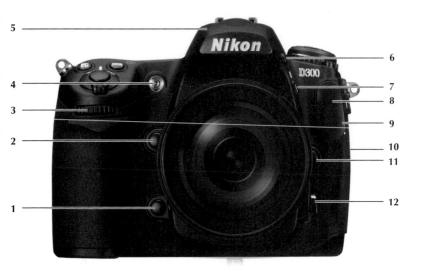

- 1. Fn button
- Depth-of-field preview button
- 3. Sub-command dial
- 4. AF-assist illuminator Self-timer lamp Red-eye reduction lamp
- 5. Built-in flash
- 6. Flash pop-up button
- 7. Flash mode \$ button Flash compensation ₩ button

- 8. Flash sync terminal cover
- 9. Ten-pin remote terminal cover
- 10. Video/DC/USB connections (undercover)
- 11. Lens release button
- 12. Focus mode selector

Nikon D300 — Back View

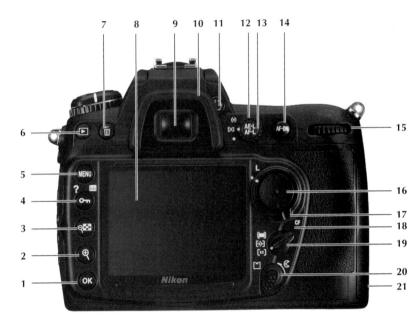

- 1. OK button
- 2. Playback zoom button 3. Thumbnail/playback
- zoom out button
- 4. Protect button On Help button INFO button
- 5. MENU button
- 6. Playback button
- 7. Delete button FORMAT button
- 8. LCD Monitor
- 9. Viewfinder eyepiece

- 10. DK-23 viewfinder eyepiece
- 11. Diopter adjustment control
- 12. Metering selector
- 13. AE/AF lock button
- 14. AF-ON button
- 15. Main command dial
- 16. Multi selector
- 17. Focus selector lock
- Memory card access lamp
 AF-area mode selector
- 20. Card slot cover latch
- 21. Memory card slot cover

Nikon D300 — Top View

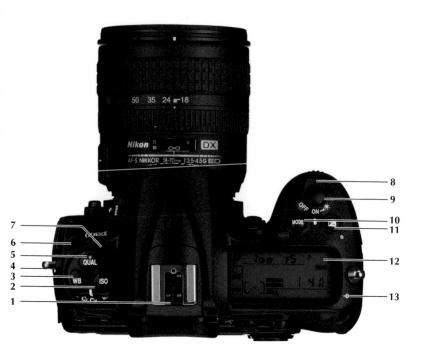

- 1. Accessory shoe (for external flash unit)
- 2. ISO sensitivity button
- 3. WB (white balance) button
- 4. Eyelet for camera strap
- 5. Image quality/size button
- Release mode dial lock release
- 7. Release mode dial

- 8. Power switch
- 9. Shutter-release button
- 10. MODE button (exposure) FORMAT button
- 11. Exposure compensation button Two-button reset button
- 12. Control panel
- 13. Focal plane indicator

Power

A single Nikon EN-EL3e (7.4V, 1500mAh) rechargeable Lithium-ion battery powers the D300. This battery weighs 2.8 oz (80 g) and is distinguished from earlier EN-EL3 batteries (see note below) by its light-gray casing. There is no alternative power source for the D300 that can be fitted internally; the standard camera body cannot accept any other type of non-rechargeable, or rechargeable battery. Battery performance is dependent on a number of factors, including condition of the battery, the camera functions and features used, and the ambient temperature. At a normal room temperature of 68°F (20°C) the power-up time of the camera is just 0.13 seconds, and it is possible to make many hundreds of exposures on a single fully charged EN-EL3e. Alternatively the D300 can be connected to the Nikon EH-5a or EH-5 AC adapter to power the camera during extended periods of use.

Note: The D300 is not compatible with the earlier EN-EL3 (7.4V, 1400mAh) or EN-EL3a (7.4V, 1500mAh) batteries originally supplied for the Nikon D70-series and Nikon D50 cameras, although these models will accept the EN-EL3e battery.

MB-D10 Battery Pack

The MB-D10 is a battery pack/grip that attaches directly to the base of the standard D300 body via the tripod socket. Unlike fitting the optional battery pack for the D200, there is no requirement to remove the battery chamber door of the D300, so the camera's internal EN-EL3e battery can be left in place. The MB-D10 has the capacity to hold either one EN-EL3e battery, one EN-EL-4 / EN-EL4a battery, or eight AA-sized batteries, which must be fitted in the MS-D10 battery holder. In addition to providing extra power, the battery pack has a shutter release button, duplicate main and subcommand dials, an AF-ON button and a duplicate multi selector to improve handling when the camera is held in the vertical (portrait) orientation.

Hint: Fitting the MB-D10 requires a rubber terminal cover to be removed from the base of the D300; it can be stowed in a depression in the top plate of the MB-D10.

When fitted with an MB-D10, which contains an EN-EL4, an EN-EL4a, or eight AA-sized batteries, the D300's maximum frame rate is raised to 8 frames per second (fps). The same frame rate can be achieved if the camera is powered from its dedicated AC adapter.

Note: All electronically controlled cameras may occasionally exhibit some strange behavior where unexpected icons or characters appear in the LCD display, error messages are displayed, or the camera ceases to function properly. This is often caused by an electrostatic charge. To remedy the situation, try switching the camera off, removing and replacing the battery, or disconnecting then reconnecting the AC supply, before switching the camera on again.

Sensor

The Complimentary Metal Oxide Semi-conductor (CMOS) sensor used in the D300 is not unique to the camera. It is produced by Sony and also used in their Alpha 700 D-SLR. There are total of 13.1 million photo sites (pixels), of which 12.3 million are effective for the purpose of recording an image. Each photo site is just 5.9 microns (mm) square. This gives the camera a maximum resolution of 4,288 x 2,848 pixels, sufficient to produce 11.8 x 17.8 inch (30 x 45 cm) prints at 240ppi without interpolation (resizing).

The imaging area is 0.66×1 inch $(15.6 \times 23.7 \text{ mm})$, which is smaller than a 35mm film frame of 1 x 1.5 inches $(24 \times 36 \text{ mm})$, but retains the same 2:3 aspect ratio. Nikon calls this their DX-format (often referred to as the APS-C format) and use the same "DX" designation to identify those lenses that have been optimized for use with their digital SLR cameras. Due to the smaller size of the DX-format digital sensor, the angle-of-view offered by any focal length is

The D300 is powered by the EN-EL3e battery. The life of a battery charge is decreased by the use of power-hungry features such as Live View, the built-in flash, and picture playback.

reduced compared with a lens of the same focal length used on a 35mm film camera. If it assists you to estimate the angle-of-view for a particular focal length in comparison with the coverage offered by the same focal on a 35mm film camera, multiply the focal length by 1.5x (see page 179 for a full explanation).

The CMOS sensor of the D300 is actually a sandwich of several layers each with a specific purpose:

Wiring Layer: Immediately adjacent and in front of the layer of photodiodes is the wiring layer that carries the electrical circuitry that not only carries the electrical signal way from each photodiode but also amplifies it before it is fed on to the analogue-to-digital converter (ADC).

Bayer Pattern Filter: Above the wiring layer is a colored filter layer. The photodiodes on the CMOS sensor do not record color-they can only detect a level of brightness. To impart color to the image formed by the light that falls on the sensor, a series of minute red, green, and blue filters are arranged over the photodiodes in a Bayer pattern, which takes its name from the Kodak engineer who invented the system. These filters are arranged in an alternating pattern of red/green on the odds numbered rows, and green/blue on the even numbered rows. The Bayer pattern comprises 50% green, 25% red, and 25% blue filters; the intensity of light detected by each photodiode located beneath its single, dedicated color filter according to the Bayer pattern, is converted into an electrical signal before being converted to a digital value by the ADC. If the camera is set to record a NEF Raw file the value for each photodiode is simply saved. When you open this file in an appropriate raw file converter the software will interpret the value from each photodiode to produce a red-greenblue (RGB) value, which in turn is converted into an image that can be viewed. However, if the camera is set to record either JPEG or TIFF files then the value from each photodiode is processed in the camera by comparing it with the values from a block of surrounding photodiodes, using a process called interpolation. The interpolation process produces a "best guess" for the RGB value for each sampling point (photodiode) on the sensor.

Microlens Layer: Immediately above the Bayer pattern filter there is a layer of micro lenses. Since the photodiodes on the sensor are most efficient when the light falling on them is perpendicular each photodiode has a miniature lens located above it to channel the light into its well to help maximize its light gathering ability

Optical Low-Pass Filter: Positioned in front of the CMOS sensor, comprising the layers of the photodiodes, wiring layer, Bayer pattern filter and micro-lenses but not connected to it is an optical low-pass filter (OLPF), sometimes called an anti-aliasing filter.

When the frequency of detail in an image, particularly a small regular repeating pattern, such as the weave pattern in a fabric, alters at or close to the pitch of the photodiodes on the sensor there is often a side effect that produces unwanted data (often referred to as an artifact) due to the way in which the incamera processing converts the electrical signal from the sensor to a digital value via the analog to digital (ADC) converter. This additional data is manifest in the final image as a color pattern known as a moiré. Furthermore, the same in-camera processing can also result in a color fringing effect, known as color aliasing, which causes a halo of one or more separate colors to appear along the edge of fine detail in the image

The OLPF is used to reduce the unwanted effects of color aliasing and moiré. However, the OPLF reduces the resolution of detail, so the camera designers must strike a balance between its beneficial effect and the loss of acuity in fine detail, which increases as the strength of the filter is increased. The OLPF also incorporates a number of important coating layers to help improve image quality:

To help prevent dust and other foreign material from adhering to the surface of the OLPF it has an anti-static coating made from Indium Tin Oxide.

To reduce the risk of light being reflected from the front surface of the OLPF onto the rear element of the lens, which could then result in flare effects, or ghost images, the filter has an anti-reflective coating.

The CMOS sensor is sensitive to wavelengths of light outside the spectrum visible by the human eye. This light, which can be either in the infrared (IR) or ultraviolet (UV) parts of the spectrum, will pollute image files and cause unwanted color shifts and a loss of image sharpness, so the OLPF has both an IR-blocking and UV-blocking coat. These IR and UV blocking coatings are very efficient, consequently, the D300 cannot be recommended for any form of IR or UV light photography, which was possible with some earlier Nikon D-SLR cameras, such as the D1 and D100.

A D300 on the assembly line in Thailand.

Note: The Indium Tin Oxide anti-static coating applied to the surface of the OLPF is more susceptible to being damaged by physical contact, or use of alcohol based cleaning fluids compared with the Lithium Niobate coating used in other Nikon D-SLR cameras such as the D200. So take extra care if you decide to clean the OLPF of your D300 for yourself.

Built-In Sensor Cleaning

The presence of dust and other unwanted particles on the front surface of the OLPF (i.e. the surface closest to the rear of the lens mounted on the camera) is the bane of all digital photographers, because it causes dark shadow spots to appear in the final image. The definition of such spots will, to some extent, be dependent on the lens aperture used; at very wide aperture settings these shadow

spots will appear less well defined and in some instances may not even be apparent. But at moderate-to-small aperture settings they will mar the image. This will require extra effort to remove them using software cloning tools in post-processing.

Regardless of how careful you are, dust will eventually find its way into a camera. The action of focusing, or adjusting the zoom ring of a lens, causes groups of lens elements to be shifted inside the lens barrel, creating very slight changes in air pressure that can cause dust in the atmosphere to be drawn through the lens into the camera. A visual inspection of the OLPF is often fruitless due to the extremely small size of the offending dust particles, which can be just a few microns across, so they are beyond the resolution of our eyes.

In an effort to help reduce the effects of such deposits, and to reduce the frequency with which external cleaning measures need be applied, Nikon has incorporated a self-cleaning mechanism into the D300 that vibrates the OLPF at four different frequencies using a piezo-electric oscillator. The cleaning process can be set to activate automatically when the camera is turned on, turned off, or both. Alternatively, it can be activated at anytime the user deems it necessary.

Beyond the self-cleaning function of vibrating the OLPF Nikon implement a comprehensive regime that spans camera production through to using software during post-processing of an image to reduce the risk of dust affecting images recorded by the camera. This includes the following:

- All internal mechanisms with moving parts such as the shutter unit are designed to minimize the generation of dust
- During manufacture of the D300 its shutter unit is activated 500 times before being installed in the camera as part of a running-in process. A similar procedure is performed once the camera is assembled.

- An anti-static coating is applied around the image sensor and OLPF assembly, while a border area surrounding the OLPF is specially treated with a tenacious adhesive material, so any dust particles dislodged from the OLPF by the self-cleaning process adhere to it and prevent them from migrating elsewhere inside the camera.
- In the D300 the space between the OLPF and image sensor has been increased, so that dust is less likely to affect
 the final image and the gap between the two is sealed to
 prevent dust particles from entering the senor assembly.
- The camera can record a reference frame that shows the location of dust spots, which can be used in Nikon Capture NX software to reduce the effects of dust in images shot in NEF (RAW) format.

File Formats

The D300 can record images as three types of files: compressed using the JPEG standard, TIFF (RGB) files, and files saved in Nikon's proprietary Nikon Electronic File (NEF) Raw format. The NEF Raw files can be saved in either uncompressed, lossless compressed, or regular compressed form.

The files using the JPEG standard can be saved at three different sizes, Fine (low compression 1:4), Normal (medium compression 1:8), and Low (high compression 1:16). As the level of compression is increased there is a greater loss of detail in the image. Furthermore, all JPEG compressed files are saved to an 8-bit depth, which can influence the width of the tonal range in the image. Likewise, the TIFF (RGB) files are also saved to an 8-bit depth but, despite using a form of lossless compression, they are significantly larger than JPEG files recorded by the D300.

The highest quality results come from the NEF Raw format files, since these contain the data direct from the sensor with virtually no modification or other in-camera pro-

cessing. The D300 provides options to have the NEF files output at either a 12-bit or 14-bit depth. This applies regardless of whether the files are uncompressed, lossless compressed, or compressed. Nikon states that the lossless compressed NEF Raw files are compressed using a reversible algorithm, which can reduce file size by 20-40% with no affect on image quality. In comparison, the compressed NEF Raw files are processed using a non-reversible algorithm that can reduce file size by 40-55%; however, this process can have a slightly adverse effect on image quality in certain circumstances.

Previously Nikon has referred to this type of compression as being "visually lossless," which is not quite the same as saying "lossless." The visually lossless claim is due to the method of compression used by the camera during the processing of the NEF Raw file. In essence it averages the highlight data to reduce the file size, but when this process is reversed to open the image file, highlight tone values are rounded up or down, which can restrict the range of tones in the image. However, it is unlikely the human eye will perceive this effect, hence the terminology. To get the most out of NEF files you will need additional software such as Nikon Capture NX, or a good quality third party raw file converter such as Adobe Camera RAW (see pages 107 and 296 for details).

Nikon D300 Viewfinder

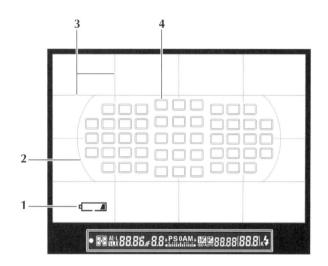

- 1. Battery indicator
- 2. AF-area brackets

- 3. Framing grid (select ON from CS d2)
- 4. Focus points

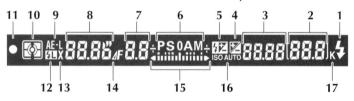

- 1. Flash-ready indicator
- Number of exposures remaining Number of shots until buffer is full

White balance indicator Exposure/Flash exposure compensation values

- PC mode indicator
 3. ISO sensitivity setting
- 4. Exposure compensation indicator
- 5. Flash compensation indicator
- 6. Exposure mode (P,S,A,M)
- 7. Aperture (f/stop)

- 8. Shutter speed
- 9. Autoexposure (AE) lock
- 10. Metering
- 11. Focus indicator
- 12. FV lock indicator
- 13. Flash sync indicator
- 14. Aperture stop indicator
- 15. Electronic analog exposure display

Exposure compensation display

- 16. Auto ISO indicators
- 17. K indicates memory for more than 1000 exposures

The Viewfinder

The D300 has a fixed, optical pentaprism, eye-level viewfinder that shows approximately 100% (vertical and horizontal) of the full frame coverage. It has an eye-point of 19.5 mm (-1.0m-1), which should provide a reasonably good view of the focusing screen and viewfinder information for users who wear eyeglasses, plus there is a built-in diopter adjustment between -2.0 to +1.0m-1. To set the diopter, mount a lens on the camera and leave it set to its infinity focus mark. Switch the camera on and point it at a plain surface that fills the frame. Rotate the diopter adjustment dial to the right of the viewfinder eyepiece until the AF sensor brackets appear sharp. It is essential to do this to ensure you see the sharpest view of the focusing screen. Since the builtin correction is not particularly strong, optional eveniece correction lenses are available between -5 to +3m-1. These are attached by slotting them on to the eyepiece frame (the rubber eyecup must be removed first). Similarly, the viewfinder eyepiece does not have an internal shutter to prevent light entering when the D300 is used remotely, so the camera is supplied with the DK-5 eyepiece cap that must be fitted, using the same method as the eyepiece correction lenses, whenever the camera is used this way in any of the automatic exposure modes.

The focusing screen is fixed and the viewfinder provides a very useful magnification of approximately 0.94x. The viewfinder display includes all the essential information about exposure and focus (see illustration page 34). The focusing screen is marked with a pair of arcs to define the area covered by the fifty-one individual autofocus points The D300 employs and LED projection system to display and illuminate the markings on its focusing screen. The screen only shows the bracket markings for the active focus area, which reduces clutter in the viewfinder, making the image easy to see. A user selectable reference grid can also be displayed that is useful for aligning critical compositions and keeping horizons level.

Control Panel A

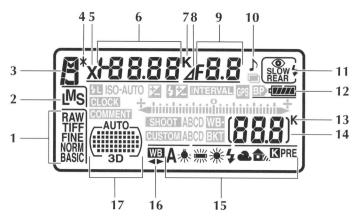

- 1. Image quality selection
- 2. Image size
- 3. Exposure mode (P,S,A,M)
- 4. Flexible program indicator
- 5. Flash sync indicator
- 6. Shutter speed
 Exposure/Flash
 compensation values
 ISO value/Focal length
 (non-CPU lenses)
 White balance preset/
 Color temperature
 Number of shots in
 bracketing for: exposure/
 flash/white balance
- 7. Color temperature indicator
- 8. Aperture stop indicator
- Aperture (f/stop)
 Number of shots
 per interval
 Max aperture (non CUP lenses)

PC mode indicator Bracketing increment for: exposure/flash/ white balance

- 10. Audible indicator
- 11. Flash mode
- 12. Battery-level indicator
- 13. K indicates memory for more than 1000 exposures
- 14. Number of exposures remaining Number of shots until buffer is full Preset white balance indicator
- 15. White balance selection
- 16. White balance fine tuning
- 17. Auto-area AF/AF-area indicator 3D-tracking

Control Panel B

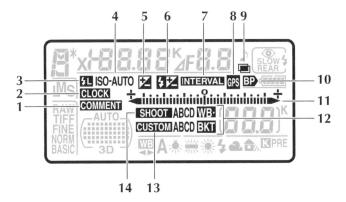

- 1. Image comment indicator
- 2. Clock not set
- 3. FV lock indicator
- 4. ISO sensitivity/Auto ISO indicator
- Exposure compensation indicator
- 6. Flash compensation indicator
- 7. Interval time indicator
- 8. GPS connection
- 9. Multiple exposure indicator
- 10. Batter pack indicator (MB-D10)

- Electronic analog exposure display
 Exposure compensation PC/Mass storage display Bracketing in progress for: exposure/flash/white balance
- Bracketing indicator for: exposure/flash/white balance
- 13. Custom settings bank
- 14. Shooting menu bank

The Control Panel

This large monochrome LCD display on the top plate of the D300, which Nikon calls the Control Panel, should not be confused with the color monitor on the rear. If the power is off, the only information shown is the number of remaining frames available on the installed memory card, and if no card is inserted, the display shows [- [-] to indicate empty. As soon as the camera is powered on, the display shows a wide range of camera control settings, including battery status, shutter speed, aperture, shooting mode, active focus sensor and focus mode, white balance, audible warning, together image quality and size. Other controls will be indicated as and when they are activated.

Shooting Information Display

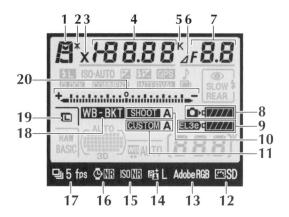

- 1 Exposure mode
- 2 Flexible program indicator
- 3 Flash sync indicator
- 4 Shutter speed / Exposure compensation value / Flash compensation value / Number of shots in exposure and flash bracketing sequence / Number of shots in WB bracketing sequence / Focal length (non-CPU lenses) / Color temperature
- 5 Color temperature indicator
- 6 Aperture stop indicator
- 7 Aperture (f-number) /
 Aperture (number of Stops) /
 Exposure and flash bracketing increment / WB bracketing increment / Maximum
 aperture / (non-CPU lenses)
- 8 Camera battery indicator
- 9 MB-D10 battery type display MB-D10 battery indicator
- 10 Shooting menu bank
- 11 Custom settings bank
- 12 Picture Control indicator
- 13 Color space indicator

- 14 Active D-Lighting indicator
- 15 High ISO noise reduction indicator
- 16 Long exposure noise reduction indicator
- 17 Release mode (single frame / continuous) indicator / Continuous shooting speed
- 18 Exposure and flash bracketing indicator / WB bracketing indicator
- 19 Image size
- 20 Electronic analog exposure display
- 21 FV lock indicator
- 22 ISO sensitivity indicator / Auto ISO sensitivity indicator
- 23 Exposure compensation indicator
- 24 Flash compensation indicator
- 25 GPS connection indicator
- 26 "Beep" indicator
- 27 Flash mode
- 28 Multiple exposure indicator
- 29 "K" (appears when memory remains for over 1000 exposures)

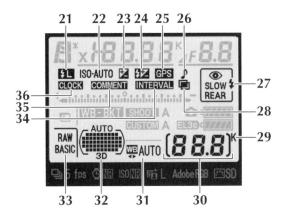

- 30 Number of exposures remaining Manual lens number
- 31 White balance / White balance fine-tuning indicator
- 32 Auto-area AF indicator / Focus points indicator / AFarea mode indicator / 3Dtracking indicator
- 33 Image quality
- 34 Interval timer indicator
- 35 Image comment indicator
- 36 "Clock not set" indicator

The Shooting Information Display (SID) essentially replicates the display shown in the control panel except it uses the 3 inch (7.62 cm) LCD monitor on the back of the camera. Not only does this make the display far clearer due to its size (and the option to have either dark lettering on a pale background or white lettering on a dark background), but it also improves camera handling by being more convenient to read, since you can quickly glance at the LCD instead of having to lower the camera and look down at the control panel.

Scene Recognition System

This innovation is part of the invisible wizardry of the D300. In essence it comprises the venerable 1,005-pixel RGB sensor for color Matrix metering with a new twist—a diffraction grating placed in front of it that acts as an optical color separation system to divide the light into its constituent colors. This enables the camera to "recognize" conditions pertaining to the subject and the overall scene in advance of an exposure being made, as it is able to make a finer assessment of color and contrast distribution within the frame area. The pioneering system brings benefits to the performance of the autofocus, autoexposure, and auto white balance functions.

Automatic Focus

The autofocus system is based on the new CAM3500 AF module, a system that assesses 3500 individual points in the process of focus acquisition. It features fifty-one focus points arranged in a rectangular pattern with its long edge parallel to the long edge of the frame. The central block of 15 focus

The focus mode selector.

points are cross-type sensing areas, while the other thirty-six (eighteen to the left and eighteen to the right of the central block) are single line-type sensors that are orientated parallel to the short edge of the frame. When selecting the focus points manually it is possible to have either all 51 available or reduce the number to just 11.

The detection range of the AF system is –1 to +19 exposure values (EV) at an ISO 100. There is an AF-assist lamp for low light levels that has an effective range from 0.5m to 3m (1'8" to 9'10"). In addition to new focus algorithms, the D300's AF system benefits from extra information supplied by the Scene Recognition System that helps with subject identification and tracking. The system has three focusing modes, Single-servo focus, Continuous-servo focus, and Manual focus. There are three focus-area modes, Single-area AF, Dynamic-area AF, and Auto-area AF. The Dynamic-area AF provides options to use a combination of 9, 21, 51 auto-focus points, or 51 autofocus points with 3D tracking. In the Continuous-servo focus mode, the camera will activate Predictive focus tracking automatically if it detects subject movement while the autofocus system is operating. The cam-

The AF-area mode selector.

era will attempt to predict the position of the subject at the moment the shutter is released. The D300 also has Nikon's proprietary Lock-on system that controls whether the camera re-focuses if the subject-to-camera distance changes significantly in an abrupt manner (see page 180 for full details of the focusing system).

Exposure Modes

The D300 offers four user-controlled exposure modes that determine how the lens aperture and shutter speed values are set when the exposure is adjusted: Programmed Auto (P), Aperture-Priority Auto (A), Shutter-Priority Auto (S), and Manual (M):

- **P** Programmed Auto selects a combination of shutter speed and aperture automatically but the photographer can override this using the flexible program feature.
- A Aperture-Priority Auto mode allows the photographer to select the lens aperture while the camera assigns an appropriate shutter speed.
- **S** Shutter-Priority Auto mode allows the photographer to select the shutter speed while the camera assigns an appropriate lens aperture.
- M Manual mode places selection of both the shutter speed and lens aperture in the hands of the photographer.

Exposure compensation can be set over a range of -5 to +5 stops in increments of 1/3, 1/2 or 1 EV. Exposure and/or flash exposure bracketing is available for 2 to 9 frame sequences in increments of 1/3, 1/2, 2/3, or 1 EV.

In the automatic exposure modes, (P), (S), and (A), the exposure settings can be locked using the AE-L/AF-L button located on the rear of the camera.

The D300 has a sensitivity range (ISO equivalent) between ISO 200 and ISO 3200 that can be set in steps of 1/3, 1/2,

2/3, or 1 EV. Additionally, the sensitivity can be reduced by up to 1EV below ISO 200, or 1 EV above ISO 3200, again in steps of 1/3EV, to ISO ratings equivalent to 100 and 6400 respectively. The camera also has a noise reduction regime that can operate at sensitivities of ISO800, or above.

Exposure Control

The D300's through-the-lens (TTL) metering system offers three options to cope with a variety of different lighting situations:

3D Color Matrix Metering II

With this metering method, the D300 uses a 1005-pixel RGB sensor within the camera's viewfinder prism head to assess the brightness, color, and contrast of light. Additional information from compatible lenses (D-type or G-type Nikkor lenses) and the autofocusing system is also taken in to account; based on the focused distance and which focus sensor is active, the camera makes an assumption as to the likely position of the subject within the frame area. The D300 then uses its innovative Scene Recognition System, which holds a reference of over sixty thousand examples of photographed scenes, and compares these with the information from the metering system to provide a final exposure value.

Note: Standard Color Matrix Metering is performed if other CPU type lenses or certain non-CPU lenses (i.e. Ai, Ai-modified, Ai-s, and E-series types) are mounted.

Center-Weighted Metering (*)

The camera meters the entire frame area but at its default setting assigns a bias to a central circle in a ratio of 75:25 (the diameter of the metered area). The default size of 0.31 inches (8mm) can be altered using the Custom menu–b5.

Spot Metering •

The camera meters a 0.1 inch (3mm) circle, which represents approximately 2% of the full frame area, centered on the selected (active) focus point. This occurs regardless of whether the camera is set to use all 51 focus points, or just 11.

The metering selector

Note: The 3D Matrix and center-weighted metering systems have an EV range of 0 to 20, while the EV range for Spot metering is 2 to 20 (ISO 100, f1/4 lens, 68°F/20°C).

White Balance

The D300 offers several choices for white balance control, including a fully automatic option AUTO that uses the same 1005-pixel RGB sensor in the viewfinder as the metering system. There are also six user selectable manual modes for specific lighting conditions. Each of these settings can be adjusted using a fine-tuning feature.

- Tungsten * (for incandescent lighting)
- **Fluorescent** ighting, with further options of seven different types of bulb)
- Direct Sunlight **
- Flash \$ (for lighting by both the internal and external flash units)
- Cloudy (for daylight under an overcast sky)
- **Shade** for daylight in deep shade).

In addition, the D300 has options to set the white balance control to a specific color temperature from thirty-one different values expressed in degrees Kelvin , or use a manual Preset option **PRE** that can be set by either assessing the color temperature of the prevailing light reflected from an appropriate test target, or taking the white balance value from a previously recorded image. Up to five Pre-set white balance values can be stored in the camera and recalled as required.

Using **PRE**, you can take a manual white balance reading from a gray or white card to ensure that your white balance matches the color temperature of the ambient light.

Expeed Image Processing

Expeed is the generic name given by Nikon to its latest image-processing regime; its purpose is to ensure consistency in the appearance of images in terms of color and contrast, although component parts of the system, both hardware and software, may differ from camera model to camera model. If you have the experience of shooting film it might help to understand the concept by thinking about the way a film can be matched with different developers to produce consistent results.

Picture Control System

The Optimize Image system seen in previous Nikon models has been dropped from the D300. In its place is the new Picture Control System that is available in P, S, A, and M

modes. Its purpose is to enable the user to control a range of image attributes, tuning them precisely to match their requirements; the system has four default settings: Normal, Standard, Vivid, and Monochrome.

Within Normal, Standard, and Vivid, it is possible to adjust sharpening, contrast, brightness, saturation, and hue. Using the monochrome option, it is possible to control sharpening, contrast, brightness, filter effects (these emulate the effects of color contrast filters used for traditional monochrome film photography), and toning, which allows the user to apply a tint to the monochrome image.

The user to can modify each default setting to meet their requirement. Furthermore, these new settings can be saved as a customized picture control option. All picture control settings can be shared between cameras and computers by writing them to a suitable storage device such as a Compact-Flash memory card and loading them into any Nikon camera or software that supports the picture control system (see page 106 for a more detailed description).

Color Space

The color space of any device defines how narrow or wide the color range is and the value a specific color will have. You can select either sRGB or Adobe RGB mode. The sRGB space has a narrower range and is best suited to display of images on computer monitors or for direct printing either at home or via a commercial printing service. The Adobe RGB space has a wider range of colors with great coverage in the red and green; it is best suited to finely controlled printing where the image has been subjected to post processing to optimize its qualities.

The Shutter

The specification of the electronically-timed all new mechanical shutter used in the D300 is impressive; the release lag time is just 45 milliseconds (ms), with a viewfinder (mirror) blackout time of approximately 90 ms, and a maximum flash

sync speed of 1/250 second (assuming Automatic Hi-speed FP Sync mode is not active). Apparently, a mechanical shutter was chosen in preference to an electro-mechanical shutter type, in which a shorter shutter speed is emulated above a certain point by switching the sensor on and off for the appropriate duration, in order to maintain image quality with a sensor that has so many photosites (pixels).

The D300's shutter speed range runs from 30 seconds to 1/8000 second and can be set in increments of 1/3, 1/2, and 1 EV. The D300 has a Long Exposure Noise Reduction feature, controlled via the Shooting menu, and takes effect at shutter speeds of 8 seconds or longer; however, the time it takes to record each image to memory will equal the exposure time, and during this period the shutter release is disabled. There is also a bulb option for exposures beyond 30 seconds.

Note: However there is a practical limit to the duration of a single exposure due to the fact that the noise reduction feature, which is essential to maintain mage quality, uses a 16-bit counter to map the exposure time in increments of 1/10 second. Hence, after a little over 109 minutes the noise reduction process ceases.

Shooting Modes

The shooting mode determines when the camera makes an exposure. In Single Frame, the camera records one photograph each time the shutter release button is fully depressed. In Continuous Low-speed mode, the camera shutter can be set to cycle at a rate of one to six frames per second (fps). In Continuous High-speed, it cycles at 6 fps, which can be raised to 8 fps with appropriate power sources. However, the effective frame rate will be limited by a number of other factors, including the camera functions that are active, the selected shutter speed, and the capacity of the remaining buffer memory.

Pressing the release mode lock dial allows you to select single, continuous low, or continuous high shooting mode.

Self-timer Mode

The Self-timer mode is useful for self-portraits or for reducing loss of sharpness caused by the effect of vibrations generated internally by the camera (although in this respect it is not as effective as using the mirror lock-up feature, or the exposure delay mode, CS-d9). The delay of the self-timer can be set to 2, 5, 10, or 20 seconds.

The D300 set for Self-timer mode.

Live View

If you have ever used a compact style digital camera that has an image as seen by the lens projected on the rear LCD monitor, you will be familiar with the concept of Live View. Essentially this is a real time image produced from the camera's sensor that is refreshed at a rapid rate, so that it appears as a continuous image on the monitor screen. The D300 and D3 models are the first Nikon digital SLR type cameras to feature Live View.

The D300 set for LiveView.

On the D300 there are two distinct modes: Hand-held mode and Tripod mode. The former uses the camera's normal phase detection AF system and can be activated by any one of the 51point autofocus points. This mode can be useful when it is awkward to view the scene through the viewfinder in the normal way. Alternatively, autofocus is performed by a contrast detection system in the Tripod mode, using data from the sensor. Tripod mode is perfect for shooting static subjects since it allows the point of focus to be set anywhere within the frame area (i.e. it is not confined to one of the designated 51-points of the normal AF system). It is also possible to magnify the image on the monitor screen to check composition and focus accuracy in this mode. The Live View function of the D300 is also supported by Nikon Camera Control Pro 2 software enabling remote control of the camera with the ability to view the image on a computer screen via USB or LAN and wireless connections with the WT-4 wireless transmitter.

The D300 set for Mirror Lock-up.

Mirror Lock-Up

The D300 can be set so that its reflex mirror is locked in the up position before the shutter is released. This may improve the sharpness of an image because it eliminates the risk of internal vibrations caused by the movement of the mirror. This is a two-stage feature during which the first press of the shutter release causes the reflex mirror to be raised and locked, followed by a second press, which releases the shutter.

Note: This feature should not be confused with the mirror lock-up feature used to facilitate inspecting and cleaning the surface of the OLPF array in front of the camera's sensor.

Additional Shooting Features

- Multiple Exposure—The camera supports a Multiple Exposure mode. Up to ten separate exposures (using either NEF Raw or JPEG standard files, but not a combination of the two) can be combined in a single image. The user can select an automatic gain control within this feature to adjust the density of the final image to compensate for the total number of exposures made.
- Image Overlay—It is possible for the D300 to create a single composite image that can be saved in either the NEF Raw or JEPG format, using two NEF Raw format files shot on the camera and saved on the same memory card. The two original NEF Raw files are unaffected by this process because the new image is saved separately.

• Interval Timer—Using the Interval Timer function, it is possible to perform time-lapse photography with the D300. The user can determine the start and finish time for photography, the duration between each exposure (or set of exposures), and the number of intervals between each exposure (or set of exposures).

The LCD Monitor

On the rear of the D300 is a 3 inch (7.62 cm), 920,000-dot, color TFT LCD monitor that offers a viewing angle of 170°. As with the viewfinder display, this monitor screen shows virtually 100% of the image file when it is reviewed. Pictures can be displayed either as a single image, or in multiples. When used to display a single image, the review function has a zoom facility that enables it be enlarged by up to 27x (large size images only—lower magnifications are available for Medium and Small size images).

Use the multi selector to scroll through a range of pages containing shooting information, which are superimposed on any image reviewed in single-image playback mode. These include a page of basic file information, one that provides an overview of shooting information, three pages of detailed shooting data, and a single page showing individual histograms for each color channel (red, green, and blue) plus a histogram for the composite channel, a page that displays a highlight warning option that causes potentially overexposed areas to blink, and another page that displays the active focus point, or where focus was first locked in Singleservo AF. An additional page displays Global Positioning System (GPS) data if this information was recorded at the same time as the image (requires connection of camera to a compatible GPS device). You can edit your pictures while they are still held in the camera by reviewing them on the LCD monitor, with the option to delete them, or protect them from being deleted unintentionally (see page 139—for more details.)

In addition to image playback and the display of image information, the LCD monitor is used to display the various camera menus (see below) from where the photographer can control a wide range of features and functions. The brightness of the LCD monitor screen can be adjusted via the Setup Menu.

Menus

Most of the principal controls of the D300 can be accessed with ease and operated by buttons or dials located on the camera body. However, to fully exploit the camera's potential and configure its control to your exact requirements, there is a comprehensive system comprising five key menus: Playback, Shooting, Custom Settings, Setup, and Retouch. To facilitate access to frequently used items in any of these five menus, a sixth option, My Menu, enables the user to create their own customized menu. To open the menu display, press the MENU button on the rear of the camera to the left of the LCD monitor. Select the appropriate menu by using the multi selector, pressing its up or down keys to scroll; the various options and sub-options are color coded to facilitate navigation and selection of the required setting. The D300 supports menus in no less than fifteen different languages, which are selected via the Setup Menu.

Built-In Speedlight

Nikon always refers to its flash units, built-in or external, as Speedlights. The D300 has a pop-up Speedlight housed above the viewfinder. The built-in Speedlight of the D300 will not activate automatically if the camera determines the light level is sufficiently low to require additional illumina-

tion from the flash (unlike the Nikon D40, D80, and D60 cameras). The flash is activated manually in any of the exposure modes by pressing the Speedlight lock release button, which is located directly above the flash mode button \$\frac{\psi}{2}\$ on the left side of the viewfinder head. At full output, the Guide Number (GN) of the Speedlight is 56 feet (17 m) at ISO 200 in Automatic Flash mode and GN 59 feet (18 m) at ISO 200 in Manual Flash mode. The built-in flash is fully compatible with Nikon's Creative Light System, including the latest i-TTL flash exposure control system for balanced fill-flash within an ISO range of 200–3200. If Spot metering is selected, flash exposure control defaults to standard i-TTL flash. The built-in flash also supports the Advanced Wireless Lighting system where by it can be used to control a number of remote flash units (SB-800, SB-600, or SB-R200).

The built-in flash can be used with any CPU-type lens with a focal length of 18–300mm, but do remember to remove any lens hood to prevent obstructing light from the flash. The minimum distance at which the Speedlight can be used is 2 feet (0.6 m). However, with certain lenses, the minimum distance must be greater due to the proximity of the

Lifting the cover on the left end of the camera body provides access to the camera's external connection ports.

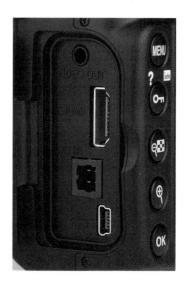

To present your travel photos to a group, the camera can be connected directly to a video monitor using the video out port on the left end of the camera body.

flash tube to the central axis of the lens, otherwise light from the flash is blocked by the lens, preventing it from illuminating the entire frame area (see pages 307-348 for full details on using the D300 for flash photography).

External Ports

On the left side of the D300 is a large rubber port cover. Beneath it, starting at the top and working down, are ports for Video-out, High Definition Media Interface (HDMI), DC-in for connecting the EH-5a / EH-5 AC adapter, and a USB port for connecting the camera to a computer or printer; the D300 supports High-speed USB (2.0) for data transfer.

Quick Start Guide

As you lift your new D300 camera from its box, you will no doubt be eager to take some pictures. However, before doing so, there are a few basic steps that you need to take to prepare the camera. It is also well worth spending a little time to acquaint yourself with the principle controls and functions.

Charging/Inserting the EN-EL3e Battery

The D300 is entirely dependent on electrical power so, at the risk of stating the obvious, it is essential the EN-EL3e battery is fully charged before you use your camera. There is no need to pre-condition the battery, but for its first charge you should leave it connected to the MH-18a charger until it is cool to the touch. Do not be tempted to remove it as soon as the charge indicator lamp on the MH-18a has stopped flashing.

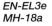

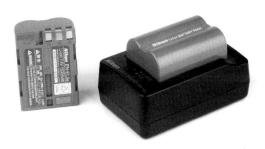

The first step in using the D300 is charging the EN-EL3e battery for the first time. Make sure to leave it in the charger until it is cool to the touch.

Before inserting the battery, make sure the camera power switch is set to OFF. Turn the camera over and slide the battery-chamber cover lock toward the center of the camera. Open the cover and insert the battery, making sure its three contacts face the battery-chamber cover and enter first. Lower the battery into place and press the chamber cover down until it locks; you should hear it click into place. Now turn the camera power switch to ON, and check the battery-status indicator in the control panel (located on the top of the camera) to confirm the battery is fully charged; should be displayed. The EN-EL3e battery is able to communicate a range of information to the D300. Additional information, beyond the charge level, can be found via the [Battery Info] option in the Setup menu.

Attaching the Camera Strap

While waiting for the battery to charge, you can attach the provided camera strap. The camera strap is not only useful for securing the camera when carrying it and preventing it from being accidentally dropped, but it can also be useful for bracing the camera to help reduce the risk of cameras shake spoiling your pictures. Adjusting the strap to a length where it is taught when wound around your arm can aid in the support of the camera.

Start with the left strap ring on the camera, thread one end of the strap through it and feed it back through the keeper-loop on the strap itself. Then, pass it through the inside of the buckle, underneath the section of the strap that is already there, before pulling it tight. Repeat these steps with the other end of the strap, working it through the right strap ring. Finally adjust the strap to your preferred length.

Choosing a Language

Once you have inserted a fully charged battery into the D300, turn the camera on by rotating the power switch to the ON position. To select the language to be used for the

It is important to remember to turn you D300 off before inserting or removing the battery, or before mounting or demounting a lens.

camera menu system, press the Menu button; the first time this is done the [Language] option from the Setup menu will be displayed. To access the [Language] menu options press the Multi Selector to the right, then press \triangle or \bigvee until the required language is highlighted. Finally, press the

button to confirm and lock your selection. If you wish to change the language at any time after the initial setup, open the Setup menu, highlight the [Language] option and repeat the procedure just described.

Setting the Internal Clock

The D300 has an internal clock powered by an independent rechargeable battery. This battery is charged from the camera's main power source – either an installed EN-EL3e battery, or the EH-5a / EH-5 AC adapter.

To set the [World Time] option, go to the Setup menu and highlight the [World Time] option. Press the Multi Selector to the right to display the menu options and use to highlight [Time Zone]; pressing the Multi Selector to the right displays a map of world time zones. Use to

select the appropriate time zone, and press to confirm the selection and return to the World Time menu.

Now, use ① to highlight the [Date and Time] option, and press the Multi Selector to the right to display the date/time clock. Use ① to select each item in turn, adjust as needed by using ① until the full date and time have been entered. Finally press ② to confirm the settings and return to the World Time menu.

Finally, use to highlight the [Daylight Saving Time] option and press to display the two choices; the default setting for [Daylight Saving Time] is OFF. If daylight saving time is in effect in the current time zone, highlight ON and press to confirm the selection. To exit the menu system and return the camera to its Shooting mode, press the shutter release button halfway down.

Hint: If you travel to a different time zone it is only necessary to adjust the [Time Zone] option in the World Time menu; the date and time will be automatically adjusted for the selected time zone. The only other option that may need to be adjusted is the [Daylight Saving Time] option.

Hint: The internal clock is not as accurate as many wrist-watches or domestic clocks, so it is important to check it regularly. If attaching accurate time and date information to each image is essential to your photography you may wish to consider connecting a GPS device to the D300 (see page 407 for details).

Note: The clock battery is not accessible by the user. It requires approximately 48 hours of charging by the camera's main battery or AC adapter to power the clock for approxi-

mately three months. Should the clock battery become exhausted the **CLOCK** will flash in the control panel and the clock is reset to a date and time of 2007.01.01 00:00:00.

Mounting/Removing a Lens

Whenever you attach or detach a lens from the D300 make sure the camera is turned off. Identify the mounting indexmark (white dot) on the lens, and align it with the mounting index-mark (white dot) next to the bayonet ring of the camera's lens mount. Enter the lens bayonet into the camera and rotate the lens counter-clockwise until it locks into place with an audible click.

Note: To access all the functions and features of the D300 pertaining to TTL metering, flash exposure control, and auto focus you will require either a G-type, or D-type Nikkor lens (see pages 349-360 for more details).

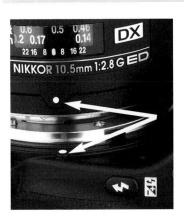

To mount the lens, turn the camera off. Next, align the white dot on the lens barrel with the one on the camera body. Gently insert the lens and rotate counter-clockwise.

If you are using a lens with a CPU, it is necessary to set and lock the aperture ring to its minimum aperture value (highest f/-number). Such lenses can be identified by the presence of a set of electrical contact pins arranged around the lens mount flange. This is not necessary for G-type lenses that lack a conventional aperture ring.

Hint: If you turn the camera on after mounting a lens and **FE E** appears and blinks in the control panel and viewfinder, the lens has not been set to its minimum aperture value. In this state, the shutter release is disabled and the camera will not operate.

To remove a lens from the camera, press and hold the lens release button (located on the front of the camera to the left of the lens mount), then turn the lens clockwise until the mounting index-mark (white dot) on the lens is aligned with the mounting index-mark (white dot) next to the bayonet ring of the camera's lens mount. Then, lift the lens clear of the camera body. If you do not intend to immediately mount another lens, make sure you place the BF-1A body cap back on the camera to help prevent unwanted material from entering the camera.

Adjusting Viewfinder Focus

The viewfinder eyepiece lens of the D300 has a diopter adjustment, enabling the camera to be used regardless of whether or not you normally wear eyeglasses. To check and set the viewfinder focus, attach a lens to the camera as described in the previous section. Turn the camera on, and select the central focus point using . Look through the viewfinder and adjust the diopter adjustment control (the small dial to the right of the viewfinder eyepiece) until the focus area brackets appear sharp. If the viewfinder display turns off while you are making adjustments, press the shutter release button halfway to re-activate the display.

Hint: It is usually easier to assess the viewfinder focus if the camera is pointed at a plain, light-colored surface. To prevent the focusing system from hunting when pointed at a featureless subject such as this switch the camera to manual focus by switching the focus-mode selector (located on the camera front to the left of the lens) to M and set the lens to focus at infinity. This can be done by setting the infinity mark on the lens distance scale against the focus index point or, if the lens lacks a focus distance scale, focusing on a distant object.

If you are traveling don't forget to adjust the camera's Time Zone setting in the World Time menu. Photo © M. Morgan

Hint: The diopter adjustment dial is positioned partially behind the DK-23 rubber eyecup, which can make the dial awkward to turn. I recommend removing the DK-23 (simply slide it upward) while you make adjustments.

Note: If the range of adjustment available with the built-in diopter does not sufficiently correct for your eyesight, Nikon also produces a viewfinder eyepiece lens (product code DK-20C) in a range of different diopters. The strength of these lenses may not match that of your prescription eyeglasses, so make sure you test it before making a purchase.

Using Memory Cards

The D300 can accept either solid-state (i.e. it has no moving parts) CompactFlash (Type I/II) cards, or a Microdrive™ (a miniature hard disk drive with moving parts). The only difference between a Type-I and Type-II CompactFlash card is their physical thickness (Type-I cards - 3.3 mm, and Type-II cards - 5 mm). Microdrives™ are mounted inside a Type-II, 5 mm thick CompactFlash card casing. The card port of the D300 can only accommodate one card at a time. (A list of memory cards tested and approved by Nikon is shown on page 409.)

To insert a memory card, turn the camera off, then rotate the card slot cover latch on the lower-right back of the camera counterclockwise.

Inserting Memory Cards

Regardless of whether you choose to use a CompactFlash card or a MicrodriveTM to store your digital pictures, the procedure for inserting them is identical. First, ensure the camera is switched off. Open the card slot cover by turning the card slot cover latch (located on the rear of the camera to the right of the LCD monitor) counterclockwise; the cover will spring open and swing back to reveal the memory card slot. Insert the card with its contact terminals pointing toward the camera and main label facing the back of the camera. The card will

easily slide in part way and then you will feel a slight resistance. Keep pushing the card until it clicks into place (the green memory card access lamp illuminates briefly, confirming the card is installed properly), and the gray eject button pops up. Finally, close the card slot cover.

Insert the memory card, as illustrated, until it clicks in place. (The gray eject button will popup.) Close the card slot cover.

Hint: Pay attention to the orientation of the memory card when you insert it into the D300. The main label of the card must face you (i.e. face toward the back of the camera). This is the reverse of many of the previous Nikon D-SLR cameras, where the memory card was inserted with the main label facing toward the front of the camera. The card can only be fully inserted in the correct orientation; do not apply force if it does not fit.

Caution: Occasionally, when carrying the D300, hung from my shoulder by its strap with the back of the camera facing toward my body, the card slot cover latch has snagged on my clothing and the card slot door has inadvertently opened. Generally, this has occurred when I have had a longer, heavier lens attached to the camera, which caused the camera body to tilt and expose the latch to a greater extent.

Formatting the Memory Card

All new memory cards must be formatted before their first use. To format a card using the D300, insert a memory card and turn the camera on. Press and hold the Mode and buttons for approximately two seconds until For flashes in the control panel, together with a flashing frame count display. To proceed with the formatting process you must release the **Mode** and buttons momentarily and then press them again.

During formatting **For** appears continuously within the frame-count brackets of the control panel display. Once complete, the frame-count display shows the approximate number of photographs that can be recorded on the inserted memory card at the current size and quality settings. Alternatively, you can use the [Format] option in the Setup menu, but this method is slower and involves using the LCD monitor, which increases power consumption and drains the battery quicker.

Note: If you press any other button after For begins to flash the format function is cancelled, and the camera returns to its previous state.

Note: You should never switch the camera off, or otherwise interrupt the power supply to the camera during the formatting process. This may corrupt the memory card.

Hint: It is good practice to format a memory card each time it is inserted into the camera. If you do not format the card there is an increased risk of problems occurring with the communication between the memory card and the camera, particularly if the memory card is used in different camera bodies.

Removing the Memory Card

To remove a memory card, make sure the green memory card access lamp has gone out and, then, switch the camera OFF. Open the card slot cover and push the grey eject button towards the center of the camera. The memory card will partially eject and can, then, be pulled out by hand.

Note: You should be aware that memory cards can become warm during use; this is normal and not an indication of a problem.

Note: If the D300 has no memory card inserted when a charged battery is installed, or it is connected to an AC power supply, [-**£**-] appears within the exposure counter brackets in both the viewfinder and control panel displays.

Simple Photography

In line with the professional specification of the D300, Nikon has, thankfully, dispensed with the subject/scene orientated point-and-shoot program mode options found on cameras such as the D80 and D60 models. I have always considered these fully automated exposure modes a backward step in encouraging users to experiment with their camera, understand more about it, and thereby develop their photography skills in the process. However, the D300 can still be used in a fully automated way if that is what you or others desire. The following section is included for those less experienced users eager to take some pictures with their camera, but reluctant to spend the time, at this point, to learn how to take control of their D300.

If you have followed the various steps set out in the previous sections of this chapter the camera should be ready to use. However, it is worth rechecking the battery charge status by looking at the icon displayed in the control panel; if it is fully charged will be displayed. It is also a good idea to check the exposure count display in the viewfinder or control panel. The number displayed within the brackets is the approximate number of exposures that can be made at the current settings for image size and quality, considering the storage capacity available on the installed memory card.

The D300 comes out of its box with factory default settings such as JPEG Normal image quality, Large file size, ISO 200, central focus point, etc.

Note: The exposure count display is only an approximation because file size can vary depending on the settings made on the camera. It is often possible for the camera to record and store slightly more images than the exposure count display initially suggests.

Shooting at Default Settings

Probably the easiest and quickest way to set up the camera for fully automated shooting is to use its default settings. These can be set, or restored, at any time by pressing and holding the QUAL and exposure compensation buttons down for more than two seconds (these two buttons have a bright green dot, indicating the dual button operation for the reset function). The default settings for the D300 are listed in the following table:

Shooting Menu Option	Default
Image quality	JPEG Normal
Image size	Large (images are 4,288 x 2,848 pixels)
ISO sensitivity	200 (equivalent to ISO 200)
White Balance	Automatic (fine tuning off)
Picture control	Settings for current picture control only
Other Camera Settings	Default
Focus point	Center point
Exposure mode	Programmed auto
Flexible program	Off
Exposure compensation	Off
AE hold	Off (Custom setting f6 is unaffected)
Bracketing	Off
Flash mode	Front curtain sync
Flash compensation	Off
FV lock	Off
Multiple exposure	Off

Note: Only the settings in the currently selected Shooting menu bank are affected by the two-button reset. Likewise, any settings made in the Custom Setting menu remain unaffected by using the two-button reset option, although the bracketing increment for exposure/flash is reset to 1EV, and 1 for white balance bracketing. (For full details see Re-setting Default Values on page 150).

In addition to ensuring the camera is set to its default values, a number of other camera controls should be set as follows to ensure easy and consistent operation:

The mode dial release button.

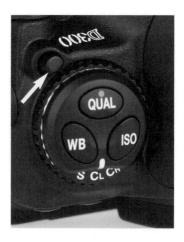

Press and hold the mode dial lock release button (located on the left top of the camera just above the Mode dial) to release the shooting mode dial. Rotate it to S, setting the camera to single frame shooting. At this setting, one exposure will be made each time the shutter release button is depressed fully.

The AF-area mode selector.

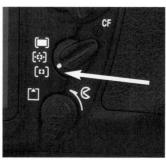

Shift the AF-area mode selector (on the rear of the camera just below the Multi Selector) down, aligning the white index mark against [13] (single-area auto focus). At this setting only the focus point selected by the user will be used to determine autofocus. Simply position the selected focus point over a portion of the subject you desire, and the camera will focus on that area.

The focus-mode selector.

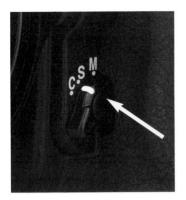

Rotate the focus-mode selector (on the front of the camera below the lens release button) until its white index mark is set against S (single-servo autofocus). At this setting, autofocus is activated when the shutter release button is pressed halfway; as soon as the camera has acquired focus will appear on the left side of the viewfinder display. In this focus mode, the camera will not take a picture until focus has been acquired.

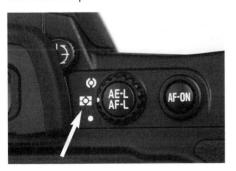

The metering selector.

Finally, select Matrix metering by turning the metering selector (on the rear of the camera to the right of the viewfinder eyepiece) until its white index mark is set to

. To confirm that Matrix metering has been selected, is displayed in the viewfinder.

Holding the Camera

It may sound rather obvious, but how you hold your camera can have a significant influence on the ability to produce sharp pictures. Camera shake, the inadvertent movement of the camera when it is held in your hands, is probably the principal cause of pictures being ruined by image blur. Using a proper hand holding technique will reduce the risk of this occurring.

Regardless of whether you want to shoot with the camera held horizontally or vertically, it should be grasped firmly but not in an overly tight grip. The fingers of your right hand should wrap around the handgrip in such a way that your index finger is free to operate the shutter release button. Cup your left hand under the camera so it acts like a cradle to support the camera and lens; leaving your left thumb and index finger available to rotate either the focus, or zoom ring of the lens. Keep your elbows tucked in towards your body, while standing with your feet shoulder-width apart and one foot half a pace in front of the other.

If you want to shoot from a lower camera position try sitting and bracing your elbows against your legs, or lying prone and propping your elbows against the ground. It can also be helpful if you can find a natural support such as a wall or lamppost, which you can lean against to support your body.

Composing and Shooting

Compose your shot by placing the active focus point over the main area of your subject. Lightly press the shutter release button to its halfway position, activating the focusing system. If the camera can acquire focus, you will hear a "beep" sound and the focus indicator, , will appear in the viewfinder. The focus will lock at the current camera-to-subject distance. If the subject moves closer or further away from the camera before you take the picture, you will need to release the shutter release button and repeat the focusing step.

Note: If the focus indicator is blinking, the camera has not been able to acquire sharp focus. You will need to re-compose the picture, place the selected focusing point over an alternative part of the subject and press the shutter release button halfway, again.

When the camera is set to P (Programmed Auto exposure) mode it will automatically select a combination of shutter speed and lens aperture. If the camera is able to select an appropriate shutter speed and lens aperture value, you are ready to make an exposure. However, if the prevailing light conditions prevent the camera from achieving a proper exposure – it would be over- or underexposed – the camera will display **H**: or **L** a respectively. To prevent overexposure, reduce the ISO sensitivity setting. If the ISO is already set to it's lowest value, try using either a polarizing, or neutral density filter to reduce the amount of light passing through the lens. To prevent underexposure, increase the ISO sensitivity setting.

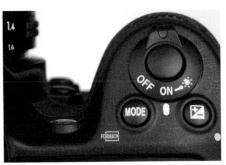

Pressing the shutter release halfway activates the camera's metering and focusing systems.

The shutter release button on the D300 is a two-stage release; pressed halfway, the camera activates autofocus and the TTL metering system, while pressing the release all the way activates the shutter mechanism and takes a photograph. Avoid stabbing you index finger down on the shutter release button, as this will increase the risk of camera shake. Practice the good hand holding technique described above and simply roll the tip of your index finger smoothly over the edge of the shutter release button to take the picture. The

If you want to make sure that you won't accidentally delete an image, press the button while the image is displayed on the LCD monitor.

green access lamp on the back of the camera will illuminate as soon as an exposure has been made, indicating the camera is saving the image. To make another exposure, lift your index finger clear of the shutter release button and repeat the process described above.

Caution: Under no circumstances should you either switch the power off, or eject the memory card while the green access lamp is illuminated and the camera is recording the image.

Basic Image Review

To review the most recent picture recorded by the D300, press the button (located to the left of the LCD monitor on the back of the camera); the image will be dis-

played on the LCD monitor screen. To review other pictures, use $\ \odot$ to scroll through the images stored on the memory card.

If you want to delete the image currently displayed on the LCD monitor, press the button. A message will appear over the displayed picture asking for confirmation of the delete action. Press the button a second time to proceed with the deletion of the picture. To cancel the delete process, press the button. To return the camera to its Shooting mode, press the shutter release button halfway.

To protect an image from accidental deletion, press the button while it is displayed on the LCD monitor. The icon will appear in the top left corner of the displayed image, indicating its protected status. To remove the protection, press the button while the protected image is displayed on the LCD monitor – the key icon will disappear.

Hint: Never be in too much of a hurry to delete pictures unless they are obvious failures. I always recommend that it is better to leave the editing process to a later stage – your opinions about a particular picture can, and often do, change. These days, memory cards are remarkably cheap and come in much larger capacities than only a few years ago, so there is no excuse to skimp on image storage!

Note: Any image file marked as protected will maintain this status (i.e. it will be a read-only file that cannot be deleted) even when the image file is transferred to a computer or other data storage device.

D300 Shooting Operations in Detail

Power

The D300 can be powered by a variety of sources. The standard battery is the rechargeable lithium-ion EN-EL3e (7.4V, 1500mAh) that weighs approximately 2.8 oz (80g). The profile of this battery ensures that it can only be inserted into the camera in the correct way. The EN-EL3 is charged with the dedicated MH-18a Ouick Charger (supplied with the camera). Alternative charging options include the predecessor to the MH-18a, the MH-18, and the MH-19 Multi-Charger, which supports both AC and DC power supplies. A fully discharged EN-EL3e can be completely recharged in approximately 135 minutes using the MH-18a or MH-18 battery chargers. Unlike some other types of rechargeable batteries the EN-EL3e does not require conditioning prior to its first use (it is supplied partially charged). However, it is advisable to ensure that the initial charge cycle for a new battery is continued until the battery cools down to room temperature while still in the charger before removing it. Do not be tempted to remove it as soon as the CHARGE lamp on the MH-18a / MH-18 / MH-19 stops flashing, as the battery is unlikely to have reached a full 100% charge.

The D300 is powered by a reliable, rechargeable lithium-ion EN-EL3e battery. If fully discharged, the battery can be recharged in about 135 minutes.

Using the EN-EL3e Battery

Before you insert or remove an EN-EL3e it is essential that you set the power switch of the D300 to the OFF position.

The EN-EL3e can only be inserted in the battery compartment in the correct orientation.

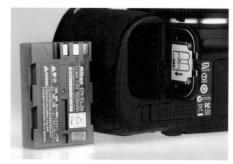

To insert an EN-EL3e into the D300:

- 1. Invert the camera and push the small button on the battery chamber cover towards the tripod socket. The battery chamber cover should swing open.
- 2. Open the cover fully and slide the battery into the camera observing the diagram on the inside of the chamber cover.
- 3. Press the cover down (you will feel a slight resistance) until it locks. You will hear a slight click as the latch closes.

To remove an EN-EL3e from the D300:

- 1. Repeat Step 1 (above).
- 2. Hold the cover open, turn the camera upright, and allow the battery to slide out. The battery will stop halfway out of the chamber, ensuring that it does not fall. To remove the battery, gently pull the battery the rest of the way out of the chamber.
- 3. Close the battery chamber cover.

Note: If you are in the process of making any changes to the camera settings and the battery is removed (or the power supply from the AC-adapter is interrupted) while the power switch is still set to the ON position, the camera may not retain the new settings. Likewise, if the camera is still in the process of transferring data from the buffer memory to the storage media (CompactFlash card or Microdrive) when the battery is removed, image files are likely to be corrupted or lost.

To charge an EN-EL3e:

1. Connect the MH-18a to an AC power supply.

Note: The MH-18a / MH-18 / MH-19 can be used worldwide; they can be connected to any AC supply, at any voltage from 100V to 250V, via an appropriate power socket adapter.

2. Align the slots on the side of the battery with the four lugs (two each side) on the top of the MH-18a / MH-18 / MH-19 and lower the battery onto the charger. Slide it toward the indicator lamp until it locks in place. The CHARGE lamp should begin to flash immediately, indicating that charging has commenced. It will take approximately 135 minutes for a completely discharged battery to reach a full charge.

Lithium-ion batteries do not exhibit the 'charge memory' effects associated with certain other types of rechargeable batteries. Therefore, a partially discharged EN-EL3e can be placed back onto the charger to be brought back to a full charge without any adverse consequences to the battery life or performance. However, if the battery is at a charge level of 90% or more, I would not recommend placing the battery back on the charger. There is a risk that this could reduce the overall battery capacity. It is also not advisable to repeatedly run a battery down to a charge level of 10%, or less before recharging it. Successive charging of a battery from near exhaustion to full charge will likely reduce its life expectancy.

Hint: To ensure the battery has charged fully do not remove it from the charger as soon as the CHARGE lamp stops flashing. Leave the battery in place a little longer until it has cooled to the ambient room temperature.

Hint: If you carry a spare EN-EL3e always ensure that you keep the semi-opaque plastic terminal cover in place. Without it, there is a risk that the battery terminals may short and cause damage to the battery.

The EN-EL3e rechargeable battery has an electronic chip in its circuitry that allows the D300 to report detailed information regarding the status of the battery. This is the reason why the EN-EL3e battery has three contact plates, as opposed to the two of its EN-EL3 and EN-EL3a predecessors. Selecting *Battery Info* from the Setup menu can access this information and three parameters concerning the battery will be displayed on the monitor screen (see the table below).

Parameter	Description			
Bat. Meter	Current level of battery charge expressed as a percentage.			
Pic. Meter	Number of times the shutter has been released with the current battery since it was last charged. This number will include shutter release actions when no picture is recorded (e.g. to record an Image Dust Off reference frame, or measure color temperature for a preset white balance value).			
Charging Life	Displays the condition of the battery as one of five levels (0 -4). Level 0 indicates the battery is new, and level 4 indicates the battery has reached the end of its charging life and should be replaced.			

Note: The EN-EL3, and EN-EL3a battery types, supplied with earlier Nikon D-SLRs, are not compatible with the D300. If you attempt to insert either of these batteries into the battery chamber of the D300, it will not fit. However, the EN-EL3e battery can be used in the earlier D100, D70-series, and

Besides the EN-EL3e, the MB-D10 also accepts EN-EL4 and four types of AA batteries.

D50 camera models.

The MB-D10 Battery Pack

The MB-D10 is a battery pack/grip that attaches to the base of the D300 body via the tripod socket. In addition to providing extra battery capacity the MB-D10 has a shutter release button, main and sub-command dials, a miniature version of the multi selector, and an AF-ON button to improve handling when the camera is held in the vertical (portrait) orientation. The additional bulk and weight the MB-D10 adds to the D300 also helps to balance the camera when using long, heavy lenses.

The MB-D10 enables the D300 to use a variety of different battery types. It is supplied with the MB-D10EN battery holder, which holds a single EN-EL3e battery (7.4V, 1500mAh). It can also accept the EN-EL4 (11.1V 1900mAh) and EN-EL4A (11.1V, 2500mAh) batteries when the standard battery chamber cover is replaced by the optional Nikon BL-3 battery chamber cover. Alternatively, the MS-D10 battery holder enables the MB-D10 to accept eight AA-sized batteries. There are four types of compatible AA-sized batteries. LR6 (Alkaline), HR6 (Nickel Metal Hydride), FR6 (Lithium), and ZR6 (Nickel Manganese). To ensure optimal camera functionality, it is important to adjust Custom Setting d10 [MB-D10 Battery Type] to the type of AA-sized batteries installed. There is no need to adjust this Custom Setting when using the EN-EL3e, EN-EL4, or EN-EL4a batteries.

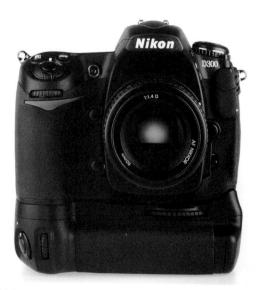

For the highest possible frame rate, I recommend using an EN-EL3e battery in the camera and the EN-EL4a battery in the MB-D10.

Note: To achieve the highest possible frame rate (8 fps) with the D300, it is necessary to use the EN-EL4a, EN-EL4, or AA batteries in the MB-D10. I recommend using a combination of the EN-EL3e battery (in the camera) and the EN-EL4a battery (in the MB-D10). This will not only achieve the highest frame rate but also provide the highest possible power level (4000mAh when combined). Installing an EN-EL3e in the MB-D10 has no affect on the maximum frame rate, which is restricted to 6 fps with this battery configuration.

Hint: When using AA-sized batteries, I strongly recommend avoiding the LR6 (Alkaline) and ZR6 (Nickel Manganese) types. In cooler ambient temperatures (i.e., below 20°C or 68°F), the performance of these batteries is impaired significantly and may even cease to function in very cold conditions.

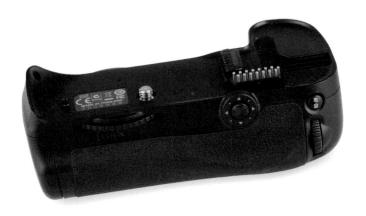

Attachment of the MB-D10 does not require the battery installed in the camera or the battery chamber door to be removed. However, the electrical contacts for the MB-D10 are located beneath a rubber contact cover in the base of the D300 that must be removed before fitting the battery pack. Once the MB-D10 is attached, Custom Setting d11 [Battery Order] allows you to determine the order in which the battery in the camera and the battery in the MB-D10 will be used. The default setting tells the camera to use the battery installed in the MB-D10 first. The BP icon that appears next to the battery charge level indicator in the camera's control panel confirms this setting.

Hint: To prevent its loss, stow the contact cover in the holder set in the top plate of the MB-D10.

Hint: By using the battery installed in the MB-D10 first, you can swap it out once it becomes discharged without interrupting the power supply to the camera. The battery installed in the camera will become the active battery as soon as the other battery dies. As soon as you insert a charged battery back into the MB-D10 the camera reverts back to drawing power from the battery pack (assuming CS d11 is set to its default value).

The status of the batteries installed in the MB-10 can be checked using the [Battery Info] option of the Setup menu. As described earlier with the in-camera EN-EL3, this option will display the values for the battery meter, picture meter, and charging life. In the case of the EN-EL4a and EN-EL4 batteries, it will also display the calibration value; indicating whether the battery requires calibration in either the MH-21 or MH-22 battery chargers. The information for the EN-EL3e battery installed in the camera is displayed on the left side of the monitor screen, while the status of the MB-D10 battery is shown on the right.

Note: If the MB-D10 contains AA-sized batteries the Battery Info option will only display the battery level. In addition, the control panel will only display three battery indicator icons when powering the camera with AA size batteries, — fresh batteries, — battery level is low, and (blinks) – batteries are exhausted.

External Power Supply

The optional Nikon EH-5A, or EH-5 AC adapters can also be used to power the D300. Both are rated for an input of 100 – 240V, AC 50 – 60 Hz, and can be particularly useful for extended periods of use; such as time-lapse photography, image playback, or data transfer direct from the camera to a computer. The adapter connects to the DC-in socket, located beneath the large rubber terminal cover on the left side of the camera, between the USB and HDMI terminals. The EH-5a/EH-5 is also useful in preventing the camera from powering off while the reflex mirror is raised for inspection or cleaning of the low-pass filter.

Hint: Always leave an EN-EL3e battery in the camera to maintain a power supply and prevent data loss, or file corruption, should the power cord to the EH-5 / EH-5A be inadvertently disconnected.

Hint: Always ensure that the power switch is set to the OFF position before connecting or disconnecting the EH-5A / EH-5 to the DC-In socket.

If you are shooting a wedding, make sure you have plenty of fire power. The best strategy is to use the MB-D10 with extra EN-EL4a batteries along with an EN-EL3e in the camera. Photo © C. Nunez-Regueiro

Note: All electronically controlled cameras may occasionally exhibit some strange behaviors on rare occasions. Unexpected icons or characters may appear in the LCD display or the camera may cease to function properly. This is usually due to an electro-static charge. To remedy the situation try switching the camera off. Before switching the camera on again, remove and replace the battery, or disconnect then reconnect the AC supply.

Internal Clock/Calendar Battery

The D300 has an internal clock/calendar that is powered by a fixed, internal rechargeable battery. Fully charged this battery will power the clock/calendar for approximately three months. It requires charging for approximately 48 hours by the camera's main power supply. Should the clock battery become exhausted, **CLOCK** (blinks) will flash in the control panel and the clock will reset itself to a date and time of 2007.01.01 00:00:00. If this occurs insert a fully charged battery and leave it in place for a few days. The clock/calendar will need to be reset to the correct time via the [World Time] option in the Setup menu.

Note: Since the user cannot change the internal clock/calendar battery, the camera must be returned to a service center for a replacement battery to be fitted should it stop holding a charge.

Battery Performance

Operation of the D300 is totally dependent on an adequate electrical power supply. Obviously, the more functions the camera has to perform the greater the demand on its battery. Reducing the number of functions and the duration for which they are active is fundamental to reducing power consumption. This can be an important consideration, especially when traveling with your camera, or spending any significant period of time away from an AC electrical supply.

Below are some of the principal causes of battery power drain, together with a few suggestions as to how you can conserve battery power.

 Using the camera's color LCD monitor increases power consumption significantly. Unless you specifically need it, turn the monitor off. Consider setting the Image Review option in the Playback menu to off. This will prevent the automatic display of an image immediately after it has been taken. Alternatively, consider selecting a 10second duration for the monitor display using Custom Setting c4 [Monitor off Delay] in place of the default 20second duration. To help reduce time spent scrolling through the camera's menu system, I recommend consolidating the menu items you use most frequently into the My Menu option. Creating the ease only needing to consult a single menu list to make adjustments, rather than maneuvering through multiple menus.

Hint: If you want to use the image review feature of the D300 (perhaps to check the histogram of a recorded image), press the shutter release button lightly as soon as you are done. This returns the camera to its shooting mode, switching the LCD monitor off immediately.

- Recording in NEF (RAW) draws far more power than recording JPEG or TIFF (RGB) files. Although the power management of the D300 appears to have been enhanced in this respect, compared with its predecessor the D200, saving NEF (RAW) files still places a significant burden on the camera's battery. Nothing can be done to mitigate this issue other than ensuring that you carry at least one spare battery if you habitually shoot in the NEF (RAW) format. In my experience, shooting in an average ambient temperature range of 60° to 75° F (16° to 24° C) using autofocus with active vibration reduction on my lens, I can expect a fully charged EN-EL3e to last for approximately 600 exposures.
- While driving the autofocus function of lenses places relatively low power demand on the battery, the vibration reduction (VR) feature available on some Nikkor lenses is another story. The VR function of all Nikkor lenses draws power from the camera battery and tends to remain active for far longer periods than traditional AF-operation. Consequently, when active, VR can reduce battery life by approximately 10-15%.
- Using the built-in Speedlight flash unit will place a significant demand on the battery and shorten the duration of any shooting session considerably

- A CompactFlash card requires significantly less power compared with a Microdrive (including the more efficient modern Microdrives). Therefore, you will be able to record more images per battery charge by using CompactFlash memory cards.
- Low temperatures cause a change to the internal resistance of a battery, regardless of its type, and impairs its performance. Lithium-ion batteries are relatively resilient to cold conditions. However, to ensure you can continue shooting, particularly in freezing conditions (i.e., below 0° C or 32° F), keep at least one spare battery in a warm place (such as an inside pocket). As the performance of the battery in the camera dwindles, exchange it with the warm one. Allow the used battery time to warm-up again and keep rotating between the batteries to maximize shooting capacity.

Battery Storage

A fully charged Nikon Lithium-ion EN-EL3e, EN-EL4, or EN-EL4a battery, in good condition, will retain its full capacity over a short period of a few days. However, if one of these batteries is left dormant for four weeks or more, regardless of whether it is installed in a camera or not, expect it to suffer a noticeable loss of charge. Before using the battery ensure it has been fully recharged.

If you expect to store a camera battery for an extended period of time avoid leaving it fully charged or heavily discharged. Storing a fully charged battery can have a long-term affect on its overall capacity. Storing a heavily discharged battery can risk it shifting to a deeply discharged state, which can damage it. The optimum charge level for a battery that will be stored for four weeks, or more, is between 20 – 80%.

Note: Always store your camera and batteries in a well-ventilated, cool, dry place.

When shooting in unusual light caused by threatening weather, it is often preferential to take a manual white balance reading by making a test exposure of a white or gray card.

White Balance

We are all familiar with the way the color of sunlight changes during the course of a day from the warm orange/yellow colors immediately after sunrise, through the cooler (blue) color of light around midday, returning to the orange/yellow colors that appear as the sun sets. These changes are significant and our eyes can see them quite clearly. However, the color of light (not to be confused with the color of the objects from which it is reflected) changes in subtle ways at other times of the day and in different climatic conditions. Furthermore, artificial light sources such a household light bulb or camera flashguns emit light with a wide range of different colors. The color of light is referred to as its color temperature (see "What is Color Temperature?" on page 90). In many instances our eyes and brain are remarkably good at adapting to these changes in the color

temperature of the light, so they are not visibly apparent to us. Think about what you see when you stand outside a building in which the interior lamps are switched on in daylight – the light the lamps emit often appears very yellow. But, if you look into the same building after dark the light from the lamps now appears to be white. This is an example of the adaptive process that our eyes and brain apply to light, one which cameras, regardless of whether they use film or a digital sensor, cannot perform!

Cameras have a fixed response to the color temperature of the light they record. Film has a response limited to a specific color temperature (for daylight balanced film this is equivalent to direct sunlight at midday under a clear sky). But digital cameras, such as the D300, are far more flexible; they can process the picture data to equate to a variety of specific color temperatures, either automatically or by selecting the color temperature manually. This function is known as the white balance control.

What is Color Temperature?

The color of light is often referred to as its "color temperature," which is expressed in units called degrees Kelvin (K). It sounds counter intuitive, but warm light (red/orange colors) has a low color temperature and cool light (blue tones) has a high color temperature.

Why is this? Well, the color temperature of a light source equates to the color of something called a "black body radiator" – a concept used by scientists that involves a theoretical object that can re-emit 100% of the energy it absorbs. As heat is applied to this "black body radiator," it becomes hotter and its color changes from black, to red, orange, yellow, through to blue. The color temperature of a particular light source is said to approximate the color of a "black body radiator" at the same temperature. Thus, at a low temperature the color of the light emitted would contain a high proportion of red wavelengths, and at a high temperature the light would contain a high proportion of blue wavelengths.

Generally, film is balanced to either direct sunlight under a clear sky at mid-day (a color temperature around 5500K), or the light emitted by a tungsten photoflood lamp (a color temperature around 3400K). If the temperature of the ambient light you are shooting under differs from these values, your photographs will take on a colorcast and you will need to use color correction filters to counter the effects.

Note: The color temperature of daylight will vary according to a number of factors including time of day, time of year, latitude, altitude, and the prevailing atmospheric and climatic conditions. The color temperature of 5500K, to which daylight film is balanced, is a somewhat arbitrary value and should only be used as a rough guide.

Digital cameras are far more versatile and can either automatically adjust their response to light within a range of different color temperatures, or allow the user to set a specific color temperature. This feature is known as the white balance control. Assuming the color temperature value of the chosen white balance corresponds to the color temperature of the prevailing light in the scene, it will be rendered without any noticeable colorcast (unnatural tint). You can also use the white balance feature creatively by setting an alternative value, which does not correspond to the prevailing light, thereby inducing a deliberate color shift.

White Balance Options

The white balance controls of the D300 share many similarities to earlier Nikon D-SLRs, but also have some new and unique features. The D300 camera offers nine principal white balance options: Auto, Incandescent, Fluorescent (with seven sub-options), Direct Sunlight, Flash, Cloudy, Shade, Choose Color Temp, and Preset manual. In addition to these options the white balance control has a newly improved fine-tuning function. The approximate color temperature for each option (except Choose Color Temp and Preset manual) is given in parentheses in the following list of descriptions for the various white balance options.

AUTO Automatic (3500 - 8000K)

Unlike previous Nikon D-SLR cameras, the D300 benefits from the newly developed Scene Recognition System (SRS), which enhances the abilities of its long established 1005-pixel RGB-metering sensor. The D300 incorporates a diffraction grating located in front of this sensor to separate light into its component colors, enabling the sensor to work more effectively and efficiently by detecting the color and brightness of elements within a scene more accurately. For example, the system helps enable the D300 to distinguish between the greens of foliage and the green wavelengths produced by a florescent light bulb.

Nikon states that the effective color temperature range of the automatic white balance option on the D300 is between 3500K and 8000K. In practice, I have found this option to be very effective and far more reliable than on any previous Nikon D-SLR when shooting in the middle of that range (i.e. typical daylight conditions). However, in lighting conditions with low color temperature values, I find the D300 consistently sets a color temperature that is too high, resulting in an overly warm colorcast. As with all automatic features, you will need to override the automatic white balance settings of the D300, when the lighting situations necessitate it. For example, if you shoot indoors under normal domestic type electric lighting the color temperature is likely to be lower than 3500K. Alternatively, outdoors in bright overcast conditions, or at high altitude the color temperature of daylight is likely to exceed 8000K.

★ Incandescent (3000K)

Use this option when shooting under typical household incandescent lighting, as its color temperature is a better match. However, you may find that results still look too warm (i.e. the red content is too high), so use the fine-tuning feature to make further adjustments (see page 97).

Fluorescent (2700K - 7200K)

The light emitted from fluorescent tubes is notorious for causing unwanted colorcasts. This is due to the way these

tubes work and the variability in the color temperature of the light they produce. In an effort to increase the accuracy of color rendition under the wide variety of fluorescent bulbs, the D300 has seven available sub-options under the [Fluorescent] white balance option in the Shooting menu. To access these options, open the Shooting menu and navigate to the [White Balance] option, press on the multi selector button and highlight [Fluorescent], then press again to display the seven bulb types. Highlight the required bulb type and press **\rightarrow** to open the fine-tuning control. Make any required adjustment before pressing of to set the bulb type and fine-tuning factor (if selected). The bulb type will be displayed in the Shooting menu, as to a number from 1 to 7 (see table below). Selecting [Fluorescent] by pressing the WB button and rotating the main command dial will select the bulb type set via the [White Balance] option in the Shooting menu, but only played in the control panel.

The details of the seven bulb types found in the [Fluorescent] white balance option are as follows:

Bulb Type	Color Temperature	Shooting Menu Display	
Sodium-vapor lamps	2700	₩ 1	
Warm-white fluorescent	3000	₩ 2	
White fluorescent	3700	₩ 3	
Cool-white fluorescent	4200	₩ 4	
Day white fluorescent	5000	₩ 5	
Daylight fluorescent	6500	₩ 6	
High temp. mercury vapor	7200	₩ 7	

Direct sunlight (5200K)

This option is intended for subjects or scenes photographed in direct sunlight during the middle part of the day (i.e. from around two hours after sunrise to two hours before sunset). At other times, when the sun is low in the sky, the light tends to be "warmer" – using this setting at those times will produce pictures with a higher red content.

Hint: White balance is a very subjective issue, but to my eye Nikon's color temperature for the Direct Sunlight option is too low. When shooting in these conditions I prefer to use either the [Flash] or [Cloudy] options. I recommend you experiment to find a setting that meets your requirements.

4 Flash (5400K)

As its name implies, this option is intended for use whenever a flash (Nikon refers to their own flash units as Speedlights) is the main lighting source.

Hint: Similarly to the [Direct Sunlight] option, I consider the color temperature of the Flash option to be slightly too low. The color temperature of light emitted by Nikon Speedlights is generally in the range of 5500 – 6000K, therefore I often select the Cloudy option when working with Nikon flash units as the main lighting source.

Cloudy (6000K)

This white balance option is intended for shooting under overcast skies, when daylight has a high color temperature. It ensures the camera renders colors properly without the typical cool (blue) tone. The cooler tone can give a 'cold' appearance to a photograph, particularly in pale skin tones.

♣//. Shade (8000K)

This option applies a greater degree of correction than the [Cloudy] option and is intended for those situations when your subject or scene is in open shade beneath a clear, or nearly clear, blue sky. Under these conditions the light will have a very high blue content, as it is principally comprised of light reflected from the blue sky above.

For this photo a color temperature reading was performed with a meter and the specific K temperature was set on the camera.

Choose Color Temp. (2500 – 10,000K)

This option allows you to select a specific color temperature from a range of values, expressed in degrees Kelvin (K). If you know the specific color temperature of the light source(s) illuminating the subject / scene the camera can be set to match it.

PRE Preset

This option allows the user to obtain a measurement of the exact color temperature of the light illuminating the subject or scene by making a test "exposure" of a white or neutral grey test target. Alternatively, the color temperature value from an existing image stored on the memory card can also be used as the source for obtaining a preset reading.

Selecting a White Balance Option

The white balance options of the D300 camera can be selected in one of two ways:

Open the Shooting menu and navigate to the [White Balance] option, press ▶ on the multi selector and highlight the required option from the displayed list by pressing either ♠ or ▼ (you must take this route if you want to alter the color temperature value for the fluorescent option). Then press ▶ to open the fine-tuning control and set any desired adjustment (see below). Finally, press ♥ to confirm the selection.

I prefer to set the white balance using the WB button on the left top of the camera. While pressing this, I rotate the main command dial until the appropriate selection is displayed.

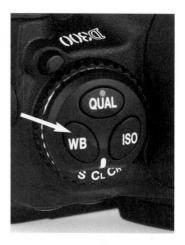

Alternatively, and in my opinion the quicker method, use the **WB** button on the top of the camera to select a white balance option. Press and hold the **WB** button and rotate the main command dial until the relevant white balance icon is displayed in the control panel. The subcommand dial can be used to adjust the fine-tuning factor while the **WB** button is held down.

Note: To select a value for the [Choose Color Temp] option; hold down the **WB** button while rotating the sub-command dial. The color temperature value, which is shown in degrees Kelvin (K), is displayed in the control panel.

Fine-Tuning White Balance

This feature enables the white balance to be fine-tuned to compensate for variations in the color temperature of a particular light source, or to create a deliberate colorcast in a picture. The new system introduced in the D300, which effects change in equally spaced MIRED values (see "What is MIRED" panel), offers considerably more precise and consistent results when compared with the somewhat arbitrary and counter intuitive method employed in previous Nikon D-SLR cameras. If you have become familiar with the previous system, where positive and negative values created cooler and warmer results, you will need to invest some time to learn the new one – the results may not be what you expect.

The fine-tuning of white balance can be achieved via two different routes: the [White Balance] option in the Shooting menu, or the **WB** button and sub-command dial. The [White Balance] option in the Shooting menu will provide the greatest control over the level of fine-tuning for both color temperature and color. Open the Shooting menu and navigate to the [White Balance] option and press to display the list of options. Highlight the desired white balance option, then press to display a color graph; its horizontal axis is used to fine tune for the level of amber (A) and blue (B), while the vertical axis is used to adjust the level of magenta (M) and green (G).

The [Fluorescent], [Choose color temp], or [Preset] options require one additional step to be performed before the color graph is displayed:

- If you opt for the [Fluorescent] option select a bulb type and press
 .
- If you opt for the [Choose color temp] option highlight a color temperature value and press
- If you opt for the [Preset] option select a preset value (see below) and press

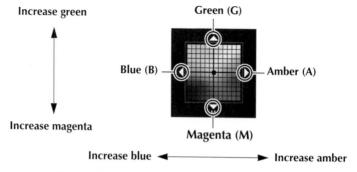

Using the multi selector, select a value between 1 and 6 along each axis of the color graph, working from the central point (see graphic above). Color temperature is fine-tuned by shifting along the amber (A) – blue (B) axis, while color is shifted along the green (G) – magenta (M) axis. Adjusting the color through this fine-tuning option is similar to using color-compensating (CC) filters. A combined color temperature and color shift is possible by moving the cursor of the graph display into one of the four quadrants of the graph. Once you have set the fine-tuning adjustment press button to save the setting and return to the hooting menu.

The alternative fine-tuning method uses the **WB** button in combination with the sub-command dial, but only provides the ability to fine-tune the color temperature (not the color), so the image looks either warmer or cooler. However, this method is not available for either the [Choose Color Temp] or [Preset] white balance options. If you use this method, the values A1 - A6 and b1 - b6 are displayed in the control panel. Each increment is equivalent to about 5 MIRED. Two opposing arrowheads are displayed beneath the WB icon in the control panel when the fine-tuning is active. Select 0 if you do not wish to apply a fine-tuning factor.

What is MIRED?

MIRED (Micro Reciprocity Degree) is a method of defining a shift in color in such a way that each shift in MIRED value is equivalent to the difference in color we perceive. The disadvantage of degrees Kelvin (K) is that a relatively small shift in Kelvin value at low color temperatures (e.g. less than 4000K) creates a much larger perceived shift in visible color than the same small shift in Kelvin value at high color temperatures (e.g. more than 6000K). The MIRED value is calculated by multiplying the reciprocal of the color temperature by ten to the power six (106). For example, the difference of 1000K between a color temperature of 3000K and 4000K is equal to 83 MIRED, whereas the difference between 6000K and 7000K is only 24 MIRED.

Choose Color Temp

The [Choose Color Temp] option under the [White Balance] option in the Shooting menu enables the selection of thirty-one different predetermined color temperature values, ranging from 2,500K to 10,000K in increments of approximately 10 MIRED.

Open the Shooting menu and navigate to the [White Balance] option, then press ▶ to display the choices. Highlight the [Choose Color Temp] option and press ▶ to display the color temperature values. Press either ▶ or ▼ to highlight the required value and press ▶ to open the fine-tuning option, make any needed adjustments, then press ♥ to save the setting.

Alternatively, press and hold the **WB** button and rotate the main command dial to select the [Choose Color Temp] option in the control panel display. To select the required color temperature, press and hold the **WB** button and rotate the sub-command dial; the color temperature value is displayed in the control panel while the **WB** button is pressed.

Creative White Balance

Feel like getting creative? It is easy with the white balance control on the D300. You do not have to set the white balance to match the color temperature of the prevailing light. Try mismatching it instead! For example, rather than shoot a subject

or scene lit by daylight using one of the daylight white balance values, set the white balance to incandescent – now your picture will have a strong blue color cast. The great appeal of digital photography is the ability to experiment!

Remember, if the color temperature of the prevailing light is lower than the color temperature of the white balance value set on the camera the subject or scene will be rendered with a warmer appearance. Conversely, if the color temperature of the prevailing light is higher than the color temperature of the white balance value set on the camera, the subject or scene will be rendered with a cooler appearance.

Preset Manual White Balance

The [Preset manual] option allows you to manually set a white balance value measured from the lighting falling on the subject or scene being photographed. This probably provides the most accurate way of setting a white balance value in conditions with mixed lighting sources, or any type of lighting that has a strong color bias.

There are two methods available with the D300 for obtaining a value for a preset manual white balance: direct measurement from a reference target, or copying the white balance value from a photograph stored on the memory card installed in the camera. The camera can store up to five different values for a preset white balance. The white balance value measured most recently will be stored as d-0. This can be copied to any one of the other four white balance files, d-1, d-2, d-3, and d-4. Likewise, a white balance copied from an existing photograph can also be copied to these same white balance value files.

Hint: The Nikon instruction manual suggests that you can use either a white or gray card as a reference target for the Preset manual white balance option. I strongly recommend that you use only a gray card for two reasons. First, white cards often contain pigments used to whiten them, which can cause the camera to render colors inaccurately. Second, it is more difficult to expose correctly for a pure white sub-

ject. To try to compensate for this, the D300 will automatically increase exposure by 1EV when measuring for the Preset manual white balance (in manual exposure mode be sure to adjust exposure, so the analog scale display is set to ± 0), but errors in exposure can affect the white balance reading you obtain from the test target.

Hint: In place of a test target, such as a piece of gray card, there are a number of products that can be attached directly to the lens and allow the camera to not only obtain a white balance measurement but also take an incident reading for the ambient light, using its TTL metering system. Probably the best device I have used for this purpose is the ExpoDisc (www.expodisc.com).

To measure a preset manual white balance value, select the [Preset manual] option (as described above), then place your test target in the same light that is illuminating the subject to be photographed. I recommend selecting manual focus and setting the focus point on the lens to infinity, this will prevent the AF system from hunting when pointed at the featureless reference target. The exposure mode you use is not critical, but I suggest you use aperture-priority auto (A). Press the WB button on the top of the camera and rotate the main command dial until PRE is displayed in the control panel. Release the WB button briefly, then press and hold it until PRE begins to flash in the viewfinder and control panel displays. Point the camera at the reference target (make sure you do not cast a shadow over the test target card) and make sure that it completely fills the viewfinder frame. There is no need to focus on the test target, simply press the shutter release button all the way down. If the camera is able to obtain an adequate measurement and set a white balance value **Good** will be displayed in the control panel, while Gd will appear in the viewfinder LCD; both icons will blink. If the camera is unable to set a white balance value it probably means that the light level is either too low or too high and noud will be shown, blinking, in both the viewfinder and control panel. In this case repeat the process until a measurement is achieved.

Note: To use the new white balance value immediately, ensure that d-0 is selected for the white balance file by pressing the **WB** button and rotating the sub-command dial, before recording the new value.

The white balance is now set for the prevailing light falling on your subject and this value will automatically be stored and retained in d-0, replacing any previous value stored there, until you make another preset option measurement. To retain the value at d-0 and store it as one of the other four preset values d-1 to d-4, open the [White Balance] option in the Shooting menu before taking a new white balance measurement and select the [Preset manual] option, then press . Highlight the destination preset (d-1 to d-4) and press the center of the multi selector . Finally, highlight [Copy d-0] and press . If a comment has been attached to the Preset manual value stored at d-0, it will be transferred to the selected preset value (d-1 to d-4).

Note: If no white balance value is measured for d-0 the color temperature will be set to 5200K (the same as the Direct sunlight option).

Copying a White Balance Value

If you want to use the white balance value of a photograph previously recorded by the D300, open the [White Balance] option in the Shooting menu, highlight the [Preset manual] option and press ▶ . Highlight the destination preset (d-1 to d-4) you wish to save the value in and press the center of the multi selector ⊕ . Highlight [Select image] and press ▶ to display a thumbnail view of all images stored on the installed memory card (use ♥ if you wish to display the image, full frame, on the monitor screen). Highlight the photograph desired as the source of the white balance value (a narrow yellow border will surround it) and press the center of the multi selector ⊕ to copy the white balance value, and any stored comment, to the selected preset (d-1 to d-4).

Selecting a White Balance Preset Value

Selection of a stored preset white balance value (d-0 to d-4) can be achieved in one of two ways: via the menu system or by using the **WB** button in combination with the main command dial.

To use the menu system, open the [White Balance] option in the Shooting menu and highlight the [Preset manual] option, then press ▶ . Highlight the desired preset (d-0 to d-4) value and press the center of the multi selector • . Highlight [Set] and press ▶ to display the fine-tuning options, adjust if required and finally press • to save the settings.

Alternatively, press the WB button and rotate the main command dial until **PRE** is displayed in the control panel. Press the **WB** button, again, and rotate the sub-command dial to display the preset value (d-0 to d-4) in the control panel.

Attaching a Comment to a Preset Value

To help identify a preset value (d-0 to d-4), a comment of up to a maximum of 36 characters can be attached to it. Open the [White Balance] option in the Shooting menu and highlight the [Preset manual] option, then press . Highlight the required preset (d-0 to d-4) value and press the center of the multi selector button . Highlight [Edit comment] and press . Use the displayed characters and controls displayed at the bottom of the screen to create a comment. Press . To save the comment.

Hint: The ability of the D300 to store preset white balance values is very useful. If the camera is to be used at a variety of different locations with different lighting conditions during the course of an event, a white balance value can be measured, stored, and named for each location in advance. Then the user only has to recall the appropriate preset value for each location as the event progresses. This is also applicable if you frequently return to a particular location, the white balance value for the lighting can be stored and recalled at will on each visit.

Located on the lower right front of the camera, the Fn button can be used to set white balance bracketing.

White Balance Bracketing

The white balance-bracketing feature on the D300 creates multiple copies of a single image recorded by the camera, but each copy has a different white balance value (as determined by the selected settings).

Note: White balance bracketing is not available with the following image quality settings: NEF (RAW), or NEF (RAW) + JPEG (Fine, Normal, Basic). Selection of any of these options will cancel white balance bracketing.

Note: White balance bracketing only affects color temperature on the amber – blue axis; there is no affect on the green – magenta axis.

Select the [WB bracketing] option at CS-e5 (Auto bracket set). Press the **Fn** button and rotate the main command dial to select the number of different white balance values to be created by the bracketing process. A scale will be displayed in the control panel to indicate the number of images that will be created. Remember, only one exposure is made – the camera applies the different white balance values as it processes the image data.

To select the adjustment level to be applied to the white balance value, press the **Fn** button and rotate the sub-command dial. Each increment is approximately equal to 5 MIRED. Choose from increments of 1 (5 MIRED), 2 (10 MIRED), or 3 (15 MIRED); higher A values correspond to an increased shift in color temperature toward a warmer rendition of the image, while higher B values shift color temperature toward a cooler rendition.

After making the single exposure, the camera will process the data to create the number of shots specified in the sequence by the user. Each file will have a different white balance value according to the increment selected.

Control Panel Display		No. of shots	WB Increment	Bracketing order (EVs)
OF	+ +	0	1	0
b3F	{ ++	3	1 B	1 B / 0 / 2 B
R3F	{ ++	3	1 A	1A/2A/0
	{ + ··········+		1 B	0/1B
RZF	; ++	2	1 A	0/1A
35	{ + ··········+	3	1 A, 1 B	0/1A/1B
58	************	5	1 A, 1 B	0/2A/1A/1B/2B
75	* + · · · · · · · · · · · · · · · · · ·	7	1 A, 1 B	0/3A/2A/1A/ 1B/2B/3B
95	{ + ·····+	9	1 A, 1 B	0/4A/3A/2A/1A/ 1B/2B/3B/4B

Note: The effect of applying a white balance fine-tuning factor and white balance bracketing are cumulative (i.e. the bracketed values will be added to the fine tuning factor for each file the camera creates).

Note: If the number of shots in the bracketing sequence is greater than the remaining capacity of images on the installed memory card the remaining exposures counter will blink "Full" in the control panel and "Ful" in the viewfinder, while the shutter release will be disabled. If this occurs simply insert a new memory card, format it, and you can resume shooting the white balance bracketing sequence.

Picture Control System

In addition to the new features in the white balance controls of the D300, the camera also has an entirely new system that affects the appearance of pictures in terms of sharpening, contrast and color. The Picture Control System (PCS) replaces the color mode options and optimize image features that were used in previous Nikon D-SLR cameras. The purpose of the PCS is to provide a single all encompassing solution for obtaining consistent results with different Nikon cameras, while also integrating Nikon software, particularly Nikon View NX, Nikon Capture NX 1.3, or later. Once a user has adjusted settings to achieve their desired result on one camera, it can be replicated by using the same settings on any other Nikon camera that supports the PCS. Furthermore, within Nikon Capture NX software it is possible to apply the same settings to a NEF RAW file recorded by a Nikon D-SLR camera that has the PCS. In a press release issued during August 2007 the Nikon Corporation stated that the PCS would be employed in all future Nikon D-SLR and Coolpix cameras, beginning with the D300 and D3 models.

It is important to mention that full integration of the PCS with Nikon View NX and Nikon Capture NX means that the settings made within the PCS on the D300 are only relevant if you shoot in either JPEG or TIFF. The values for the various parameters are embedded in those file types and cannot be altered at a later stage, at least not without a lot of trial and error testing, and even then there is no guarantee the process will be successful. Since the

Monochrome picture control allows you to see your photo in the LCD monitor in black and white. This can be useful when you want to make sure you have a pleasing grayscale rendition of the scene.

full range of the PCS settings is replicated in Nikon View NX and Nikon Capture NX, if pictures are recorded in the NEF RAW format it is possible to adjust all PCS settings, subsequently, at will.

Note: If you use an alternative RAW file converter (i.e., Adobe Camera RAW or Lightroom, or Apple's Aperture 2) the embedded JPEG file within the NEF RAW file, which is used for preview purposes, will not match the converted NEF file unless the PCS settings on the camera were at their default values. It will be necessary to invest time and effort to establish the settings required within a third-party RAW converter that will match the changes to attributes, such as color and contrast, at certain PCS settings. This issue is compounded by the fact that many third-party RAW converters do not reproduce Nikon's white balance settings with precision, so color may look a little "off" compared with a NEF RAW file converted by Capture NX.

The Picture Control System offers four basic picture control options: Standard, Neutral, Vivid, and Monochrome. Depending on which option is selected, a range of attributes can be adjusted; including, sharpening, contrast, brightness, saturation, and hue. The monochrome option offers controls to simulate traditional contrast control filters used for black and white photography, and toning effects. The standard and vivid options also have a quick adjustment feature that allows sharpening, contrast and saturation to be adjusted simultaneously. There is also an automated option to adjust sharpening, contrast and saturation. There is a graphical display available on the camera's monitor screen that maps contrast against saturation, assisting the user in their understanding of how one group of settings relates to another.

The full flexibility of the PCS comes with the ability to modify the four default picture control options and create your own customized picture control settings. A maximum of nine custom picture controls can be saved in the camera; they can also be copied to a memory card and transferred to other compatible cameras, or to a computer for use with Nikon Capture NX.

Selecting a Nikon Picture Control

Open the Shooting menu and navigate to the [Set Picture Control] option, then press to display the four basic picture control options: Standard, Neutral, Vivid, and Monochrome. Highlight the required option and press . To access the graphical display of contrast and saturation, in order to compare the selected option with the others, press and hold the solution (if the monochrome option is selected only the value for contrast is shown).

Option	Sharpening	Effect
SD Standard	3	Probably the most useful option for most shooting situations. Modest levels applied to image attributes.
□NL Neutral	2	Provides a good starting point for any image that will be subjected to extensive post-processing, as virtually no processing is applied in camera.
☑VI Vivid	4	Useful for images that will be printed directly from the camera. Saturation and contrast are relatively high.
Monochrome	3	Used for producing black and white images direct from the camera.

Hint: There is no indication in the control panel or viewfinder as to which picture control is selected, but if you press the **INFO** button the information will be shown in the bottom right corner of the shooting information display.

Note: Each of the four basic Picture Control options applies some degree of sharpening in the camera (see table above). This is embedded in all file types recorded by the camera. With JPEG and TIFF files, it is fixed and any sharpening applied in post processing will be cumulative. With a NEF RAW file the original sharpening can be removed, but only by selecting a different picture control option within Nikon Capture NX and then adjusting the settings. Unless you intend to produce finished pictures direct from the camera it is advisable not to apply sharpening in the camera, but as a last stage in post processing using a level that is appropriate for the size and method of display for the image.

Modifying a Picture Control

The PCS enables the user to modify any one of the four basic picture controls to create a custom picture control. Furthermore, once a custom picture control has been saved, it can be modified at any time.

Start by navigating to the [Set Picture Control] option, and to display the stored Picture Control options. Highlight the required option and press display the settings: use and to select the required attribute and use and to adjust its value. Alternatively, where available, you can use the quick adjust to select a preset combination of settings, these will be displayed against each attribute as you adjust the level in the guick adjust option. If at any time you want to restore a Picture Control to its original settings, press the ton. Press the (OK) button to save the settings you have selected. When you adjust the level of a Picture Control setting a vellow line is displayed beneath the previous level, for your reference. If a picture control is modified from its default, or original settings in the case of a custom picture control, it will be marked with an asterisk.

Note: At the default setting I find the brightness of the monitor screen is too high to accurately assess attributes such as color, saturation, brightness and contrast. If you modify a Picture Control and do not see the results you expect, try reducing the brightness of the screen display. Also remember that while the screen has greater resolution compared with previous Nikon D-SLR cameras, it is still not capable of displaying the gamut of colors defined by the Adobe RGB color space. Its capabilities are much closer to the narrower gamut of sRGB.

The settings available for each of the picture control options is outlined in the following table:

Option	Settings	
Quick adjust	Choose values between ±2 to reduce (negative value) or enhance (positive value) the effect of the selected Picture Control. This option resets any manually adjusted settings and is only available with the Standard or Vivid options.	
All Picture Controls		
Sharpening	A (auto), or a manually set value between 0 (no sharpening) and 9; the higher the value the greater the degree of sharpening.	
Contrast	A (auto), or a manually set value between ±3; negative values reduce contrast, while positive values increase contrast.	
Brightness	Choose values between ±1 to reduce (negative value) or enhance (positive value) brightness (luminance) of an image.	
Picture Controls (except Monochrome)		
Saturation	A (auto), or a manually set value between ±3; negative values reduce saturation, while positive values increase saturation.	
Hue	Manually set value between ±3; see description of the effect below.	
Monochrome Picture Controls only		
Filter effects	Use to emulate the effects of contrast control filters used with traditional black-and-white photography.	
Toning	Use to emulate the effect of chemical toners used in traditional black-andwhite photography.	

Sharpening: Sharpening is a process applied to digital data that can increases the apparent sharpness (acuity) of a picture. It is applied to correct the side effects of converting light into digital data, which often causes distinct edges between colors, tones, and objects in a digital picture to look ill defined (fuzzy). The process identifies an edge by analyzing the differences between neighboring pixel values. It then lightens the pixels immediately adjacent to the brighter side of the edge, and darkens the pixels adjacent to the dark side of the edge. This causes a local increase of contrast around the edge, making it appear sharper; the higher the level of sharpening applied, the greater the contrast at the edge.

If you select the automatic setting for this option you surrender all control to the camera and have no way of ensuring consistency in the degree of sharpening it applies; the camera will vary the amount of sharpening according to the nature of the scene being photographed. Scenes with a high degree of fine detail will receive a greater degree of sharpening, compared with scene that contains large area(s) of continuous tone.

Note: Sharpening is not a method for rescuing an out-of-focus picture – remember once out-of-focus always out-of-focus!

Hint: There is no single level of sharpening that is appropriate for all shooting conditions. The level of sharpening should be based on your ultimate intentions for the image (i.e. display on a web page, publication in a book or magazine, or producing a print for framing). Therefore, it is often preferable to apply sharpening during the final stages of post-processing, particularly if you want to work on images for a range of different output purposes.

I would make the following suggestions with regard to incamera sharpening when shooting with the D300:

- For general photography, using JPEG and TIFF format files
 If you intend to work on these images in post-processing, set sharpening to zero or a low value.
- For general photography, using JPEG and TIFF format files
 If you intend to print pictures direct from the camera without any further post-processing, set sharpening to a mid-range value.
- On occasions when you need to expedite the output of pictures for publishing on a web page or in newsprint, use the JPEG format and set the sharpening level in the mid to higher range. In this specific case a slightly stronger degree of sharpening is probably more appropriate, as images will be viewed on computer monitor screens or at low reproduction resolutions. It is probably also more prudent because it will save valuable time in post-processing.
- If you shoot in the NEF file format, I recommend setting sharpening to zero. Otherwise, there is a risk that any incamera sharpening, applied by a RAW file converter, will create a cumulative effect with any further sharpening that is subsequently applied.

Contrast: The contrast control allows you to adjust the distribution of tones in an image, and works by applying a curve control similar to those used in software for post processing. It is important to remember that it is far easier to increase contrast than reduce it. Therefore, I recommend that this control be used judiciously, if at all. This is especially important if you intend to subject the image to further contrast adjustments in post-processing.

If you select the automatic setting for this option, you surrender control to the camera and have no way of ensuring consistency in the degree of contrast adjustment it applies. **Brightness:** The brightness (luminance) control is used to make an overall image lighter or darker, while the contrast control is used to increase or reduce the difference between lighter and darker tones in an image. Adjusting the brightness affects all three color-channels (red, green and blue); a positive value increases brightness and a negative value decreases brightness.

Note: Adjusting the brightness level of an image does not affect the exposure.

Saturation: Adjusting the saturation of an image changes the overall vividness (chroma) of color without affecting the brightness (luminance) of an image. A positive value increases saturation and a negative value decreases saturation. As with contrast, I suggest you exercise restraint with the saturation control – over doing it will make returning an image to a more natural looking color a difficult task.

If you select the automatic setting for this option you surrender control to the camera and have no way of ensuring consistency in the amount of saturation it applies.

Hint: There will always be a degree of subjective opinion when assessing color, but I find the D300 tends to produce a slightly more saturated color than previous Nikon D-SLR cameras. I do not feel the extra punch in otherwise accurate colors produced by the Neutral Picture control and Adobe RGB color space is inappropriate, and this probably represents a good reference point when adjusting other Picture Controls.

Hue: The RGB color model (sRGB, or Adobe RGB), used by the D300 to produce images, is based on combinations of red, green, and blue light. By mixing two of these colors a variety of different colors can be produced. If the third color is introduced, the hue of the final color is altered. For example, by applying a positive adjustment reds will look more orange, greens more blue, and blues more purple. If you apply a negative adjustment the hue shifts so that red is more purple, blue is more green, and green is more yellow.

Hint: Personally, unless you need to produce images direct from the camera, I believe it is better to leave adjustment of contrast, saturation, brightness, and hue until post-processing. Appropriate software offers a far greater degree of control over these adjustments.

Monochrome - Filter Effects: In the Monochrome Picture Control there are options to select a filter effects that emulate the results of using contrast control filters with traditional black and white film. These filters modified the tonal response of the film to certain wavelengths (colors) of light. The options available in the D300 are off (default), yellow, orange, red, and green. Just like their optical filter counterparts, these filter effects reduce the amount of their complimentary color in the image. For example, the yellow, orange, and red options reduce the level of blue making a blue sky appear darker; the yellow filter has the least effect and the red the greatest. The result of this effect is an increase in the level of contrast between the blue sky and any white clouds, making the clouds more prominent. The green option reduces the amount of red making red and orange colors appear darker. This option can be useful for enhancing the range of skin tones in a portrait picture and making them appear more natural, and separating the tones of the various shades of green in landscape photography. Of course, you can also use the filters for creative purposes; for example, selecting the red option and shooting a portrait of a person with pale skin renders a result akin to taking the picture on black-and-white infrared film producing very light, almost white skin. The orange and yellow filter options have a lesser effect that can be useful for reducing the appearance of skin blemishes. My advice is to experiment with these options to determine if, how, and when they will best suit your needs.

Monochrome – Toning: In addition to the filter effects described above, the Monochrome picture control also offers a range of options that simulate the effects of traditional chemical toning of black and white prints. The options include black-and-white (default), sepia (yellow/brown), cyanotype (blue tint), red, yellow, green, blue-green, blue,

You can also select filter and toning effects when shooting in the monochrome picture control option.

purple-blue, and red-purple (similar to selenium toning). Once you have selected the [Toning] option and selected the desired tone press \bigvee to adjust the saturation of the toning effect (this is not available with the BW option).

Note: In company with the other image settings available under the PCS, the effects of the options available under filter effects and toning can all be achieved with a greater degree of control during post-processing. However, for images that will be output direct from the camera these options provide a good level of control.

Note: Regardless of the black-and-white option selected under the Monochrome Picture Control option, the D300 always saves black and white picture recorded in the NEF RAW format as an RGB file. Therefore, it can always be converted back to a full color image using the Picture Control utility in Nikon View NX or Nikon Capture NX v1.3, later.

Creating Custom Picture Controls

The four basic Nikon Picture Controls can be modified and the new settings saved to create a custom Picture Control. Starting from the Shooting menu, navigate to the [Manage Picture Control] option then press ▶ to display the available options, and highlight [Save/Edit]. Highlight the required Picture Control and press ▶ to open the options, adjust these as required and then press ৩ to display the Save As list (if you do not wish to modify the highlighted Picture Control press nin place of ▶, then press to display the Save As list). Up to nine different custom Picture Controls (C-1 to C-9) can be stored by the D300.

Highlight the destination of the custom Picture Control and press to display the text-entry dialog box. Use the controls beneath the text field to create a name for the custom Picture Control, with a maximum length of nineteen characters. Press to save the name and return to the Picture Control list. A Picture Control can be renamed at any time by using the [Rename] option in the [Manage Picture Control] option of the Shooting menu.

Sharing Custom Picture Controls

To copy a Custom Control to the D300, highlight the [Manage Picture Control] option in the Shooting menu and press

to display the options. Highlight [Load/Save] and press

then highlight [Copy to camera] and press

Highlight the required custom Picture Control and press

to display the Save As list. Select the destination for the custom Picture Control and press

to display the text-entry dialog box. Name the custom Picture Control, as described previously under Creating Custom Picture Controls. Finally, press

to save the name and return to the Picture Control list.

To copy a custom Picture Control to a memory card display the Load/Save menu as described above, highlight [Copy to card], and press . Highlight the required custom Picture Control and press to display the Choose

destination list. Select the destination for the custom Picture Control from one of the 99 locations listed and press to save the custom Picture Control to the memory card. If you select a destination that already has a custom Picture Control saved to it, it will be over-written by the new save command. A maximum of 99 custom Picture Controls can be stored on a memory card.

Managing Custom Picture Controls

To rename a custom Picture Control, highlight the [Rename] option in the [Manage Picture Control] option of the Shooting menu and press

. Highlight the required Picture Control and press to display the text-entry dialog box. Create the new name for the custom Picture Control. Finally, press
to save the name and return to the Picture Control list.

To delete a custom Picture Control from the camera, highlight the [Delete] option in the [Manage Picture Control] option of the Shooting menu and press . Highlight the required Picture Control and press to display the Yes/No options. Highlight the required option and press to confirm the action.

Note: The four basic Nikon Picture Controls (Standard, Neutral, Vivid, and Monochrome) cannot be renamed or deleted.

To delete a custom Picture Control from a memory card, highlight the [Load/Save] option in the [Manage Picture Control] option of the Shooting menu and press ▶ to display the list of custom Picture Controls stored on the card. Highlight the desired custom Picture Control and either press ▶ to display its settings, or press ❤ to display the Yes/No options in the Delete from card dialog box. Highlight the required option and press ❤ to confirm the action.

Active D-Lighting

Active D-Lighting is a feature first found on the Nikon D40-series D-SLR cameras; it has since been adopted for more sophisticated models such as the D300. Active D-Lighting (not to be confused with the D-Lighting option available in the retouch menu) applies a localized adjustment to contrast to improve the rendition of areas of deep shadow and bright highlights. It can be thought of as an automated dodge and burn effect. It is only available with Matrix metering, which is used to assess scene contrast. If necessary it will modify exposure by reducing it accordingly to preserve highlight detail, then after the exposure has been made and the image data is being processed the shadow and middle tones are adjusted to optimize the dynamic range by adjusting the tone curve of the image.

I recommend restraint if using Active D-Lighting feature by choosing either the Low or Normal settings if recording JPEG or TIFF files; there is only one file created, unlike the normal D-Lighting feature in the retouch menu where a copy file is created from the original to which the adjustments are applied. Any Active D-Lighting setting applied to a NEF RAW file can always be modified later, using Nikon Capture NX software. If the effect of the Active D-Lighting setting is too strong it may compromise the tonal range of the entire image, especially if the contrast in the scene is very high.

To select Active D-Lighting, highlight the item in the Shooting menu and press to display the options: Off, Low, Normal, and High. Highlight the required option and press to confirm the selection and return to the Shooting menu.

Color Space

A color space (sometimes called color gamut) defines the range of colors that are available for reproduction and what particular RGB values should represent those colors in the digital image file. Unless you know your pictures will only ever be displayed on a computer monitor (i.e., as part of a

Web page) or you will be using a direct printing method with no intention of carrying out any post-processing, I would recommend using the Adobe RGB color space – it provides the widest range of colors, permitting more subtle rendition and well-graduated tonal transitions. This increases the flexibility of an image file that will be subjected to post-processing, and the quality of any print made from that image file produced by an appropriate printing process. The sRGB color space is ideal for an image that will be used directly from the camera with no post-processing.

To choose a color space, highlight the [Color space] option in the Shooting menu and press ▶ to display the two choices: sRGB (default) and Adobe RGB. Highlight the required option and press ᅟ to confirm the selection, returning to the Shooting menu.

Hint: It is essential that any software used for post-processing be set to the same color space as the image file recorded by the camera. Otherwise, the application will more than likely assign its own default color space and you will lose control over the rendition of colors.

Shutter Release

The shutter release button of the D300 is located, conventionally, on the top, right end of the camera. When the camera is switched to ON, a light pressure on the shutter release button that depresses it halfway will activate the metering system and initiate autofocus (assuming an autofocus mode has been selected). Once you release the button the camera remains active for a fixed period of time, the duration of which depends on the selection made within CS-c3 (Auto Meter-off Delay); 6-seconds is the default setting.

If you continue to press the shutter release button until it pushed down fully, the shutter mechanism will operate and an exposure will be made. There is a short delay between pressing the button all the way down and the shutter open-

The D300's shutter release can be pressed half way to activate focus and metering. Pressing it completely fires the shutter and an image will be captured.

ing. This delay is usually referred to as shutter "lag." The shutter release lag time of the D300 is approximately 45-milliseconds, only slightly longer than that of the D3 camera. The mirror black out time is approximately 90-milliseconds when shooting at a frame rate of 6 fps, and drops to approximately 86-milliseconds when the frames rate is raised to 8 fps. (1-millisecond = 1/1000 second)

However, if certain features and functions are in operation at the time the release button is pressed, the release of the shutter can be delayed further or, in some cases, prevented. The following are some of the reasons for causing an extended delay in shutter operation:

• The capacity of the buffer memory is probably the most common cause of shutter delay. It does not matter whether you shoot in single or one of the continuous shooting modes (see below for description); once the buffer memory is full, the camera must write data to the memory card before any more exposures can be made. As soon as sufficient space for another image is available in the buffer memory, the shutter can once again be released. For this reason, using memory cards with a fast data write speed is recommended. The D300 supports the UDMA-standard, so using UDMA compliant memory cards (i.e., Lexar x300 or SanDisk Extreme IV types), makes sense.

- If the camera is set to single-servo autofocus mode the shutter is disabled until the D300 has acquired focus. In low light or low contrast scenes the autofocus system will often take longer to achieve focus, adding to the delay (see D300 Shooting Operations In Detail – Limitations of AF System page 196 for a full explanation). Although, CS-a2 (AF-S Priority selection) allows this priority to be overridden.
- In low light conditions, the D300 will activate the AFassist lamp (if its operation is selected via CS-a9, and the required camera settings have been made), which introduces a short delay while the lamp illuminates and focus is acquired.

Note: The AF-assist lamp only operates in single-servo autofocus mode, either Auto-area AF mode, or if single-point or dynamic-area AF is selected with the center AF point active.

• The Red-eye reduction function (one of the flash modes available on the camera) introduces an additional, and significant, one-second delay between pressing the shutter release button and the exposure being made. This is the time the lamp takes to emit a light that causes a subject's pupils to constrict before the shutter opens and the flash unit fires.

Shooting Modes

Obviously, unlike a 35mm film camera, the D300 does not have to transport film between each exposure. Therefore, it does not have a motor drive, but the shutter mechanism still has to be cycled. The camera offers a range of shooting modes: single-frame, continuous-frame, a self-timer option,

mirror lock-up, plus a new feature known as Live View that provides a real time image on the camera's monitor screen to enable focusing and composition of a picture.

The camera set for continuous low-speed shooting.

To set the shooting mode, hold down the shooting mode dial lock button and rotate the dial to the required position:

S single frame, CL continuous low-speed, CH continuous high-speed, W Live View, S self-timer, Mup mirror-up.

Single Frame

A single image is recorded each time the shutter release button is pressed. To make another exposure the button must be released, then pressed again. You can continue to do so until the buffer memory is full, in which case you must wait for data to be written to the memory card. The shutter release button will also become locked if the memory card becomes full.

Hint: You do not have to remove your finger from the shutter release button completely between frames; by raising it slightly after each exposure but maintaining a slight downward pressure on the shutter release button, you can keep the camera active and be ready for the next shot.

Hint: If you want to take a rapid sequence of pictures in single-frame mode, avoid "stabbing" your finger down on the shutter release button in quick succession. Keep a light pressure on the button and roll your finger over the top of the button in a smooth, repeating action. This will reduce the risk of camera shake spoiling your pictures.

(L Continuous Low-Speed

Continuous-low speed: In this mode, if you press and hold the shutter release button down, the D300 will continue to record images up to a maximum rate of 6-frames per second (fps). The actual frame rate can be set via CS-d4 (CL mode shooting speed).

CH Continuous High-Speed

In this mode, if you press and hold the shutter release button down, the D300 will continue to record images up to a maximum rate of 6-frames per second (fps).

Note: The quoted frame rates for the D300 are based on the camera being set to continuous-servo AF, manual or shutter-priority auto exposure mode, and a minimum shutter speed of 1/250-second. It is important to remember that buffer capacity, other auto-exposure modes, and single-servo auto-focus (particularly in low-light) can, and often does, reduce the frame rate significantly.

Note: The maximum number of exposures that can be made in a single sequence can be set via CS-d5 (Max continuous release).

Self-Timer

The self-timer option is used to release the shutter after a predetermined delay. The default delay is 10 seconds, but it can be adjusted to 2, 5, or 20 seconds via CS-c3. Traditionally, the self-timer has been used to enable the photographer to be included in the picture, but there is another very useful function for this feature. The self-timer enables the photographer to release the shutter without touching the camera, thus reducing the chance of camera shake. This is particularly

The camera set for self-timer operation.

useful for long exposures when the subject is static and precise timing of the shutter release is less critical. To use the self-timer, the camera should be placed on an independent means of support, such as a tripod. Compose the picture and ensure focus is confirmed before depressing the shutter release button (the shutter release will be disabled unless focus is acquired).

Hint: Make sure you do not pass in front of the lens after setting the self-timer, as autofocus operation may shift the point of focus and prevent the camera from operating. I recommend that the camera be set to manual focus mode when using the self-timer feature.

Note: If the P, A, and S automatic exposure modes are used in conjunction with the self-timer feature it is essential to cover the viewfinder eyepiece with the supplied DK-5 eyepiece cap. In normal shooting, the photographer has their eye pressed to the viewfinder, which blocks extraneous light from entering the viewfinder eyepiece and influencing the camera's TTL metering sensor (located in the viewfinder head above the eyepiece). If you fail to cover the eyepiece, exposures will be inaccurate.

Hint: Fitting the DK-5 eyepiece cap requires the user to remove the DK-23 rubber eyecup; this is a nuisance and increases the risk that the eyecup might be lost. I recommend keeping a small square of thick felt material in your camera bag; drape this over the viewfinder eyepiece when using the self-timer mode. It is far quicker and more convenient!

After the shutter release button is pressed, the AF-assist lamp will begin to blink (if the audible warning is active, it will also beep) until approximately two seconds before the exposure is due to be taken. At this point, the light stops blinking and remains on continuously (the frequency of the audible warning beep will increase) until the shutter is released. To cancel the self-timer operation during the countdown, turn the shooting mode dial to another release mode.

The camera set for mirror lock up.

Mup Mirror-Up

The mirror-up **Mup** option should not be confused with the [Mirror-up] option available via the Setup menu, which is used to facilitate inspection and cleaning of the low-pass filter. By locking the reflex mirror into its raised position, the vibrations that can often occur when the reflex mirror lifts up out of the light's path to the camera's sensor are eliminated. These vibrations are particularly troublesome at shutter speeds between 1/2-second and 1/30-second. However,

once the mirror is locked into the up position it is not possible to see through the viewfinder. The photographer must confirm exposure, composition, and focus before initiating this mode

Note: Once in the raised position the reflex mirror prevents light from reaching the 1005-segment RGB metering sensor located in the viewfinder head. Likewise, autofocus detection is no longer possible; in autofocus modes the focus distance is locked at the distance set prior to the mirror being raised.

The mirror lock-up feature has two distinct phases; the first press of the shutter release button will cause the mirror to lift and lock in its raised position. The shutter release button must be pressed a second time to operate the shutter and make the exposure. Once the exposure has been completed the mirror will return to its normal position. It is important to pause briefly between these two phases to allow any vibration caused by the mirror movement to dissipate.

Lv Live View

The Live View setting sends a real time video signal, which has a refresh rate of 24 fps, to the monitor screen. This enables pictures to be composed in situations when using the optical viewfinder is difficult. It can be very helpful when using the camera in a low position or when the enlarged view offered by the monitor screen will assist in precise focusing. (See page 130 for a full description.)

Using a Remote Release

Since the purpose of using the mirror lock-up feature is to eliminate camera vibrations it is counter-productive to touch the camera by pressing the shutter release button after the mirror has been raised. To reduce any other potential sources of vibration, mount the camera on a tripod, or other type of rigid camera support, and use a remote shutter release to operate the shutter.

The D300 has a 10-pin terminal for connecting a variety of remote release accessories. The most useful is probably the MC-30 cord, which is 2ft 7in (80cm) long (see General Nikon Accessories, page 363, for details on other remote release accessories compatible with the D300).

Power Source and Frame Rate

In addition to buffer capacity, auto-exposure modes, and single-servo auto-focus (particularly in low-light), the frame rate of the D300 is affected by the choice of power source used in the camera. The varying frame rates are outlined in the following table:

Power Source	Maximum frame rate 1	
EN-EL3e battery	6 fps ²	
EH-5 / EH-5a AC adapter	8 fps ³	
MB-D10 battery pack with EN-EL3e	6 fps ²	
MB-D10 battery pack with EN-EL4a	8 fps ³	
MB-D10 battery pack with x8 AA batteries 4	8 fps ³	

- 1 Maximum frame rate when the camera is set to record NEF RAW or NEF RAW + JPEG files with 14-bit selected for recording NEF RAW is 2.5 fps regardless of the power source.
- 2 Maximum frame rate with the EN-EL3e battery is always 6 fps, even when 7 fps is selected at CS-d4 (CL mode shooting speed).
- 3 Maximum frame rate in (icon 22) mode is 7 fps. If the [ISO sensitivity auto control] option in the Shooting menu is set to ON, the maximum frame rate in (icon 23) mode is 7.5 fps.
- 4 Low ambient temperatures and use of partially used batteries will affect the maximum frame rate.

Multiple Exposure

The Multiple Exposure feature of the D300 enables a number of exposures (a maximum of ten), shot in sequence, to be combined into a single image. The images are not saved individually, but rather as a single combined image.

To use Multiple Exposure:

- Highlight [Multiple Exposure] in the Shooting menu, and press ► .
- 2. Highlight [Number of Shots] and press ▶ , then use and ▼ to select a figure between 2 10.
- 3. Press to confirm the selection and return to the Multiple Exposure menu.
- 4. Highlight [Auto Gain] and press ▶ , then highlight either On or Off and press ☻ to confirm the selection and return to the Multiple Exposure menu.
- 5. Highlight [Done] and finally press .
- 6. Frame and shoot the images you wish to combine. In either of the continuous release modes, the camera can record all exposures in a single sequence and will stop once the designated number has been recorded. In single release mode an exposure is made each time the shutter release is pressed; you must continue to take pictures until the designated number has been recorded.
- 7. To interrupt the multiple exposure feature before the designated number of exposures have been recorded, press the **menu** button to highlight the [Multiple Exposure] option in the Shooting menu and press ▶ to display the [Cancel] option. Press ❤ to confirm the action.

Hint: When Auto Gain is turned ON the camera will automatically make adjustments to the exposure level of each image recorded in the sequence, so the final cumulative exposure is correct. This useful feature eliminates the need to make exposure calculations to compensate for the cumulative effect of combining the individual exposures.

A small double exposure icon will appear in the control panel while the exposures are being made. When the selected number of exposures has been completed it will disappear from the control panel, and the multiple exposure feature is automatically turned off. To create another multiple exposure sequence at different settings, you will need to repeat steps 1-6 above. However, to shoot another multiple exposure sequence using the same settings for [Number of Shots] and [Auto Gain], simply select [Done] from the options under the [Multiple Exposure] option and press

Interval Timer Shooting

The Interval Timer Shooting feature of the D300 enables a set number of pictures of the same scene to be shot over a specified period of time, at predetermined intervals – a technique often called time-lapse photography, which has application in both scientific and pictorial photography.

Given a suitable subject or scene this technique can produce some visually interesting results – especially if you play the images sequentially in a slide show. For example, the opening and closing of a flower head during the course of a day or the changes that take place at a busy street corner every few minutes during rush-hour can be fascinating to observe. The D300 provides you with the ability to capture such changing conditions using the [Interval Timer Shooting] option in the Shooting menu.

To configure the camera for Interval Timer Shooting involves several steps but the results are definitely worth the effort. Due to the prolonged duration of time required for some time-lapse sequences, it may be necessary to use the EH-5, or EH-5a, AC adapter. If an AC adapter is not available, make sure the EN-EL3e battery is fully charged, or better yet use the MB-D10 battery pack. This will enable you to combine the EN-EL3e battery installed in the camera with another, or with the EN-EL4a battery for an even higher capacity, extending the potential shooting period.

Note: Precise and consistent framing is often an important aspect of time-lapse photography. I recommend the use of a tripod or other form of sturdy, rigid camera support.

To configure Interval Timer Shooting:

- Highlight [Interval Timer Shooting] in the Shooting menu and press
- 2. Two options are presented in the Choose start time dialog box.

Now – The camera will initiate the shooting sequence approximately 3 seconds after settings have been confirmed in the camera.

Start time – The camera will delay the beginning of the shooting sequence until the specified time.

- 3. If Start time is selected, press ▶ to set the time at which you wish the first image to be taken. Press ▶ and ▼ to highlight hours or minutes and press ♠ and ▼ to adjust the settings. The maximum delay is 23 hours 59 minutes. (If [Now] was selected for Start time this step is skipped.) Once the settings have been made, press ▶ to highlight the [Interval Setting] options.
- 4. Press ▶ and ◀ to highlight hours, minutes, or seconds; and press ▲ and ▼ to adjust setting for the time interval between each single exposure, or between each sequence of exposures. The maximum duration is 24 hours. Once settings have been made, press ▶ to set the number of intervals and number of shots.
- 5. Press ▶ and ◀ to highlight the number of intervals and number of shots, and press ▲ and ▼ to adjust the setting for each. The first number in the equation is the number of intervals. Use ▶ to select each of its three digits. The second number is the number of shots at each interval. The third number is the total number of shots that will be fired throughout the duration of the Interval Timer Shooting process (the maximum num-

ber of intervals is 999, and the maximum number of shots at each interval is 9). Once the settings have been made press

to highlight the [Start] options.

6. Highlight [On] and press to initiate the timer sequence. Highlight [Off] to save the settings without initiating the timer sequence.

Once Interval Timer Shooting has been set correctly and is activated, a TIMER ACTIVE message will appear in the monitor screen momentarily, and INTERVAL is displayed in the control panel, blinking. The number of intervals remaining will be displayed in the shutter speed display, while the number of exposures remaining in the current interval will be displayed in the aperture display until the full shooting sequence has been completed. To view this information at any time during Interval Timer Shooting, press the shutter release button down half way.

Interval Timer Shooting can be paused by doing any of the following:

Pressing button between intervals.

• Highlighting the [Pause] option in the interval timer menu and pressing
 .

• Turning the camera off and then on again.

• Selecting Lv , 🖒 , or Mup .

To resume Interval Timer Shooting, open the Interval Timer menu and set a new start time as described above, then press . Highlight [Restart] in the displayed options and press .

Note: It is possible to apply exposure and white balance bracketing during Interval Timer Shooting. The settings for the bracketing sequence must be set before interval timing commences. In exposure bracketing the camera will take the number of exposures specified in the bracketing sequence regardless of the number of shots set in the interval timer option. If white balance bracketing is set, the camera will make a single exposure at each interval and create the number of images specified in the bracketing sequence.

The camera set for the Live View function.

Live View

The D300, along with the D3, were the first Nikon D-SLR cameras to feature a Live View (LV) function. Essentially, the system provides a real time video signal to the camera's monitor screen, which refreshes at 24 fps, showing a view of the scene the lens is pointed towards (the same view seen through the camera's optical viewfinder). This enables pictures to be composed in situations when using the optical viewfinder is difficult, such as when the camera is in a very low position or when the enlarged view offered by the monitor screen will assist in precise focusing.

The method of focusing used by the camera depends on the LV option selected. In the Hand-held mode the camera uses the same phase-detection autofocus as normal, with focus controlled by the Multi-CAM 3500 DX AF sensor; thus, focus is set using the fifty-one AF points. However, in Tripod mode the camera switches to contrast-detection autofocus, which uses information from the camera's CMOS sensor to assess contrast at the selected focus point and adjust focus to produce the highest level of contrast. The advantage of this option is that the point of focus can be selected from anywhere within the frame area.

Obviously, the reflex mirror of the camera must be raised for the LV mode to operate, so the optical viewfinder is blacked out when LV is active. The only time this is not true is when the camera briefly lowers the mirror to allow the camera to meter exposure, adjust any necessary flash value, set focus using the phase detection method in Hand-held mode, and set auto white balance. If you press the shutter release button all the way down in LV mode, the mirror being lowered creates the sound of a double shutter release, which can be misinterpreted as a double exposure. The double shutter release sound is quite normal and only a single exposure is made.

One notable disadvantage of the LV system is that the mirror lock-up feature cannot be used. However, to help offset the effects of internal camera vibration CS-d9 (Exposure delay mode) can be selected, but its one-second delay is no substitute for a proper mirror-lock up feature.

Note: The Live View feature of the D300 is also supported by Nikon Control Pro 2 software, enabling the monitor screen view of the camera to be replicated on a computer screen. All camera controls can be performed from the computer, either via a hard wire connection or a wireless network (using the WT-4 / WT-4a wireless transmitter).

Note: One matter that is not mentioned in the Nikon D300 User's manual is the use of non-CPU type lenses with Live View. The assumption must be that Live View does not support this type of lens. However, provided the camera is set to manual exposure mode, manual focus, and the relevant lens data is entered via the [Non-CPU lens data] option in the Setup menu, it appears that Live View can still be used with these lenses.

Live View Options

The first phase in using the LV mode involves setting the desired LV mode (Hand-held, or Tripod mode) and the release mode. The Hand-held mode is intended for photographing subjects, including moving ones, when it is awkward to frame the image using the normal optical viewfinder. The Tripod mode is intended for photographing static subjects under more controlled conditions,

such as in a studio, when the ability to enlarge the view of the subject on the monitor screen to assist in precise focusing can be a real benefit. The release modes available in LV mode are: single frame, continuous low-speed, and continuous high-speed.

To select the LV mode highlight the [Live view] option in the Shooting menu and press ▶ then highlight [Live view mode] and press ▶ . Finally highlight the desired mode and press ★ to confirm the selection. Now, highlight [Release mode] and press ▶ and highlight the required option before pressing ★ to confirm the selection. Press the shutter release button half way to return the camera to its shooting mode.

Hand-Held Mode: If Hand-held mode is selected as the LV mode, turn the mode dial to the LV position and press the shutter release button all the way down. The mirror lifts and the view through the lens is displayed on the monitor screen. To improve focus accuracy it is advisable to pause briefly with the release button pressed halfway down to allow the camera to acquire focus, before pressing the release the rest of the way down to raise the mirror. To exit from LV mode without making an exposure, either rotate the mode dial to an alternative release option or press the Menu button.

Compose the picture as you desire. If you want to magnify the image on the screen by up to three-times, press the (icon 58) button. Use the navigation window in the lower right corner of the monitor screen as a guide to the area of the image being displayed. Press the button to reduce the magnification, or press to return to the normal view.

To choose the focus area, the button can be used to scroll between the 51 AF points and choose the one to be used. To set focus automatically, align the selected AF point with the subject and press the shutter release button or the AF-ON button; the mirror will lower to its normal position while either button is depressed blacking out the monitor screen. Let go of whichever button you used to acquire focus and the mirror will lift, restoring the LV display. If you

choose to use manual focus, simply turn the focus ring until the image on the monitor screen appear to be sharp (again you can magnify the image to assist in this process).

Finally, press the shutter release button all the way down to make an exposure. The camera will check and adjust focus, exposure, and white balance before making the exposure. If you shoot using a continuous release mode the monitor screen will turn off while the shutter release button is depressed.

Note: When the shutter release button is pressed halfway down or the AF-ON button is pressed, the sound of the mirror being lowered and raised when the button is released (in Hand-Held mode) can be mistaken for the operation of the shutter. No exposure is made in this situation.

Note: If the camera cannot acquire focus in single-servo AF mode when the shutter release is press down all the way, LV mode is cancelled and no photograph is recorded.

Tripod Mode: If Tripod mode is selected as the LV mode, turn the mode dial to \Box , mount the camera on a tripod or other form of stable platform, then look through the viewfinder. Point the camera at the subject before pressing the AF-ON button to activate autofocus (autofocus is not activated by pressing the shutter release down half way). Adjust the exposure, composition, and selection of focus point. Press the shutter release button all the way down; the mirror will lift and the view through the lens is displayed on the monitor screen (the viewfinder will now be blacked out). To exit from LV mode without making an exposure, either rotate the mode dial to an alternative release option or press the Menu button.

Compose the picture as you desire. If you want to magnify the image by up to 13x, press the (icon 58) button. When the view is magnified a navigation window appears in the lower right corner of the monitor screen; use this as a guide to view areas of the frame not displayed on the monitor

In Tripod mode you can select the focus point used for contrastdetect AF anywhere within the frame. The active focus point will remain green if the camera has successfully acquired focus.

screen while scrolling over the image using Screen while screen w

In Tripod mode, the focus point that is using the contrast-detect AF can be positioned anywhere within the frame using the multi selector . To adjust focus, press the AF-ON button. The AF point (marked in green) will blink, and you may observe the brightness of the monitor screen alter as the camera performs AF. Contrast-detect AF is significantly slower than phase-detection; you may need to be a little patient at this point! If the camera can acquire focus, the focus point will remain green and stay on continuously. However, if the camera is unable to obtain focus, the AF point will change to red and blink. If you hear a low chattering noise as the lens is focusing, this is quite normal. If you use manual focus, simply turn the focus ring until the image

on the monitor screen appears to be sharp (again you can magnify the image to assist this process). The AF point remains shown in red when focusing manually.

Finally, press the shutter release button all the way down to make an exposure. The camera will check exposure and white balance and adjust them if necessary before making the exposure. If you shoot using a continuous release mode the monitor screen will turn off while the shutter release button is depressed.

Note: The brightness of the monitor screen in either LV mode can be adjusted by pressing and holding the button, then using either ▲ , to increase brightness, or ▼ , to reduce brightness.

Note: It is possible to use a remote release cord, such as the Nikon MC-30, to activate the AF in Tripod mode. The release button of the remote cord must be pressed down half way for at least a second. Avoid pressing the release button all the way down, as AF will not be activated and the shutter will be released.

Note: LV mode will cause the internal circuitry of the D300 to become warm, especially over an extended period of operation. This may lead to an increase in the level of noise and/or a distortion of colors recorded by the camera. LV mode can be used for a maximum period of 60 minutes. If you exceed this time period, protective circuitry in the camera will automatically shut down LV mode, using a 30-second countdown, to prevent the camera from overheating. In extremely high ambient temperatures, this feature may activate as soon as LV mode is switched on.

Note: If you remove the lens from the camera when it is set to LV mode, shooting will immediately cease.

Caution: Never point the camera at the sun or other very strong light source, when using LV mode. Damage may be caused to the sensor or other associated electrical circuitry.

Note: Under certain types of light sources that emit light in a series of charge and decay cycles (i.e., fluorescent, mercury vapor, and sodium lights), you may observe distortion and/or banding effects on the monitor screen. These effects will occur if the frequency of light emission does not correspond to the 24 fps refresh rate of the image displayed on the monitor.

Note: If you pan the camera in LV mode, or a subject moves across the frame at high speed, you may observe distortion and/or banding effects on the monitor screen. Similarly, very bright light sources may create ghost images if the camera is panned. These effects are due to the fact that the image displayed on the monitor is refreshed at 24 fps (i.e. it is not a continuous image).

Note: If the P, A, and S automatic exposure modes are used in conjunction with the LV feature it is essential to cover the viewfinder eyepiece with the supplied DK-5 eyepiece cap. In normal shooting the photographer has their eye to the viewfinder, which blocks extraneous light from entering the viewfinder eyepiece and influencing the camera's TTL metering sensor that is located in the viewfinder head above the eyepiece. If you fail to cover the eyepiece exposures will be inaccurate.

Hint: Fitting the DK-5 eyepiece cap requires the user to remove the DK-23 rubber eyecup; this is a nuisance and increases the risk that the eyecup might be lost. I recommend keeping a small square of thick felt material in your camera bag; drape this over the viewfinder eyepiece when using the self-timer mode, as it is far quicker and more convenient!

Image Review Options

One of the most useful features of a digital camera is the ability to get near instant feedback on photographs as you shoot. Using the playback functions on the D300 will allow you to see, not only, the images you have taken but also a range of useful information about them.

The 3-inch, 920,000-dot, color TFT LCD monitor screen of the D300 offers a viewing angle of 170°. As with the viewfinder display, the monitor screen shows virtually 100% of the image file when it is reviewed. Pictures can be displayed either as a single image, or in multiples. When used to display a single image, the review function has a zoom facility that enables the view to be enlarged by up to 27x, producing a near 400% view (full magnification is only available with files shot at the large size, 4,288 x 2,848 pixels). To get a 100% view (i.e. an actual pixel view) step back two presses from full magnification, using the 🏻 button. At this magnification it is possible to make a sound assessment of the sharpness and noise level in the image. As far as considering color and contrast, any critical analysis should be left until the image is displayed on a computer monitor screen, but the screen of the D300 can certainly provide a good representation of the image. You must remember that the preview image. including those for NEF RAW files, is always derived from a JPEG file to which in-camera processing (white balance, contrast, saturation, etc) has been applied. A NEF RAW file will contain more data and have a wider range of tonal values; therefore, an overexposed highlight in the JPEG preview may not be an overexposed highlight when the NEF RAW file is examined in a RAW file converter such as Nikon Capture NX.

Hint: At the default setting the screen of the D300 is overly bright; try selecting -1 for the [LCD brightness] option in the Setup menu.

Immediately after taking an exposure on the D300, the image review will provide a brief display of the photograph on the LCD monitor (assuming On is selected for [Image review] in the Playback menu). In single frame and self-timer shooting modes, the image is displayed almost immediately after the exposure is made. In either of the continuous shooting modes, the camera must write the image data from the buffer memory to the memory card for each image recorded before they can be viewed, so a short delay is induced; the camera displays each image chronologically as soon as it has been saved.

Note: Select [Off] for the [Image review] option in the Playback menu if you do not want the camera to display the image automatically after shooting. This can help conserve battery power.

Single-Image Playback

To view the last image recorded by the camera press the
▶ button. If you wish to view other images saved on the memory card, press
■ and ▶ to scroll through them. To return to the shooting mode, press the ▶ button again - although the quicker method, if you are in the midst of shooting, is to press the shutter release button down halfway.

Note: If you want images shot in an upright (vertical) composition to be displayed in the correct orientation select ON for the [Auto Image Rotation] option in the Setup menu.

Information Pages

A very useful feature of the image playback function on the D300 is the host of information that can be accessed while viewing the image on the monitor screen. This information can help ensure that you have achieved a good exposure, as well as give you detailed information about how, when, and where the exposure was made. Depending on the selections made in the [Display Mode] option in the Playback menu, and whether an image file contains data recorded from an attached GPS, there are up to seven different pages of information that can be displayed for each image file viewed on the monitor screen.

To access these information displays, press to scroll through each page in the following order: File information (Highlights warning), RGB and Composite Histograms, Shooting Data (1), Shooting Data (2), Shooting Data (3), GPS Data (only displayed if file contains GPS data), and Overview data. Press to scroll through in the reverse order.

The File information and Overview data pages are always displayed. The four additional pages can be selected/deselected through the [Detail photo info] option of the [Display

Mode] option of the Playback menu: RGB and Composite Histograms, Shooting Data (1), Shooting Data (2), and Shooting Data (3). A highlights warning and focus point information can be selected using the [Basic photo info] option of the [Display Mode] option of the Playback menu.

Note: GPS data is only available if the displayed image file contains data recorded from a GPS unit attached to the camera at the time the exposure was made.

File Information: Displays an unobstructed view of the image while providing additional information.

Displays: Protect Status

Retouch indicator

Image highlights (set from Display Mode

in Playback menu)

Focus point (set from Display Mode in

Playback menu) AF area brackets

Frame Number/Total Number of Frames

File Name Image Quality Image Size

Image authentication Time of Recording Date of Recording Folder Name

Highlight display indicator

RGB Histogram: Provides an individual histogram for each of the red, green, and blue channels, together with an RGB composite histogram and a thumbnail of the image file.

Displays: Protect Status

Image Highlights Highlights warning

Folder Number/File Number Histogram – RGB composite Histogram – Red Channel Histogram – Green Channel Histogram – Blue Channel Current Channel

Note: This page will only be displayed if [RGB Histogram] is selected in the [Display Mode] option in the Playback menu.

Note: To show a highlight warning display, which indicates areas of the image that may be over-exposed, press

while holding the

button down. This will scroll through a highlight warning for each channel; a yellow frame will surround the histogram of the selected channel.

Shooting Data Page 1: A block of information will be displayed superimposed over the center portion of the screen, obstructing the view of the image.

Displays:

Protect Status Retouch indicator Metering Method Shutter Speed **Aperture** Exposure Mode ISO sensitivity (displayed in red if ISO auto control was on) Exposure Compensation Optimal exposure tuning Focal Length Lens data Focus mode VR lens (only displayed if VR lens attached) Flash mode Flash compensation Commander mode/group name/flash control mode Camera name Folder Number/Frame Number

Note: This screen can be particularly useful if you are trying to achieve similar results in a similar environment, learn about your shooting style, and learn what settings produce particular results.

Note: This page will only be displayed if [Data] is selected in the [Display Mode] option in the Playback menu.

Shooting Data Page 2: A block of information will be displayed superimposed over the center portion of the screen, obstructing the view of the image.

Displays:

Protect Status Retouch indicator

White Balance/color temperature/ WB

fine-tuning/preset

Color space

Picture control / Quick adjust / Original picture control

Sharpening Contrast Brightness Saturation Filter effects

Hue Toning Camera name

Folder Number/Frame Number

Note: This screen can help you understand the effects of image settings and adjustments on the appearance of your picture.

Note: This page will only be displayed if [Data] is selected in the [Display Mode] option in the Playback menu.

Shooting Data Page 3: A block of information will be displayed superimposed over the center portion of the screen, obstructing the view of the image.

Displays:

Protect Status Retouch indicator

High ISO noise reduction/Long exposure

noise reduction Active D-Lighting Retouch history Image comment Camera name

Folder name/frame number

Note: This page will only be displayed if [Data] is selected in the [Display Mode] option in the Playback menu.

GPS Data: A block of information will be displayed superimposed over the center portion of the screen, obstructing the view of the image.

Displays:

Protect Status

Retouch indicator

Latitude Longitude Altitude

Coordinated Universal Time (UTC) Heading (only displayed if GPS unit has

electronic compass)

Folder number/Frame number

Note: This screen will only be displayed if the camera was connected to a compatible GPS unit that was switched on and active at the time the exposure was recorded

Overview Data: Provides a thumbnail view of the image file with two panels of information.

Displays:

Folder number/Frame number

(upper panel)

Protect Status Camera name Retouch indicator

Histogram (composite only)

ISO sensitivity Focal length

GPS data indicator

Image comment indicator

Flash mode

Flash compensation Exposure compensation

Metering method Exposure mode Shutter speed Aperture

Displays: (lower panel)

Picture control Active D-Lighting

File name Image quality Image size

Image authentication indicator

Time of recording Date of recording Folder number

White balance/Color temperature/White balance fine-tuning/Preset manual

Color space

Viewing Multiple Images

To scroll through the images use ③; a yellow border surrounds the image currently highlighted. Once highlighted, you can use ① to return the image to a full frame view (press ① to return to the thumbnail view). The highlighted image can be protected by pressing (icon 60) and deleted by pressing ② . To return to the shooting mode press the ② button or the shutter release button.

Playback Zoom

The image displayed on the monitor screen is usually too small to check its sharpness with any certainty. The playback zoom will allow you to enlarge a large size image by up to 27x (equivalent to a 400% view on a computer screen), a medium size image up to 20x, and a small size image up to 13x.

To zoom into the image displayed on the monitor screen, press the \mathfrak{R} button. The image will appear slightly enlarged. To increase the degree of magnification, press the

button. A navigation window is displayed when the zoom ratio is changed; the area currently visible in the monitor screen is shown with a yellow border. To move around the enlarged image, use . To view the same area at the current zoom ration in other images, rotate the main command dial. This is a useful feature if there are a number of similar images of the same subject on your memory card and you want to check a specific detail, such as a certain person's eyes in a group portrait. To return to the shooting mode press the button or the shutter release button.

Protecting Images

To protect an image against inadvertent deletion, display the image on the monitor screen in full-frame single image playback and press the button. A small key icon will appear in the upper left corner, superimposed over the image. To remove the protection, open the image and press again. Check to make sure the key icon is no longer displayed.

Don't forget that reformatting a memory card will erase protected images. Always make sure you have downloaded files before reformatting the card.

Note: Any protected image will be "deleted" if the memory card is formatted. The protect status is preserved when any image file is transferred to another storage device, or computer.

Deleting Images

Images can be deleted using one of two routes. The quickest and easiest way is to press the button when the image to be deleted is displayed on the monitor screen. The first press of the button opens a warning dialog box that asks for confirmation of the delete command. To complete the process, simply press the button again. To cancel the delete process, press the button to return to viewing the image. Images can also be deleted via the [Delete] option in the Playback menu. There are two options: delete selected images, or delete all images stored on the memory card.

Assessing the Histogram Display

The shape and position of the histogram curve indicates the range of tones that have been captured in the picture. Dark tones are distributed on the left side of the histogram graph and light tones on the right. In a picture of a scene containing an average distribution of tones with a few areas of dark shadow, a wide number of mid-tones, and a few bright highlights; the curve will start in, or near, the bottom left corner, raise through the center and lower back down to, or close to, the bottom right corner. In this case a wide range of tones has been recorded.

If the curve begins or ends at a point some way up the left (dark tones) or right (light tones) sides of the histogram display, causing the curve to look as though it has been cut off abruptly, the camera will not have recorded tones in either the shadows or highlights, respectively. This "clipping" of the histogram curve is usually an indication of under or over-exposure. But remember that the preview image, including those for NEF RAW files, is always derived from a IPEG file to which the camera settings (white balance, contrast and saturation, etc) have been applied. It is the tonal distribution of this IPEG file that the histogram portrays. A NEF RAW file will contain more data and have a wider range of tonal values: therefore, an overexposed highlight in the IPEG preview may not be an overexposed highlight when the NEF RAW file is examined in a RAW file converter such as Nikon Capture NX.

Generally, controlling exposure to ensure highlight detail is retained is more important than shadow areas. If the histogram curve is weighted heavily toward the right side of the graph and is clipped at a point along the right-hand vertical axis, highlight data will probably have been compromised and lost. In this case, reduce the exposure until the right-hand end of the curve stops on the bottom axis, before it reaches the vertical one. The exception would be in a scene with very bright specific highlights, such as the reflection off water or streetlights in a nighttime cityscape – these small

areas will almost invariably be much brighter than most of the other light tones in the scene and, therefore, it is of little consequence if they are overexposed. Conversely, if shadow detail is important to the composition of your image, make sure the curve stops on the bottom axis before it reaches the left hand vertical axis.

Obviously, not all scenes contain an even spread of tones — they have a natural predominance of light or dark areas. In these cases the histogram curve will be biased to the right (light scenes) or the left (dark scenes). However, provided the histogram curve stops on the bottom axis at, or just before, it reaches either end of the graph, the image should contain a full range of the available highlight or shadow tones in the subject or scene being photographed. Many photographers adopt a technique known as "expose to the right", in which they adjust the exposure to the point that the histogram curve is as far to the right as it can be without clipping. This ensures that they are capturing as wide a tonal range as possible, with as many levels to describe those tones.

Two-Button Reset

The QUAL and exposure compensation buttons are pressed simultaneously to restore a range of default settings on the D300.

If you want to restore the settings listed below to their default values, simultaneously press and hold the **QUAL** and **exposure compensation** buttons (they both have green dots beside them) for more than two-seconds.

Option	Default		
Focus point	Center		
Exposure Mode	Programmed-auto		
Flexible Program	Off		
Exp. Comp	±0 (Off)		
AE hold	Off ¹		
Bracketing	Off ²		
Flash mode	Front-curtain sync		
Flash compensation	±0 (Off)		
FV Lock	Off		
Multiple exposure	Off		

- 1 CS-f6 (Assign AE-L/AF-L button) is not affected
- 2 Number of shots reset to zero, increment to 1EV (exposure), or 1 (WB)

Shooting Menu Options

Option	Default JPEG Normal		
Image Quality			
Image Size	Large		
White Balance	Auto ³		
ISO	200		

3 Fine-tuning set to 0 (Off)

Note: If the current Picture Control has been modified, the existing, saved settings for the Picture Control will also be restored.

Exposure and the Autofocus System

Regardless of whether you are content to let the D300 make decisions about exposure settings or you prefer to take control of the camera and make them for yourself, it is essential to understand how the camera sees, evaluates, and processes light.

ISO Sensitivity

Film requires you to make a decision about which ISO (sensitivity) rating to choose in order to cope with the prevailing or expected lighting conditions, and the entire roll must be exposed at the same ISO value. One of the great advantages of digital photography is that digital cameras allow you to adjust the ISO sensitivity from picture to picture. The ISO sensitivity rating used by Nikon D-SLR cameras follows the guidelines laid down by the International Organization for Standardization for rating film speed (sensitivity) using the ISO scale; therefore, where the sensitivity setting on a camera complies with these guidelines, it is referred to as being ISO equivalent.

The D300 offers ISO equivalent sensitivity settings from 200 to 3200 that can be adjusted in steps of 0.3, 0.5, or 1.0EV, plus the option to decrease sensitivity by approximately 1EV below ISO 200 (offering ISO equivalents of 100 – 160), or increase it by 1EV above ISO 3200, in steps of 0.3, 0.5, 0.7, and 1.0EV (offering ISO equivalents of 4000 –

The D300's base sensitivity is ISO 200. However, the camera can be set for ISO equivalent setting from 200 to 3200. The sensor will deliver optimal performance at its base sensitivity.

6400). These two latter options are referred to as LO and HI respectively. For example, a setting of LO 0.3 corresponds to an ISO sensitivity of 160, while HI 0.7 is equivalent to an ISO sensitivity of 5000.

It is easy to assume that using the lowest possible ISO setting would deliver the maximum potential image quality, after all this applies with film. However, digital sensors are not the same as film. The standard base ISO sensitivity is where the sensor usually delivers optimal performance and in the case of the D300, that is ISO 200. At settings below this, the dynamic range of the camera is effectively reduced; although low and midtone values are preserved, there is a tendency for highlight values to become overexposed more quickly. So unless you really need to reduce the sensitivity, for example to use a wider aperture in bright conditions, I recommend you shoot at ISO 200 to get the best out of your camera.

The ISO button on the left top of the camera is pressed while the main command dial is rotated to select an ISO setting.

To adjust the ISO sensitivity, press the ISO button and rotate the main command dial until the required value is displayed in the control panel and viewfinder. Alternatively, the ISO sensitivity can be adjusted via the [ISO sensitivity] item in the Shooting menu. To set the step value for the adjustment of ISO sensitivity, use CS-b1. The camera also has the ability to adjust the ISO sensitivity automatically according to the light conditions; this feature is also set via the Shooting menu (see page 222).

ISO Noise

The analogy with film ISO continues in so much as that, at higher ISO sensitivity settings, a digital image will show increasing amount of electronic noise. Generally, as the ISO sensitivity value is hiked higher and higher, the saturation of color and the level of image contrast are reduced.

The noise performance of the D300 is better than its predecessor, the D200, provided exposure accuracy is spot on. That said, still expect to see noise in any image that comprises mostly dark tones or has distinct areas of dark tone. The noise performance of the D300 puts it about 1EV above that of the D200, so for the optimum image quality, keep ISO sensitivity set to 200.

Pushing ISO sensitivity to 400 presents no problem, as image quality is virtually indistinguishable from ISO 200. At ISO 800, there is a very slight increase in the noise level but the noise pattern is random (rather like a film grain pattern), and thus not intrusive. Even at this elevated ISO level, the color saturation and contrast remain remarkably good, as they do all the way out to ISO 3200. Beyond ISO 800, noise becomes clearly perceptible, but is still well controlled. It will be a matter of personal opinion as to the point at which noise becomes unacceptable, but for most users looking for excellent to good image quality, this is likely to be around ISO 1600. That is not to say that ISO sensitivity settings above 1600 should not be used if the shooting conditions dictate that there is no other option. Plus, the noise at ISO 1600 to 3200 can be used for creative purposes, and is particularly effective with the blackand-white options available on the D300, emulating the qualities of high-speed, grainy black-and-white film.

Hint: To help reduce the effects of noise at higher ISO sensitivity settings, there is a specific noise reduction feature available via the Shooting menu.

ISO Sensitivity Auto Control

Compared with the D200, Nikon has improved the functionality of this feature in some ways but made it worse in one key area, by imposing a maximum shutter speed limit when it is used with Aperture-Priority auto (A) and Programmed auto (P) exposure modes. It is important to understand how this feature works, as it is not quite what you might expect.

In P and A exposure modes, the ISO sensitivity will not be altered unless underexposure would occur at the minimum shutter speed, as specified under the ISO sensitivity auto control feature. For reasons best known to the engineers and designers at Nikon, the range of shutter speeds available in these modes runs from one-second to 1/250-second. This is of little use if you are shooting fast paced action where a shutter speed of a 1/500-second or less is often required. The problem is compounded if the camera cannot achieve a proper exposure at the ISO sensitivity specified as the maximum value, as the D300 will then begin to select slower shutter speeds.

In Shutter-priority auto exposure mode, the ISO sensitivity is shifted when the exposure reaches the maximum aperture available on the lens. Indeed, this is probably the exposure mode that is most useful with this feature because it will raise the sensitivity setting and thus maintain the pre-selected shutter speed, which is usually critical to the success of the picture. Again, the maximum value for the ISO sensitivity can be specified under the [ISO sensitivity] auto control feature. In Manual exposure mode, the sensitivity is shifted if the selected shutter speed and aperture cannot attain a correct exposure (as indicated by the display in the viewfinder). When the ISO sensitivity auto control feature is active, ISO-AUTO is displayed in the control panel and the viewfinder; if the ISO sensitivity is altered from the value set by the user, the ISO-AUTO icon will blink and the adjusted ISO sensitivity value is shown in the viewfinder

The camera offers a choice of three metering patterns. These are selected by rotating the metering mode dial, which surrounds the AE-L/AF-L button.

TTL Metering

The D300 has three metering pattern options that will be familiar if you have used a Nikon AF camera before: Matrix, center-weighted, and spot. To select a metering mode, rotate the metering mode dial set around the AE-L/AF-L button to the right of the viewfinder eyepiece. The appropriate icon will be displayed in the control panel.

The coverage of the Matrix metering pattern extends virtually to the edge of the full frame area.

Matrix Metering

The metering pattern for this mode covers virtually the entire frame area with each of the 1005 segments on the 1005-segment RGB metering sensor, located in the viewfinder head

of the camera just above the eyepiece, acting as a sampling point. This long established sensor that was first used in the Nikon F5 camera has been enhanced by the addition of a small diffraction grating placed immediately in front of it. This helps to separate the light falling on the sensor in to its component colors and thus improves the efficiency and accuracy with which the camera assesses both the nature and color of the light from the scene being photographed. This Scene Recognition System, as it is called, assesses distribution of color within the frame and uses this information to improve metering accuracy, especially for skin tones.

To derive the most from the Matrix metering capabilities of the D300, it is necessary to use a D- or G-type Nikkor lens since these provide additional focus distance information, which assists the camera in estimating how far away from the camera the subject is located. The metering system also knows which AF point is selected and uses this information to estimate the position of the subject within the frame. Nikon call the system 3D Color Matrix Metering II. If an AF Nikkor lens that does not communicate distance information to the camera is used, the system defaults to standard color Matrix metering II (i.e., the distance information is not integrated in the exposure computations). This also applies to use of a non-CPU type lens, provided the focal length and maximum aperture value are specified using the [Non-CPU lens data] item in the Setup menu.

In the three automated exposure modes, the Matrix metering (and i-TTL flash control) also benefits from the enhanced analysis of highlights within the frame performed by the Scene Recognition System feature. By assessing color as well as brightness and contrast then comparing the results against a database of over 60,000 sample images that cover an enormous range of lighting conditions (twice as many as stored in previous Nikon D-SLR cameras), the D300 offers the most advanced TTL metering available in a Nikon camera to date.

Matrix metering uses four principal factors when calculating an exposure value:

- · The overall brightness level of in a scene
- The ratio of brightness between the 1005-segments
- The focused distance, provided by the lens (D- or Gtype only)
- The location of the active AF point

Note: Nikon has clearly modified the way midtones are reproduced by the D300 as compared with the D200. D300 images are noticeably brighter.

Hint: When shooting an evenly illuminated scene with moderate contrast with the active AF point covering a midtone value, the D300 produces consistently good exposures via its Matrix metering. However, the Matrix metering does appear to be influenced into producing greater variability in results when the active AF point covers a very light or very dark tone. In these situations, it is advisable to check the histogram display.

(w) Center-Weighted Metering

The center-weighted metering pattern harkens back to the TTL metering systems used by early Nikon SLR film cameras. In these cameras, the frame area was usually divided in a 60:40 ratio, with the bias placed on the central portion of the frame. The D300 uses a higher ratio of 75:25, with 75% of the exposure reading based on the central area of the

The coverage of the center-weighted metering pattern can be adjusted via CS-b5 [Center-weighed area]; at its default setting, it covers an 8 mm diameter circle at the middle of the frame.

frame and the remaining 25% based on the outer area. Unlike Matrix metering, no color information is assessed when the center-weighted pattern is selected, so metering is performed using a grayscale.

Hint: Center-weighted metering offers nowhere near the level of sophistication of Matrix metering, but for some subjects, its simplicity can be an advantage for photographers who like to control exposure and understand how it works.

Spot Metering

Spot metering is extremely useful for metering from a highly specific area of a scene. For example, faced with a subject against a virtually black background, which might cause the Matrix metering system to overexpose the subject, the spot meter allows you to take a reading from the subject without it being influenced by the background. The sensing area for the spot metering pattern is a circle approximately 0.12in (3mm) in diameter, which represents about 2% of the total frame area. This circle is centered on the active AF point, unless Auto-area AF is selected, or a non-CPU lens is used, in which case the central AF point is the only area to perform metering. Again, as with the center-weighted pattern, no color information is assessed when the spot metering pattern is selected, so metering is performed using a grayscale.

The coverage of the spot metering pattern extends across a 3 mm diameter circle, which represents approximately 2% of the frame area. It is centered on the active AF point.

Hint: It is essential to remember that, in center-weighted and spot metering, the TTL metering system measures reflected light and is calibrated to give a correct exposure for mid-

tones. When using either of these two metering patterns, you must make sure that the part of the scene you meter from represents a midtone, otherwise you will need to compensate the exposure value.

Hint: In Dynamic-area AF, the D300 will attempt to follow a moving subject by shifting focus control between different AF points. If this occurs, the spot metering also shifts, following the active AF point.

Exposure Modes

The D300 offers four exposure modes; to select an exposure mode, press and hold the MODE button on the top of the camera and rotate the main command dial until the required mode (P, A, S, or M) is displayed in the top left corner of the control panel.

Note: For P or S modes to operate, you must have a CPU lens attached to the camera. If you attach a non-CPU type lens, the exposure mode defaults to A and the icon for the selected mode, P or S displayed in the control panel will blink, while A is displayed in the viewfinder.

Note: If you use a non-CPU lens when shooting in A and M modes, ensure the focal length and maximum aperture value are specified using the [Non-CPU lens data] item in the Setup menu.

Note: If you use a CPU type lens with an aperture ring, ensure that it is set and locked to the minimum aperture value (i.e., the highest f/number).

Programmed Auto (P)

Programmed-auto mode automatically adjusts both the shutter speed and lens aperture to produce a properly exposed image, as determined by the selected metering mode. If you decide that a particular combination of the shutter speed and aperture chosen by the camera is not suitable, you can

override the P mode settings by turning the main command dial when the camera meter is activated. This is called flexible program mode and P * appears in the control panel; there is no indication in the viewfinder that you have overridden the exposure, other than the altered shutter speed and aperture values. The two values change in tandem, so the overall exposure level remains the same (i.e., increasing the shutter speed decreases the aperture).

Note: If you override the Program mode, it will remain locked to its new settings for shutter speed and aperture even if the meter auto-powers off and is then switched on again by pressing the shutter release halfway. To cancel the override, you must do one of the following: rotate the main command dial until the asterisk * next to the P is no longer displayed, change the exposure mode, turn the power off, or perform a two-button reset.

Hint: In my opinion Program mode is little better than the point-and-shoot exposure control options on many entry-level cameras, as you are relinquishing control of exposure to the camera. If you want to make informed decisions about shutter speed and aperture for creative photography, do not use Programmed-auto mode!

Aperture-Priority Auto (A)

In this mode, the photographer selects an aperture value and the D300 will choose a shutter speed to produce an appropriate exposure, as determined by the selected metering

The exposure mode is displayed in the top left corner of the control panel of the D300. Here, Aperture-Priority auto is selected.

You can change the shutter and aperture combination selected by the camera in Program mode, while maintaining the equivalent exposure. To do this turn the main command dial while the meter is active.

mode. The aperture is controlled by the sub-command dial (default) and is changed in increments of 1/3EV (default). The shutter speed the D300 selects will also change in increments of 1/3-stop (default). The EV step level can be adjusted using CS-b2 [EV steps for exposure cntrl].

Note: If the maximum aperture value of a non-CPU lens is specified using the [Non-CPU lens data] item in the Setup menu when a non-CPU lens is attached to the camera, the f/number is displayed in the viewfinder and control panel, rounded to the nearest whole stop value. Otherwise, the aperture displays in the viewfinder and control panel will only show the total number of stops from the maximum aperture value of the lens. The maximum aperture is displayed as **AF** 0. For example, using a lens with a maximum aperture of f/2.8 set to f/8, the displays show **AF** 3.

Shutter-Priority Auto (S)

In this mode, the photographer selects a shutter speed between 30 seconds and 1/8000 second (or the flash sync speed x250) and the D300 will choose an aperture value to produce an appropriate exposure, as determined by the selected metering mode. The shutter speed is controlled by the main command dial (default) and is changed in increments of 1/3-stop (default). The aperture value the D300 selects will also change in increments of 1/3-stop (default). The EV step level can be adjusted using CS-b2 [EV steps for exposure cntrl].

Note: In P, A, and S modes, if the subject or scene is too bright, the D300 will display the H warning in the viewfinder and control panel. Likewise, if the subject or scene is too dark the D300 will display the warning in the viewfinder and control panel.

Hint: If you use the D300 remotely when you make an exposure, as you would when taking a self-portrait using the self-timer or using the ML-3 IR Remote Control to release the shutter, you must cover the viewfinder eyepiece. The 1005-segment RGB metering sensor of the D300 is located within the viewfinder-head; therefore, light entering via the viewfinder eyepiece will influence exposure calculations made in P, A, and S, modes. Nikon supplies the D300 with the DK-5 eyepiece cover for this purpose, but to use it, the DK-23 rubber eyecup must be removed. Personally, I find attaching the DK-5 a fuss, so I keep a small square of thick, black felt fabric in my camera bag, and drape this over the camera to block light from reaching the viewfinder eyepiece.

Manual (M)

Manual mode offers the photographer total control over exposure, and is probably the most useful if you want to learn more about the relationship between shutter speed and aperture and how they affect the final appearance of your pictures. You choose and control both the shutter speed, via the main command dial (default), and lens aperture, via the sub-command dial (default). If required, the priority of the two command dials can be changed via CS-f7.

Here, Manual mode is selected. Note the analog exposure display below the shutter speed and aperture values.

An analog display shown in the control panel and viewfinder indicates the level of exposure your settings would produce. If the camera determines the exposure values are set for a proper exposure, a single indent mark appears below the central 0. If the camera determines that the settings would produce an underexposed result, the degree of underexposure is indicated by the number of indent marks that appear to the right (minus) side of the central 0. Conversely, if the chosen settings would create an overexposed result, the degree of overexposure is indicated by the number of indent marks to the left (plus) side of the central 0. The more indent marks that appear, the greater the degree of exposure "error."

Autoexposure (AE) Lock

If you take a meter reading in any of the three autoexposure modes (P, A, or S) and recompose the picture after taking a reading, it is likely, particularly with spot metering, that the metered area will now fall on an alternative part of the scene and probably produce a different exposure value. The D300 allows you to lock the initial exposure reading in center-weighted or spot metering before you reframe and shoot. Start by positioning the part of the scene you want to meter within the appropriate metering area. Next, press the shutter release halfway to acquire focus and an exposure reading, then press and hold the AE-L/AF-L button to lock the exposure (and focus, except in manual focus

mode). You can now recompose and take the picture at the metered value. AE-L will appear in the viewfinder display while this function is active. When using AE lock, it is possible to alter the shutter speed and/or aperture value in P, A, and S modes without altering the metered exposure level. In P mode, shutter speed and aperture can be changed; in S mode, the shutter speed can be changed; in A mode, the aperture can be changed.

Hint: It is possible to use the shutter release button to perform the autoexposure lock function; select [On] at CS-c1 [Shutter-release button AE-L] the exposure will lock while the shutter release button is held down halfway.

Hint: Use of the exposure lock function is not recommend when the camera is set to perform Matrix metering, as it will produce inconsistent results.

Exposure Compensation

Exposure compensation can be applied regardless of the TTL metering pattern in use, but the most consistent results are achieved with either center-weighted, or spot metering. As mentioned previously, in these latter two TTL metering patterns, the D300 uses simple grayscale metering with no color information or influence of the Scene Recognition System to affect the metered reading. Working on the assumption that the camera is pointed at a scene with a reflectivity that averages out to that of a midtone, it appears Nikon has calibrated the TTL metering against a reference that has a reflectivity value of approximately 12% to 13%. Hence, if you use an 18% gray photographic card to estimate exposure, you will find your results will be approximately a third to half-stop underexposed.

Many scenes you encounter will not reflect 12% to 13% of the light falling on them. For example, a landscape under a blanket of fresh snowfall is going to reflect far more light, while an animal with a very dark coat will reflect far less

This scene was metered using center-weighted metering with -1/2 exposure compensation.

than an average midtone. Unless you compensate your exposure accordingly for these extremes, the camera will attempted to render them as midtones, causing a light one to appear underexposed and a dark tone to be overexposed.

To set an exposure compensation factor in P, S, A, and M exposure modes, hold down the exposure compensation button, located to the rear and right of the shutter release button. Turn the main command dial until the required value is shown in the control panel. The value is also displayed in the viewfinder while the button is held down.

Note: The degree of compensation will change in steps of 1/3, 1/2, or 1EV depending on which step size is selected at CS-b3 [Exp comp/fine tune].

In Manual exposure mode, the exposure is set according to the value suggested by the camera's TTL meter if the analog display shows no deviance either side of the 0 midpoint. If an exposure compensation factor is applied in this mode, the display shifts either to the left (+ compensation) or right (- compensation) of the 0 midpoint by the amount of compensation applied, while the numerical value of the compensation amount is displayed and the 0 blinks. As you dial in the compensation, will see a small + or - icon displayed to the right of the analog scale along the bottom of the viewfinder display (the exposure compensation button must be depressed to see this). As soon as you release the exposure compensation button, a +/- icon appears in its place (it is also shown in the control panel), and the numerical value of the compensation amount is no longer displayed. To put the exposure compensation in to effect, you must now adjust the shutter speed and/or aperture so the analog scale display is shifted back to where no indent marks are shown either side of the 0 midpoint.

Note: Once you have made these adjustments and the analog scale is centered on 0 again, if you press the exposure compensation button, the analog scale shifts to show the amount of compensation applied and the icon to the right of the scale indicates whether it is a + or - value. This is a quick and useful way to check how much compensation you have applied.

Note: Although exposure compensation can be applied in Manual exposure mode, as described, it is often quicker to simply adjust the shutter speed and/or aperture so the required level of exposure adjustment is displayed on the analog exposure scale.

The +/- exposure compensation icon remains visible in the viewfinder and control panel, regardless of the exposure mode in use, as a reminder that you have an exposure compensation value applied. Once you have set a compensation factor, it will remain locked until you hold down the exposure compensation button and reset the compensation value to 0.0.

Bracketing Exposure

It is important when shooting digital pictures to expose as accurately as you can, as overexposure will lose highlight detail, and underexposure tends to degrade image quality due to electronic noise and blocked shadow detail. In exposure bracketing, the D300 varies the exposure compensation with each exposure in a sequence of a set number. While in flash bracketing, the flash level is adjusted with each exposure in i-TTL flash control (it also works with auto-aperture flash control available with the SB-800 only). Such bracketing of exposures can be useful in difficult lighting conditions when there is insufficient time to check exposures and/or adjust camera settings appropriately.

Bracketing is also a very useful feature for any photographer shooting High Dynamic Range (HDR) pictures, which is a technique that uses software to combine a number of shots of the same scene taken at different exposure levels to produce a single image with an extended dynamic range (i.e., a dynamic range beyond a level the camera could record in a single exposure). For more information, check out the Lark Books publication *Complete Guide to High Dynamic Range Digital Photography*, by Ferrell McCollough.

The bracketing system in the D300 allows you to take a sequence of exposures varied in steps of 0.3EV, 0.5EV, 0.7EV, or 1EV, subject to the setting selected at CS-b2 [EV

The Fn button is one of three buttons on the D300 that can be configured to activate exposure bracketing.

steps for exposure cntrl]. The bracketing sequence can be selected to affect the exposure [AE only], flash output [Flash only], or a combination of the two [AE & Flash], by selecting the appropriate option at CS-e5 [Auto bracketing set]. The combinations of number of exposures and exposure compensation level are shown in the following table:

Contro	ol Panel Display	No. of shots	WB Increment	Bracketing order (EVs)
OF	; +	0	1	0
63F	{ + ······+	3	1 B	1B/0/2B
RBF	; ++	3	1 A	1A/2A/0
62F	; ++	2	1 B	0/1B
RZF	; + · · · · · · · · · · · · · · · · · ·	2	1 A	0/1A
35	{ ++	3	1 A, 1 B	0/1A/1B
55	; + · · · · · · · · · · · · · · · · · ·	5	1 A, 1 B	0/2A/1A/1B/2B
75	{ + ·····+	7	1 A, 1 B	0/3A/2A/1A/ 1B/2B/3B
95	{ + ·····+	9	1 A, 1 B	0/4A/3A/2A/1A/ 1B/2B/3B/4B

A lot of the questions I received about the D300 when it was first announced concerned the fate of the bracketing (BKT) button, familiar to users of other Nikon D-SLR cameras, as it is not visible on the exterior of the camera. The Fn button is one of three buttons on the D300 that can be configured to activate exposure bracketing (the others are the Depth-of-Field Preview button, and the AE-L/AF-L button). Each button can be assigned a single function, with a further option to assign it a second function, which is activated by pressing the button and rotating either of the command dials.

At the camera's default settings the bracketing function (BKT) has been assigned to the Fn button, and whichever way you configure the camera, one of the six options that can be assigned to the three buttons and the command dials has to be the bracketing function if you want to be able to

use it. At best, it is a rather clumsy piece of design, whereas retention of a single dedicated BKT button would have improved camera handling and increased the flexibility of the Fn button.

Assuming the camera is at its default setting and bracketing is assigned to the Fn button, the bracketing function is set by pressing the Fn button and rotating the main command dial to select the number of exposures to be made in the bracketing sequence; BKT will be displayed in the control panel and the exposure compensation +/- icon will be shown in the control panel and viewfinder. While bracketing is active, a progress indicator that shows the number of exposures in the sequence is displayed in the control panel; as each exposure is made, one indent mark will disappear from this display.

To cancel bracketing, press the Fn button and rotate the main command dial until the number of shots in the bracketing sequence is set to zero (BKT and the exposure compensation +/- icon are no longer displayed in the control panel).

Bracketing Considerations

- Using S single frame mode the shutter release button must be depressed to make each exposure in the bracketing sequence.
- If you set the D300 to one of the continuous frame modes CL or CH then press and hold the shutter release button down, the camera will only take the number of frames specified in the bracket sequence. The camera stops regardless of whether the shutter release continues to be depressed.
- If you turn the D200 off or have to change the memory card during a bracketing sequence, the camera remembers which exposure values are outstanding, so when you turn the camera on, or insert a new memory card, the sequence will resume from where it stopped.

• You can combine a bracketing sequence with a fixed exposure compensation factor. For example, if you apply an exposure compensation of +1.0EV to deal with a scene containing predominantly very light tones, and then set a bracket sequence of three-frames at an increment of 1EV, the actual exposures you make will be at, 0, +1EV, and +2EV.

Using Non CPU-Type Lenses

The D300 supports the use of older manual focus Nikkor lenses that lack the electrical components built in to modern AF and Ai-P type lenses. Nikon defines their lenses in two broad groups: non-CPU lenses and CPU lenses (though, strictly speaking, it is not a CPU that is used in these lenses but an ASIC that handles lens aperture and focus distance information to control the lens and support functions performed in the camera body such as Matrix TTL metering).

Compatible Non-CPU type lenses include most manual focus lenses manufactured since 1977 and some earlier lenses that have been converted to the Ai lens mount standard (the exceptions are the Ai-P type, PC-Micro 85mm f/2.8D, PC-E 24mm f/3.5D, PC-E 45mm f/2.8D, and PC-E Micro 85mm f/2.8D lenses, all of which are classified as CPU-types). I have several older manual focus Nikkor lenses that I treasure, not least for their optical quality, that work very well with the D300. All autofocus Nikkor lenses are classified as CPU type lenses.

By specifying the focal length and maximum aperture (smallest f/number) of a lens to the D300, many of the features and functions available with the CPU-type lenses will also be supported when a non-CPU lens is used. If lens data is stored in the camera, the following operations can be performed when using a non-CPU type lens:

 The automatic zoom-head function of the SB-800 and SB-600 Speedlights will function

- The lens focal length, marked by an asterisk, is listed in image file information
- The aperture value is displayed in the control panel and viewfinder
- Flash output is adjusted automatically for changes to the aperture value
- The aperture value, marked by an asterisk, is listed in image file information
- Color Matrix metering is available (although it may be necessary to use center-weighted or spot metering with some lenses, such as Reflex-Nikkor types)
- The precision of center-weighted metering, spot metering, and i-TTL flash exposure control is improved

Specifying Lens Data

The information about a Non-CPU type lens can be entered using the [Non-CPU Lens data] option in the Shooting menu. Highlight [Non-CPU Lens Data] and press ▶ to open a page that displays three parameters: [Lens number], [Focal length (mm)] and [Maximum aperture]. Highlight [Lens number] and press ◀ or ▶ to select a number between 1 and 9; highlight [Focal length (mm)] and press ◀ or ▶ to select a focal length between 6 and 4000 mm; highlight [Maximum aperture] and press ◀ or ▶ to select a maximum aperture value between f/1.2 and f/22. (If you use a teleconverter, the maximum aperture is the effective maximum aperture of the lens and teleconverter). Finally, highlight [Done] and press the ❸ button to store the lens data.

The stored data can be recalled at anytime by using the following camera controls. Select [Choose non-CPU lens number] as the [+ command dials] option for one of the following: CS-f4 [Assign FUNC button], CS-f5 [Assign preview button], or CS-f6 [Assign AE-L/AF-L button]. Once assigned, press the appropriate button and rotate either of the command dials to scroll through the list of stored lens data.

You can make sure that the aperture in use provides enough depth of field by using the depth-of-field preview button on the upper right front of the camera.

Note: If you attach a Non-CPU type zoom lens, the lens data is not adjusted automatically as the focal length/maximum aperture value is altered when operating the zoom function. If these values change, it is necessary to input the new focal length and maximum aperture value accordingly.

Depth of Field

When a lens brings light to focus on a camera's sensor, there is only ever one plane-of-focus that is critically sharp. However, in the two dimensional picture produced by the camera, there is a zone in front of and behind the plane-of-focus that is perceived to be sharp. This area of apparent sharpness is often referred to as the depth of field, and its extent is influenced by the camera-to-subject distance together with the focal length and aperture of the lens in use.

If the focal length and camera-to-subject distance are constant, depth of field will be shallower with large apertures (low f/numbers) and deeper with small apertures (high f/numbers). If the aperture and camera-to-subject distance are constant, depth of field will be shallower with a long focal length (telephoto range) and deeper with shorter focal length (wideangle range). If the focal length and aperture are constant, depth of field will be greater at longer camera-to-subject distances and shallower with closer camera-to-subject distances. Depth of field is an important consideration when deciding on a particular composition, as it has a direct and fundamental effect on the final appearance of the picture.

Depth-of-Field Preview

In order that the viewfinder image is as bright as possible for composing, focusing, and metering, the D300 operates with the lens automatically set to its maximum aperture (lowest f/number). The iris of the lens does not close down to the shooting aperture until after the shutter release has been pressed and the reflex mirror has lifted, just a fraction of a second before the shutter opens. However, this means that the image you see in the viewfinder is as it would appear if the photograph were to be taken at the maximum aperture of the lens. To assess the depth of field visually, you must close the lens iris down to the shooting aperture.

The Depth-of-Field Preview button is located immediately above the Fn (FUNC) button.

The D300 has a Depth-of-Field Preview button (the upper button of the two buttons on the front of the camera between the finger grip and the lens mount) which, when pressed, stops the lens down to the selected shooting aperture, allowing you to see the effect the aperture has on the depth of field. The viewfinder image will become darker as less light passes through the lens when the aperture iris in the lens is closed down.

Hint: At apertures of f/11 or smaller (higher f/number), the viewfinder image will become very dark and difficult to see, even with brightly lit scenes. It is often better to make a general assessment of depth of field at f/8, and then change the aperture value to the one required for shooting.

Depth of Field Considerations

Probably the most important consideration concerning depth of field is that it is slightly less for images shot on a D300 than those shot on a 35mm film camera. This is due to the smaller format of the DX sensor in the D300 (23.7 x 15.6mm) as compared with a 35mm film frame (24 x 36mm); the digital picture must be magnified by a greater amount compared with 35mm film to achieve any given print size. Therefore, at normal viewing distances, detail that appears to be sharp in a print made from a film-based image may no longer look sharp in a print of the same dimensions made from a digital file recorded by a DX format sensor. If you use the depth of field values given in tables for 35mm film format, you will find they do not correspond to images shot on the D300, assuming the same camera-to-subject distance and focal length apply. To guarantee that the depth of field in pictures taken on the D300 is sufficiently deep, use the values for the next larger lens aperture. For example, if set your lens to f/11 use the depth of field values from your old 35mm table for f/8 with the D300.

Apart from setting a small aperture (large f/number) to maximize depth of field, it is worth remembering that at mid to long focus distances, the zone of apparent sharpness will extend about 1/3 in front of the point of focus and 2/3

behind it. Therefore, by placing the point of focus about a third of the way into your scene, you will maximize the coverage of the depth of field of the shooting aperture.

In portrait photography, is often preferable to render the background out-of-focus so it does not distract from the subject(s). The simplest way to achieve this effect is to use a longer focal length lens (a short telephoto of 70 – 105mm is ideal) in combination with a large aperture (low f/number). You can assess the effect using the camera's Depth-of-Field Preview button.

In close-up photography, depth of field is very limited, so convention suggests you set the lens to its minimum aperture (largest f/number) value. However, I strongly recommend that you avoid doing this to avoid the effects of diffraction (see below). It is likely that, even in good light, the shutter speed will be rather slow when shooting with a small lens aperture, so a rigid camera support such as a good quality tripod is essential.

Unlike the distribution of the depth-of-field zone for mid to long focused distances, at very short distances, the depth of field extends by an equal amount in front of and behind the plane of focus. By placing the plane of focus with care, you can use this fact to further maximize depth of field. Once again the camera's Depth-of-Field Preview button will allow you to preview the depth of field in your composition.

Diffraction

Diffraction is an optical effect that, under certain circumstances, will limit the resolution you can achieve in a photograph. Assuming conditions of a uniform atmosphere (i.e., still, clear air), light waves will travel in straight lines. However, if those same light waves have to pass through a small hole, such as the aperture in the iris diaphragm of a camera lens, they become dispersed, or diffracted. At wide apertures (low f/numbers), the number of diffracted light waves is pro-

portionally very small to the total number that pass through the aperture, hence the diffraction effect is negligible, but the proportion of diffracted waves increases as the size of the aperture is reduced to point where it becomes significant. After passing through a small aperture the previously parallel light waves become diverged (i.e., they spread out in different directions) and consequently travel different distances between the iris diaphragm and the digital sensor causing some light waves to shift out of phase and interfere with others. This process of interference creates a diffraction pattern that is manifest as a general softening of detail in the image.

In the pursuit of increased sharpness through increased depth of field, many photographers habitually set small aperture values, particularly in close-up and macro photography. However, at a certain lens aperture, the loss of resolution (softening) that occurs due to the effects of diffraction cancels out any gain in sharpness due to increased depth of field. At this point, the camera lens is said to have become "diffraction limited." It is essential to know the diffraction limit for your lens(es) and different cameras, since there is no point in selecting aperture values beyond the diffraction limit, as image resolution will become increasingly degraded and exposure times extended with the risk of further loss of resolution through camera or subject movement.

I recommend you test each of your lenses with your D300 to determine the diffraction limit for your own equipment. All you need to do is set up a suitable test subject that contains plenty of fine detail and then shoot a series of pictures at different aperture values under the same lighting conditions and at the same overall exposure level. Then examine the results at a 100% view and look at how the fine detail is resolved. The greatest level of acuity will usually be achieved in the middle range of aperture values, typically between f/5.6 to f/11, but at smaller apertures there will come a point where there is a perceptible drop in acuity—this is the diffraction limit. As a general rule, I find that the D300 diffraction limit is around f/11 to f/13, so bear this in mind when you are looking to maximize depth of field.

Shutter Speed Considerations

If you handhold your camera, it is worth remembering a rule of thumb concerning the minimum shutter speed that is generally sufficient to prevent a loss of sharpness due to camera shake. Multiply the focal length of the lens by 1.5 then take its reciprocal value and use this as the slowest shutter speed with that lens while handholding. For example, a focal length of 200mm would require a minimum shutter speed of 1/300 second; the closest value available on the D300 is 1/320-second.

Shutter speed can also be used for creative effect because it controls the way that motion is depicted in a photograph. Generally, fast shutter speeds are used if you wish to freeze motion, as in sports or action photography. Slower shutter speeds can be used to introduce a degree of blur that will often evoke a greater sense of movement than a subject that is rendered pin-sharp. Alternatively, you can pan the camera with the subject so that it appears relatively sharp against an increased level of blur in the background.

If you want a moving element in your picture of a static subject to "disappear," a very long shutter speed of several minutes or more can often be very effective. While the subject is rendered properly, the moving element(s) do not record sufficient information in any part of the frame to be visible. Generally, this technique will require a strong neutral density filter to be effective in daylight conditions. So next time you want to take a picture of a famous building and exclude all the other visitors from cluttering up your composition you know how!

Exposure Considerations

If the D300 is your first digital SLR camera and your previous photography has been done with a 35mm camera and color negative film, you may find controlling exposure with the D300 rather more demanding. Color negative (print) film is

very tolerant to exposure errors, particularly overexposure, and the automated processing machines used to produce your prints are capable of correcting exposure errors over a range of -2 to +3 stops while adjusting color balance at the same time. Chances are that you will never have noticed your exposure errors when looking at the finished prints!

Controlling exposure with a digital SLR is analogous to shooting on transparency (slide) film; there is virtually no margin for error. Even moderate overexposure will "blow out" highlight detail, leaving no usable image data in these areas. Underexposure is little better since it soon gives rise to digital noise, which will degrade image quality, particularly in areas of dark tone. Make sure you check the histogram display and pay attention to all three color channels.

Digital Infrared and UV Photography

Many digital cameras have the ability to record light beyond the limits of the spectrum visible to the human eye, particularly in the region of near infrared (IR), around a wavelength of 780nm (one nanometer = one millionth of a millimeter). Designers of digital cameras work hard to exclude IR light from digital cameras because it adversely affects apparent sharpness, reduces the contrast in skies, and can reveal unappealing features of skin that would otherwise not be visible. Similar adverse effects occur due to ultra-violet (UV) light. The low-pass filter array in front of the CMOS sensor in the D300 includes a layer designed to reduce the transmission of IR and UV light. It is very effective, and therefore the D300 cannot be recommended for either digital IR or UV light photography.

The D300 Autofocus System

The autofocus (AF) system of the D300 is unlike the AF system of any Nikon D-SLR that has come before; it is highly capable and its frame coverage far surpasses that of its predecessor, the D200. At the time of its announcement, the 51-

point AF system of the D300 represented the largest number of autofocus points in any D-SLR on the market. It also offers a significant coverage of the total frame area. The 51 points are subdivided into 15 cross type sensors and 36 line type sensors, which are orientated parallel to the short edge of the frame.

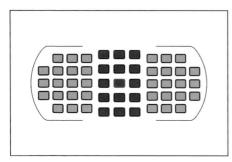

The AF points shown in black are the 15 cross type sensors, while the remaining 36 are line type sensors (the shading is for illustrative purposes only).

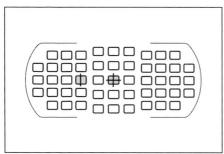

The two types of AF sensors are orientated as shown.

The Autofocus Sensor

The D300 has an entirely new autofocus module – the Multi-Cam 3500 DX. At the time of publishing this module is exclusive to this camera. As its name implies, the sensor has a total of 3500 photosites distributed between the 51 AF points.

When autofocus operation is initiated, the system uses a phase detection method; first detecting the current focus situation, it then determines not only the extent to which the frame covered by the selected AF point is out of focus, but also which direction the focus error is in (i.e. whether it needs to set the focus point closer or further from the cam-

era). As soon as the focus has been adjusted, the system analyzes focus accuracy for any error. Provided focus is deemed to be within system tolerances, no further re-focusing is performed; at this point, the camera has acquired focus at the selected AF-point.

The central 15 AF points are cross-type, meaning they are sensitive to detail in both a horizontal and vertical orientation; therefore, they are the most reliable. The remaining 36 AF points, separated into two groups of 18, are line-types; these are only sensitive to detail in a direction that is perpendicular to their orientation, therefore, they only detect detail aligned with the long edge of the viewfinder frame.

Hint: Sometimes when using one of the line-type sensing areas the autofocus system of the D300 will "hunt" (i.e. the camera will drive the focus of the lens back and forth, but is unable to attain focus). This indicates that the detail in the subject is aligned in the same orientation as the focus sensing area. If this occurs, try twisting the camera slightly (10 – 15°). This slight adjustment is often a sufficient enough change to allow the camera to acquire focus – the focus sensing area is no longer parallel to the detail. Once focus is confirmed, lock it (see Focus Lock section on page 194) and recompose the picture before releasing the shutter.

The AF point, selected in either Single-point AF or Dynamic-area AF, can have a profound effect on the ability of the camera to achieve autofocus; depending on whether it is a cross or line type. Furthermore, the number of AF points selected in Dynamic-area AF (9, 21, or 51) should be considered with care and based on the nature of the subject and scene being photographed. As a rule of thumb, if the subject is relatively small in relation to the frame, and the scene contains other elements that the camera may consider to be potential subjects, you will want to use fewer AF points. Conversely, with a larger subject, especially if it is set against a plain background that is well defined because it has soft focus, you can use more AF-points (see "Limitations of the AF System" on page 196).

The autofocus system of the D300 also benefits from the capabilities of Nikon's Scene Recognition System (SRS). This has enhanced the abilities of the established 1005-pixel RGB-metering sensor by using a small diffraction grating located in front of it; this separates light into its component colors enabling the sensor to work more effectively and efficiently. The 1005-pixel sensor is now able to recognize a subject by its shape, size and color. To employ the benefits of the SRS it is necessary to use a D- or G-type Nikkor lens. The SRS requires the focus distance information these lenses provide to perform the necessary calculations in order for its two principle features, subject identification and subject tracking, to function.

The SRS is optimized to recognize skin tones, particularly in any area on the 1005-segment RGB sensor that relates to the average size of a human face; this is why the focus data from a D or G-type lens is essential, as the camera calculates the size of the area on the 1005-segment RGB sensor based on the distance information supplied by the lens. An example of how this improves the focusing system can be seen in how this subject identification information is used in the Auto-area AF mode to assist the D300 in focusing on people in the scene. The subject identification is also used in the Dynamic-area AF 3D-tracking mode to enhance focus tracking of a moving subject, not just directly toward and away from the camera but also laterally across the frame. In very simple terms the camera monitors the location of the pattern of pixels on the 1005-segment RGB sensor created by the shape and color distribution of the subject (i.e. the subject identification information) to determine the position of the subject in the frame. This tracking of the subject by the 1005-segment RGB sensor is combined with the focus tracking information from the Multi-CAM 3500 DX autofocus sensor; determining the relative levels of focus and enabling the system to predict with speed and precision which AF point(s) to use to maintain focus.

The 3D-tracking mode differs from other Dynamic-area AF modes because the camera automatically selects the active focus point as soon as focus is acquired, even if the camera and/or subject move relative to one another. This enables

focus to be maintained while rapid and significant changes in composition are made because it is no longer necessary to maintain tracking by keeping the selected AF-point on the subject (necessary in other Dynamic-area AF options).

Traditional Dynamicarea AF, offers faster AF compared with the 51 points (3D tracking) option, but the disadvantage is the selected AF point (marked in black) must be positioned over the subject.

When one of the other options available under Dynamicarea AF (i.e. 9, 21, or 51 points) is selected, the D300 only uses its Multi-CAM 3500 DX AF sensor to perform focus tracking. Essentially, the camera reverts to the established AF system used by previous Nikon D-SLR cameras. In some situations this can be an advantage; since the camera has far fewer computations to perform compared with the 51-point (3D tracking) option, the AF response is faster.

Focus Modes

The D300 has three principal methods of focusing, known as focusing modes: single-servo AF (S), continuous-servo AF (C), and manual focus (M). To select the focusing mode, rotate the AF mode lever (located on the left side of the lens mount below the lens release button) until the white index mark is aligned with the appropriate letter.

S - Single-Servo AF

As soon as the shutter release button is pressed down halfway, the D300 focuses the lens. At the default settings the shutter can only be released once focus has been acquired; the in-focus indicator

is displayed in the

Single-servo AF is the ideal choice for static subjects such as this.

To select the focusing mode, rotate the focus mode lever located below the lens release button on the lower-left front of the camera.

viewfinder. Focus will remain locked while the shutter release button is depressed halfway. No form of focus tracking is performed when the camera is set to single-servo AF; therefore, this mode should be used when the camera to subject distance will remain constant.

C - Continuous-Servo AF

The D300 focuses the lens continuously while the shutter release button is pressed down halfway. If the camera-to-subject distance changes (i.e., the subject begins to move) the camera will initiate predictive focus tracking in order to shift focus as it follows the subject. By monitoring focus constantly, it does not matter whether the subject continues to move, or stops and starts periodically; the camera will continue to focus until either the shutter is released, or you remove your finger from the shutter release button.

M - Manual Focus

The user must rotate the focusing ring of the lens to achieve focus. There is no restriction on when the shutter can be released. When using a lens with a maximum aperture of f/5.6 or larger, the electronic rangefinder feature will display the in-focus confirmation signal when focus is achieved. This confirmation can be particularly useful in low light or low contrast conditions.

Note: The focus mode selector lever on the camera must be set to M to manually focus with most AF-Nikkor lenses. However, if the lens you are using has a switch that allows you to select an M/A (manual/autofocus) mode on the lens, you need only to touch the focusing ring and the lens can be focused manually. As soon as you release the focusing ring and press the shutter release button down halfway the camera will resume autofocus operation. If the lens attached to the camera has an M/A mode option, the focus mode selector lever on the D300 can be left at either S or C.

Hint: The profile and position of the AF mode lever makes it quite easy to move it inadvertently, particularly when changing a lens. Since each focusing mode introduces fundamental differences in the way the camera focuses, the consequences of this are potentially serious. I recommend you get into the habit of checking the position of the lever regularly.

Single-Servo vs. Continuous-Servo

It is important that you appreciate the fundamental difference between the single-servo AF (S) and continuous-servo AF (C) modes. In single-servo AF, with the default setting for CS-a2 (AF-S Priority selection), the shutter cannot be released until focus has been acquired; Nikon refers to this mode as having "focus priority." Once focus is acquired in this mode, the focus distance is locked as long as the shutter release button is pressed down half way, or the AF-ON button is depressed. In most shooting conditions, particularly in good light, the delay in acquiring focus is so brief that it is not perceptible and it is has no practical consequence. However, under certain conditions, such as low light or subjects with low contrast, there is often a discernable lag between pressing the shutter release button and the shutter opening. This is because it generally takes longer for the camera to establish focus in these circumstances, particularly if one of the outer line-type sensing areas is used. Conversely, in continuous-servo AF, with the default setting for CS-a1 (AF-C Priority selection), the shutter will operate immediately on pressing the shutter release button all the way down, regardless of whether focus has been achieved; Nikon refers to this mode as having "release priority."

Some photographers mistakenly assume that if the shutter is released before the camera has attained focus in the continuous-servo AF, that the picture will always be out-offocus. In fact, the combination of constant focus monitoring and predictive focus tracking in this mode (engaged when the camera detects a moving subject), is normally successful in causing the focus point to be shifted within the split second delay between the reflex mirror lifting and the shutter opening, resulting in a sharp picture. Even if the camera's calculations are slightly off, minor focusing errors are often masked by the depth-of-field of the image. To maximize AF performance, while using continuous-servo AF mode to photograph a moving subject, it is imperative that the camera is given sufficient time to assimilate information to perform the focusing action. To achieve this either press and hold the shutter release button half way down, or press and hold the

AF-ON button as far in advance of releasing the shutter as possible (see details of CS-a5 – (AF Activation) for options when using the AF-ON button).

Note: The focus and release priority assigned in single-servo AF and continuous-servo AF modes can be reversed using CS-a2 and CS-a1, respectively. I recommend that changes from the default settings should only be made once you have understood how the focusing system works; and then, only if the specific shooting situation requires the priorities to be reversed.

Predictive Focus Tracking

Whenever the shutter release is pressed all the way down to activate the shutter mechanism, there is a short delay between the reflex mirror lifting out of the light path to the camera's sensor and the shutter actually opening. If a subject is moving toward or away from the camera, the camera-tosubject distance will change during this delay. In continuous-servo AF mode the D300 uses its predictive tracking system to shift the point of focus on the lens to compensate for this change in camera-to-subject distance; regardless of whether the subject is moving at a constant speed, is accelerating, or decelerating. Predictive focus tracking is always initiated when the camera detects the camera-to-subject distance is changing (i.e. the subject is moving toward or way from the camera) when the shutter release is held down half way, or the AF-ON button is pressed. In continuous-servo AF mode, predictive focus tracking is initiated as soon as the camera detects the subject movement, regardless of whether this occurs while the camera is establishing focus, or if it detects the subject beginning to move after focus is first acquired. The camera monitors focus constantly before the shutter is released

Note: AF-S type lenses, which have an internal focusing motor that provides faster focusing, are recommended to increase the chance of attaining sharp focus with a moving subject.

Focus Tracking with Lock-On

In an effort to prevent the camera from re-focusing on an object that appears, briefly, between the intended subject and the camera, the D300 will deliberately delay shifting focus once it has been established. The duration of the delay before the camera shifts focus can be controlled using CS-a4 (Focus Tracking with Lock-On). However, if you want to photograph a subject where the camera-to-subject distance is changing abruptly during a series of shots, the Lock-On feature can prevent rapid acquisition of focus. In this case I recommend selecting either [Short] (to reduce the delay to its minimum), or [Off] (the camera will re-focus immediately) at CS-a4.

Note: Nikon does not publish the specific duration of the various delay periods that can be selected using CS-a4.

Using Trap Focus

It is possible to use the functionality of the focus system in the D300 to perform the trap focus technique. Trap focus allows the camera to be pre-focused at a specific point and have the shutter released automatically, as soon as a subject passes through the area. If you can accurately predict the path of the subject, this technique can be very effective.

The following steps will enable you to set up the D300 for trap focusing:

- Set Custom Setting a5 (AF Activation) to AF-ON Only. This means that focusing is only performed when the AF-ON button is pressed, not when the shutter release button is pressed.
- Select S (single-servo AF) focus mode.
- Select Single-area as the autofocus area mode. If the lens you are using has a focus mode switch on it set it to A or M/A.

Pre-focus the lens on a point that is the same distance from the camera as the point through which the subject will pass by aligning it with the selected autofocus sensing area and pushing the AF-ON button. Once focus is acquired release the AF-ON button (focus is now locked at that distance). Re-compose the picture so the selected AF point covers the point you expect the subject to pass through. Now, fully depress the shutter release button (this is necessary to keep the camera activated and enable the shutter to be released as soon as focus is detected). I recommend using a remote shutter release with a lock facility, such as the Nikon MC-30 to make this easier. When the subject enters the space covered by the selected AF point, the camera will detect focus and the shutter will automatically be released.

Set the AF area mode using a lever on the back of the camera, located below the multi selector.

Autofocus Area Modes

The D300 has three focusing area modes (not to be confused with the three focusing modes described above) that determine how the 51 AF sensing areas will be used: Single-point AF, Dynamic-area AF, and Auto-area AF. The autofocus area mode is selected with the lever on the rear of the camera (immediately below the multi selector). The three available options operate as follows:

[13] Single-Point AF

The D300 uses only the single AF point selected by the user for focusing. The camera takes no part in choosing which AF point is used. The selected AF point is highlighted in the viewfinder.

[::] Dynamic-Area AF

In single-servo AF the D300 only uses the AF point selected by the user. In continuous-servo AF, the D300 uses the AF point selected by the user for focusing. However, if the subject leaves the area covered by this AF point briefly, the camera immediately evaluates information from the other surrounding AF points and will attempt to maintain focus using these AF points as needed until the AF point originally selected by the user covers the subject. The number of focus points can be set to 9, 21, or 51 using CS-a3 (Dynamic-area AF). The selected area is highlighted in the viewfinder and remains highlighted, even if another AF point is used to momentarily maintain focus. Alternatively, if 51 point 3D tracking is selected at CS-a3 (Dynamicarea AF), selection of the AF point is fully automated and the camera will use its 3D tracking feature to maintain focus.

Auto-Area AF

In both single-servo AF and continuous-servo AF, the D300 selects the AF point(s) automatically using information from the Multi-CAM 3500 DX autofocus sensor. If a D or G-type Nikkor lens is used, the subject identification information established by the Scene Recognition System using the 1005-segment RGB sensor will also be used. This system is particularly adept at identifying skin tones and is, therefore, very useful when photographing people. In single-servo AF the active AF point(s) are highlighted for approximately 1-second. In continuous-servo AF the active AF point(s) are not indicated.

AF-area mode	Control Panel Display	
[12] Single point AF		C ·)
(•) Dynamic-area AF	9-points (default)	(")
(selected via CS-a3)	21-points	(#)
	51-points	
	51-points (3D tracking)	(11111)
Auto-area AF		

Note: Single-point AF mode is selected automatically when the D300 is set to manual focus.

This shows normal distribution of AF points in the 21-point option for Dynamicarea AF.

Note: If either the 9-point or 21-point options for Dynamicarea AF are used and the selected AF point is located at the periphery of the area covered by the 51 AF points, where the normal symmetrical distribution of AF points surrounding the selected AF point cannot be maintained, the camera continues to use the designated number of AF points (i.e. 9, or 21) but they are now arranged in an asymmetrical pattern.

Selecting an Autofocus Point

To manually select the AF point that the D300 will initially use to attain focus in single-point AF or dynamic-area AF:

- 1. Rotate the focus selector lock lever (set around the multi selector) counter-clockwise so the two white dots are aligned.
- 2. If the camera is not already active press the shutter release button down half way and release it.
- 4. To prevent unintentional selection of an alternative AF point, rotate the focus selector lock lever back to the "L" position.

If your main subject is off-center, you will have best success if you manually select the active AF point.

Note: Selection of the autofocus area can be set to wrap around the frame by selecting the Wrap option at CS-a7 (Focus point wrap-around). The selection of autofocus area will scroll continuously in the direction in which the multi selector switch is pressed, enabling the selected autofocus area to be rapidly shifted from one side of the frame to the other.

Focus Mode and AF-Area Mode Overview

If you are new to Nikon's AF system it will probably take a while to get used to the functionality of the Focus Mode and Focus Area Mode options of the D300. Therefore, you may wish to re-read the sections above and refer to the following table that summarizes the various autofocus operations.

AF Mode	AF-Area Mode	Selection of Focus Area
Manual	Single-point AF	User
Single-servo	Single-point AF	User
Single-servo	Dynamic-area AF	User
Single-servo	Auto-area AF	Camera ¹
Continuous-servo	Single-point AF	User
Continuous-servo	Dynamic-area AF	User ²
Continuous-servo	Auto-area AF	Camera ³

- 1 Active AF point(s) are highlighted for approximately one-second.
- 2 Camera will use an alternative AF point if the subject momentarily leaves the selected AF point.
- 3 Active focus point(s) is not displayed.

Hint: As you rotate the focus area mode lever on the back of the camera clockwise from the [13] position you relinquish more control to the camera in the selection of the AF point; therefore, consider the most appropriate option based on the nature of the subject you are photographing and whether or not it is moving. For static subjects, use singleservo AF with single-point AF. For subjects that move in a predictable direction, use continuous-servo AF with its predictive focus tracking in combination with the 9, 21, or 51 points options. For subjects that move in an unpredictable manner, or when you need to recompose the picture rapidly while maintaining focus, use the Dynamic-area AF 51 points (3D tracking) option. Finally, for point and shoot style photography, especially with people in the scene, consider the Auto-area AF (remember, a D-, or G-type Nikkor lens is necessary to make the most of this feature).

Focus Lock

Once the D300 has acquired focus it is possible to lock the autofocus system so the shot can be re-composed and the original focus distance will be retained, even if an AF point no longer covers the subject.

In single-servo AF autofocus, pressing the shutter release button halfway will activate autofocus. As soon as focus is acquired the in-focus indicator is displayed in the viewfinder and focus is locked and will remain locked while the shutter release button is held halfway down. Alternatively, press and hold the AE-L/AF-L button to lock focus; once focus is locked using the AE-L/AF-L button it is not necessary to keep the shutter release button depressed.

In continuous-servo AF autofocus: the autofocus system remains active while the shutter release button is held halfway down, constantly adjusting focus as necessary. To lock focus in this focus mode, press and hold the AE-L/AF-L button; once focus is locked using the AE-L/AF-L button it is not necessary to keep the shutter release button depressed.

Hint: Once focus has been locked in either S or C focus modes, ensure the camera-to-subject distance does not alter. If it does, re-activate autofocus and re-focus the lens at the new distance before using the autofocus lock options.

AF Assist Illuminator

The D300 has a small, built-in AF-assist illuminator, located on the front of the camera between the finger grip and the viewfinder head. This small light is designed to facilitate focusing in low light conditions. Whatever the intentions of the camera's design team were, I consider this feature largely superfluous!

Here are a few reasons why I suggest using CS-a9 (Built-in AF-assist illuminator) to cancel its operation:

- The lamp only works if you have an autofocus lens attached to the camera, the focus area mode is set to either single-point or Dynamic-area AF (with the center focus point selected), or Auto-area AF is active.
- It is only usable with focal lengths between 24mm 200mm.

- The operating range is restricted to 1'8'' 9'10'' (0.5 3.0 meters).
- Due to its location, many lenses obstruct its output, particularly if they have a lens hood attached.
- The lamp overheats quite quickly (6 to 8 exposures in rapid succession is usually sufficient) and will automatically shut down to allow it to cool. Plus, at this level of use it also drains battery power faster.

Hint: Provided the conditions described above are met, it is possible to use the built-in AF-Assist Illuminator lamp of either the SB-600, SB-800 Speedlight, or SU-800 Speedlight commander unit (operation of the camera's lamp is disabled in these circumstances). If you want to use either the SB-600 or SB-800 off camera the SC-29 TTL flash lead has a built-in AF-assist lamp that attaches to the camera's accessory shoe.

Limitations of the AF System

Although the autofocus system of the D300 is very impressive, there are some circumstances or conditions that can impair or limit its performance:

- Low light
- Low contrast
- Highly reflective surfaces
- Subject too small within the autofocus sensing area
- The AF point covers a subject comprising fine detail
- The AF point covers a regular geometric pattern
- The AF point covers a region of high contrast

SB-600 and SB-800 Speedlight flash units offer built-in AF assist lamps which enable the camera to focus in lowlight conditions.

• The AF point covers objects at different distances from the camera.

If any of these conditions prevent the camera from acquiring focus, either switch to manual focus mode or focus on another object at the same distance from the camera as the subject, then use the focus lock feature to lock focus before re-composing the picture.

The Menu System

The control of many of the features and functions on the D300 relies on an extensive and comprehensive menu system that is displayed on the LCD monitor. It is divided into six main sections:

- **Playback menu** Used to review, edit, and manage the pictures stored on the inserted memory card.
- Shooting menu Used to select more sophisticated camera controls that have a direct influence on the quality and appearance of the pictures being recorded by the camera. This menu also contains several special features such as the Picture Control, Active D-Lighting, configuration of multiple exposures, and time-lapse photography.
- Custom Settings menu As the title of this menu suggests, the options available here allow the user to select and set a wide range of controls to fine tune camera operation to their own specific requirements. The menu is sub-divided into six groups that deal with a specific area of camera operation: autofocus, metering/exposure, timers/AE lock, shooting/display, bracketing/flash, and controls.
- **Setup menu** Used to establish the basic configuration of the camera. Once the settings for the items in this menu are set, they generally are not changed very frequently.

The D300's "My Menu" option allows for customization of a variety of items contained in its other menus.

- Retouch menu This menu is only available when a
 memory card containing picture files is inserted in the
 camera. It offers a range of items that enable the user to
 crop, enhance, and add effects to a picture and save it as
 a separate copy without affecting the integrity of the original picture file.
- My menu Allows the user to create their own fully customized menu from any variety of the items contained in the Setup, Shooting, Custom Settings, Playback, and Retouch menus. This menu improves the efficiency of camera operation because it saves the user from having to navigate through the full menu system to access frequently used items. The menu can be edited and reordered by the user, at any time.

The menu system of the D300 has become even more complex than that of previous Nikon D-SLR cameras, due to the incorporation of more features and functions. The addition of the My menu item on the D300 is not only helpful but also a recognition of the challenges such an extensive menu can bring. There are a total of 109 main menu items, many of which have numerous sub-options. Since each page in the menu system can only display eight items, a lot of time can be spent scrolling through pages and options, using ① , to reach a desired setting. Unfortunately, with the exception of the My menu item, it is not possible to rearrange the order of the items in the menus. This compounds the amount of navigation required, as in many cases items that a user is most likely to want to access are located beyond the first page of the menu display. That said, it is only possible to add a maximum of five items to the My menu display before it becomes necessary to start scrolling to a subsequent page!

If you use the menu bank options available in the Shooting menu or the Custom Settings menu, it is important to be aware that, while you can reset any bank to the default settings, it is not possible to protect the settings that you create in any menu bank. However, is it possible to save most

menu settings to a memory card using the [Save/Load Settings] item in the Setup menu. These settings can then be restored to the same camera or loaded to another D300.

In short, the menu system has become cumbersome and overly extended. Many of the options within the menu system can be set using buttons and dials located on the camera body. Where such an alternative route is available, I would recommend using it, as this will improve the efficiency of camera handling with the benefit of reduced battery power consumption by avoiding use of the monitor screen.

Accessing Menus

To access any of the menus, push the **MENU** button and press to highlight one of the five tabs used to identify each menu (top to bottom): Playback menu, Shooting menu, Custom setting menu, Setup menu, Retouch menu, and My menu.

When you highlight the required menu tab, by using \blacktriangle and \blacktriangledown , the chosen menu will be displayed to the right of the five tabs. Press \blacktriangleright to enter the selected menu and highlight an option. To navigate to a specific menu item, press \blacktriangle or \blacktriangledown on the multi selector. To display the sub-options available for a selected menu item, press \blacktriangleright . Again, use \blacktriangle or \blacktriangledown to highlighted the desired sub-option and press the \circledcirc button to confirm the selection.

To exit the menu system, either press the shutter release button lightly to the halfway position or press the **MENU** button twice.

Note: Most menus have multiple pages; so keep scrolling up or down using to access options not shown on the first page displayed.

Note: Pressing or egenerally has the same effect as pressing the button. However, there are some menu options that can only be selected by pressing egenerally has the same effect.

Note: If a menu option is displayed in grey it cannot be accessed. This can be for one of a number of reasons including the current camera settings, state of the memory card, or condition of the battery.

In the following sections of this chapter I will deal with those features and functions controlled by the various menus. Some of these will be outlined fully in this chapter, while others are discussed in full detail elsewhere in the book; please refer to the relevant pages as referenced.

Playback Menu

The Playback Menu will only be displayed if a memory card is currently installed in the camera.

Delete Images

By using the [Delete] option in the Playback menu you can choose to erase individual images, a group of images, or all of the images on the card.

Note: Deleting all of the images on the card in this manner does not have the same effect as formatting the memory card.

Hint: To delete images one by one from the D300, it is quicker and easier to use the button on the rear of the camera. However, using the Delete function in the playback menu to erase a group of images will probably save a lot of time.

To delete a group of images:

- 1. Highlight the [Delete] option in the Playback menu and press ▶ .
- 2. Highlight [Selected] and press
- 3. Thumbnails of all of the images stored on the inserted memory card will be displayed on the monitor screen, regardless of whether they are stored in different folders. Scroll through the images using ; a yellow frame

will be displayed around the selected image. To see an enlarged view of the selected image, press and hold the

- 4. To select the highlighted image for deletion press the center of the multi selector . A small icon of a trashcan will appear in the upper right corner of the thumbnail image.
- 5. Once all the files to be deleted have been selected, press the 69 button.
- 6. The total number of images to be deleted will be displayed, along with two options: [No] or [Yes]. Highlight the required option and press the button to complete the process.

To delete all images:

- 1. Highlight the [Delete] option in the Playback menu and press ▶ .
- 2. Highlight [All] and press
- 3. Highlight either [No] or [Yes] as required.
- 4. Press the button to complete the process.

Note: It is not possible to delete pictures that have been protected. Images that have been hidden will not be displayed and, therefore, cannot be selected for deletion.

Hint: If you select a high volume of pictures for deletion the duration of the process can become lengthy (it may take 30 minutes or longer). To avoid draining the camera battery and placing additional wear and tear on the camera, it is preferable to manage the images stored on the memory card by connecting it to a computer, via a card reader.

Playback Folder

The [Playback folder] option in the Playback menu allows you to determine which images on the installed memory card will be displayed during playback. There are three options available:

- ND300 (default) All images on the card that were recorded by the D300 will be available for display, independent of what folder they are in.
- All All of the images stored on the card can be displayed, regardless of the camera used to record them; provided it conforms to the Design Rule for Camera File System (DCF). All Nikon digital cameras and most other current digital cameras are DCF compatible.
- **Current** Only the images in the folder currently set for image storage (via the [Folders] option in the Shooting menu) will be displayed.

To select the [Playback folder] option:

- 1. Highlight the [Playback folder] option in the Playback menu and press ▶ .
- 2. Highlight the desired option.
- 3. Press (x) to confirm the selection.

Hide Image

The [Hide image] option of the Playback menu enables the user to hide or reveal selected images. Images that are hidden cannot be viewed during normal image playback. Hidden images can only be viewed using the Hide Image item menu. They are also protected against deletion; they will only be "deleted" from the memory card if it is formatted.

Note: Remember, formatting does not actually delete the image file data; it merely overwrites the file directory on the memory card, so the camera can no longer navigate to the image files stored on it. It is often possible to recover files from a card that has been formatted using appropriate image recovery software, but the chances of this process being successful diminish as new data is saved to the card.

To use [Hide image]:

- Highlight the [Hide image] option in the Playback menu and press ► .
- 2. Highlight [Select/set] and press
- 3. Thumbnails of all of the images stored on the inserted memory card will be displayed on the monitor screen, regardless of whether they are stored in different folders. Scroll through the images using ; a yellow frame will be displayed around the selected image. To see an enlarged view of the selected image, press and hold the
- 4. To select the highlighted image to be hidden press the center of the multi selector . A small icon of a frame with a diagonal line through it will appear in the upper right corner of the thumbnail image.
- 5. Once you have selected all images to be hidden, press the button to finalize your selection and hide all selected images.

To reveal selected hidden images:

- 1. Highlight the [Hide image] option in the Playback menu and press ▶ .
- 2. Highlight [Select/set] and press
- 3. Thumbnails of all of the images stored on the inserted memory card will be displayed on the monitor screen, whether or not they are hidden and regardless of whether they are stored in different folders. Scroll through the images using ; a yellow frame will be displayed around the selected image. To see an enlarged view of the selected image, press and hold the \$\mathbb{Q}\$ button.
- 4. To select a highlighted hidden image and allow it to be seen during playback, press the center of the multi selector . The small icon of a frame with a diagonal line through it, that denotes a hidden image, will disappear.
- 5. Once you have selected all hidden images that are to be revealed, press the button.

To reveal all hidden images:

- 1. Highlight the [Hide image] option in the Playback menu and press ▶ .
- 2. Highlight [Deselect All?] and press
- 3. Reveal all hidden images? is displayed in the monitor screen. Highlight [Yes] or [No] as required.
- 4. Press the button to confirm the action.

Note: Images can be protected by selecting them using the image review function and pressing the button. (see page 147 for details)

Display Mode

The [Display mode] option on the D300 determines which pages of image information, in addition to the Basic Information and File Information pages, are available during single-image playback. The [Basic photo info] option allows you to choose whether or not to display highlights and focus point information, while the [Detailed photo info] option allows you to choose whether or not to display RGB Histogram and Data (three-pages) information.

To select an option(s) for [Display mode]:

- 1. Highlight the [Display mode] option in the Playback menu and press ▶ .
- 2. Highlight the desired option using ▲ or ▼, then press ▶ ; a check mark will appear in the box to the left of the option title.
- 3. Repeat step 2 for any other desired option(s).
- 4. Finally, highlight [Done] and press ▶ to confirm the selection and return to the Playback menu.

Display mode allows you to see data other than Basic and File information during single-image playback.

Image Review

The [Image review] option in the Playback menu determines if an image will be displayed on the monitor screen immediately after it is recorded. There are situations when immediately reviewing every image recorded by the camera is undesirable, such as when shooting in low-light conditions where the light from the screen is a distraction. When weighing the necessity of immediate image review, you should consider that the monitor screen consumes a relatively large amount of power, considerably increasing the drain on the battery. My recommendation is to switch this option off and use the button whenever you wish to review an image.

To select [Image review]:

- 1. Highlight the [Image review] option in the Playback menu and press ▶ .
- 2. Highlight On or Off (default).
- 3. Press (%) to confirm the selection.

After Delete

The [After Delete] option in the playback menu enables the user to select whether the following or previous image (based on the order in which they were recorded) is displayed after an image is deleted.

To set [After Delete]:

- Highlight the [After Delete] option in the Playback menu and press ► .
- 2. Highlight the desired option from the following:
 - [Show Next] (default) the next image to be displayed will be the image that was recorded after the one deleted. If the deleted picture was the last to be recorded, the previous picture will be displayed.
 - [Show Previou]s the next image to be displayed will be the image that was recorded before the one deleted. If the deleted picture was the first to be recorded, the following picture will be displayed.

• [Continue as Before] – the next image to be displayed after an image is deleted will be the next image that would have been viewed, based on the direction in which the user was scrolling through the recorded images when the delete process was initiated.

Hint: In my opinion, the [After Delete] option is a prime example of the unnecessary complexity of the menu system. Not only does it take up valuable space in the menu, it burdens the user with yet more decisions. Personally, I leave this option at its default setting and forget it is there.

Rotate Tall

The [Rotate Tall] option determines whether pictures shot in the vertical (portrait) format are displayed automatically in that orientation, or displayed in the horizontal (landscape) format. Displaying an image in the vertical orientation will decrease the overall size of the image to about two-thirds the size of an image displayed horizontally, as a horizontal image uses the full viewing area of the screen.

Note: The [Auto Image Rotation] option in the Setup menu must be turned on for the Rotate Tall function to operate.

To select [Rotate Tall]:

- 1. Highlight the [Rotate Tall] option in the Playback menu and press ▶ .
- 2. Highlight [On] or [Off].
- 3. Press to confirm the selection.

Slide Show

The Slide Show option in the playback menu allows you to view all of the images stored on the current memory card in sequential order. This can be a useful and enjoyable feature, especially if the camera is connected to view the images on a television.

To use [Slide Show]:

- 1. Highlight the [Slide Show] option in the Playback menu and press ▶ .
- 2. [Start] will be highlighted. To commence the slide show immediately, press or the button.
- 3. To select the display duration for each image, highlight [Frame interval] and press ▶ to display the four options: 2, 3, 5, or 10 seconds. Highlight the desired interval, and press ᅟ to confirm the selection and return to the Slide show page of the Playback menu.
- 4. Repeat step 2 above to start the slide show.

There are a variety of controls available when the slide show function is active:

- To return to previous image; press < .
- To skip to next image; press
- To display and scroll the Photo information pages; press
- To pause the display; press the button. A sub-menu with three options will be displayed: Restart, Frame Interval, or Exit. Highlight as required and press to select the option.
- To stop the display and return to the Playback menu; press the **MENU** button.
- To stop the display and return to the Playback mode (full frame or thumbnail view); press .
- To stop the display and return to the shooting mode; press the shutter release button down halfway.

At the end of the slide show display, a menu will be displayed with the following options: [Restart], [Frame Interval], or [Exit]. This is the same menu that is displayed when the slide show is paused by pressing the $\ensuremath{\mathfrak{G}}$ button. Highlight the required option and press $\ensuremath{\mathfrak{G}}$.

Note: Images that have been hidden will not appear during the slide show display.

Hint: Due to the prolonged use of the monitor screen, the slide show function consumes a large amount of power, especially if a large number of images are stored on the memory card. Ensure you use a fully charged battery, or the EH-5 / EH-5a AC adapter.

Print Set (DPOF)

The [Print Set (DPOF)] item in the Playback menu enables the user to create and save instructions that will enable a set of images to be automatically printed by a compatible printing device. This "print order" will communicate which images should be printed, how many prints of each image, and the information that is to be included on each print. The information is saved on the installed memory card in the Digital Print Order Format (DPOF) and can be read subsequently by DPOF compatible printing device. (See page 381 for more details.)

Shooting Menu

The following are the various options available in the D300's Shooting menu.

Shooting Menu Bank

The D300 can store all of the options in the shooting menu in one of four separate banks; allowing the user to store four different configurations of camera settings for quick and easy access. Changes made in one bank do not affect the settings in the other three. This feature is particularly useful if you shoot a variety of different subjects that require different shooting setups, such as portraiture and sports photography; rather than having to change a group of settings each time you change your subject matter, you simply need to switch to the relevant bank of settings. Likewise, if the camera is used by a variety of different photographers each one can store their own group of settings in a specific bank. The default bank is A.

To select [Shooting Bank]:

- 1. Highlight the [Shooting Menu Bank] option in the Shooting menu and press ▶ .
- 2. Highlight the name of the bank you wish to select.
- 3. Press to confirm the selection.

The default names for the four banks are A, B, C, and D, but these can be changed for easier reference. For example, you may wish to name each bank for a particular style of photography (portraiture, landscape, or sports). Alternatively, you could connect a particular bank with a specific photographer by using their name as the bank title. The name of each bank is limited to 20 characters.

To rename a shooting bank:

- 1. Highlight the [Shooting Menu Bank] option in the Shooting menu and press ▶ .
- 2. Highlight the [Rename] option from the [Shooting Menu Bank] options list and press ▶ .
- 3. Highlight the bank you wish to rename and press to open the keypad of characters.
- 4. To enter the new name, highlight the character you wish to input using and press . If the wrong character is entered inadvertently, use the button in combination with to move the cursor over the unwanted character and press to remove it.
- 5. Press the button to save the name and return to the [Shooting Menu Bank] options list.

Reset Shooting Menu

The [Reset shooting menu] option allows the user to restore all settings, in the current shooting bank, back to their default values. A list of the affected settings and their default values is shown below.

Note: The default settings for image quality, image size, white balance, and ISO sensitivity can also be reset by using the two button reset, as described on page 150.

To use [Reset Shooting menu]:

- 1. Highlight the [Reset shooting menu] option in the Shooting menu and press ▶ .
- 2. Highlight [No] (default) or [Yes] as required.
- 3. Press ▶ , or the ⊗ button, to confirm the selection and return to the Shooting menu.

With the exception of the [multiple exposure] and [interval timer] options, only the settings in the current shooting menu bank will be reset. The [multiple exposure] and [interval timer] options will be reset in all banks.

Option	Default
File naming	DSC
Image Quality	JPEG Normal
Image Size	Large
JPEG Compression	Size Priority
NEF (RAW) recording - type	Lossless compressed
NEF (RAW) recording - type	12-bit
White Balance	Auto
White balance – fine-tuning	Off
White balance – choose color temp	5000K
Set Picture Control	Standard
Color Space	sRGB
Active D-Lighting	Off
Long Exp. Noise Reduction	Off
High ISO noise reduction	Normal
ISO sensitivity	200
ISO sensitivity auto control	Off
Live View mode	Hand-held
Live View release mode	Single frame
Multiple exposure	Reset
Interval timer shooting	Reset

Active Folder

The D300 uses a folder system to organize images stored on the installed memory card. The [Active folder] option in the Shooting menu allows you to select which folder the images you are currently recording will be saved in, and enables you to create new folders.

If you do not use any of the folders options, the camera will automatically create a folder named 100ND300, in which the first 999 pictures recorded by the camera will be stored. If you exceed 999 pictures, the camera will create a new folder, named 101ND300. A new folder will be created for each set of 999 pictures.

You can create your own folder(s) and name them for your reference. A three digits number between 100 and 999 always prefixes the folder title; the user can assign this number. The suffix, ND300, always remains the same.

If you use multiple folders on a single memory card, you must select one "active" folder to which all images will be stored until an alternative folder is chosen. If the maximum capacity of 999 pictures is exceeded in the active folder, the D300 will create a new folder using the same five-character suffix and assign a three-digit prefix with an incremental increase of one (i.e., if folder 100ND300 became full, the D300 would create folder 101ND300).

Note: If the folder that has reached full capacity (i.e. 999 images) is folder number 999ND300, the camera will disable the shutter release button and prevent you from making an exposure. You will have to create a new folder with a lower number, or choose another folder on the memory card that still has space for new images. Likewise, the shutter release button will be disabled if the active folder contains a picture numbered 9999.

To create a new folder:

 Highlight the [Active folder] option in the Shooting menu and press ►.

2. Highlight the [New folder number] option from the [Active folder] options list and press .

- 3. Designate the number of the new folder by using to increase of decrease the first digit, then use to select the second digit. Use to select the desired number.
- If a folder with the selected number already exists, a small icon will be displayed to the left of the folder number: ☐ Folder is empty, ☐ folder is partially full, ☐ Folder is full, or contains a file numbered 9999.
- 5. Press to confirm the action and return to the Shooting menu.

To select an existing folder:

1. Highlight the [Active folder] option in the Shooting menu and press ▶ .

2. Highlight the [Select folder number] option from the [Active folder] options list and press .

3. A list of the folders currently stored on the memory card is displayed; highlight the folder you wish to use by pressing ①.

4. Press (w) to confirm the action and return to the Shooting menu.

Hint: Folders may be useful if you expect to take pictures of a variety of subjects (i.e., various different locations on a vacation), but with the relatively low cost of memory cards it is probably easier, and more efficient, to use multiple cards.

Hint: Personally, I believe that using multiple folders is time consuming, potentially confusing, and fraught with danger! If you have more than one Nikon digital camera and move cards between them, the different cameras will not be able to display images stored in folders created by another cam-

era. If the second camera then creates a new folder, it will have a higher prefix number than the folder created by the first camera. Even multiple folders created by the D300 can present problems in other cameras, as new images will be saved to the currently selected folder with the highest prefix number. I would rather use a browser application such as Nikon View NX to organize my image files.

File Naming

The file names of all images taken with the D300 contain three letters, a four-digit number, and the three-letter file extension (JPG, TIF, or NEF). The default for the three letters in the file name is DSC. They will also have an underscore mark to denote the selected color mode; as a prefix it denotes Adobe RGB, as a suffix it denotes sRGB. (i.e., DSC_0001.JPG denotes a JPEG file, number 0001, saved in the sRGB color space.) The [File Naming] option in the Shooting menu is used to change the three letters from the default of DSC (this section of the file name must contain three letters, no more or less).

To select [File naming]:

- 1. Highlight the [File Naming] option in the Shooting menu and press ▶ .
- 3. To enter the new name, highlight the character you wish to input using and press to select. If the wrong character is entered inadvertently, use the button in combination with to move the cursor over the unwanted character. Now select the correct letter/number and press the button to confirm it.
- 4. Press the button to save the name and return to the Shooting menu.

Beware of the 999 curse! If folder 999ND300 has reached full capacity (999 images), the camera will disable the shutter release and you won't be able to shoot until you rectify the situation.

The file names of all subsequent images recorded by the camera will contain the three letters selected by the [File naming] option.

Image Quality

The [Image Quality] option in the Shooting menu allows the user to select the file format for images recorded by the camera. The D300 can record images in JPEG, TIFF, or NEF (RAW) formats.

See page 302 for full details. (Image Resolution & Processing - Image Quality & Size).

Image Size

Image Size determines the file size, or resolution, of an image. Image Size is expressed as the number of pixels used in the file.

See page 302 for full details. (Image Resolution & Processing - Image Quality & Size)

Note: Image size adjustments will only apply to images saved using the JPEG or TIFF format. NEF (RAW) files are always saved at the camera's highest resolution.

JPEG Compression

The size of an image file recorded in the JPEG format will be affected by the complexity of the scene being recorded. Usually, a more intricate scene will require more information to be recorded, which increases the file size. However, the [JPEG Compression] option in the Shooting menu enables the user to control this increase in size by determining whether the camera will place priority on recording JPEG files at a fixed size, independent of the complexity of the scene, or vary the file size to optimize image quality.

See page 291 for full details. (Image Resolution & Processing - Image Quality & Size)

NEF (RAW) Recording

The D300 provides the option of saving NEF (RAW) files in either an uncompressed, lossless compressed, or compressed form. Lossless compressed NEF (RAW) files are approximately 20-40% smaller than uncompressed files, while compressed NEF (RAW) files are approximately 40 – 55% smaller than uncompressed files. Compression increases the number of pictures that can be stored in any given storage space. Nikon states that lossless compressed NEF (RAW) files exhibit no change in image quality, while compressed NEF (RAW) files exhibit almost no change in terms of reduced image quality. (See page 294 for more details.)

White Balance

The [White Balance] option in the Shooting menu allows you to select the color temperature to which the images you are shooting will be balanced. (See page 89 for more details.)

Set Picture Control

The new Picture Control System in the D300 replaces the Optimize image system used in previous Nikon D-SLR cameras. It allows the user to set specific controls that determine how the D300 will perform image processing. The D300 has four basic Nikon Picture Controls: Standard, Neutral, Vivid, and Monochrome. (See page 106 for more details.)

Manage Picture Control

Using the four basic Nikon Picture Controls, the user can create and save custom Picture Controls. These custom Picture Controls can be copied to a memory card and applied in another D300 camera, or used in compatible Nikon software. Picture Controls created in compatible Nikon software can also be uploaded to a D300. See page 117 for more details.)

Color Space

The range of colors capable of being displayed in an image recorded by the D300 is determined by the [Color Space] setting. The D300 provides two options for color space: [Adobe RGB] and [sRGB]. The color space determines the range (gamut) of colors that will be available in an image file for color reproduction and should be chosen according to how the image will be processed after it has been exported from the camera. See page 119 for more details.)

Active D-Lighting

The Active D-Lighting feature (not to be confused with the D-Lighting item in the Retouch menu) can be used to optimize the exposure settings when using Matrix metering. Since the effects of Active D-Lighting are applied during the processing of an image file, it is not possible to reverse them when recording either JPEG or TIFF files. The effects of Active D-Lighting on an image recorded in the NEF (RAW) format can be altered subsequently using appropriate Nikon software. (See page 367 for more details.)

Long Exposure Noise Reduction

Images taken at shutter speeds of 8 seconds or longer will often exhibit a higher level of electronic noise. Noise is the result of amplification processes that are applied to the data captured by the sensor, which is then compounded by the higher internal temperature of the camera due to the extended shutter speed. It manifests as irregularly placed bright, colored pixels that disrupt the appearance of an image, particularly in areas of even tonality. Long Exposure Noise Reduction, abbreviated to [Long Exp. NR] in the camera menus, will help reduce the appearance of noise when using long exposure.

To select [Long Exp NR]:

- 1. Highlight the [Long Exp. NR] option in the Shooting menu and press ▶ .
- 2. Highlight [On] or [Off] (default) as required.
- 3. Press ▶ , or the ❷ button, to confirm the selection and return to the Shooting menu.

If [On] is selected for [Long Exp NR], the processing time for each recorded image will increase by approximately 100%. While the image data is being processed "Job nr" will appear, blinking, in place of the shutter speed and aperture value displays in the control panel. No other picture can be recorded while "Job nr" is displayed and image processing is in progress.

Note: The process used by the D300 to perform the Long Exp NR involves the camera making a second "exposure" known as a "dark frame exposure" during which the shutter remains closed but the camera maps the sensor and records the values of each photodiode (pixel). Sometimes a photodiode (pixel) can "lock-up" and retain a value that is erroneous; this can often occur if the sensor gets hot due to prolonged usage, such as in a long exposure, or due to a high ambient temperature. After "mapping" the sensor for "hot" (overly bright) photodiodes, the camera subtracts the "dark frame" photodiode values from the photodiode values of the main exposure in an effort to reduce the effect of noise in the final image.

Long Exposure Noise Reduction is a boon for lowlight images. Make sure that you use it as the clean images it produces are one of the pluses of shooting with the D300.

Hint: Nikon states that when the long exposure noise reduction feature of the D300 is on, it will operate whenever the shutter speed exceeds 8 seconds. Personally, I have found that the in-camera signal processing of the D300 is so effective that this feature is not necessary for shutter speeds under 30-seconds.

High ISO NR

At high ISO sensitivity settings the presence of electronic noise in an image increases due to the greater degree of signal amplification that takes place during in-camera processing (analogous to the more visible grain structure of higher ISO film). The High ISO Noise Reduction feature, abbreviated to [High ISO NR] in the camera's menu system, will help reduce the amount of noise in images taken at ISO sensitivities of 800 and higher.

To set [High ISO NR]:

- 1. Highlight [High ISO NR] option in the Shooting menu and press .
- 2. Highlight the required option: [High], [Normal], [Low], or [Off] (see table below).
- 3. Press ▶ , or the ❷ button, to confirm the selection and return to the Shooting menu.

Option	Effect
High Normal Low	Noise reduction is applied at ISO sensitivities of ISO800, or higher. Select the level of noise reduction from one of the three options.
Off	Noise reduction is only applied at ISO sensitivities of HI 0.3 (ISO 4000) and higher. The level applied is lower than the amount applied when Low is selected for High ISO NR.

Hint: Noise reduction will affect the resolution of fine detail and, at high levels, the brightness of colors. The noise performance of the D300 is very good and the random, almost film-like quality exhibited by the noise in D300 images is not, for the most part, troublesome. The in-camera noise reduction for higher ISO sensitivities does not offer the same level of control as found in dedicated noise reduction software. Unless you must use the in-camera options, I recommend applying noise reduction during post-processing.

ISO Sensitivity

ISO sensitivity in the D300 simulates the sensitivity to light of film bearing the same ISO number. The higher the ISO number the greater the sensitivity to light. (See page 153 for more details.)

Live View

In Live View, the D300 displays an image on its monitor screen in real time, showing a view of the scene the lens is pointed towards. There are two Live View modes: Hand-held

and Tripod. There are also options for the release mode that will be used when Live View is active. (See page 133 for more details.)

Multiple Exposure

The Multiple Exposure feature of the D300 enables the camera to take up to 10 different exposures that the camera will combine into a single image. The individual files must be shot in consecutive order and are not saved as separate files. (See page 128 for more details.)

Interval Timer Shooting

The Interval Timer Shooting feature of the D300 enables the camera to take a set number of pictures over a period of time, at predetermined intervals – a technique often called time-lapse photography. (See page 130 for more details.)

Custom Settings Menu

The Custom Settings menu allows the user to fine tune the performance of the D300 to satisfy their particular requirements and adapt the camera to meet the demands of specific shooting situations. It contains a comprehensive set of no less than 50 items, each with a range of options that covers virtually every aspect of camera operation. The items are logically grouped by the nature of their function, as set out in the table below:

	Group	Custom Settings
a	Autofocus	a1 – a10
b	Metering / Exposure	b1 – b6
С	Timers / AE&AF Lock	c1 – c4
d	Shooting / Display	d1 – d11
е	Bracketing / Flash	e1 – e7
f	Controls	f1 – f10

Selecting Custom Settings Options

The multi selector is used to navigate through the Custom Settings menu. Highlight the Custom Settings menu tab to display the list of the six Custom Settings groups plus, [C: Custom setting bank], and [R: Reset Custom Settings]. Highlight the required group and press to display a full list of the items in that group. Use to highlight the desired item, and press to display the options available for that item. Use to select the desired option and use to confirm the selection and return to the list of items in the group.

C: Bank Select

The D300 can store a full range of custom settings in one of four different, independent banks. Alterations made to custom settings in one bank have no affect on the settings in the other three banks. To select a particular bank, highlight [C: Custom settings bank] and press ▶ ; a list of the four banks, identified as A, B, C, and D will be displayed. Each bank of settings can be renamed using the [Rename] option. Each bank can be configured with a different combination of settings for the various options, allowing the user to swiftly switch from one group of settings to another. If the selected bank has been modified from its default settings CUSTOM is displayed in the control panel, and an asterisk is shown besides each altered item in all six groups.

R: Menu Reset

To reset a particular custom bank back to the defaults used in the Custom Settings menu, use the [R: Menu Reset] option.

- Select the custom setting bank to be reset and highlight [R: Reset custom settings].
- Select [No] or [Yes] and press .

The default custom settings are outlined in the table below:

	Option	Default	
a1	[AF C priority selection]	Release	
12	[AF S priority selection]	Focus	
a3	[Dynamic AF area]	9 points	
a4	[Focus tracking with lock on]	Normal	
a5	[AF activation]	Shutter/AF ON	
a6	[AF point illumination]	Auto	
a7	[Focus point wrap around]	No wrap	
a8	[AF point selection]	51 points	
a9	[Built in AF assist illuminator]	On	
a10	[AF ON for MB D1 0]	AF ON	
oi	[ISO sensitivity step value]	1/3 step	
b2	[EVsteps forexposure cntrl.]	1/3 step	
b3	[Exp comp/fine tune]	1/3 step	
b4	[Easy exposure compensation]	Off	
b5	[Center weighted area]	Ø 8 mm	
b6	[Fine tune optimal exposure] (Matrix metering] [Center weighted] [Spot metering]	0 0 0	
c1	[Shutter release button AE L]	Off	
c2	[Auto meter off delay]	6s	
с3	[Self timer delay]	10s	
c4	[Monitor off delay]	20s	
d1	[Beep]	High	
d2	[Viewfinder grid display]	Off	
d3	[Viewfinder warning display]	On	
d4	[CL mode shooting speed]	3 fps	
d5	[Max. continuous release]	100	
d6	[File number sequence]	On	
d7	[Shooting info display]	Auto	
d8	[LCD illumination]	Off	

	Option	Default	
d9	[Exposure delay mode]	Off	
d10	[MB D1 0 battery type]	LR6 (AA alkaline)	
d11	[Battery order]	Use MB D10 batteries first	
e1	[Flash sync speed]	1/250s	
e2	[Flash shutter speed]	1/60s	
e3	[Flash cntrl for built in flash]	TTL	
e4	[Modeling flash]	On	
e5	[Auto bracketing set]	AE & flash	
e6	[Auto bracketing] (Mode M)]	Flash/speed	
e7	[Bracketing order]	MTR> under > over	
f1	[Multi selector center button [Shooting mode] [Playback mode]	Select center focus point Thumbnail on/off	
f2	[Multi selector]	Do nothing	
f3	[Photo info/playback]	Info /Playback	
f4	[Assign FUNC. button] [FUNC. button press] [FUNC. button+dials]	None Auto bracketing	
f5	[Assign preview button] [Preview button press] [Preview+command_dials]	Preview None	
f6	[Assign AE L/AF L button] [AE L/AF L button press] [AE L/AF L+command dials]	AE/AF lock None	
f7	[Customize command dials] [Reverse rotation] [Change main/sub] [Aperture setting] [Menus and playback]	No Off Sub command dial Off	
f8	[Release button to use dial] No		
f9	[No memory card?]	Enable release	
f10	[Reverse indicators]		

Autofocus

a1: AF-C Priority Selection

Description: Controls whether an exposure is made whenever the shutter release is pressed all the way down (release priority) or only after

focus has been attained (focus priority), in

continuous-servo AF mode.

Options: [Release] (default) – An exposure can be made whenever the shutter release is fully

depressed.

[Release + focus] - An exposure can be made whenever the shutter release is fully depressed. However, in continuous shooting mode the effective frame rate is reduced to help improve the accuracy of focus in low light conditions or with subject that have low contrast

[Focus] – The shutter can only be released once focus has been attained, although focus does not lock in this mode.

Hint: I recommend leaving this item set to the default option, at least until you become familiar with the focusing system of the D300.

a2: AF-S Priority Selection

Description: Controls whether an exposure is made whenever the shutter release is pressed all

whenever the shutter release is pressed all the way down (release priority) or only after focus has been attained (focus priority), in single-servo AF mode. Regardless of the option selected, focus is always locked when the in-focus indicator is displayed in the viewfinder.

Options: Focus (default) – An exposure can only be made when focus has been attained and the

in-focus indicator

is displayed in the viewfinder.

Release – An exposure can be made whenever the shutter release is fully depressed.

Hint: Again, I recommend leaving this item set to the default option, at least until you become familiar with the focusing system of the D300.

a3: Description:

Dynamic AF area

This item determines the number of AF points used by Dynamic-area AF, when shooting in continuous-servo AF mode. If the subject leaves the area covered by the selected AF point the D300 will use information from the selected number of surrounding AF points to try to maintain focus.

Options:

- (#) 9-points (default) The relatively small number of AF points used in this option means the camera has less computations to perform, so it potentially provides the quickest autofocus. It is useful in situations where the path of the subject is relatively predictable.
- (#) 21-points This option is potentially slower than the 9-point option, as the camera must process more information. But, it provides a greater area of coverage and therefore is useful with subjects that are moving erratically.
- 51-points Another step back from the 21-point option because even more information must be processed. But it does provide comprehensive coverage and is, therefore, very useful with subjects that are moving quickly and unpredictably.

51-points (3D tracking) – Using Nikon's innovative Scene Recognition System (SRS) the camera is able to identify a subject by its distribution of color via the 1005-segment RGB sensor. It is also able to enhance the tracking of a moving subject by using further information from the Multi-CAM3500 AF sensor. See page 191 for full details (AF system – Dynamic-area AF)

Hint: You will want to shift between these options, based on the type of subject you are photographing and the light conditions that prevail at the time of shooting. In my experience the 9-point and 21-points options are best in low light, a condition where the 51-point (3D tracking) can be left searching. I keep this item in My menu, so that it is quickly accessible.

a4:

Focus Tracking with lock-on

Description:

This item determines how the autofocus system adjusts to abrupt changes in the camera-to-subject distance.

Options:

Normal (default), Long, & Short – The D300 delays adjusting the focus point when the camera-to-subject distance changes suddenly. The purpose is to prevent the camera from re-focusing inadvertently when an object briefly passes between the camera and the subject. (Nikon provide no information on the duration of the three delay options.)

Off – The camera immediately re-adjusts focus when the camera-to-subject distance changes suddenly.

Hint: To ensure the D300 can perform focus tracking efficiently and effectively, I recommend setting this option to [Off]. However, in situations such as photographing a game of football where a player may momentarily obstruct the

camera's view of the intended subject, it can be useful to set a delay period. The default option of [Normal] is probably the best choice.

a5: AF Activation

Description: This item determines whether both the shutter release button and the AF-ON button

can be used to activate autofocus, or whether autofocus is only activated when

the AF-ON button is pressed.

Options: Shutter/AF-ON (default) – Autofocus is acti-

vated when either the shutter release button,

or the AF-ON button is pressed.

AF-ON Only – Autofocus can only be activated by pressing the AF-ON button.

Hint: Using the AF-ON button to activate autofocus can be useful when photographing moving subjects; the focusing system can be given more time to assess focus distance and perform predictive autofocus as you follow the subject in the viewfinder (before pressing the shutter release button). It can also be useful to pre-focus on a specific point and lock focus at that distance, then wait until the subject arrives at the pre-focused point before releasing the shutter. [See page 189 for full details (AF system – Trap focus.]

a6: AF Point Illumination

Description: To facilitate the identification of the active

AF point, particularly in low light situations,

it can be highlighted in red.

Options: Auto (default) – The selected autofocus sensing area is highlighted in red when necessary, depending on the level of ambient light.

On – The selected autofocus sensing area is always highlighted in red, regardless of the

level of ambient light.

Off – The selected autofocus sensing area is never highlighted in red.

Hint: The default option of Auto is probably the best for most shooting situations. However, you may wish to consider setting the off option for this item if you expect to shoot rapid sequences of frames; displaying the active AF point introduces a very slight delay in shutter operation.

a7:

Focus point wrap-around

Description:

This item controls how the selection of an autofocus sensing area is performed.

Options:

No Wrap (default) – If the selected AF point is at the edge of the viewfinder screen, pressing the multi selector in the direction of the edge has no effect.

Wrap – This allows the selection of AF points to "wrap around" the viewfinder from top to bottom, bottom to top, left to right, and right to left.

Hint: I recommend setting the [Wrap] option for this item – it helps to speed up selection of the focus sensing area.

a8:

AF point selection

Description:

The D300 can be configured to use either all 51 AF points, or just 11 AF points, when selection of the AF point is performed manually.

Options:

AF51: 51 points (default) – The camera uses all 51 AF points available in its autofocus system.

AF11: 11 points – The camera uses only 11 AF points, in a pattern that will be familiar to users of the D2-series Nikon D-SLR cameras .

Hint: The default setting of [AF51: 51 points] provides the most comprehensive coverage of the frame area. However, there may be situations where having fewer AF point to choose from may be of benefit, because your ability to select them will be faster.

a-9: Built-in AF-assist illuminator

Description: The D300 has a built-in lamp that illuminates to assist autofocus operation in low light shooting conditions. This item deter-

mines whether the lamp operates or not.

Options: ON (default) - The built-in lamp will acti-

vate to assist autofocus operation in low

light shooting conditions.

Off - The lamp does not illuminate, regard-

less of the level of ambient light.

Hint: As discussed in the section of this book that deals with the autofocus system of the D300 (see page 180), I consider the lamp to be of little practical value and recommend you select the [Off] option.

a10: AF-ON for MB-D10

Description: This item determines the function assigned

to the AF-ON button on the MB-D10 battery

pack, when it is fitted to the D300.

Options: AF-ON (default) – The AF-ON button on the

MB-D10 performs the same function as the

AF-ON button on the D300.

AE/AF lock – While pressed and held, the AF-ON button on the MB-D10 locks focus

and exposure.

AE lock only - While pressed and held, the AF-ON button on the MB-D10 locks expo-

sure only.

AE lock (Reset on release) – Pressing the AF-ON button on the MB-D10 locks the exposure, which remains locked until the AF-ON button is pressed a second time, the shutter is released, or the exposure meter is turned off.

AE lock (Hold) – Pressing the AF-ON button on the MB-D10 locks the exposure, which remains locked until the AF-ON button is pressed a second time or the exposure meter is turned off.

AF lock only – While pressed and held, the AF-ON button on the MB-D10 locks focus only.

Same as FUNC button – The AF-ON button on the MB-D10 performs the same function as the FUNC button on the camera (set using CS-f4).

Hint: The current shooting situation will determine the best for this option.

Metering / Exposure

b1:

ISO Sensitivity Step Value

Description:

Use this item to select the size of the exposure value step when adjusting ISO sensitivity.

Options:

1/3 Step (1/3EV) (default)

1/2 Step (1/2EV) 1 Step (1EV)

Hint: This item can be useful in situations when you want to use the lowest ISO sensitivity level to maintain image quality but still want to adjust exposure, while continuing to use your selected shutter speed and lens aperture. To provide the finest degree of control use the [1/3 Step] option.

You can change the size of the exposure step change from 1/3 step, to 1/2 step, or even to 1 full step.

b2: EV Steps for Exposure Control

Description: Use this item to select the size of the step

when adjusting shutter speed, lens aperture,

and exposure bracketing.

Options: 1/3 Step (default) – Shutter speed and aperture change in steps of 1/3EV. Bracketing steps can be selected from 1/3,1/2, and 1EV.

1/2 Step – Shutter speed and aperture change in steps of 1/2EV. Bracketing steps can be selected from 1/2 and 1EV

1 Step - Shutter speed and aperture change in steps of 1EV. Bracketing step is set to 1EV.

Hint: I recommend using the [1/3 Step] option to provide the finest degree of exposure control.

b3: Exposure Compensation / Fine Tune

Description: Use this item to select the size of the step

when setting exposure compensation levels

and exposure fine-tuning levels.

Options: 1/3 Step (1/3EV) – (default)

1/2 Step (1/2EV) 1 Step (1EV)

Hint: I recommend using the [1/3 Step] option to provide the finest degree of exposure control.

b4 Easy Exposure Compensation

Description: This item controls whether the exposure compensation button is required to set an

exposure compensation value.

Options: Off (default) – Exposure compensation is set by pressing the exposure compensation button and rotating the main command dial.

On (Auto Reset) – Exposure compensation is set by rotating one of the command dials, without pressing the exposure compensation button. The exposure compensation value set with the command dial is cancelled when the camera or exposure meter is turned off

On - Exposure compensation is set by rotating one of the command dials, without pressing the exposure compensation button. Compensation selected using this method is not reset when the camera or exposure meter is turned off. This option is not available with manual exposure mode. The choice of which command dial will control exposure compensation depends on the exposure mode and option selected at CS-f7 - (Customize command dials).

P	CS-f7	Off	Sub-command dial
Α	CS-f7	Off	Main-command dial
S	CS-f7	Off	Sub-command dial
P	CS-f7	On	Sub-command dial
Α	CS-f7	On	Sub-command dial
S	CS-f7	On	Main-command dial

Hint: This item introduces additional complexity to the D300, especially if you have other Nikon cameras that do not offer this level of control. Most modern Nikon cameras use a combination of pressing a button and turning a command dial to set exposure compensation. I suggest, especially if you have other cameras, to leave this item set to the default option of [Off].

b5: Center-Weighted Area

Description: In center-weighted exposure metering the

D300 assigns approximately 75% of the metering influence to a circular area in the center of the frame. This option allows you to select the diameter of the circular metering area, or have the camera average the exposure reading across the entire frame.

Options: 6 mm

8 mm (default)

10 mm 13 mm Average

Hint: This is definitively a personal preference item. I do not use center-weighted metering, so I leave it set to the default 8mm circle. Using a smaller circle will enable you to meter from a more precise area of the frame.

b6: Fine Tune Optimal Exposure

Description: This option enables you to fine-tune expo-

sure measurement. It can be set, independently, for each metering method over a range of +/- 1EV in steps of 1/6EV. Highlight

CS-b6 and press **b** to display the options [No] and [Yes].

Options:

No – Use this option to exit the item without adjusting exposure.

Yes – Highlight [Yes] and press ▶ to open a sub-menu that displays the three metering methods: Matrix, center-weighted, and spot. Highlight the required metering method and press ▶ to open the next menu page that displays the exposure adjustment value. Use ♠ and ▼ to selected an adjustment level and press ♥ to save the setting.

Hint: I recommend you avoid using this item if you use Matrix metering, as it will adjust exposure by unknown amounts based on each individual subject or scene. However, if you use the spot meter function to take a meter reading from a known test target, this item is useful to ensure that the meter reading suggested by the camera actually matches the reflectivity of the test target. For example, if you use an 18% grey card as a test target you will probably want to set a fine tune value of +1/3 to +1/2EV, due to the way the camera meter is calibrated. The key to using this option successfully is to test your equipment with care and precision and only make an adjustment when you are positive it is necessary.

Timers / AE Lock

c-1:

Shutter-release Button AE-L

Description:

This option determines how the exposure

value can be locked.

Options:

Off (default) – The exposure is only locked by pressing the AE-L/AF-L button.

On – The exposure can be locked by either pressing the AE-L/AF-L button, or pressing the shutter release button down half way.

Hint: This is a matter of personal preference, but if you wish to recompose the picture after taking a meter reading having the exposure locked by simply pressing the shutter release button can be convenient.

c2: Auto Meter-off Delay

Description: This item determines how long the camera's

exposure meter will remain active when no

camera operation is performed.

Options: 4 seconds

6 seconds (default)

8 seconds
16 seconds
30 seconds
1 minute
5 minute
10 minute
30 minute
No Limit

Hint: To prevent undue drain on the battery, I recommend using either the default setting or the 8 second option. These provide a good compromise between having sufficient time to read and assess the meter reading and conserving battery power.

c3: Self-timer

Description: This item controls the duration of the shutter

release delay in the self-timer mode.

Options: 2 seconds

5 seconds 10 seconds 20 seconds

Hint: Set the duration of the delay to match the shooting situation; using a duration that is unnecessarily long will just increase the drain on battery power.

c4: Monitor-off delay

Description: This option determines how long the LCD

monitor screen on the back of the camera will remain on, if no other camera opera-

tion is performed.

Options: 10 seconds

20 seconds 1 minute 5 minutes 10 minutes

Hint: Use the shortest possible duration to prevent undue drain on the battery power.

Note: If the EH-5 / EH-5a AC adapter is used the exposure meter will not turn off and the LCD monitor will switch off only after 10 minutes.

Shooting / Display

d1: Beep

Description: Controls the pitch of the audible warning

that sounds when the self-timer function is counting down, or the camera attains focus in S (single-servo) autofocus with [Focus]

(focus priority) selected at CS-a2.

Options: High (default)

Low Off

Hint: This is a matter of personal preference, but the audible warning can be a distraction in many shooting situations. For that reason, I recommend selecting [Off] for this option.

d2: Viewfinder Grid Display

Description: A pattern of grid lines is displayed in the

viewfinder.

Options: On

Off (default)

Hint: A very useful feature for any photography that requires precise alignment of elements in the picture (i.e., a horizon, surface of water, or buildings). I keep this item in My menu, so that it is accessible at short notice.

d3: Viewfinder Warning Display

Description: At the default setting of [On], the camera

will display a warning in the viewfinder to

indicate when the battery is low.

Options: On (default)

Off

Hint: I recommend leaving this setting at its default option of [On]. You are more likely to notice the warning in the viewfinder, than the battery indicator in the control panel.

d4: CL Mode Shooting Speed

Description: This item determines the frame rate of the

camera when the shooting mode is set to continuous low (CL) shooting. It also determines the frame rate for single-frame and mirror-up modes when using the interval

timer feature.

Options: Frame rates of 1, 2, 3 (default), 4, 5, 6 and 7

frames per second

Hint: I never use the CL shooting mode, as I prefer to have the camera shoot at its fastest rate when necessary or control shooting by taking individual frames in rapid succession in continuous high shooting mode. Your own specific shooting requirements will determine the choice you make for this item.

Note: The effective frame rate can be influenced by the shutter speed and capacity of the buffer memory. The top frame rate in CL shooting mode when using the D300 without the MB-D10 is 6 fps.

d5:

Max Continuous Release

Description:

Determines the maximum number of pictures that can be shot in a single sequence

(burst).

Options:

Number can be set anywhere between 1

and 100.

Hint: Regardless of the option set at CS-d5, the frame rate may slow down as the camera's buffer memory becomes full.

d-6:

File Number Sequence

Description:

Controls whether file numbering continues in a consecutive sequence from the last number used when a memory card is formatted, a new folder is created, or a new memory card is inserted in the camera, or if it is reset to 0001.

Options:

On (default) - Whenever a memory card is formatted, or a new memory card is inserted in the camera file numbering continues, consecutively, from the last number used or the largest number in the current folder, whichever is higher. If the current folder contains a photograph numbered 9999, a new folder will be automatically created, and numbering will be reset to 0001.

Off – File numbering is reset to 0001 whenever a memory card is formatted, a new folder is created, or a new memory card is inserted in the camera.

Reset - The same as the [On] option, except that the file number for the next exposure is assigned by adding one to the largest file number in the current folder.

Hint: If you expect to shoot pictures using more then one memory card, I strongly suggest that you use the [On] option. Otherwise you will potentially end up with duplicate file numbers and names, which could become very confusing once images are saved to your computer.

d7: Shooting Info Display

Description: Determines the nature of the shooting info display that is shown when the "info" button

is pressed in the shooting mode.

Options: Auto – The display will change automatically from black on white to white on black to maintain the best contrast with the back-

ground.

Manual – Select [B] for dark characters on a light background, or [W] for white characters on a dark background. The monitor brightness adjusts automatically for maxi-

mum contrast.

Hint: This option is very much a personal preference. I have found the manual [W] setting useful when shooting in low-light, as the monitor screen emits far less light compared with the [B] option, making it less distracting. Conversely, the [W] setting is probably easier to read in bright conditions.

d8: LCD Illumination

Description: Controls the operation of the backlight in

the LCD display of the control panel.

Options: On – The backlight remains on while the

exposure meter is active.

Off (default) – The backlight only illuminates when the power switch it rotated past the [On] position and released.

Hint: Since the use of the backlight will increase drain on the battery power I recommend leaving this item set to [Off], its default option.

d9: Exposure Delay Mode

Description: This item enables the camera to delay the

release of the shutter by approximately 1 second after the shutter release button is pressed and the reflex mirror has been raised. Its purpose is to help reduce the risk of camera vibration, which might affect the

sharpness of a picture.

Options: On

Off (default)

Hint: Since the camera has a proper mirror lock-up setting that can be used in conjunction with a remote shutter release, I see little worth in using this item. For that reason, I recommend leaving it set to its default option of [Off]; unless you use the Tripod mode of Live View, when the normal mirror lock-up option in the shooting modes is not available.

d10: MB-D10 Battery Type

Description: To ensure efficient and proper operation of

the MB-D10 battery pack, when fitted with AA size batteries, use this item to select the type of batteries installed in the MS-D10

battery holder.

Options: Alkaline (LR6)

NiMH (HR6) Lithium (FR6) NiMn (ZR6) **Hint:** Although I would suggest that use of AA batteries in the MB-D10 battery pack should only be considered as an emergency measure, if you have to resort to using AA batteries make sure the correct type is selected for this item.

Bracketing / Flash

e1: Flash Sync Speed

Description: Use this item to select the flash synchro-

nization speed.

Options: Shutter speeds between 1/250 and 1/60 sec-

ond, plus 1/250 (Auto FP) and 1/320 (Auto FP), can be selected for the flash sync

speed.

Hint: If you use the built-in Speedlight of the D300, the SB-800, SB-600, or SB-R200 Nikon Speedlights I recommend setting 1/320 (Auto FP), if you expect to be shooting with fill-flash outdoors on a bright day. Otherwise, leave this item set to the 1/250 second option to ensure the maximum flash shooting range (see pages 320-322 for full details).

Note: 1/250 (Auto FP) is only supported when using a Speedlight compatible with the Nikon Creative Lighting System; currently this includes the SB-800, SB-600, and SB-R200.

e2: Flash Shutter Speed

Description: Use this item to select the slowest possible

flash synchronization speed in A (aperture priority) and P (programmed auto) exposure modes when using front or rear-curtain

sync, or red-eye reduction.

Options: Shutter speeds between 1/60 and 30 sec-

onds.

Hint: I recommend using a shutter speed at which you are confident you can hold the camera steady, otherwise there is a risk that any part of the picture illuminated by ambient

light will not be sharp due to the effects of camera shake. For most practical purposes with a short focal length lens (i.e. < 50mm) this will be around 1/30 to 1/15 second. At longer shutter speeds use a tripod, or some other form of camera support.

e3: Flash Control for Built-in Flash

Description: Use this item to select the flash mode for

the built-in Speedlight of the D300.

Options: TTL (default) -The camera uses its 1,005-segment RGB sensor (the same sensor used for Matrix metering) to automatically control flash output; it performs multi sensor balanced fill-flash (monitor pre-flashes are used), and distance information is included

used), and distance information is included with a D or G-type lenses. Standard TTL flash is used if the camera is set to spot metering; alternatively, it can be selected on

an external Speedlight.

Manual – The flash can be set to deliver a specific amount of light between its maximum output and 1/128 of its maximum output. The guide number (in manual flash mode only) is 59/18 (ft/m, ISO200).

Repeating Flash – The flash can be set to emit a sequence of outputs during a single exposure to produce a strobe-light effect. This item has three options: Output - similar to manual flash, the output of the flash is set to a specific level between 1/4 and 1/128; Times – choose the number of times the flash fires (this is dependent on the shutter speed used and frequency for flash outputs); and Frequency – used to set the frequency of flash outputs.

Commander Mode – Use this item to use the built-in Speedlight as a master flash to control one or more remote Speedlights, in up to two separate groups. All Speedlights must be compatible with the Advanced Wireless Lighting system (at the time of writing the only external Speedlights that support this system are the SB-800, SB-600, or SB-R200).

Option	Description	
Built in flash	Choose a flash mode for the built in flash (commander flash).	
TTL	i TTL mode. Choose flash compensation from values between +3.0 and 3.0 EV in increments of 1/3 EV.	
M	Choose the flash level from values between [Full] and [1/128] (1/128 of full power)	
	The built in flash does not fire, but the AF assist illuminator lights. The built in flash must be raised so that it can emit monitor pre flashes	
Group A	Choose a flash mode for all flash units in group A.	
TTL	i TTL mode. Choose flash compensation from values between +3.0 and 3.0 EV in increments of 1/3 EV.	
AA	Auto aperture (available only with SB 800 flash units). Choose flash compensation from values between +3.0 and 3.0 EV in increments of 1/3 EV.	
М	Choose theflash level from values between [Full] and [1/128] (1/128 of full power).	
	The flash units in this group do not fire.	
Group B	Choose a flash mode for all flash units in group B. The options available are the same as those listed for [Group A] above	
Channel	Choose from channels 1 4. All flash units in both groups must be set to the same channel.	

Hint: The options available within this item provide a variety of ways for using the built-in Speedlight. See pages 344-346 for a full explanation of the flash modes available here.

Hint: If the SB-400 Speedlight is attached to the D300 and turned on CS-e3 changes to Optional flash, which allows the flash control mode for the SB-400 to be selected from TTL and manual. The Repeating flash and Commander options are not available.

e4: Modeling Flash

Description: Pressing the depth-of-field preview button will cause either the built-in flash, or an

external flash unit (currently, only the SB-800, SB-600, or SB-R200) to emit a very rapid series of low intensity light pulses that act as a modeling light, enabling you to assess the effects of the flash illumination.

Options: On (default) – The modeling light function

operates when the depth-of-field preview

button is pressed.

Off - No light will be emitted.

Hint: Due to the low intensity and brevity of the light pulses emitted by this feature, it is only really useful at shorter distances. However, if you take an external Speedlight off the camera, using a dedicated TTL flash cord such as the SC-28, it can be helpful in assessing the position and nature of shadows cast by the flash.

e-5: Auto Bracketing Set

Description: This item allows you to decide which set-

tings are affected when the automatic brack-

eting feature is used.

Options: AE & Flash (default) – The camera brackets

the exposure for both ambient light and

flash output.

AE Only - The camera only brackets the

ambient light exposure.

Flash Only - The camera only brackets the flash output level.

WB Bracketing - The camera brackets the white balance value when recording pictures in the JPEG format (this feature is not available for NEF (Raw), or NEF (Raw) + JPEG options).

Hint: Choice of the options available within this item will be a matter of personal preference based on the prevailing shooting conditions.

e-6:

Auto Bracketing (Mode M)

Description:

This option adds refinement to the AE & Flash, and AE Only options of custom setting CS-e5 when using manual exposure mode.

Options:

Flash/Speed - The camera will bracket shutter speed and flash output level if AE & Flash is selected at CS-e5, or just the shutter speed if AE Only is selected at CS-e5.

Flash/Speed/Aperture - The camera will bracket shutter speed, aperture, and flash output level if AE & Flash is selected at CSe5, or just the shutter speed if AE Only is selected at CS-e5.

Flash/Aperture - The camera will bracket aperture and flash output levels if AE & Flash is selected at CS-e5, or just the aperture if AE Only is selected at CS-e5.

Flash Only - The camera will bracket just the flash output level if AE & Flash is selected at CS-e5.

When set for AE Only, the camera will only vary the ambient 🗘 light exposure.

Hint: Choice of the options available within this item will be a matter of personal preference based on the prevailing shooting conditions.

e-7: Bracketing Order

Description: This option allows you to select the order in

which the camera makes exposures in a

bracketing sequence.

Options: MTR>Under>Over – (default) The "correct"

exposure is followed by underexposed, and

then overexposed frames.

Under>MTR>Over - The underexposed frame is taken first, followed by the "cor-

rect" and then overexposed frames.

Hint: Choice of the options available within this item will be a matter of personal preference based on the prevailing shooting conditions. But, I recommend you use one option consistently; you can assess exposure quickly as you always know which frame is which in the sequence.

Controls

f-1: Multi Selector Center Button

Description: Pressing the center of the multi selector

switch can be used to select a variety of camera operations in both the shooting

mode and playback mode.

Options: Shooting Mode:

Select center AF point (default) – Pressing the center of the multi selector will select the center AF point.

Highlight active AF point -Pressing the center of the multi selector illuminates the

active AF point.

Not Used – Pressing the center of the multi selector has no effect when the camera is in the shooting mode.

Hint: The [Highlight active AF point] option does not operate if the focus point selector lock is set to L.

Playback Mode:

Thumbnail On/Off (default) – Pressing the center of the multi selector will cause the display to switch between single image and multiple image playback.

View histograms – Press the center of the multi selector to turn the histogram display on or off.

Zoom On/Off – Press the center of the multi selector to enlarge the selected image on the monitor screen. Press it again to return to either single image or multiple image display. A sub-menu allows you to choose the degree of magnification – Low, Medium, or High.

Hint: I do not find the options for the Shooting mode very helpful, so I leave this item set to [Not Used] to avoid any confusion when handling the camera. However, the ability to display the histogram quickly is very useful, so I do recommend setting this option in the playback mode.

f2: Multi Selector

Description: If required, the multi selector can be used to activate the exposure metering system, or

activate the autofocus system.

Options: Do Nothing (default) – Pressing the multi selector has no affect on the exposure

metering or autofocus systems.

Reset meter-off delay – Pressing the multi selector switch activates the exposure metering system.

Hint: Choice of the options available within this item will be a matter of personal preference. But, since pressing the shutter release button down halfway activates the exposure meter I see little point in this item.

f3: Photo Info / Playback

Description: This item determines the way the multi selector will display images for playback

and the image information pages.

Options: Info (icons 62 & 63) / Playback (icons 65 &

64) (default) – Press the multi selector up or down to change image information pages, and left and right to scroll through stored

images.

Info (icons 65 & 64) / Playback (icons 62 & 63) – Press the multi selector left or right to change image information pages, and up or down to scroll through stored images.

Hint: Choice of the options available within this item will be a matter of personal preference, but I recommend you select one and use it consistently to avoid confusion when reviewing images.

f4: Function Button

Description: The Function button, located on the front of

the camera, below the depth-of-field preview button, can be assigned a variety of different functions. It can also be used in conjunction with either command dials.

Function Button only:

Options:

Option		Description
®	Preview	Press the Fn button to preview depth of field Preview
31	FV lock	Press the Fn button to lock flash value (built in flash and SB 800, SB 600, SB 400, and SB R200 flash units. Press again to cancel FV lock.
Æ	AE/AF lock	Focus and exposure lock while the Fn button is pressed.
Æ	AE lock only	Exposure locks while the Fn button is pressed.
	AE lock on release)	Exposure locks when the Fn button is pressed, and remains locked until the button is pressed a second time, the shutter is released, or the exposure meters turn off.
(Hold)	AE lock	Exposure locks when the Fn button is pressed, and remains locked until the button is pressed a second time or the exposure meters turn off.
Æ	AF lock only	Focus locks while the Fn button is pressed.
3	Flash off	The flash will not fire in photos taken while the Fn button is pressed.
Bracket	ting burst	If the Fn button is pressed while exposure or flash bracketing is active in single frame release mode, all shots in the current bracketing program will be taken each time the shutter release button is pressed. If white balance bracketing is active or continuous release mode (mode CH or CL) is selected, the camera will repeat the bracketing burst while the shutter release button is held down (in single frame release mode, white balance bracketing will be repeated at the frame rate for CH release mode).
Q	Matrix metering	Matrix metering is activated while the Fn button is pressed.
(0)	Center weighted	Center weighted metering is activated while the Fn button is pressed.

Option	Description	
• Spot metering	Spot metering is activated while the Fn button is pressed.	
None (default)	No operation is performed when the Fn button is pressed.	

Hint: Choice of the options available within this item will be a matter of personal preference based on the specific shooting situation. When using flash the FV Lock is useful and when shooting in ambient light I find the ability to switch to spot metering from Matrix metering at the press of this button very useful.

Function button + command dials:

Options:

Option	Description
① 1 step spd/ aperture	If the Fn button is pressed when the command dials are rotated, changes to shutter speed (exposure modes Sand M) and aperture (exposure modes A and M) are made in increments of 1 EV.
Choose non-CPU lens nmuber	Press the Fn button and rotate a command dial to choose a lens number specified using the [Non-CPU lens data] option.
Auto bracketing (default)	Press the Fn button and rotate the main command dial to choose the number of shots in the bracketing program. Press the Fn button and rotate the sub command dial to select bracketing increment.
Dynamic AF area	Press the Fn button and rotate either of the command dials to choose the number of focus points used for dynamic area AF.
None	No operation is performed when the command dials are rotated while the Fn button is pressed.

Hint: Since the D300 does not have an external button to activate exposure bracketing, it is necessary to assign that control to the Fn, preview button, or AE-L/AF-L button. It is probably easiest to leave it set to the default option of the Fn button and command dials item.

f5: Assign Preview Button

Description: The preview button, located on the front of the camera above the function button, can

the camera above the function button, can be assigned a variety of functions. It can also be used in conjunction with either command dial. The options are the same as for the Function button and Function button + Dials options, except the default for the

preview button is preview.

Options: See above at CS-f4

f6: Assign AE-L / AF-L button

Description: The AE-L / AF-L button, located on the rear of the camera to the right of the viewfinder

eyepiece, can be assigned a variety of functions. It can also be used in conjunction with either command dial. The options are the same as for the Function button and Function button + Dials options, except the default for the AE-L / AF-L button is AE / AF lock . The AE-L / AF-L button has the additional option of AF-ON, which is used to initiate AF, and it lacks the [1 step spd/aper-

ture] option.

Options: See above at CS-f4

f7: Customize Command Dials

Description: This item provides additional functionality

to the main and sub command dials.

Options: Reverse rotation – Set [No] (default) to have

the command dials operate as described in

this book and the Nikon manual. Set [Yes] if you wish to have the command dials operate in the reverse direction.

Change Main / Sub – Set [Off] (default) to have the main command dial control the shutter speed and the sub-command dial the aperture. Set [On] to reverse these controls.

Aperture Setting - If [Sub-command Dial] (default) is set, the aperture can only be adjusted using the sub-command dial (or main command dial if ON is selected at Change Main / Sub). When [Aperture Ring] is set, the aperture can only be adjusted using the lens aperture ring and the camera aperture display will show aperture increments of 1EV (aperture for G-type Nikkor lenses is still set via the sub-command dial). Live View is not available when [Aperture ring] is selected and a CPU lens with an aperture ring is mounted on the camera. Regardless of the chosen option, the aperture ring must be used to adjust aperture when a non-CPU lens is used.

Menus & Playback – Set [Off] (default) to use the multi selector to select images for display, highlight thumbnails, and navigate through menus. Set [On] to have the main command dial perform the same function as pressing the multi selector to the left or right, and the sub-command dial perform the same function as pressing the multi selector up or down. To make a selection in a menu when using the command dials to navigate press

Hint: Choice of the options available within this item will be a matter of personal preference. Personally, I leave each option set to its default to avoid confusion when I use other Nikon camera models that do not offer the alternatives that can be set here. If you use other Nikon camera models I recommend you do the same.

Hint: Probably the most important aspect of these options concerns the Aperture ring option, which disables the Live View feature when using a CPU lens with a conventional aperture ring.

f8: Release Button to Use Dial

Description:

Normally many adjustments on the D300 require a button to be pressed and held down while rotating a command dial. This item allows you to make the same adjustment by pressing and releasing the appropriate button, and then rotating the appropriate command dial.

Options:

No (Default) – Adjustments to settings are made by pressing and holding the appropriate button, while rotating the appropriate command dial.

Yes – Adjustments to settings are made by pressing and releasing the appropriate button, then rotating the appropriate command dial. To end the setting press the button again, press the shutter release button, or press the MODE ISO, QUAL, WB, or exposure compensation button (except when No Limit is selected at CS-c2, the EH-5 / EH-5a AC adapter is attached, or the exposure meter turns off).

Hint: Is this control not for the sake of control? I recommend you avoid this item and leave it set to [No] (default); in my opinion this is a prime example of the unnecessary complexity of the menu system.

No Memory Card? f9:

This item allows the shutter to operate without **Description:**

a memory card being installed in the camera

Options: Release locked (default) - The

release is disabled if no memory card is

installed in the camera.

Enable release - The shutter release operates if no memory card is installed in the camera. The camera stores no images; however, the last recorded image is displayed in demo mode.

Hint: Disaster potentially looms with this item, unless it is set to the default - you do not want the camera to operate as though it is recording pictures when in fact there is no memory card installed!

f10: Reverse indicators

Description: At the default setting, the exposure indicator

display shown in the control viewfinder, and shooting information display has positive values to the left and negative values to the right. The display can be

reversed using this item.

Options: + 0 - (default) - Positive values are shown to

the left and negative values to the right.

- 0 + - The exposure indicator display is reversed; positive values are shown to the

right and negative values to the left

Hint: If you are familiar with previous Nikon SLR cameras, film or digital, you will probably already be familiar with the default exposure display; therefore, it is probably best to leave this option set to the default.

Setup Menu

The Setup menu is used to establish the basic configuration of the camera; once the settings for most of the items in this menu are made, they will not be changed very frequently.

Format Memory Card

A new memory card should always be formatted when it is first placed into the D300. It is also a good idea to format any memory card you insert into the camera, even if the card has been formatted using a computer. This is particularly important if you use your memory cards between different camera bodies. Before you format any memory card ensure that any image files stored on the card have been saved to another storage device.

The most convenient way to format a memory card is to use the two-button method. Press and hold the MODE and buttons together until For appears, blinking, in the control panel screen. Release the two buttons briefly, then simultaneously press them again until For appears continuously in the frame count brackets. For will remain in the control panel during the formatting process. Once complete, the number of remaining exposures in the frame counter will be reset to show the estimated maximum number of pictures that can be taken at the current image quality/size settings on the inserted memory card.

Note: In the Nikon instruction manual it states "formatting permanently deletes all pictures and other data on the card." This is not entirely true. Actually, the formatting process only overwrites the file directory on the memory card, making it no longer possible to access any data stored on it. If you should format a card inadvertently, it is often possible to recover image files by using appropriate image recovery software. To maximize the chances of this process being successful, ensure no further data is written to the card after it has been formatted. (See page 286 for more details.)

LCD Brightness

The brightness of the LCD monitor on the back of the camera is set to a default value. However, this can be adjusted to help improve the visibility of any displayed image or page of information. This feature can be particularly helpful when trying to review images in bright outdoor light.

To adjust LCD brightness:

- 1. Highlight the [LCD Brightness] option from the Setup menu and press ▶ .
- 2. Adjust the brightness value up or down by pressing \bullet or \checkmark .
- 3. Press the button to confirm the screen brightness value.

A negative value reduces screen brightness, while a positive value increases screen brightness. The screen displays a grayscale to help you judge the effect of the brightness level on the full tonal range present in your images.

Note: I consider the default value for the screen brightness level to be too high. For a more accurate assessment of images, I suggest setting screen brightness to -1.

Clean Image Sensor

This item is used to automatically clean the optical low-pass filter of the D300 by vibrating it at high frequencies. It is effective in removing loose, dry particles that have settled on the filter surface, but will not remove smear marks caused by liquids or grease; these will require cleaning with an appropriate fluid and swabs. (See page 396 for more details.)

Lock Mirror Up for Cleaning

This option is used to manually cleaning or inspecting the optical low-pass filter; it should not be confused with the mirror lock-up option available in the camera's shooting modes. It is essential that the power supply to the camera is not disconnected or interrupted while this function is active; particularly if you have any cleaning utensils in the

camera at the time, as the reflex mirror will drop to its normal position with potentially dire consequences. Make sure the camera battery is fully charged; this option will not function if the battery charge indicator displayed in the control panel shows a level of or lower. Better yet, use the optional EH-5a/EH-5 AC adapter and keep a fully charged battery installed in the camera, in case the adapter becomes disconnected.

Note: Because the low pass filter is exposed, exceptional care should be taken whenever the Mirror Lock-up function is in use. There is an increased risk that unwanted material, such as dust or moisture, might enter the camera during this process. Whenever possible, keep the camera facing down; in this situation, gravity is your best friend! (See page 394 for more details.)

Video Mode

The Video Mode option allows you to select the type of signal used by any video equipment, such as a DVD player or television, to which your camera may be connected. This option should be set before connecting your camera to the device with the supplied A/V cord. (See page 373 for more details.)

HDMI

The D300 has an HDMI (High Definition Media Interface) connector located under the large rubber connector cover on the left side of the camera. This connection port allows pictures to be played back on high definition television and monitors using a type-A HDMI cable. The [HDMI] option in the Setup menu allows the user to select one of five HDMI formats. Ensure you select the correct format before connecting the camera to the HDMI device. The camera monitor will turn off automatically when an HDMI device is connected.

Option	Description
Auto	The D300 selects the appropriate format automatically
480p (progressive)	640 x 480 (progressive) format
576p (progressive)	720 x 576 (progressive) format
720p (progressive)	1280 x 720 (progressive) format
1080i (interlaced)	1920 x 1080 (interlaced) format

World Time

World Time enables you to set and change the date and time recorded by the camera's internal clock, and how it is displayed. Once you have selected [World Time] from the Setup menu four options are displayed: Time Zone, Date, Date Format, and Daylight Savings Time. Each setting requires the user to input the relevant information for their location. (See page 59 for more details.)

Language

The [Language] option in the Setup menu of the D300 allows you to select one of 15 languages for the camera to use when displaying menus and messages. (See page 58 for more details.)

Image Comment

The Image Comment feature of the Setup menu allows you to attach a short note or reference to an image file. Comments can be up to 36 characters long and may contain letters and/or numbers. Since the process requires each character to be input individually, this is not a feature you will use for every picture you take. However, as a way of assigning a general comment (i.e., the name of a location / venue / event) or attaching notice of authorship/copyright it is very useful.

To attach an image comment:

- 1. Highlight the [Image Comment] option from the Setup menu and press ▶ .
- 2. Highlight [Input Comment] from the options list and press ▶ .

- 3. To enter your comment, highlight the character you wish to input by using and press to select it. If you accidentally enter the wrong character, use the button in combination with to move the cursor over the unwanted character and press the button to erase it.
- 4. Press the button to save the comment and return to the Image comment options list.
- 5. To actually attach the comment to your photographs, scroll down to the [Attach Comment] option, highlight [Set] and press ▶ . A small check mark will appear in the box to the left of the option.
- 6. Finally, highlight [Done] and press the

 button to confirm the selection.

If you wish to exit this process at any time without attaching the comment, prior to step 5, simply press the MENU button. When the check mark is present in the [Attach Comment] option of the [Image Comment] item, the saved comment will be attached to all subsequent images shot on the D300. To prevent the comment from being attached to an image, simply return to the Image Comment menu and uncheck the Attach Comment box. The Image Comment will remain stored in the camera's memory and can be attached to future images simply by rechecking the Attach Comment box.

The comment will be displayed on the third page of the photo information display, available via the single image playback option. It can be also be viewed in Nikon View NX or Capture NX software.

Auto Image Rotation

The D300 automatically recognizes the orientation of the camera as it records an image: horizontal, vertical - rotated 90° clockwise, or vertical --rotated 90° counter-clockwise. At its default setting, the camera stores this information so the image will be automatically rotated during image playback. It will also be displayed in the correct orientation on a computer with compatible software. If you do not want the camera to record the shooting orientation, the Auto Image Rotation feature can be switched off.

To set Auto Image Rotation:

- 1. Highlight the [Auto Image Rotation] option from the Setup menu and press ▶ .
- 2. Highlight [On] or [Off] as required.
- 3. Press (R) to confirm the selection.

Note: If you shoot with the camera tilted up or down it may not record the orientation correctly. In this case it is probably easier to select [Off] and rotate the pictures in appropriate software, such as Nikon View NX or Nikon Capture NX.

Note: The [Rotate Tall] item in the Playback menu must be turned on for images to be displayed in the orientation in which they were originally taken during image playback.

USB

This menu item allows you to select the correct USB interface option for the type of operating system used by the computer or printer to which the D300 may be connected, for the purposes of transferring images. The selection for the USB option should be made before connecting the camera to the external device. (See page 376 for more details.)

Dust Off Reference Photo

The [Dust Off Ref Photo] item of the D300 is designed specifically for use with the Image Dust Off function in Nikon Capture NX (version 1.3, or higher). The image file created by this function creates a mask that is electronically "overlaid" on a NEF (Raw) file to enable the software to reduce, or remove, the effects of shadows that are cast by dust particles on the surface of the optical low pass filter. To obtain a reference image for the Dust Off Ref Photo function you must use a CPU-type lens (Nikon recommends use of a lens with a focal length of 50mm or more). This function can only be used with NEF (Raw) files; it is not available for IPEG or TIFF files.

To use Dust Off Ref Photo:

- 1. Highlight the [Dust Off Ref Photo] option from the Setup menu and press ▶ .
- 2. [Start] will be highlighted on the monitor screen. Press

 ▶ to begin the process. The message, "Take photo of bright featureless white object 10cm from lens. Focus will be set to infinity" will be displayed in the monitor screen.
- Point your camera at a white, featureless subject positioned approximately 4-inches (10 cm) from the front of the lens.
- 4. Press the shutter release button all the way down (focus will be set automatically to infinity).

Once you have recorded the Dust Off Reference Photo it can be displayed in the camera during image playback. It appears as a grid pattern with Image Dust Off Data displayed within the image area. A Dust Off Reference Photo can be identified by its file extension, which is NDF; these files cannot be viewed using a computer.

Battery Info

The EN-EL3e rechargeable battery has an electronic chip in its circuitry that allows the D300 to report detailed information regarding the status of the battery. To access this information select [Battery Info] from the Setup menu; three parameters concerning the battery will be displayed on the monitor screen (see the table below).

Parameter	Description
Bat. Meter	Level of current battery charge, expressed
	as a percentage.
Pic. Meter	Number of times the shutter has been
	released with the current battery since it
	was last charged. This number will include
	shutter release actions when no picture is
	recorded (i.e., to record an Image Dust
	Off reference frame or measure color tem-
	perature for a preset white balance value).

Calibration Only displayed when the camera is powered

by the MB-D10 battery pack using the

EN-EL4/EN-EL4a battery. If [CAL] is displayed, the battery requires recalibration using its

dedicated charger. If [-] is displayed

calibration is not required.

Charging Life Displays the condition of the battery as one

of five levels (0-4); level 0 indicates the battery is new, and level 4 indicates the battery has reached the end of its charging life and should be replaced. Batteries charged at temperatures below 41° F (5° C) may show a reduced charge life; this will return to normal once charged at a temperature of 68° F (20° C), or higher.

If the MB-D10 battery pack is fitted to the D300, the Battery Info display will show information for each battery separately according to the table below:

Battery Type	Bat. Meter	Pic. Meter	Calibration	Charging Life
EN-EL3e	Yes	Yes	No	Yes
EN-EL4 / EN-EL4a	Yes	Yes	Yes	Yes
AA (x8)	Yes	No	No	No

Note: Use CS-d11 to determine the order in which batteries are used when the camera is fitted with the MB-D10 battery pack.

Wireless Transmitter

By using the optional Nikon WT-4 wireless transmitter, it is possible to transfer or print photographs over a wireless or Ethernet network. Furthermore, the D300 can be controlled from a network computer(s) running Nikon Camera Control Pro 2 software. In all instances the [USB] option in the Setup menu must be set to MPT/PTP before the WT-4 wireless transmitter is connected. For full information see the instruc-

tion manual supplied with the WT-4. The WT-4 can be used in any of the following modes:

Mode	Function
Transfer mode	Upload new or existing image files
	to a computer or ftp server.
Thumbnail select mode	Preview photographs on a computer
	monitor before upload.
PC mode	Control the D300 from a computer
	using Camera Control Pro 2 software.
Print mode	Print JPEG image files on a printer
	connected to a network computer

Image Authentication

This item is used to embed information into an image file as it is recorded so that any subsequent alteration to the image file data can be detected, using Nikon's Image Authentication software. It is not possible to use this feature retrospectively with images that have already been recorded. Images recorded when image authentication is active are marked with a small icon of a rubber stamp.

To select Image Authentication:

- 1. Highlight the [Image Authentication] option from the Setup menu and press ▶ .
- 2. Highlight, [On] or [Off] as required.
- 3. Press (x) to confirm the selection.

Note: Image authentication information will not be embedded in any copy images created through the options in the Retouch menu.

Save/Load Settings

It is possible to save most menu settings to a memory card by using the [Save/Load Settings] option in the Setup menu. These settings can then be restored to the same camera or uploaded to another D300 by using the [Load settings] option. The [Save/Load Settings] option is only available when a memory card is installed in the camera. Saved set-

tings are stored in a file named NCSETUP1; if the file name is changed, the D300 will not be able to load the settings. The following settings can be saved to a memory card:

Menu	Option
Playback menu	Display mode
	Image review
	After delete
	Rotate tall
Shooting menu	Shooting menu bank
(all banks)	File naming
	Image Quality
	Image Size
	JPEG Compression
	NEF (Raw) recording
	White Balance with fine-tuning & presets
	Set Picture Control
	Color Space
	Active D-Lighting
	Long Exp. Noise Reduction
	High ISO noise reduction
	ISO sensitivity
	Live View
Custom setting banks (all banks)	All Custom Settings except (Reset)
Setup menu	Clean image sensor
	Video mode
	HDMI
	World time (except date and time)
	Language
	Image comment
	Auto image rotation
	USB
	GPS
	Non-CPU lens data
My Menu	All My Menu items

GPS

It is possible to use the D300 camera, in conjunction with Garmin Global Positioning System (GPS) units, to record additional data about the camera's location at the time of exposure. The GPS unit must conform to version 2.01 or 3.01 of the National Marine Electronics Association (NMEA) NMEA0183 data format. The GPS unit is connected to the camera's ten-pin remote terminal using the optional Nikon MC-35 cord. (See page 407 for more details.)

Non-CPU Lens Data

The D300 can be used with non-CPU type lenses. By registering details of the lens (focal length and maximum aperture) in the Non-CPU lens data feature of the Setup menu, the functionality of many of the options and settings available with CPU-type lenses become available with non-CPU type lenses. This enables the use of color matrix metering, the display of aperture value, control of flash output for balanced fill-flash, and inclusion of information about the lens in the shooting data stored by the camera with each image file. (See page 172 for more details.)

AF Fine Tune

The phase detection autofocus system used by the D300 (as in all other Nikon D-SLR cameras) assumes that all Nikkor AF lenses will behave alike when the AF system adjusts the focus point. As soon as the camera assesses the current level of focus and the direction of the focus error (i.e., if it is in front of, or behind, the point where it calculates the focus point should be), it signals the lens to refocus by what it considers is the required amount. Once focus is set the AF system will not re-focus, provided any newly calculated focus errors fall within a pre-set tolerance. These very fine tolerances are of no consequence when using a wide-angle lens at long focus distances; however, at very close focus distances with a lens that has both a long focal length and wide maximum aperture, those tolerance levels become far more critical.

Sometimes a specific camera body and lens combination produces a consistent focus error; resulting in either "backfocus," where the focus point falls behind the intended point

of focus, or "front-focus," where it falls in front of it. Since the focus error for a particular combination tends to be consistent, it is usually possible to address the problem by setting a constant level of adjustment. This is the purpose of the AF Fine Tune item in the Setup menu, which allows the AF system to be tweaked for up to twelve specific lenses (when used on a specific D300 camera).

It is important to test your own equipment extensively and exhaustively to establish if there is a "back-focus" or "front-focus" problem with particular lenses. If you determine this is the case then, and only then, should you use the AF Fine Tune item.

Option	Description	
AF Fine Tune On/Off	On – Turn AF tuning on Off (default) – turn AF tuning off	
Saved value	Tune AF for the lens currently mounted on the camera. Press or to select a value between ±20. A positive value moves the focus point away from the camera; a negative value has the opposite effect.	
Default	If no AF tuning value is saved for the current lens use this option to set a value. Adjustment operates in the same way as described above.	
List saved values	Previously saved values for AF fine-tuning are listed. To delete a setting, highlight the required lens and press To change the lens number used to identify a particular lens, highlight the required lens and press A and to select a two-digit number. Press to save any changes and return to the Setup menu.	

Note: The AF fine-tuning item cannot be applied to the contrast-detection focus used in the Tripod mode of the Live View feature.

Note: Only one AF fine-tune value can be stored per lens; however, if a teleconverter is used, a separate value for each combination of lens and teleconverter can be stored.

Firmware Version

When [Firmware Version] is selected from the Setup Menu, the current version of the firmware (A & B) installed on the camera is displayed on the monitor screen.

Since the release of the D300, up to the time of publishing, there has been one firmware update released by Nikon. Its purpose is to resolve a problem whereby vertical bands might occasionally appear in exposures made with shutter speeds slower than 8-seconds. This update only applies to the A firmware, which is upgraded to version 1.02 (the B firmware remains unchanged at version 1.00). Firmware updates can be downloaded from any of the Nikon technical support web sites. Go to www.nikon.com to check for current updates. To check the current firmware installed on your camera, highlight the [Firmware version] option from the Setup menu and press

1. The details of the firmware are displayed on the next

▶ . The details of the firmware are displayed on the next page. Press ⊗ button to return to the Setup menu.

Retouch Menu

The Retouch menu enables you to create retouched (modified), trimmed (cropped), or resized versions of the image files saved on your memory card. When the features in this menu are applied to an image, a new copy of the file is created and stored on the installed memory card. The original image file remains in the card in its unmodified form.

Note: With the exception of the options available in the [Trim] item, all of the Retouch menu items can also be applied to a copy image that was previously created using the Retouch menu. D-Lighting, red-eye correction, filter effects, and color balance cannot be applied to monochrome copies. Depending on the option used, repetitive retouching may result in a loss of image quality. Once an option has been applied, it cannot be repeated.

Note: While I feel Nikon should be commended for including the options available in the Retouch menu, I believe it is important to keep them in perspective. The items available in this menu cannot be considered anywhere near as sophisticated as their equivalent adjustments in any good digital imaging software. They are intended to provide a quick, convenient, and largely automated method of producing a modified version of the original image without the use of a computer. As such, they offer an unprecedented level of control when using in-camera processing to produce a finished picture directly from the camera.

Selecting Images

You may select images to be used with the Retouch menu options from either the full-frame playback of the image review function, or directly from the Retouch menu itself.

To select an image from the full-frame playback function, display the required image on the LCD monitor and then open the Retouch menu by pressing the ⊕ button. Highlight the desired menu item, and then press ▶ to display the retouch options within the selected item. Highlight the desired option and press the ⊕ button to create a retouched copy of the original file. You can return to the full-frame playback mode at anytime, without creating a copy image, by pressing the ▶ button.

Note: It is not possible to use the Image overlay item during full-frame playback.

To select an image directly from the Retouch menu, open the Retouch menu, highlight the desired function, and press to select it and display up to six thumbnail images on the monitor screen. Depending on the item selected, a further menu of options may be displayed before the thumbnail images; if so, highlight the required option and press again. Use to scroll through the thumbnail images; a yellow border will frame the currently selected picture. To view an image full frame, press and hold the button. Once you have selected the picture to be modified and

copied, press the button. A preview of the retouched copy will be displayed on the LCD monitor screen with the option to save it by pressing the button, or cancel it by pressing the button. You can return to the full-frame playback mode at anytime, without creating a copy image, by pressing the button.

Image Quality and Size

The image quality and size of the copy image created by the Retouch menu will depend on the quality and size of the original image file(s). The selected option within the Retouch menu may also affect image size and quality.

- Copies created from JPEG images are the same size and quality as the original file.
- With the exception of the [Image Overlay] option, copies of NEF (Raw) files are saved as a JPEG files with Large and Fine selected for size and quality. Copies of TIFF (RGB) files are saved as Fine quality JPEG files at the same size as the original file.
- The copy the [Image Overlay] option creates is always saved at the image quality and size currently set on the camera, regardless of the fact that this option is only available with NEF (Raw) images. If you wish to save the copy image as a NEF (Raw) file, ensure the image quality on the camera is set to NEF (Raw) before you apply this option.

D-Lighting

The D-Lighting feature of the Retouch menu brightens shadow areas to reveal more detail. It is not an overall brightness control, its application is selective; by modifying the tone curve applied to the image, it only affects the shadow areas of the recorded image and preserves the mid and highlights tones.

Select the image (as described above) and press the button to display two thumbnail images; one unmodified (left) and the other modified (right). You can

select three levels of D-Lighting: low, normal, or high. Once you have decided which level is most appropriate, press the button to apply the change and create the copy image. You can press to cancel the function without making any changes.

Red-Eye Reduction

This option is only available with pictures taken using either the built-in or an external Speedlight; if the option is grayed out in the menu, no flash was used for the chosen exposure. First, examine the picture for the presence of red eye in full-frame play back mode; use the \$\mathbb{Q}\$ button to zoom into the image and the \$\mathbb{Q} \bullet \text{button to zoom back out. You can navigate around the image using the multi selector \$\mathbb{Q}\$. Press the \$\mathbb{Q}\$ button to cancel the zoom control and return to the full-frame playback.

If you can see the effects of red-eye in the selected picture, highlight the [Red-eye correction] option in the Retouch menu and press ▶ . Confirm that a yellow border highlights the image you want to edit; if not, select it by using ⊕ and press the (icon56) button. The D300 will then analyze the original image data and assess it for potential red-eye effects. If the camera determines that redeye is present it will create a copy image, using automatically processed image data, to reduce the red-eye effect. If no red-eye is detected a message will be displayed to inform you and a thumbnail view of the [Red-eye correction] option will appear.

Note: Since this is a completely automated process, it is possible for the camera to apply the red-eye correction to areas of an image that are not affected by red-eye, which is why it is important to check the preview image before selecting this item.

Trim

The [Trim] option enables you to crop (trim) the original image to exclude unwanted areas. Highlight the [Trim] option in the Retouch menu and press

to display a set

of six thumbnails images. Use 0 to scroll through the images stored on the memory card, and press 0 to select the required image.

The selected image is displayed on the LCD monitor, along with a yellow frame to show the crop area; you can navigate around the image using . Use the button to increase the size of crop area and the button to decrease the size of crop area; the crop size is displayed in the top left corner of the image in pixel dimensions (width x height). It is also possible to adjust the aspect ratio of the cropped area; rotating the main command dial allows you to switch between 3:2, 4:3, and 5:4. To preview the crop press the button.

Once you have decided on the location, size, and aspect ratio of the crop area, press the button to create the cropped copy. The new copy image will be displayed on the LCD monitor. Press the MENU button to return to the Retouch menu display.

Monochrome

This item allows you to save the copied image in one of three monochrome effects: black-and-white (grayscale), sepia (brown tones), or cyanotype (blue tones). In all three cases the image data is converted to black and white using an algorithm dedicated to this feature; it is a different algorithm than the one used for the [Monochrome] option in the Picture Controls. The image data for the black-and-white copy is still saved as an RGB file (i.e., it retains its color information).

If you select either the [Sepia] or [Cyanotype] options, the appropriate color shift is applied after the copy picture is converted to black-and-white. The degree of the color shift can be adjusted using **A** and **V** to increase/decrease the effect. Once you are satisfied with the preview image, press the **B** button to save the copy picture.

Filter Effects

The [Filter Effects] option in the Retouch menu offers two choices that simulate the effects of a skylight or color correction ("warm") filter.

- **Skylight** Nikon describes this option as providing a "cold" bluish cast. But in fact, the effect is very subtle, reducing the amount of red in the image by a modest amount.
- Warm tone This effect increases the amount of red in the image and produces a result similar result to the use of a Wratten 81-series color correction filter. Again the effect is subtle, and proper white balance control should eliminate the need to use it.

To apply the [Filter effects] option:

- 1. Highlight the [Filter effects] option in the Retouch menu and press ▶ .
- 2. Highlight the required option and press to display a set of six thumbnails images.
- 3. Use to scroll through the images stored on the memory card, and press to select the desired image.
- 4. A preview of the filter effect is displayed. To apply the effect and save a copy image press the button, otherwise press (icon55) to cancel the function.

Color Balance

To use the [Color Balance] option:

- 1. Highlight the [Color balance] option in the Retouch menu and press ▶ .
- 2. Highlight the desired option and press to display a set of six thumbnails images.
- 3. Use to scroll through the images stored on the memory card, and press to select the desired image.

A thumbnail image of the selected picture is displayed alongside histograms for the red, green, and blue channels. Below the thumbnail is a two-dimensional CIE color space map with a vertical and horizontal axis aligned on its center. The central point of the color space map represents the color balance of the original file. Press the multi selector up to increase the level of green, and down to increase the level of magenta. Pressing the multi selector to the left increases the level of blue, and to the right increases the level of red. The black square cursor will shift position accordingly, the RGB histograms will reflect the altered tonal distribution, and the thumbnail image can be used to preview the effect. Once you are satisfied with the adjustment press the button to apply the color shift and save a copy of the image.

Image Overlay

Image Overlay is one of two methods available on the D300 that enables the combination of multiple images into one file. Image Overlay is limited to using a pair of NEF (Raw) files and combining them to form a single, new image (the original image files are not affected by this process). The images do not have to be taken in consecutive order, but must have been recorded by a D300 and be stored on the same memory card.

Note: The new image is saved at the image quality and size currently set on the camera. Therefore, before using this feature, ensure the image quality and size are set to the values you desire. If you want to save the new image as a NEF (Raw) file, set the image quality on the camera to NEF (Raw).

To use Image Overlay:

- Highlight the [Image Overlay] option in the Shooting menu and press the button.
- 2. The Image Overlay page will open with [Image 1] highlighted.
- 3. To select the first picture, press ; a thumbnail view of all NEF (Raw) files stored on the memory card will be displayed. Scroll through the images using to high-

light the image you wish to select.

- 4. Press and the selected image will appear in the [Image 1] box and the [Preview] box.
- 5. Adjust the gain value of [Image 1] by pressing ▲ and ▼ . The effect of the gain control can be observed in the preview box (the default value is x1.0; x0.5cuts the gain in half, while selecting x2.0 doubles the gain).
- 6. Highlight the [Image 2] box and repeat steps 2 5 above.
- 7. Once you have adjusted the gain of both images to achieve the desired effect, highlight the [Preview] box by pressing ▶ . Highlight [Overlay] and press ♥ to display a preview of the combined images. If the result is satisfactory press the ♥ button to save the new image, otherwise press ♥ to return to the previous step.
- 8. To save the image without displaying a preview, highlight [Save] at step 7 above, instead of [Overlay], and press the button. The new image will be displayed full-frame.

The image will be saved on the memory card using the quality and size settings currently selected on the camera. Image attributes such as white balance, sharpening, color mode, saturation, and hue will be copied from the image selected as [Image 1]. The shooting data is also copied from [Image 1]. Image Overlays saved as NEF (Raw) files use the same compression and bit depth as the original files; JPEG overlays are saved using size-priority compression.

Side-by-Side Comparison

Use this item to compare a retouched copy with the original (source) file. Use the multi selector to select an image you wish to compare; only images that have been retouched can be viewed through this item. Once the required image is displayed in single image playback press . The original (source) image will be shown on the left of the page, the retouched copy to the right. The options used to create the copy are displayed above the two images. Use and to switch between the two images; the selected ver-

sion is shown with a yellow border. Press and hold

to view an enlarged view of the selected image. If the image was created using the [Image Overlay] option, use and view the second source image. Press to return to the shooting mode.

My Menu

My Menu allows the user to create a customized menu from practically any combination of items in the playback, shooting, custom setting, setup, or Retouch menus. The only items that cannot be used in My Menu are: [Format memory card] (Setup menu), [Reset Custom Settings] (Custom Settings menu), and [Reset Shooting menu] (Shooting menu).

Options can be added, deleted, and reordered at any time. Given the complexity and size of the menu system, this useful item allows those menu items frequently accessed by a user to be located in a single menu. Up to five items can be added to My menu before it becomes necessary to scroll to additional pages. The default My Menu control items (Add items, Remove items, and Rank items) are always displayed.

Add Menu Items

To add a menu item:

- Open My menu, highlight [Add items], and press to display a list of the five menus.
- Highlight the required menu and press
- Highlight the required item within the menu and press the button.

Note: Any menu item previously selected and added to My menu is displayed with a check mark when scrolling the various menus via the [Add items] option.

Delete Menu Items

To delete a menu item:

- Open My menu, highlight [Remove items], and press to display the list of items in My menu.
- Highlight the item(s) to be removed and press ; a check mark will be shown in the box to the right of the selected menu item.
- To confirm the deletion of the selected item(s), highlight [Done] and press the button. A confirmation dialog box is displayed with the message Delete selected items?, if you wish to proceed press the button.

Note: There is an alternative short-cut route to delete a single item from the My menu list: open My menu, highlight the item to be deleted, and press the button. A confirmation dialog box is displayed with the message "Delete selected items?" if you wish to proceed press the button again.

Reorder Menu Items

To reorder the items in My menu:

- Open My menu, highlight [Rank items], and press to display a list of the items in My menu.
- Highlight the item to be relocated and press
- Use ◀ and ▶ to position a solid yellow line in the desired location within the menu list.
- Once positioned, press the

 button and the menu item will be moved.

Image Resolution and Processing

Image Storage

CompactFlash cards are solid-state memory cards capable of retaining data even when they are receiving no power, and since they have no moving parts they are also reasonably robust. Obviously you should treat any memory card with the same care you would afford your camera equipment, but a minor knock, or exposure to the natural elements should not cause any problems for your CompactFlash card and the images stored on it. Although total immersion in water should be avoided! Typically, they have a temperature operating range of -4F° to 167F°(-20°C to 75°C), and no altitude limit. Unlike photographic film, they are not affected by ionizing radiation from X-ray security equipment that has become common these days.

SanDisk Extreme IV CompactFlash cards provide faster write speeds. Photo (c) SandDisk Corp.

UDMA CompactFlash Memory Cards

While the D300 can be used with any Type I or Type II CompactFlash memory card it adds another twist to the available choices because it supports the Ultra Direct Memory Access

The Nikon D300 stores images using CompactFlash memory cards. To maximize write speed, be sure to purchase a UDMAcompatible card. (UDMA) standard. An UDMA-compatible memory card enables data to be written at a significantly faster rate compared with memory cards that do not comply with the UDMA standard. For example, using a fast, non-UMDA card (i.e., Lexar x133 or Sandisk Extreme III) the D300 will write data at a rate of about 8-9MB per second, while using a UDMA-enabled card (i.e., Lexar x300, Sandisk Extreme IV, Delkin, or Hoodman) you can expect a write speed about four times as fast. In practical terms this translates into capturing one or two extra frames in a rapid shooting sequence, because the buffer memory is cleared much faster. The other benefit of using a UDMA card and a compatible card reader is the increased data write speed, which can reach up to 45MB per second – significantly reducing download times for your digital images.

Microdrives

As their name implies, Microdrives™ are miniature hard disk drives. They have an actual disk inside that spins while an arm with a recording head tracks across it, writing the data to the disk. They are more susceptible to damage, particularly shock from an impact, and are far less resilient to the effects of moisture and temperature. They also have a considerably narrower temperature operating range of 41°F to 131°F (5°C to 55°C), and can become unreliable above an altitude of about 9,000 feet (3,000 meters).

There are several other issues you should be aware of when it comes to MicrodrivesTM:

- Because of their moving parts, Microdrives[™] consume far more power compared with CompactFlash cards. Although the most recent Microdrives[™] have become more efficient in this respect.
- Microdrives[™] cannot achieve anything close to the data write speed of the new UDMA-compatible CompactFlash memory cards. If you expect to shoot plenty of rapid sequences, avoid Microdrives[™]!

- Microdrives[™] produce relatively high levels of heat during extended periods of use, which will inevitably increase the internal temperature of the camera. This may have undesirable consequences in terms of generating electronic 'noise'.
- Microdrives[™], like any mechanical device, will suffer the
 effects of wear and tear, which can lead to subsequent
 failure.

Hint: When handling Microdrives™ always hold them by its edges. Do not pinch them in the center of their two largest surfaces. Any force that compresses the card casing in this region could result in damage to the internal mechanism.

Memory Card Capacity

When considering the capacity of the memory cards you will use, bear in mind is that the 12MP resolution of the D300 will result in larger file sizes, compared with even the 10MP D200 or D80 models. If you regularly used 1GB or 2 GB memory cards with your 6MP to 10MP digital SLR, you may want to think about stepping up to 4GB. On average, I find when shooting lossless compressed, 12-bit NEF files I can expect to record about 250 images on a 4GB card. This provides plenty of scope, especially if you shoot for techniques such as high dynamic range (HDR) or panoramic, requiring stitching multiple images together. I find a 4GB card offers a good compromise between storage capacity and the risks (card failure or loss) inherent with saving all your shots to a single, higher capacity 8GB or 12GB card.

Formatting a Memory Card

When a new card is inserted in the camera, it must be formatted before it is used.

The memory of a CompactFlash card or Microdrive[™] has a similar structure to that of a hard disk drive – a file directory, file allocation table, folders, and files. As data is written to and deleted from the card, small areas of its memory can become corrupted and files can become 'fragmented'. This is particularly true if you delete individual image files. Formatting the card in the camera will clean up the majority of the worst effects of fragmentation.

In the D300 instruction book, Nikon states that formatting a memory card "permanently deletes all pictures and other data on the card." While this is a salutary warning, it is somewhat misleading. The formatting process actually causes the existing file directory information to be overwritten, so that the indicators that direct any reading device, including the camera itself, to the image data held on the card are removed; it does not actually delete/erase all the data as Nikon claims. This makes it extremely difficult, although not impossible, to recover previously written data from a card once it is formatted. If you inadvertently format a card it is often possible to recover the image files by using appropriate recovery software, provided no further data is written to the card. Since prevention is better than a cure, always save your images to a computer, or other storage device, before formatting a card. Also make sure to create a back up copy of these files.

To format a card using the D300, insert a memory card and turn the camera on. Press and hold the Mode and buttons for approximately two seconds until For flashes in the control panel, together with a flashing frame count display. To proceed with the formatting process you must release the Mode and buttons momentarily and then press them again. During formatting For appears continuously within the frame-count brackets of the control panel display. Once complete, the frame-count display shows the approximate number of photographs that can be recorded on the inserted memory card at the current size and quality settings. Alternatively, you can use the [Format] option in the Setup menu, but this method is slower and involves using the LCD monitor, which increases power consumption and drains the battery quicker.

Hint: After ensuring its contents have been saved and backed-up, format the memory card each time you insert it into the camera. This is especially important if it has been used in a different camera model, or formatted by a computer or other device. Failure to follow this procedure may lead to image files being rendered as unreadable or becoming corrupted.

Note: If you press any other button after For begins to flash, the format function is cancelled and the camera returns to its previous state.

Note: You should never switch the camera off, or otherwise interrupt the power supply to the camera during the formatting process. This may corrupt the memory card.

Image Quality and File Formats

The D300 saves images to the memory card in three file formats, Joint Photographic Experts Group (JPEG), Tagged Image File Format (TIFF), and Nikon Electronic File (NEF) Raw format. Nikon's new Expeed processing concept is applied in the D300, using the new Expeed processing engine, so if you set the camera to record images in either the JPEG, or TIFF file format the camera uses the integrated ADC (analogue to digital converter) on the sensor to convert the electrical signals generated by the photodiodes at a 12-bit depth to produce 12-bit raw data before the value for each pixel is rendered via a demosaicing (conversion) process to 12-bit RGB data. (Remember, each photodiode only records a value for red, green, or blue, so the demosaicing process is necessary to render an RGB value for each pixel.)

Next, the 12-bit RGB data is passed to the Expeed processing engine where all further processing, such as color manipulation, contrast control, and sharpening (plus an automated reduction of the effects of lateral chromatic aberration to reduce color fringing at distinct edges in image detail) is performed in a 16-bit depth space to ensure there is no compromise of the data. The final stage of the image processing is the encoding of the data to create the JPEG or TIFF file; it is only at this point that the 12-bit data is reduced to 8-bit. The result is a noticeable improvement in image quality compared with JPEG and TIFF files generated by earlier Nikon D-SLR camera models, particularly in fine detail and the lower shadow tones. This is of particular benefit if the finished 8-bit JPEG and TIFF files are to be sub-

In the final stages of image processing and data conversion to create a JPEG, the file is reduced from 12-bit data to 8-bit data.

jected to post-processing in a computer, which would otherwise compound errors generated during in-camera processing had this been performed on 8-bit data rather than the 12-bit data handled by the D300.

When the D300 is set to record an image in the Nikon Electronic File (NEF) format, the data saved is essentially the "raw" data generated by the ADC with no interpolation, or other adjustment, of the information from the sensor. The lack of processing is the reason why these files are often referred to as a RAW file. When recording NEF (RAW) files, the camera can be configured to deal with the information from the sensor in two specific and mutually exclusive ways; you can select the bit depth used to hold the image data, as well as determining whether this data will be retained in an uncompressed or compressed state. If the data is compressed, you can also control what form of compression is applied to the data.

The D300 offers the choice of having the ADC perform the conversion of the information from the sensor at either a 12-bit or 14-bit depth. The data is maintained in the selected bit depth while it is built and, subsequently, output. This means that at a 12-bit depth each pixel can have one of 4,096 distinct values for its color (red, green, or blue) while at a 14-bit depth the same pixel can have one of 16,384 values. This provides the potential for the color and tone graduation in the 14-bit file to be superior, but this is not always the case (see NEF file attributes below).

Note: If you select 14-bit for the [NEF (RAW) Bit Depth] option in the Shooting menu, the frame rate of the D300 will be reduced to approximately 2.5 fps regardless of the frame rate option set or power source options used.

You can select one of three levels of compression when saving NEF (RAW) files in the camera: uncompressed, lossless compressed, or compressed. If the camera is set to record uncompressed or lossless compressed NEF files, the original data values calculated for each pixel are preserved. However, if the camera is set to record compressed NEF files, some of the information from the sensor is discarded in a process that Nikon describes as being "visually lossless" (see page 298 for the explanation of what actually occurs). Regardless of the level of compression, NEF files are constructed in the same way. Essentially a NEF file uses the same structure as a TIFF file; it starts with tags that point to the EXIF (camera settings) and white balance value information, then saves a small 'thumbnail' image as a JPEG file, followed by the raw pixel data.

To summarize, when comparing between the JPEG and TIFF formats and the NEF (RAW) format the principal differences lie in how the camera deals with the data from the sensor that forms the image. Using the JPEG and TIFF formats the camera produces a 'finished' image based on the sensor data and camera settings at the time of the exposure, selected by either you or the camera. Although it is possible to use these "finished" files directly from the camera to pro-

duce a print or post to a web site, these files can still be post-processed after they have been imported to a computer, if required. However, using the NEF format requires the work necessary to produce a finished image to be done by the photographer, after the fact, using a computer with NEF compatible software.

If you are beginning to form the impression that to eek out every last ounce of quality the D300 has to offer you should shoot in the NEF format you are not too far off the mark! However, while many photographers refer to the NEF (RAW) format as being better than JPEG or TIFF, I prefer to consider this issue in terms of the flexibility the formats offer and recommend that you use the one that is best suited to your specific requirements.

JPEG

Probably the greatest benefit of the JPEG format it that it can be read by most software and it supported by HTML, the computer language used to build web pages. Such ubiquitous acceptance of the JPEG format enables these files to be shared widely regardless of the type of computer or software that may be used.

Note: Strictly speaking, JPEG is a data compression regime and not a file format but since a file saved using this regime is usually assigned an extension of .jpg, or .jpeg it has become common convention to refer to it as a file format.

The process of saving a file in the JPEG format involves taking 8 x 8 blocks of pixels and subjecting each block to a series of calculations that determine the compression of the file. Essentially the numerical value of the pixels is converted into an equation that represents an average value of the pixels in that block. The compressed result for each block is then brought together as a single sequence of binary values, which is encoded using a further lossless form of compression. While the compression process varies, depending on the range of pixel values in each block, it will ultimately result in the permanent loss of some data. As a rule of thumb using a JPEG com-

pression ratio of 1:4 or less will produce an image in which the effects of the compression process are, for all intents, imperceptible. However, the JPEG format has three qualities that can potentially influence image quality in an adverse manner:

- The in-camera processing reduces the 12-bit data from the sensor to 8-bit values when it creates a JPEG file. The D300 does have the advantage that it makes all in-camera adjustments to image attributes (i.e., sharpening, contrast, and saturation) at a 12-bit level before the data is reduced to an 8-bit level. Therefore, if you have no intention of doing any post processing work on your images, the reduction to 8-bits is of no real consequence. However, if you make significant changes to an image using software in post processing the 8-bit data of a JPEG file can impose limits on the degree of manipulation that can be applied. This is particularly true with the level of color and contrast adjustments that can be made.
- When the camera saves an image using the JPEG format it encodes most of the camera settings for attributes such as white balance, sharpening, contrast, saturation, and hue into the image data. If you make an error and inadvertently select the wrong setting you will need to try to fix your mistake in post-processing. Inevitably, this is time consuming and there is no guarantee it will be successful.
- The technology of digital imaging is fast paced and the electronics used in any particular camera are only as good as the day the manufacturer decided on the specifications and finalized the design of the camera. Granted, most modern camera can have their firmware (installed software) upgraded by the user. This helps to offset obsolescence, but it is only effective for so long. By processing images in software on a computer you can often take advantage of the very latest advances in image processing, which are unavailable in the camera.

JPEGs are often used by photojournalists on deadline, because they provide them with the ability to quickly transmit newsworthy photos.

TIFF

The Tagged Image File (TIFF) format is a long-established standard graphics file format that was developed for desktop publishing applications. The common file extension for a TIFF file is .tif. Essentially, a TIFF file comprises a set of pointers (known as tags) that direct any software reading the file to the data held within it. As I mentioned above, the NEF format is constructed using the same basic structure as a TIFF file.

Setting aside the issue of compression, a TIFF file possess the same restrictions as a JPEG file because the image data is eventually reduced to an 8-bit depth and the values for white balance, sharpening, contrast, saturation, and hue are embedded in the file. The principle difference is that a TIFF file is saved with no compression applied to it. As a consequence they are much larger than a JPEG file – on the D300 a JPEG file saved at the Large/Fine settings produce an average file size of 5.8MB, while a TIFF file saved at the Large image size (i.e. the full resolution of the sensor) is 36.5MB. This has two major impacts: TIFF files will take up far more space on the memory card and it will take the camera longer to write the file to the card.

It is hard to think of any good reason why you would want to save your images in the TIFF format. The only plausible justification I can think of is if you have no option other than to submit files in this format to an established workflow and there is no opportunity to conduct any post-processing using another file format to simply re-save it as a TIFF file.

NEF (RAW)

Using the NEF format has only one real disadvantage in my mind—the extra time you will need to invest in post-processing each image to produce a finished picture. The larger file size of the NEF format can present an issue in terms of

NEF files provide the ability to control much of the final look of the image in the computer without the fear of image degradation or artifacts.

the amount of available storage in your memory card or external storage device. But modern data storage devices are relatively cheap, so this shouldn't be too much of a concern. Equally, there can be limitations and variability with third party software's ability to read and interpret Nikon NEF files.

The benefits of NEF format include:

- More consistent and smoother tonal graduations.
- Color that is more subtle and accurate to the original subject or scene.
- A slight increase in the level of detail that is resolved.
- The ability (within fairly limited parameters) to adjust exposure in post processing to correct for slight exposure errors.
- The increased post-processing ability to correct and/or change image color by resetting attributes such as the white balance value, saturation, and hue. Control over image contrast and brightness is also improved.

Note: Many modern software programs are capable of reading NEF files generated by the D300. For compatibility between NEF files from the D300 and Nikon software you will require: Nikon Transfer 1.0.2, Nikon View NX 1.0.3, or Nikon Capture NX 1.3.2, or later. There are a wide variety of third party RAW file converters that enable NEF (RAW) files to be opened in most popular digital imaging software. Examples include: Adobe Camera RAW 4 (for Adobe Photoshop, Photoshop Elements, and Adobe Lightroom), Apple Aperture 2, Bibble, and Phase One. Most manufacturers offer their software for a free trial period, so I recommend you try a few to see which meets your requirements before you commit to a licensed purchase.

I have already alluded to the fact that the D300 can be configured to save NEF files at either a 12-bit or 14-bit depth, and with three options for file compression. So which of these options should you choose? The possible benefits of using a higher bit depth can be found in the appearance of the deepest shadow values in the image, which can be render with richer, smoother looking tones, particularly at higher ISO settings. I say "can be" because these results will, in part, be dependent on properties of the raw file converter that you decide to use; hence, my recommendation that you experiment with a few. Even then the improvement is modest at best. If you are intent on extracting the very best a NEF has to offer and your camera technique and workflow post-processing are impeccable, you will want to select the 14-bit option.

Connected to the choice of bit depth will be the choice of what level of compression to use. Remember, to maximize potential quality and flexibility in post-processing you will want to avoid compressed RAW files. So do you choose uncompressed or lossless compressed? Because the lossless compression has no adverse effect on the image data, I see no reason to use the uncompressed option. Saving a NEF file without compression results in a much larger file, reducing storage and battery capacities (the camera uses more battery power to save a NEF file compared with the other two formats). For most users, 12-bit depth and lossless compression will offer the best combination for most shooting situations.

There are two decisions to be made when setting the camera controls to record NEF (RAW) files: the bit depth used to record the file and whether or not compression should be applied (and, if so, what sort of compression). The D300 offers the option to have a NEF file recorded at either a 12-bit or 14-bit depth and it can be saved in either an uncompressed, lossless compressed, or compressed form. A compressed NEF file is approximately 40 - 50% smaller than the uncompressed NEF file, while a lossless compressed NEF file is approximately 20-40% smaller.

Note: NEF files taken with the D300 using the [Monochrome] option in the Set Picture Control menu are only slightly smaller than color files because the NEF file retains all the original raw data, including the color information. Consequently, using the appropriate options in a raw file converter a NEF file saved as a black-and-white image can be converted to produce a color image.

Note: Compressed black-and-white NEF files are slightly smaller than color NEF files due to the thumbnail image embedded in the NEF file being a smaller grayscale file, with no color information.

Compressed NEF

If the camera is set to record uncompressed, or lossless compressed NEF files, the data value for each pixel is preserved. However, when the camera records compressed NEF files. some of the image data is discarded. Nikon has described the compression applied to NEF files as "visually lossless," by which they mean it is impossible to visually differentiate between an image produced from an uncompressed file and one produced from a compressed file. The "compression" process used by Nikon is selective; it only works on certain image data while leaving other data unaffected. Nikon's use of the word "compression" in this context is rather misleading, as the process involves two distinct phases. The first phase sees certain tonal values grouped and then rounded, and the second phase is the point at which a conventional lossless compression is applied. Once the analog signal from the sensor has been converted to digital data the first phase of the compression process separates the values that represent the very darkest tones from the rest of the data. Then the data with values that represent the remaining lighter tones is divided into groups, but this process is not linear. As the tones become lighter the size of the group increases, so the group with the lightest tones is larger than a group contain-

The D300 can store images as both NEF files and JPEGs. This provides the ultimate versatility for quick transfer of files, or image processing later in the computer.

ing mid-tone values. A lossless compression is then applied to each individual dark tone value and the rounded value of each group in the mid and light tones.

When an application such as Nikon View NX or Nikon Capture NX opens a NEF file it reverses the lossless compression process. The individual dark tone values are unaffected (remember the compression applied here is lossless) but, and here is the twist, each of the grouped values for the mid and light tones must be expanded to fit its original range. Since the rounding error in each group becomes progressively larger as the tonal values it represents become lighter and lighter, the "gaps" in the data caused by the rounding process also become progressively larger at lighter tonal values.

It is important to put these data "gaps" into perspective. A single compression/decompression cycle performed on a NEF file produces an image that is indistinguishable from one produced from an uncompressed NEF file. The human eye does not respond in a linear way to increased levels of brightness; therefore it is incapable of resolving the very minor changes that have taken place, even in the lightest tones where the rounding error is greatest and therefore the data "gap" is largest (remember Nikon's phrase "visually lossless").

Furthermore, our eyes are, generally, only capable of detecting tonal variations equivalent to those produced by 8-bit data. Since even a compressed NEF file has the equivalent to more than 8-bit data, the data "gaps" caused by Nikon's "compression" process are of no consequence. Similarly, many photographers will ultimately reduce their 12-bit NEF RAW files to 8-bit RGB-TIFF, or JPEG files prior to printing. This can mask any loss of tonal graduation caused by compressing NEF RAW files.

In spite of our eyes inability to recognize these changes, it is important to understand that the data loss caused by compression of NEF files can affect final image quality. It can cause the appearance of posterization, which creates course shifts in color and tone where there should be gentle, smooth transitions. This will most likely manifest in highlight area of an image that are subjected to a significant level of adjustment during post-processing, or where excessive sharpening is applied.

Which Format?

In considering the attributes of the JPEG, TIFF, and NEF formats many photographers make an analogy with film photography; they consider the NEF file as though they have the original film negative to work from, and the JPEG or TIFF file as being akin to a machine-processed print. I do not disagree, but this is where my point about the flexibility of the two formats comes back to be relevant; not every photographer has the desire, ability, or time to spend post processing NEF files. The good news is that we have a choice, so consider the points made in this section and make your decision based on which format is best suited to your purposes. If you have sufficient storage capacity on your memory card(s) you could always select one of the NEF + JPEG combinations from the [Image Quality] options, as the D300 can save a copy of a single image in both formats.

JPEG Image Quality and Size

The QUAL button is located on the left top of the D300 camera body.

The D300 allows you to save JPEG files at three different levels of quality:

- **FINE** uses a low compression ratio of approximately 1:4
- NORMAL uses a moderate compression ratio of approximately 1:8
- BASIC uses a high compression ratio of approximately 1:16

Each JPEG file can also be saved by the D300 at one of three different sizes:

- **L** Large (4,288 x 2,848 pixels)
- **M** Medium (3,216 x 2,136 pixels)
- **S** Small (2,144 x 1,424 pixels)

Note: As the processing involved in the creation of a JPEG files uses compression that discards data, to maintain the highest image quality you should select the lowest level of compression. A file saved at the FINE setting will be visually superior to a file saved at the BASIC setting.

Note: JPEG compression can generate visual "artifacts." The higher the compression ratio the more apparent these become. If you are shooting for web publication this is unlikely to be an issue, but if you intend to make prints from your JPEG file pictures you will probably want to use the Large FINE settings.

Setting Image Quality and Size

To set image quality on the D300 open the Shooting menu and use to highlight the [Image Quality] option, press to open the list of options and use to highlight the required setting, then press the button to confirm the selection. Alternatively, and in my opinion by far the more convenient and quicker way to select image quality is to use the button and dial method. Press and hold the QUAL button then rotate the main command dial; the selected value is displayed in the control panel. There are eight options available: NEF (RAW), JPEG Fine, JPEG Normal, JPEG Basic, NEF (RAW) + JPEG Basic, and TIFF (RAW) + JPEG Normal, NEF (RAW) + JPEG Basic, and TIFF (RGB).

To set image size for the JPEG and TIFF format on the D300, open the Shooting menu and use to highlight the [Image Size] option (note if you only have NEF (RAW) selected for [Image Quality] this option is grayed out); press to open the list of options and use to highlight the required setting. Again, my opinion is that using the alternative button and dial method is the more convenient and quicker way. Press and hold the **QUAL** button then rotate the sub command dial; the selected value is displayed in the control panel as L (large), M (medium), or S (small).

File Compression Options for JPEG

In addition to the image quality settings that apply a varying degree of compression to the image data when saving JPEG format files, the D300 has two further options in respect to JPEG compression. Open the Shooting menu and use to highlight the [JPEG Compression] option. Press to open the next menu page and use to select one of the two options:

- [Size Priority] (default) Image files are compressed to a
 near uniform size, which results in a variation of quality
 dependent on the level of fine detail in the subject or
 scene. The more detail the subject or scene contains, the
 more likely the image quality will be reduced.
- [Optimal Quality] Image files are compressed to a
 varying size to allow for different levels of detail in the
 subject or scenes being photographed. Unless you really
 need files of a consistent size or image storage capacity
 is an issue, I recommend you use this option instead of
 [Size Priority].

Once your desired option is highlighted press w to confirm the selection.

File Compression Options for NEF (RAW)

To choose compression for NEF (RAW) files open the Shooting menu and use to highlight the [NEF (RAW) Recording] option. Press to open the next menu page and use to select one of the two items displayed: [Type] and [NEF (RAW) Bit Depth].

- [Type] has three options: (icon 16) Lossless compressed (default), (icon 17) Compressed, and Uncompressed. Use to select the required option and press to confirm the selection.
- [NEF (RAW) Bit Depth] has two options: 12-bit (default), or 14-bit. Again, use to select the required option and press to confirm the selection.

Note: If you select 14-bit for [NEF (RAW) Bit Depth] option in the Shooting menu, the frame rate of the D300 will be reduced to approximately 2.5 fps regardless of the frame rate options set or power source options used.

Ultimately, the type of image file you shoot is a personal choice based on the use of the image and how much time you are willing to invest in image processing. All file types are capable of producing quality images, which are suitable for enlarging.

Nikon Flash Photography

Before we take a look at the flash capabilities for the D300 it is important that you understand a little bit about flash exposure. Light from a flash unit falls off, as it does from any other light source, by what is known as the Inverse Square Law; put simply if you double your distance from the light its intensity drops by a factor of four, because it is now lighting an area four times the size. Since a flash unit emits a precise level of light, it will only light the subject correctly at a specific distance, depending on the intensity of the light, the lens aperture, and the ISO sensitivity. If the flash correctly exposes the subject, anything closer to the flash will be overexposed and anything farther away will be increasingly underexposed. So, to produce a balanced exposure between the subject and its surroundings you need to balance the light from the flash with the ambient light.

When the D300 is used with a D- or G-type Nikkor lens, and its built-in Speedlight, or an external Speedlight, such as the SB-600, or SB-800, and the camera is set to Matrix metering it will perform i-TTL Balanced Fill-flash (i.e. the camera attempts to balance the ambient light to the flash output). The system used in the D300 is Nikon's third generation of TTL flash exposure control, which is known as i-TTL (intelligent TTL), and it represents their most sophisticated flash exposure control system to date. It is part of a wider set of flash features and functions that Nikon has named the Creative Lighting System (CLS).

Nikon's Creative Lighting System offers a wide range of flash and commander units, which provide a wealth of options for sophisticated use of flash in digital photography.

Note: Currently the SB-800, SB-600, SB-400, and SB-R200 are the only external Speedlights supporting i-TTL and the CLS. If any other external Nikon Speedlight is attached to the D300 no form of TTL flash exposure control is supported; this includes the earlier DX-type Speedlights, such as the SB-80DX, designed for digital SLR cameras.

The Creative Lighting System

The CLS encompasses a range of features and functions that are as much a part of the various compatible cameras, such as the D300, as the Speedlight units themselves. These features include: i-TTL, the latest iteration of Nikon's through the lens flash exposure control, Advanced Wireless Lighting that provides wireless control of control multiple Speedlights using i-TTL flash exposure control, Flash Value (FV) Lock, Flash Color Information Communication, Auto FP High-Speed Sync, and Wide-Area AF-Assist Illuminator. The CLS has expanded and at present compatibility extends to the D3-series, D2-series, D300, D200, D80, D70-series, D60, D50, D40-series, and F6 cameras, with the SB-800, SB-600, SB-400, and SB-R200 Speedlights, and SU-800 Wireless Speedlight Commander, although the D70-series, D60, D50, and D40-series camera models do not support all the features of the CLS.

Understanding Nikon Flash Terminology

Many photographers fail to understand how their choice of exposure mode can affect the appearance of a photograph made with a mix of flash and ambient light. All too often they assume that because the camera is performing automated i-TTL balanced fill-flash that both the subject and background will be rendered properly. Their frustration deepens when they realize that any exposure compensation factor that they apply on the camera, Speedlight, or both, is often either overridden, or ignored completely!

The i-TTL balanced fill-flash is a fully automated process, so the photographer is not the one in control here! The camera is responsible for all exposure decisions in i-TTL bal-

Light from an electronic flash unit spreads out and falls off as it travels away from the flash unit. Thus, objects that are farther from the unit will not be as bright as those close to the flash.

anced fill-flash when the camera is set to any of the automatic exposure modes (P, A, and S), and all flash exposure decisions in i-TTL balanced fill-flash when the camera is set to manual exposure mode.

Furthermore, if you select either Aperture-Priority auto (A), or Programmed-automatic (P) exposure modes, the available shutter speed range is restricted to between 1/250 and 1/60 second. So, if the level of ambient light requires a shutter speed outside of this range, as is usually the case when shooting in low ambient light conditions such as a dimly lit interior, the areas of the scene lit by the ambient light will be underexposed.

You can have a lot of fun experimenting with flash photography in the black of night. The photo on the left was a long ambient light exposure, without flash. The photo on the right used 15 outputs of an

Hint: If you use Aperture-Priority (A) exposure mode habitually with flash consider setting Slow-sync flash mode (do not confuse this with Rear-sync mode). This overrides the restriction on shutter speed range, and allows the full range of speeds available on the camera, between the maximum flash sync speed and the slowest shutter speed to be used, so areas lit by ambient light appear more balanced with those lit by flash.

Note: Alternatively, on the D300 it is possible to select the slowest shutter speed to be used with front-curtain sync, rear-curtain sync, or red-eye reduction flash when the camera is set to either Aperture-Priority auto (A), or Programmed-automatic (P) exposure modes. This feature is set via CS-e2 (Flash Shutter Speed).

off-camera flash directed at different parts of the scene, creating an intriguing appearance to the final photo.

Another clue as to what occurs in i-TTL balanced fill-flash is the word "balanced;" this means that the camera assess the flash output level and the ambient light to create a balanced exposure using both light sources. The camera achieves this more often than not by compensating the exposure for either the ambient light, the flash, and sometimes both. As mentioned above any exposure compensation factor applied by the photographer to adjust either the ambient light, or flash exposure is frequently overridden, or even ignored, because i-TTL balanced fill-flash is a wholly automated process, which can make achieving consistent repeatable results difficult to accomplish.

The reference to fill-flash in the name of this flash control method just serves to confuse users even further! Fill-flash is a recognized lighting technique in which the flash is used to provide a supplementary light to the main ambient light

source, and as such its output is always set at a level below that of the ambient light. Generally, the purpose of this fill light from the flash is to provide additional illumination in the shadows and other less well-lit areas of a scene to help reduce the overall contrast range, although many photographers also use the technique to put a small catch light in their subject's eyes.

The use of the term fill-flash by Nikon is misleading on two counts in the context of i-TTL balanced fill-flash: first, depending on the prevailing light conditions, generally when the level of ambient light is very low, the Speedlight becomes the principal light source for illuminating the scene, and second, as discussed above "balanced" implies that the exposure for the ambient light and flash comprise equal proportions, which is often not the case.

So, whenever you see the term i-TTL balanced fill-flash remember that existing ambient light and flash will be mixed in a fully automated process to produce the final exposure; how the two light sources are mixed and in what proportion will depend on a wide variety of factors, including ISO sensitivity, lens aperture, exposure mode, exposure compensation value, brightness of both the ambient and flash illumination, and nature of the scene being photographed.

If you want to achieve consistent repeatable results when using a true fill-flash technique, where the flash is the supplementary light I recommend you use standard i-TTL flash, as any flash output compensation, or exposure compensation you set will be applied without influence from the camera. Likewise in any situation where you wish to use flash as the main source of illumination and have control over the flash output level and any exposure of ambient light, I suggest you select standard i-TTL flash.

TTL Flash Modes

The D300 supports two methods for TTL control flash exposure with either its built-in Speedlight or a compatible external Speedlight.

- i-TTL Balanced Fill-flash—the most sophisticated version of Nikon's TTL flash exposure control system the Speedlight(s) emit an short series of nearly imperceptible pre-flashes (sometimes referred to in Nikon literature as monitor pre-flashes) a faction of a second before the reflex mirror lifts to record the exposure. The light from these pre-flashes is reflected from all areas of the scene within the camera's frame area is detected by the 1005-segment RGB-metering sensor of the D300 and assessed as described above to adjust the flash output so it produces a balanced exposure of the main subject and the background lit by any ambient light. The most precise calculations are obtained when either a D. or Gtype lens is attached to the D300, since focus information including distance in included in the computations for flash output Even using non-CPU lenses, such as compatible manual focus types, other than Ai-P types, flash output the accuracy of these calculations can be increased by inputting lens data (focal length and maximum aperture value).
- Standard i-TTL Flash—this differs from i-TTL balanced fill-flash control method just described as the 1005-segment RGB-metering sensor and metering system of the D300 determine the output of the flash, exclusively, so measurement of the ambient light in the background remains wholly independent, and is not integrated in any way with the flash exposure calculations. For reasons explained below standard i-TTL flash control is often the best option when flash exposure of the main subject is the priority, or when flash output compensation is used.

Note: Standard i-TTL Flash has very important implications when mixing ambient light with light from a Speedlight for the fill-flash technique, as any exposure compensation level selected for either the ambient light exposure, or the flash exposure, or both will be applied at the level pre-determined by the photographer and is not influenced by the any automated adjustment the camera may apply.

Note: Selecting spot metering on the D300 will cause the flash exposure control to default to standard i-TTL flash.

Intelligent TTL (i-TTL) Flash Control

The most recent Nikon's TTL flash exposure control system, i-TTL offers an enhanced and refined method of flash exposure control. It uses only one or two pre-flash pulses with a shorter duration and higher intensity than those used for the TTL and D-TTL methods performed by previous Nikon cameras and Speedlights. Currently, the D300 supports i-TTL with these compatible Speedlights: its built-in Speedlight, SB-800, SB-600, SB-400, and SB-R200.

Note: Due to its design the SB-R200 cannot be mounted on the accessory shoe of a camera; it can only be used as a wireless remote flash controlled by either the SU-800 Commander unit, an SB-800 Speedlight, or the built-in Speedlight of compatible camera models, such as the D300.

There are several key differences between the D300's i-TTL system and the earlier TTL and D-TTL systems:

- i-TTL uses fewer monitor pre-flashes but they have a higher intensity. This greater intensity improves the efficiency of obtaining a measurement from the TTL flash sensor, and by using fewer pulses the amount of time taken to perform the assessment is reduced.
- The D300 uses its 1005-pixel RGB-metering sensor located in the prism head to control flash exposure

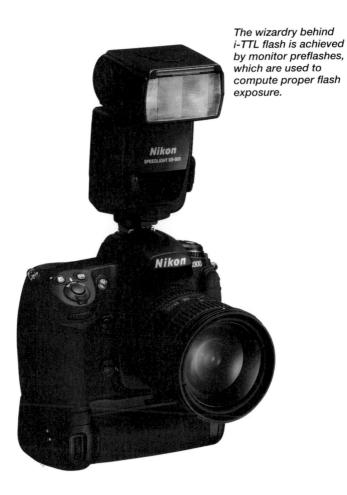

regardless of whether a single Speedlight, or multiple Speedlights are used as part of a wireless TTL configuration. In both configurations monitor pre-flashes are always emitted before the reflex mirror is raised.

The following is a summary of the sequence of events used to calculate flash exposure in the D300, when it is used with a single or multiple compatible Speedlights (i.e. its built-in unit, SB-800, SB-600, SB-400, or SB-R200) and a D- or G-type Nikkor lens:

- 1. Once the shutter release is pressed the camera reads the focus distance from the D- or G-type lens.
- 2. The camera sends a signal to the Speedlight to initiate the pre-flash system, which then emits one or two pulses of light from the Speedlight(s).
- 3. The light from these pre flashes is bounced back from the scene, through the lens on to the 1005-pixel RGB-metering sensor, via the reflex mirror.
- 4. The information gathered by the 1005-pixel RGB-metering sensor is then analyzed along with information about the ambient it detects in the scene, and further information supplied by the focusing system. The camera then determines the amount of light required from the Speedlight(s) and sets the duration of the flash discharge accordingly.
- 5. The reflex mirror lifts up out of the light path to the shutter, and the shutter opens.
- The camera sends a signal to the Speedlight(s) to initiate the main flash discharge, which is quenched the instant the amount of light pre-determined in Step 4 has been emitted.
- 7. The shutter will close at the end of the predetermined shutter speed duration, and the reflex mirror is lowered to its normal position.

Note: The emission of the monitor pre-flashes occurs before the reflex mirror is raised – this can be significant if, during the slight delay between the mirror being raised and the shutter opening, the light from the pre-flash causes the subject to blink.

Flash Output Assessment

The crucial phase in the sequence described above is of course, step 4, which is the point at when the required output from the flash is calculated. Unlike previous Nikon D-SLR cameras the D300 has the additional benefit of the newly developed Scene Recognition System (SRS), which enhances the abilities of the established 1005-pixel RGB-metering sensor by separating light into its component colors enabling the sensor to work more effectively and efficiently. The 1005-pixel sensor is able to recognize shapes and objects not only by their profile but also by their structure and distribution of color. This evaluation of the shape and color of elements in the scene is performed together with conventional assessment of the overall level of brightness and contrast within the scene.

The camera compares the relative brightness of each segment in its 1005-pixel RGB-metering sensor used in Matrix metering. For example, if a majority of the outer segments in the outer parts of the frame area detect a high level of brightness and those close to the center of the frame detect a much lower level of brightness the system is likely to conclude that there is strongly back lit subject at the center of the frame.

Once the camera has collected all the information pertaining to the shapes, colors, brightness, and range of contrast it detects in the scene, it compares these values against a database of over 60,000 examples, more than twice as many stored by previous Nikon cameras, covering an enormous range of lighting conditions. If the first comparison generates conflicting assessments the segment pattern maybe re-configured and further analysis is performed. For example, if any segment, or group of segments report an abnormally high level of brightness in comparison to the others, as might occur if there is a highly reflective surface in a part of the scene that was causing an intense reflection, such as glass, or a mirror, the metering system will usually ignore this information in its flash exposure calculations.

Note: The scene recognition system only operates when Matrix metering is selected; if the D300 is set to centerweighted, or spot metering the system reverts to simple grayscale metering.

Focus Information

Focus information is provided in two forms; camera-to-subject distance, and the level of focus/defocus at each focus point. Compatible cameras use this information to assess approximately how far away the subject is likely to be and also its approximate location within the frame area.

The D300's RGB metering sensor.

Generally the focus distance information will influence which segment(s) of the 1005-pixel RGB-metering sensor affect overall exposure calculations. For example, assuming the subject is positioned in the center of the frame and the lens is focused at a short range, the camera will, generally, place more emphasis on those segments that cover the outer part of the frame area and less on the central ones. An exception to this occurs if the camera detects a very high level of contrast between the central and outer areas of the frame it may, and often does, reverse the emphasis and weights the exposure according to the information received from central segments of the 1005-pixel RGB-metering sensor. Conversely, if the subject is positioned in the center of the frame and the lens is focused at a mid to long range, the

camera will place more emphasis on the segments at the center of the frame and less on those in the outer areas. Essentially what the camera is trying to do in both cases is prevent overexposure of the subject, which it assumes is in the center of the frame.

Note: The focus distance information requires a D- or G-type lens to be mounted on the camera distance.

Individual focus point information is integrated with focus distance information, as each AF point is checked for its degree of focus. This provides the camera with information about the probable location of the subject within the frame area. Using the examples given in the previous paragraph, the camera notes that the central AF point has acquired focus while the other AF points each report varying levels of defocus. Therefore, exposure is calculated on the assumption that the subject is in the center of the frame and the camera biases its computations according to the focus distance information it receives from the lens, as described.

However, it is important to understand that other twists occur in this story of interaction between exposure calculation and focus information. For example, when you acquire and lock focus on a subject using the center AF point and then recompose the shot, so that the subject is located elsewhere in the frame (the central AF point consequently no longer detect focus), the camera will, generally, use the exposure value it calculated when it first acquired focus. However, if it detects that the level of brightness detected by the metering segments at the center of the frame has changed significantly from the level when focus was first acquired with the subject at that position, the camera can, and often does adjust its exposure calculations—sometimes not necessarily for the better. To help improve flash exposure accuracy in situations when you wish to compose picture with the subject close to the periphery of the frame I recommend you use the flash value (FV) lock feature (see page 335).

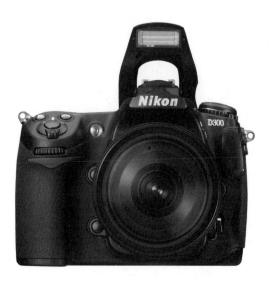

The D300 features a handy built-in Speedlight that can also be used as a commander unit in multiple flash photography.

The Built-in Speedlight

The D300 features a built-in Speedlight (Nikon's proprietary name for a flash unit) that has an ISO 200 guide number of 56 feet (17 m) at 68°F (20°C) for i-TTL flash, and 59 feet (18 m) at 68°F (20°C) for manual flash. The camera has a standard flash synchronization speed of 1/250th second, although for the first time in a Nikon D-SLR camera, this can be raised slightly to 1/320th second, as the built-in Speedlight supports the automatic FP high-speed flash sync feature of the CLS. It has a minimum range of 2 feet (0.6 m) below which the camera will not necessarily calculate the correct flash exposure. The built-in Speedlight is activated by manually pressing the flash release button, located immediately above the \$\frac{1}{2}\$ flash mode button. This causes the flash head to pop up.

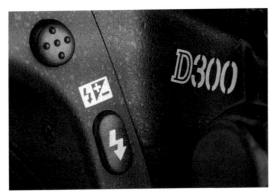

To activate the built-in Speedlight, press the flash-release button.

The built-in Speedlight draws its power from the camera's main battery so extended use of the flash will have a direct effect of battery life. As soon as the flash unit pops up it begins to charge. The flash ready symbol \$\frac{1}{2}\$ appears in the viewfinder to indicate charging is complete and the flash is ready to fire. If the flash fires at its maximum output the same flash ready symbol will blink for approximately three seconds after the exposure has been made, as a warning of potential underexposure.

Note: The flash ready symbol operates in exactly the same way when an external Speedlight is attached and switched on, as it does with the built-in Speedlight.

Note: The i-TTL is designed to work with ISO sensitivities between ISO 200 and ISO 3200; outside of this range Nikon state that flash exposure control may be less accurate.

Lens Compatibility with the Built-in Speedlight

The built-in flash can be used with CPU lenses (i.e. all AF and Ai-P types) with focal lengths between 18mm to 300mm (it can also be used with Ai-, Ai-modified, and E-series Nikkor lenses with a focal length between 18mm to 300mm) but always remove the lens hood to prevent light form the flash being obscured. Regardless, the built-in flash may be unable to illuminate the entire frame area evenly when using

the following lenses at a focus distance less than those given in the following table:

Zoom Lens Focal length / Minimum Shooting Range

Lens	Focal length	Minimum distance
AF-S DX 12–24mm f/4G ED	18mm	4 ft 11 in (1.5 m)
	20mm	3 ft 3 in (1.0 m)
AF-S 17–35mm f/2.8D ED	24mm	3 ft 3 in (1.0 m)
AF-S DX 17-55mm f/2.8G ED	24mm	3 ft 3 in (1.0 m)
AF 18–35mm f/3.5–4.5D ED	18mm	4 ft 11 in (1.5 m)
AF-S DX 18–135mm f/3.5–5.6G ED	18mm	3 ft 3 in (1.0 m)
AF-S DX VR 18–200mm f/3.5–5.6G ED	18mm	3 ft 3 in (1.0 m)
AF 20–35mm f/2.8D	20mm	3 ft 3 in (1.0 m)
AF-S 24–70mm f/2.8G ED	28mm 35mm	4 ft 11 in (1.5 m) 3 ft 3 in (1.0 m)
AF-S 28–70mm f/2.8D ED	28mm	4 ft 11 in (1.5 m)
	35mm	3 ft 3 in (1.0 m)

Note: It is not possible to use the built-in Speedlight with the AF-S 14–24mm f/2.8G ED, as light is always obscured regardless of focal length.

Note: The built-in flash has a minimum range of 2 feet (60 cm); therefore it cannot be used at the close focus distances of macro zoom lenses.

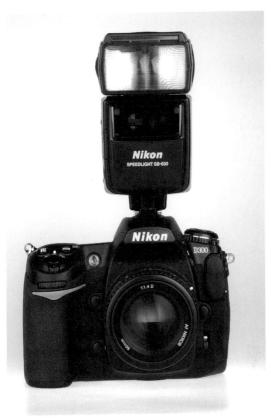

The D300 with an SB-600 mounted in its hot shoe.

Using External Speedlights

In addition to the built-in Speedlight the D300 offers full i-TTL flash exposure control with three external Speedlights that are compatible with the CLS: the SB-400 with a GN 98 feet (30 m) at ISO 200, the SB-600 with a GN 138 feet (42 m) at ISO 200 with the head set to the 35mm position, and the SB-800 with a GN of 175 feet (53 m) at ISO 200 with the head se to 35mm. All models can either be attached to the camera directly, or via a dedicated TTL remote flash cord.

Note: The D300 does not support for TTL flash exposure control with any other shoe mount Nikon Speedlights.

Note: The SB-R200, which has a GN 49 feet (14 m) at ISO 200 can only be controlled as part of the Nikon Advanced Wireless Control (AWL) flash system, via either the built-in Speedlight of compatible cameras, such as the D300, the SU-800 commander unit, or an SB-800 Speedlight used as a master flash unit.

Apart from being more powerful, these three Speedlights are considerably more versatile than the built-in unit since their flash heads can be tilted, and in the case of the SB-600 and SB-800 swiveled for bounce flash. The two latter units also have an adjustable auto zoom-head (SB-800, 24-105mm) (SB-600, 24-85mm) that controls the angle-of-coverage of the flash beam, and a wide-angle diffuser to allow them to illuminate the field of view of a lens with a focal length of 14mm.

Note: Unlike earlier Nikon Speedlights, which cancelled monitor pre-flashes if the flash head was tilted or swiveled for bounce flash, the SB-400, SB-600, and SB-800 emit pre-flashes regardless of the flash head orientation.

Hint: The coverage of the SB-600 and SB-800 is set to correspond to the field of view of a lens with one of focal lengths within the range of its zoom head. However, this is based on the assumption that the Speedlight is attached to a camera with an FX-format sensor (24 x 36 mm), or a 35mm film camera, and not a digital SLR with a DX-format sensor (such as the D300 with its reduced angle-of-view for the same focal length due to its smaller sensor). Therefore, the flash will be illuminating a greater area than is necessary when used on the D300, which means you will be restricting your shooting range and squandering flash power. Use the following table to adjust the zoom head position, and thus, maximize the performance of an external Speedlight with any DX-format Nikon D-SLR camera:

Focal length of lens (mm)	Zoom head position (mm)
14	20
18	24
20	28
24	35
28	50
35	50
50	70
70	85
85	105¹

^{1 -} Available on SB-800 only.

Non-TTL Flash with the SB-800 Speedlight

When using the SB-800 external Speedlight with the D300 there are two additional non-TTL flash modes available.

Auto Aperture (AA) – in this mode the SB-800 reads the ISO sensitivity setting and lens aperture from the camera automatically, and also receives the "fire flash" signal from it as

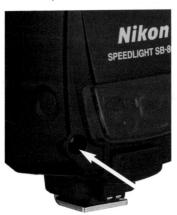

A sensor on the front of the external flash unit monitors the flash exposure in AA flash mode.

well. It can be used in aperture-priority auto, or manual exposure modes. Thereafter the flash output level is determined using a sensor on the front panel of the Speedlight to monitor the flash exposure and as soon as this sensor detects that the flash output has been sufficient, the flash pulse is quenched. If, between exposures, you decide to alter the focal length, or change the lens aperture the Speedlight will adjust its output accordingly to maintain a correct flash exposure. The problem with this option is that the sensor does not necessarily "see" the same scene as the lens, which can lead to inaccuracies in flash exposure.

Automatic (A) – this is the only automatic (non-TTL) flash mode available with the earlier DX-type Speedlights, such as the SB-80DX, as well as the SB-800. It can be used in aperture-priority auto, or manual exposure modes. Similar to the AA mode a sensor of the front of the SB-800, or DX-type Speedlight, monitors flash levels and shuts off the flash when the Speedlight calculates sufficient light has been emitted. However, the lens aperture and ISO sensitivity values must be set manually on the Speedlight to ensure the subject is within the flash shooting range. As with the AA mode the sensor does not necessarily "see" the same scene as the lens, which can lead to inaccuracies in flash exposure.

Flash Synchronization

The flash synchronization (sync) speed is the briefest shutter speed that can be set while maintaining full illumination of the frame area by a flash unit and have the flash produce its maximum output if required. On the D300 the maximum flash sync speed is 1/250 second. This can be selected via CS-e1, where it is the default option, or set to a slower shutter speed between 1/200 and 1/60 second if required. Alternatively, in shutter speed-priority auto and manual exposure modes the maximum flash sync speed can be set by selecting the x250 shutter speed option, which is the next setting beyond the slowest shutter speed (30 seconds, or bulb, respectively) in those two exposure modes. The shutter speed is displayed as x250 in the control panel and viewfinder.

Use rear curtain sync when you want to achieve a realistic portrayal of motion. It will fire the flash at the end of the exposure so that the motion blur appears to be following the frozen object.

It is also possible to synchronize the built-in Speedlight and external Speedlights at shutter speeds briefer than 1/250 second by using the Auto FP (Focal Plane) High-speed flash sync feature. Again this can be selected via CS-e1 (see below under Additional Flash Features & Functions for a full description).

Flash Sync Modes

Not to be confused with the flash modes available on the D300 (i.e. i-TTL Balanced Fill-flash, or Standard i-TTL flash), as described above, the flash synchronization (flash sync) modes determine when the flash is fired in relation to the opening and closing of the shutter and the range of shutter speeds that is available. These apply to both the built-in Speedlight, and external Speedlights.

To set a flash sync mode on the D300 press and hold the button, and rotate the main command dial to scroll through the various options until the icon for the required mode appears in the control panel.

The flash button, located on the camera on the upper left front, is pressed and the main command dial rotated to set the flash sync mode.

Front-curtain sync – the flash fires as soon as the shutter has fully opened. In P and A exposure modes the shutter speed range is restricted to between 1/60 and 1/250 second, unless a lower speed has been selected via custom setting e2 (Slowest Speed When Using Flash). In S and M exposure modes the Speedlight synchronizes at shutter speed between 30 seconds and 1/250 second.

Red-eye reduction – the D300 uses the AF-assist lamp on the front right side of the camera body to light for approximately one second before the main exposure; the purpose is to try an induce the pupils in the subject's eye to constrict and thus reduce the risk of red-eye. Shutter speed synchronization is the same as for front curtain sync.

Hint: This mode not only alerts your subject that you are about to take a picture but also causes an inordinate delay in the shutter's operation by which time the critical moment has generally passed and you have missed the shot! Personally, I never bother with this feature.

Slow-sync – only available in P and A exposure modes the flash fires as soon as the shutter has fully opened and at all shutter speeds between 30 seconds and 1/250 second. It is useful for recording low-level ambient light as well as those areas of the scene or subject illuminated by flash (see full description below).

Slow sync with red eye – as for slow-sync mode except the AF-assist lamp is switched on for approximately one second before the shutter opens for the reason stated above under red-eye reduction.

Hint: The same advice applies - avoid this mode!

Rear-curtain – in S and M exposure modes, the flash fires just before the shutter closes and at all shutter speeds between 30-seconds and 1/250 second. Any image of a moving subject recorded by the ambient light exposure will appear to be behind the image of the subject illuminated by the flash output.

Slow rear-curtain sync - in P and A exposure modes, the flash fires just before the shutter closes and at all shutter speeds between 30 seconds and 1/250 second. Any image of a moving subject recorded by ambient the ambient light exposure will appear to be behind the image of the subject illuminated by the flash output.

The following table sets out a summary of how the shutter speed and lens aperture values are influenced according to the exposure mode selected when either the built-in, or an external Speedlight is used:

Exposure mode	Shutter speed	Lens aperture		
Programmed-auto (P)	Set automatically by the camera (1/250 -1/60 second) ^{1,2}	Sat automatically		
Shutter-priority (S)	Value selected by user (1/250 - 30 seconds) ²	by the camera		
Aperture-priority (A)	Set automatically by the camera (1/250 - 1/60 second) ^{1,2}	Value selected		
Manual (M)	Value selected by user (1/250 – 30 seconds) ²	by the user 3		

Shutter speed may be set as slow as 30s in slow sync, slow rear-curtain sync, and slow sync with red-eye reduction flash modes.

Flash Range, Aperture, and ISO Sensitivity

The flash shooting range will vary depending on the values set for the lens aperture and ISO sensitivity.

Lens a	perture	at ISC) (sensit	ivity)	Range			
200	400	800	1600	3200	Meters	Feet		
1.4	2	2.8	4	5.6	1.0 - 8.5	3 ft 3 in – 27 ft 11 in		
2	2.8	4	5.6	8	0.7 - 6.1	2 ft 4 in – 20 ft		
2.8	4	5.6	8	11	0.6 - 4.2	2 ft – 13 ft 9 in		
4	5.6	8	11	16	0.6 - 3.0	2 ft – 9 ft 10 in		
5.6	8	11	16	22	0.6 - 2.1	2 ft – 6 ft 11 in		
8	11	16	22	32	0.6 - 1.5	2 ft – 4 ft 11 in		
11	16	22	32	-	0.6 - 1.1	2 ft – 3 ft 7 in		
16	22	32	-	-	0.6 - 0.8	2 ft – 2 ft 7 in		

² Speeds as fast as 1/8,000 s are available with optional SB-800 and SB-600 flash units when [1/320 s (Auto FP)] or [1/250 s (Auto FP)] is selected for Custom Setting e1 ([Flash sync speed], pg. 288).

³ The useable range for flash varies according to the aperture and ISO sensitivity values set on the camera. Use the table below when setting aperture in A and M modes.

Maximum Aperture Limitation According To ISO Sensitivity In programmed-auto (P) exposure mode, the maximum aperture (smallest f/number) is limited according to the ISO set on the D300.

Maxim	um Aperture	at set ISO		
200	400	800	1600	3200
3.5	4	5	5.6	7.1

Slow Synchronization Flash

Attaching a Speedlight directly to the accessory shoe, or via a dedicated TTL flash cord such as the SC-28 or SC-29, to the D300 when the camera is used in either Programmed automatic, or Aperture-Priority exposure mode will cause the camera to set a shutter speed in the range of 1/60 to 1/250 second as soon as you switch the Speedlight on. The actual speed that is used within this narrow range depends on the level of ambient light (the brighter the conditions the shorter the shutter speed).

The restriction imposed on the range of available of shutter speeds when using flash in P and A modes can have a significant effect on the overall exposure. For example, in situations when you photograph a subject outside at night, or in a dark interior, any area of the scene illuminated by ambient light alone will be lit dimly compared with those areas that will be illuminated by the flash. It is more than likely that the level of ambient light will not be sufficient for a proper exposure within this restricted range of shutter speeds; consequently these areas of the scene will be underexposed. A typical photograph taken under these conditions has a well-exposed subject set against a dark, featureless background.

To avoid this situation, select slow synchronization flash mode (abbreviated to Slow Sync), which enables the camera to use all shutter speeds below 1/60 second to the longest shutter speed available on the camera, 30 seconds. The camera will now be able to select an appropriate shutter speed

for the low level of ambient light, so the correct exposure can be achieved for the background (remember the flash output will have little if any effect in this region as the intensity of light from the flash will diminish according to the Inverse Square Law), and the flash output will be controlled for a proper exposure of the subject and foreground.

Hint: Since the shutter speed may be quite slow when using slow sync flash mode, consider supporting the camera on a tripod, or similar stable platform to avoid the effects of camera shake.

Rear-curtain Synchronization

If the subject is moving, it is possible to achieve some interesting effects by using slow sync flash mode with a slow shutter speed, as the flash will illuminate the subject briefly to record it as sharp, while the slow shutter speed permits the ambient motion blur to record. This technique can be particularly effective when used with either rear-curtain sync flash mode in either Aperture-Priority (A), or Manual (M) exposure modes. Alternatively in Programmed (P), or Shutter-Priority (S) exposure modes, use slow rearcurtain sync flash mode. This allows the blur due to subject movement to appear to "follow" the sharp image of the subject formed by the flash illumination, which heightens the natural rendition of subject motion.

Auto Focal Plane (FP) High-speed Sync

Available with both the SB-800 and SB-600 Speedlight flash units, or the SB-R200 when it is used as part of a wireless flash control system, this feature is set from the D300 via CS-e1 (Flash sync speed).

One of the limitations of using daylight fill-flash is the maximum flash sync speed of the D300, which is 1/250 second; working in bright lighting conditions it is often not possible to open the lens aperture very far, due to the restriction of the maximum (briefest) shutter speed limit imposed by the

If you want a realistic portrayal of motion, always use rear-curtain sync with flash in action photography.

use of flash. The Auto FP High-Speed Sync feature allows a compatible external Speedlights to sync at any shutter speed beyond a 1/250 second to the shortest shutter speed available on camera, while adjusting the flash output automatically, which makes using fill-flash far more flexible; select the 1/250 s (Auto FP) option at CS-e1. To achieve this the flash emits its output of light as a very rapid series of pulses instead of a single continuous pulse; however, this has the effect of reducing the intensity of the light, so as the flash is synchronized with increasingly faster shutter speeds the flash output is progressively reduced, which in turn reduces the operational range of the Speedlight.

The D300 also has an additional Auto FP High-Speed Sync option, 1/320 second (Auto FP), again selected via CS-e1, which allows the built-in Speedlight, or a compatible external Speedlight to synchronize at shutter speeds up to 1/320-sec-

ond. With this option flash synchronization is achieved by reducing the flash output (i.e. shortening the duration of the single flash pulse) when the shutter speed is increased above 1/250 second to a maximum of 1/320 second, so the effective guide number of the flash unit and hence its operational range is reduced. The following table sets out the combination of shutter speed ranges and flash sync options:

Flash sync	1/320 s (Auto FP)	1/250 s (Auto FP)	1/250 se	cond	
Shutter speed 1/8000 – 1/320-s 1/320 –	Built-in flash	External flash	Built-in flash	External flash	Built-in flash	External flash	
	Not possible	Auto FP	Not possible	Auto FP FP	Not possible	Not possible	
1/320 – 1/250-s	Standard Synchron		Not possible	Auto FP FP	Not possible	Not possible	
1/250 – 30-seconds		Standard	Flash Sync	hronization			

¹ Effective flash range is reduced when shutter speed is increased from 1/250 second to a maximum of 1/320 second

For example, at flash sync speeds of 1/250 second, or less the SB-800 has a guide number of 174 feet (53 m) at ISO 200, with the flash head at 35mm, at 68°F (20°C) , but selecting the 1/320 s (Auto FP) option reduces its guide number to 125 feet (38 m) at the same specifications as above. The flash range is calculated by dividing the guide number by the lens aperture value; so using f/5.6, the SB-800 has a maximum range of 31 feet (9.5 m) at flash sync speeds of 1/250 second or less, but only 22 feet (6.7 m) when the 1/320 s (Auto FP) option is active.

Hint: The very modest increase in shutter speed made available by the 1/320 s (Auto FP) option is unlikely to be of much use in many situations, unless you only have the built-in Speedlight of the D300 available to you. Since an external Speedlight (SB-800, or SB-600) provides far greater flexibility in the control of lighting for fill-flash I would recommend using one of these units with the 1/250 s (Auto FP) option of the Auto FP High-Speed Sync feature.

Hint: Since either of the Auto FP High-Speed Sync options reduce flash shooting range, always check the distance scale displayed in the control panel of the SB-800 when using the Auto FP feature; "FP" will be displayed in the control panel of the SB-600 and SB-800 when Auto FP is active.

Additional Flash Features & Functions

Flash Compensation

Flash compensation is used to modify the level of the flash output, and is set on the D300 by pressing and holding the button while turning the sub-command dial. Compensation can be set in increments of 1/3, 1/2 or 1EV (subject to settings in custom setting b3 (Exp Comp/Fine tune) over a range of +1 to -3EV.

Hint: If you use the default i-TTL Balanced Fill-flash mode it will automatically set flash compensation based on scene brightness, contrast, focus distance, and a variety of other factors. The level of automatic adjustment applied by the D300 will often cancel out any compensation factor entered manually by the user. Since there is no way of telling what the camera is doing you will never have control of the flash exposure. To regain control set the flash control to standard i-TTL by either selecting spot metering on the camera (this is the only option for the built-in Speedlight, or set the flash control mode on an external Speedlight accordingly by ensuring that only TTL is displayed in the control panel of the Speedlight and not TTL-BL.

Flash Value (FV) Lock

Flash Value (FV) Lock allows you to use the camera and Speedlight to estimate the required flash output for a subject and then retain this value temporarily, before making the main exposure. This is a very useful feature if your want to compose so that the main subject is located toward the edge of the frame area, particularly if the background is very bright or dark. Under these circumstances, using the normal i-TTL flash exposure control, there is a risk that the camera may calculate an incorrect level of flash output, and cause the main subject to be either under- or overexposed.

On the D300 the FV lock feature can be activated via a number of different routes. The following describes how to assign its operation to the Function button. Navigate to CS-f4, then select the following options: Assign FUNC button > FUNC button press. Select FV Lock and press

Raise the built-in flash by pressing the flash pop-up button. Check the flash ready light \$\forall is lit then compose the picture with the main subject in the centre of the viewfinder area, acquire focus by half-depressing the shutter release, before pressing the Fn button on the camera. The Speedlight will emit the pre-flashes, which are used to assess the required amount of flash output. The output value of the flash is remembered by the camera and [11] is displayed in the control panel and viewfinder to indicate that the function is active. Now you can recompose the picture and place the subject toward the edge of the frame area. Finally, make the exposure by fully depressing the shutter release button. The flash will fire at the predetermined level. If you alter the focal length of a zoom lens, or adjust the lens aperture, the FV Lock function will compensate the flash output automatically. To release the FV Lock press the Fn button and ensure that **5L** is no longer displayed.

The FV Lock function can only be used with the built-in Speedlight of the D300 when TTL is selected at CS-e3. FV Lock is supported by the following external Speedlights: SB-800, SB-600, SB-400, and SB-R200. These external Speedlights must be set to perform TTL flash control; the SB-800 can also be used in its auto aperture (AA) flash control mode. The FV Lock function is also supported by the SB-800, SB-600, and SB-R200 when the built-in Speedlight of the D300 is set to commander mode via CS-e3 and any of these Speedlights is used as a remote unit in either group A, or Group B, provided TTL is set at the flash mode. If the remote

Flash compensation may be necessary when shooting subjects of unusual reflectance, such as this dog's dark fur. By adding plus flash compensation, the exposure was improved.

group composed exclusively of one or more SB-800 Speedlights the FV Lock feature can be used with either TTL or AA flash control modes.

Note: The FV Lock function can also be assigned to either the depth-of-field preview button via CS-f5, or to the AE-L/AF-L button via CS-f6

The area of the frame from which the camera takes a light meter reading when the FV Lock function is active varies according to the number of Speedlights and flash control mode in use.

Metering Area with FV Lock

Speedlight	Flash Mode	Metered Area
Single Speedlight connected to the	i-TTL	4 mm circle at center of frame
camera	AA	Area metered by built-in sensor on SB-800
Speedlight used with	i-TTL	Entire frame
others as part of wireless flash control	AA	Area metered by built- in sensor on SB-800
system	A (master flash only)	

Note: The camera-to-subject distance must remain unaltered during the use of the FV lock function otherwise the flash exposure may be inaccurate.

Flash Color Information

Used with D300, the built-in Speedlight, and external SB-800, SB-600, and SB-400 Speedlights automatically transmit information about the color temperature of the light they emit to the camera. Provided the camera is set to automatic white balance control, it will then use this information to adjust its final white balance setting in an attempt to match the color temperature of the light from the flash and the color temperature of the prevailing ambient light.

Note: This function only operates when automatic white balance is selected on the D300.

Wide-Area AF-Assist Illuminator

The purpose of the AF-assist lamp built-in to the SB-800 and SB-600 Speedlights, and the SU-800 wireless commander unit is to facilitate auto-focus in lowlight situations. The AF-assist lamp of these units illuminates a much wider area compared with the AF-assist the lamp of previous Speedlights, and the built-in AF-assist lamp of the D300. The AF-assist lamps of these external units is also much more powerful than the built-in lamp of the D300. The latter also has a further disadvantage as many Nikkor lenses obstruct the light it emits due to its proximity to the lens mount.

The wider coverage provided by the AF-assist lamp of the external units is particularly useful with cameras such as the D300, with is wide array of fifty-one AF points that cover a large proportion of the frame area. The effective range of the wide-area AF-assist lamp varies according to the focal length of the lens in use and the location within the viewfinder area of the selected AF point. When used with an AF lens with a focal length between 24mm and 105mm, the SB-800 and SB-600 Speedlights, and the SU-800 wireless commander unit provide AF-assist illumination for the AF points indicated in the following table:

Focal length of AF lens	AF points supported by AF-assist illumination
24 – 34mm	
35 – 49mm	000000
50 – 105mm	000000000000000000000000000000000000000

Note: The AF-assist function can be used in isolation on the SB-800 by selecting 'Cancel' for the flash 'FIRE' option in the custom setting on the Speedlight.

Limitations of the Built-in Speedlight

While the built-in Speedlight of the D300 is not as powerful as an external Speedlight, it can still provide a useful level of illumination at short ranges, especially for the purpose of fill-flash, since it supports flash output level compensation. However, if you want to use it as the main light source you should be aware of the following:

The built-in Speedlight is handy in a pinch and useful for fill-flash in outdoor portraiture. However, be aware of its limitations in terms of power output.

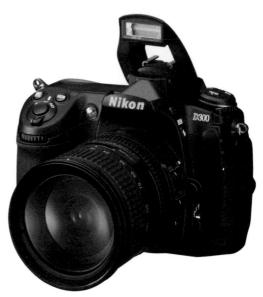

- The GN is limited (see page 54) so at f/5.6 with TTL flash control, this unit provides its full output at a range of approximately 10 ft (3 m).
- The flash head of the built-in Speedlight is much closer to the central lens axis than that of an external flash; hence the likelihood of red-eye occurring is increased significantly.
- Again, the proximity of the built-in Speedlight to the central lens axis often means that the lens obscures the output of the flash, especially if a lens hood is mounted on

the lens. If the camera is held in a horizontal orientation, the obstruction of the light from the flash may cause a shadow to appear on the bottom edge of the picture.

• The angle of coverage achieved by the built-in Speedlight is limited, and only extends to cover the field of view of a lens with a focal length of 18mm. With a shorter focal length the flash will not be able to illuminate the corners of the frame and these areas will appear underexposed. Even at the widest limit of coverage it is not uncommon to see a noticeable fall off of illumination in the extreme corners of the full frame.

Note: Any flash unit places a high demand on the batteries used to power it; the built-in Speedlight draws its power from the camera's battery, so extended use will exhaust it quite quickly.

Using a Speedlight Off-Camera with a TTL Cord

When you work with a single external Speedlight it is often desirable to take the flash off the camera. There are several different dedicated Nikon cords for this purpose: the SC-17, SC-28, and SC-29. All three cords are 4.9 feet (1.5 m) long: up to three, SC-17, or SC-28 cords can be connected together to extend the operating range away from the camera.

The benefits of taking a Speedlight off camera include:

- Increasing the angle between the central axis of the lens and the line between the flash head and a subject's eyes will reduce, significantly, the risk of the red-eye effect with humans, or eye-shine with other animals.
- In situations when it is not practicable to use bounce flash, moving the flash Off-Camera will usually improve the quality of the lighting, especially the degree of modeling it provides, compared with the typical flat, frontal lighting produced by a flash mounted on the camera.

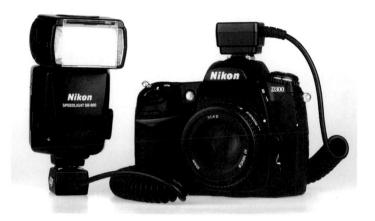

- By taking the flash off camera, and directing the light from the Speedlight accordingly, it is often possible to control the position of shadows so that they become less distracting.
- When using fill-flash it is often desirable to direct light to a specific part of the scene to help reduce the level of contrast locally.

Hint: Whenever you take a Speedlight off camera and use any flash mode that incorporates focus distance information in the flash output computations take care as to where you position the flash. If the Speedlight is moved closer or further away by a significant amount compared with the camera-to-subject distance the accuracy of the flash output may be compromised, as the TTL flash control system works on the assumption that the flash is located at the same distance from the subject as the camera.

Taking flash off-camera with an SB-28 cord allowed its light to be directed at specific parts of a flower for a more interesting effect.

Note: Compatible with either the SB-800, or SB-600 Speedlights, the SC-29 has a built-in AF-assist lamp in its terminal block that attaches to the camera accessory shoe; positioning an AF-assist lamp immediately above the central axis of the lens can help improve the accuracy of autofocus compared with using the AF-assist lamp built-in to Speedlights used off the camera, as the light emitted by the lamp may not be reflected with sufficient strength to be effective if it strikes the subject at an oblique angle.

Note: A Speedlight connected to the camera via one of Nikon's dedicated TTL cords can be used as the master flash to control multiple Speedlights off camera, using the Advanced Wireless Lighting system (see below).

When shooting flowers, photographers often use flash to make colors pop.

Using the Built-in Speedlight in Commander Mode

In addition to being used for conventional flash photography the built-in Speedlight of the D300 camera can be set to control one or more remote Speedlights, wirelessly, in P, A, S, and M exposure modes; this feature is compatible with the SB-800, SB-600, and SB-R200. The remote Speedlights can be controlled a variety of flash modes: TTL, Auto Aperture (for use with remote SB-800 Speedlights only), or Manual. Control is limited to a maximum of two independent groups named A and B respectively, using any one of four communication channels (1 to 4).

To use the Commander mode, which sets the built-in Speedlight of the Nikon D300 camera to act as a master flash:

1. Open the custom setting menu and navigate to CS-e3 (Flash Cntrl for Built-in Flash).

- 2. Highlight the Commander Mode option and press to open a sub-menu of flash mode, flash output level compensation, together with flash group and control channel options.
- 3. Highlight Built-in flash / Mode to set the required flash mode and use ▲ or ▼ to select TTL, M, or - (Flash cancelled). If TTL, or M is selected press ▶ to highlight Comp (flash output level compensation) and use ▲ or ▼ to select the required value. Press ▶ to set and confirm the value, and highlight Group A / Mode.
- 4. Set the required flash mode for group A by using or ▼ to select TTL, AA (SB-800 only), M, or -- (Flash cancelled). If TTL, AA, or M is selected, and you want to set a flash output compensation level repeat the procedure from Step 3, otherwise press the multi-selector switch to the right to highlight Group B / Mode. Repeat Steps 3 and 4 to set flash mode and flash exposure compensation.
- 5. Highlight Channel and use ▲ or ▼ on the multiselector switch to select the required channel number.
- 7. Check that each remote Speedlight is set to operate as a remote flash unit (this is selected via the custom menu of the Speedlight), and that each unit is also set to the same channel as selected on the D300 at step 5 above.
- 8. Press the flash pop-up button to raise the built-in Speedlight of the camera and ensure the ready light of each flash unit is lit. The system is now ready to be used.

Note: In TTL mode the flash output compensation can be set ± 3 EV in steps of 1/3EV; in manual flash mode the output can be set full output and 1/128 of full output.

Note: If the SB-400 is attached to the D300 and turned on CS-e3 changes to Optional flash, which allows the flash control mode of the SB-400 to be either TTL or manual; the Repeating flash and Commander flash options are not available.

Effective Flash Range

When the following units are used as the master flash or commander unit for wireless control of compatible remote Speedlights (SB-800, SB-600, and SB-R200) the effective range of operation is:

- **SB-800** when the SB-800 is used as a master flash the maximum effective operating range between it and the remote Speedlights is 33 feet (10 m) along the central axis of the lens, and 16 feet (5 m) to 23 ft (7 m) within 30° of the central axis of the lens.
- SU-800 the SU-800 is a dedicated IR transmitter (i.e. unlike flash units that emit control signals as part of a full spectrum emission, the SU-800 only emits IR light). It is a more powerful unit compared with the Speedlights that can perform the master flash role, and is capable of controlling remote SB-800 and SB-600 Speedlights up to a maximum range of 66 ft (20 m).
- SU-800 / SB-R200 Nikon states that when the SU-800 is used as the commander unit, the maximum effective operating range between it and remote SB-R200 Speedlights is 13 ft (4 m) along the central axis of the lens, and 9.8 ft (3 m) within 30° of the central axis of the lens.
- D300 Built-in Speedlight used as the master flash this can control remote Speedlights placed within 30° of the central axis of the lens up to a range of 33 ft (10 m), between 30° and 60° from the central axis of the lens the maximum range is 16 ft (5 m).

Note: I have found Nikon's quoted maximum operating ranges for the components of the Advanced Wireless Lighting system to be very conservative. For example, I have used SB-800 Speedlights as master and remote units at ranges outdoors of 100 feet (30 m) or more, particularly in situations where there have been reflective surfaces such as walls and foliage close by, which is three times greater than Nikon's suggested maximum range. However, in bright sunlight, which will contain a high level of naturally occurring IR light you may find the practical limit of the operating range is reduced.

Note: Nikon states that communication between the master and remote flash units cannot be performed properly if there is an obstruction between them. In practice I have used remote flash units very successfully without line-of-sight between the master flash and the sensor on the remote Speedlight(s). However, every shooting situation is different, so my advice is to set up the lighting system to your requirements and always take test shots to ensure it works as you intended. If not, adjust the location of the remote Speedlights.

Nikon Lenses and Accessories

Nikon makes a huge range of lenses known by their proprietary name, Nikkor. The "F" mount used on these Nikkor lenses is legendary; it has been used on all Nikon 35mm film and digital SLR cameras, virtually unchanged, since the introduction of the original Nikon F SLR in 1959. As such, a great many of the lenses Nikon has produced in the past five decades can be mounted on the D300, including most manual focus lenses that conform to the Ai lens mount standard. The fullest level of compatibility is offered by modern autofocus Nikkor lenses (D and G-types), but the D300 can support aperture-priority and manual exposure control with color Matrix, center-weighted, or spot metering when using earlier manual focus Nikkor lenses.

The DX-Format Sensor

The D300 has a sensor that Nikon refers to as the DX-format; you will also see this sensor type referred to as an APS-C sensor. At 15.6 x 23.7mm it is smaller than a 35mm film frame or the FX format sensor of the Nikon D3 D-SLR camera (both are 24 x 36 mm). As a consequence, regardless of the focal length of the lens mounted on the camera, the field of view covered by the DX-format sensor of the D300 is narrower than the field of view produced by a lens of the same focal length on a 35mm film or FX format sensor camera.

The DX-format sensor in the D300 is smaller than its FX-format fullframe counterpart, used in the D3 camera.

**Diagram not shown to scale

The circle represents the total area covered by the image circle projected from a 35mm format lens. The pale grey rectangle is the image area for a 35mm film frame (24×36 mm), and the dark grey rectangle represents the area covered by the DX-format (15.6×23.7 mm) sensor used in the D300.

Through their shooting experience, many photographers have become familiar with this conversion, while others still find the issue confusing. Furthermore, misconceptions persist as to what causes the altered field of view. Use of phrases such as, "it's like getting a free 1.4x teleconverter" or "the focal length is magnified by 1.5x" suggest, as if by magic, that the focal length of a lens when mounted on a camera with a DX-format sensor somehow increases by 1.5x. This is completely false – the focal length of any lens will remain constant, regardless of the size of the sensor or piece of film it projects an image on to, it is the field of view that alters.

To clarify this concept, consider that a lens with a focal length of 200mm will produce a specific field of view on a 24×36 mm frame (35mm film or FX-format sensor). But when the same focal length is used on the D300, and the field of view is reduced, it produces a field of view equivalent to that produced on a 24×36 mm frame when a lens with a focal length of 300mm is used. In other words, if you

are accustomed to choosing a focal length based on the field of view it produces on a 24 x 36mm frame you will want to multiply that focal length by 1.5x (the actual factor is closer to 1.52x) in order to estimate the coverage it will provide on the DX-format. Using the example of the 200mm focal length discussed above, $200 \, \text{mm} \times 1.5 = 300 \, \text{mm}$. Put it another way, if you where to shoot two pictures, one with a D300 and the other on a camera with a 24 x 36mm frame while the cameras were mounted side-by-side and pointing at exactly the same scene with the same focal length lens, then cropped the image on the 24 x 36mm frame to the same area as the sensor of the D300 – you would end up with identical pictures.

If you still find it easier to think in terms of the angle of view that a particular focal length would give on a 24 x 36mm frame camera, the following table provides an approximate effective focal length you can use to estimate the field of view on the D300:

Focal length with 24 x 36mm frame	12	14	17	18	20	24	28	35	50	60
Focal length – DX-format	18	21	25.5	27	30	36	42	52.5	75	90

Focal length with 24 x 36mm frame	70	85	105	135	180	200	300	400	500	600
Focal length – DX-format	105	127.5	157.5	202.5	270	300	450	600	750	900

There is a beneficial side effect to the reduced angle of view of the DX-format sensor. The D300 only uses the central portion of the total image projected by those lenses designed to cover a 24 x 36 mm frame. Therefore, the effects of optical aberrations and defects are kept to a minimum; these are generally more prevalent toward the edges

of the image circle. Using many of the Nikkor lenses designed to project an image circle that covers a 24×36 mm frame will significantly reduce or eliminate some or all of the following:

- Light fall-off (vignetting) toward the edges and corners of the image area, which can be particularly troublesome at large lens apertures.
- Appearance of chromatic aberration
- Linear distortion both barrel and pin-cushion
- Effects of field curvature (i.e. center and corners of frame are not in the same plane of focus)
- Light fall-off (vignetting) when using filters

Nikon also produces a range of Nikkor lenses designed specifically for use on their DX-format D-SLR cameras; known as DX lenses. These lenses only need to project an image circle that covers the DX-format sensor enabling them to be made smaller and lighter than their counterparts, designed for the 24 x 36mm frame cameras. However, it does mean that in most cases DX lenses cannot be used on a 24x36mm frame camera – an important consideration if you shoot on both formats.

Lens Types

Lenses are classified into different types, generally based on their focal length and/or design. Probably the most useful and popular are:

Wide-angle lenses – On the DX format these will have a
focal length of less than 30mm. They offer a large fieldof-view and are typically associated with the sweeping
vista of landscape photography, but wide-angles are great
for many subjects. Their close focusing ability, extended

depth of field, and angle of view can be combined to create some dynamic compositions if the subject is placed close to the lens, dominating the foreground, and is set against an expansive backdrop.

- Telephoto lenses On the DX format these will have a focal length of more than 30mm. They provide a narrower angle of view that magnifies a subject, making them good for sports, action, and wildlife photography. The optical effects of a telephoto can be used in many other areas of photography, such as portraits and landscapes. Due to their limited depth-of-field, they can help isolate a subject from its background, particularly at large apertures.
- **Zoom lenses** These allow you to adjust the focal length. the range of which can be exclusively wide-angle, telephoto, or span both. Speaking strictly, most modern lenses described as "zooms" are in fact vari-focal lenses. A true zoom lens maintains focus as the focal length is altered, which cannot be said of many lenses currently produced. Zoom lenses are extremely versatile. They have several focal lengths available in one lens, which reduces the amount of lenses you need to carry and time spent changing lenses. However, convenience comes at a price; many zoom lenses have smaller maximum apertures (larger f/ numbers) that often vary according to the focal length set. Their maximum aperture is commonly around two-stops less than fixed focal length lens types, which can be an issue when shooting in low light. Zoom lenses with large, constant maximum apertures (small f/numbers) tend to be expensive due to the complexity of their optical engineering.

For general photographic work with the D300 a lens, or lenses, that offer focal lengths between say 18mm and 200mm will cover most shooting situations. For the greatest level of compatibility and functionality you should use either D-type, or G-type Nikkor lenses (see descriptions below).

Lens Compatibility

Camera setting

The following table provides details of the compatibility of Nikkor lenses with the D300:

Exposure

	Camera setting		Focus mode			ode	Mete	ering sys	stem
Len	ns/accessory	s C	M (with electronic range finder)	М	P S	A M	3D	Color	
0	Type G or D AF Nikkor ² AF-S, AF-I Nikkor	•	•	•	•	•	•		• 3
CPU lenses	PC Micro 85mm f/2.8D ⁴	_	• 5	•	_	• 6	•	_	• 3
len	AF-S / AF-I Teleconverter ⁷	•8	• 8	•	•	•	•	_	• 3
ses 1	Other AF Nikkor (except lenses for F3AF)	•9	• 9	•	•	•		•	• 3
	AI-P Nikkor	•	• ¹⁰	•	•	•	_	•	• 3
	Al-, Al-S, Al-modified, or Series E Nikkor ¹²	_	● ¹⁰	•	_	● ¹³	_	● ¹⁴	• ¹⁵
Z	Medical Nikkor 120mm f/4 (IF)	_	•	•	_	● ¹⁶		_	_
Non-CPU lenses	Reflex Nikkor	_	_	•	_	● 13	_		15
υď	PC-Nikkor	_	● 5	•	_	● ¹⁷	1	_	•
ler	Al-type Teleconverter 18	_	• 8	•	_	● ¹³	_	●14	• ¹⁵
ises 11	PB-6 Bellows Focusing Attachment ¹⁹	_	• 8	•	_	•20	_	_	•
	Auto extension rings (PK-series 11A, 12, or 13; PN-11)	_	• 8	•	_	●13		_	•

- 1 IX Nikkor lenses can not be used.
- 2 Vibration Reduction (VR) supported with VR lenses.
- 3 Spot metering meters selected focus point.
- 4 The camera's exposure metering and flash control systems do not work properly when shifting and/or tilting the lens, or when an aperture other than the maximum aperture is used.
- 5 Electronic range finder can not be used with shifting or tilting.
- 6 Manual exposure mode only.
- 7 Can be used with AFS and AFI lenses only (pg. 353).
- 8 With maximum effective aperture of f/5.6 or faster.

- 9 When focusing at minimum focus distance with AF 80 200mm f/2.85, AF 35¬70mm f/2.8S, new AF 28 85mm f/3.5 4.55, or AF 28 85mm f/3.5 4.5S lens at maximum zoom, in focus indicator may be displayed when image on matte screen in viewfinder is not in focus. Adjust focus manually until image in viewfinder is in focus.
- 10 With maximum aperture of f/5.6 or faster.
- 10 With maximum aperture of 175.6 of faster 11 Some lenses can not be used.
- 12 Range of rotation for AI 80 200mm f/2.85 ED tripod mount is limited by camera body. Filters can not be exchanged while AI 200 400mm f/4S ED is mounted on camera.
- 13 If maximum aperture is specified using [Non CPU lens data] (pg. 198), aperture value will be displayed in viewfinder and control panel.
- 14 Can be used only if lens focal length and maximum aperture are specified using [Non CPU lens data] (pg. 198). Use spot or center weighted metering if desired results are not achieved.
- 15 For improved precision, specify lens focal length and maximum aperture using [Non CPU lens data] (pg. 198).
- 16 Can be used in manual exposure modes at shutter speeds slower than 1/1255 If maximum aperture is specified using [Non CPU lens data] (pg. 198), aperture value will be displayed in viewfinder and control panel.
- 17 Exposure determined by presetting lens aperture. In aperture priority auto exposure mode, preset aperture using lens aperture ring before performing AE lock or shifting lens. In manual exposure mode, preset aperture using lens aperture ring and determine exposure before shifting lens.
- 18 Exposure compensation required when used with Al 28 85mm f/3.5 4.5S, Al 35 105mm f/3.5 4.SS, Al 35 135mm f/3.5 4.SS, or AF S 80 200mm f/2.8D. See teleconverter manual for details.
- 19 Requires PK 12 or PK 13 auto extension ring. PB 6D maybe required depending on camera orientation.
- 20 Use preset aperture. In aperture priority auto exposure mode, set aperture using focusing attachment before determining exposure and taking photograph. PF 4 Reprocopy Outfit requires PA 4 Camera Holder.

Incompatible Lenses and Accessories

The following accessories and lenses are incompatible with the D300. If you attempt to use them it may damage the equipment.

- TC-16AS AF teleconverter
- Non-Al lenses
- Lenses that require the AU-1 focusing unit (400mm f/4.5, 600mm f/5.6, 800mm f/8, 1200mm f/11)
- Fisheye (6mm f/5.6, 7.5mm f/5.6, 8mm f/8, OP 10mm f/5.6)

- 21mm f/4 (old type)
- K2 rings
- ED 180–600mm f/8 (serial numbers 174041–174180)
- ED 360-1200mm f/11 (serial numbers 174031-174127)
- 200–600mm f/9.5 (serial numbers 280001–300490)
- Lenses for the F3AF (AF80mm f/2.8, AF ED200mm f/3.5, TC-16S teleconverter)
- PC 28mm f/4 (serial number 180900 or earlier)
- PC 35mm f/2.8 (serial numbers 851001–906200)
- PC 35mm f/3.5 (old type)
- 1000mm f/6.3 Reflex (old type)
- 1000mm f/11 Reflex (serial numbers 142361–143000)
- 2000mm f/11 Reflex (serial numbers 200111–200310)

Compatible Non-CPU Lenses

It is possible to use many of the features available with CPU-type lenses when a compatible non-CPU type lens is mounted on the D300, if the relevant lens data (lens focal length/maximum aperture value) is specified via the Shooting menu under the [Non-CPU lens data option].

Note: If the relevant lens data is not entered via the Shooting menu, Matrix metering cannot be used. The D300 will default to center-weighted metering, even if Color Matrix metering is selected.

Non-CPU type lenses can only be used in A (aperture-priority) or M (manual) exposure modes and the lens aperture must be set using the aperture ring on the lens. If the maximum aperture is not specified via the Shooting menu the aperture displayed on the D300 will not show the actual aperture value. Instead, the deviance between the maximum aperture available on the lens and the aperture value set on its aperture ring will be shown as a whole number. For example, if a lens with a maximum aperture of f/2.8 is used and the aperture ring is set to f/5.6, the display in the viewfinder and control panel LCD will show F2, indicating a difference of 2-stops.

If you attempt to select the P (program) or S (shutter-speed priority) exposure mode, the D300 will automatically set the

camera to A (aperture priority) mode; the exposure mode icon in the control panel LCD will blink, while A is displayed in the viewfinder.

Using Nikon AF-S/AF-I Teleconverters

The Nikon AF-S/AF-I teleconverters can be used with the following AF-S and AF-I lenses:

AF-S VR Micro 105mm f/2.8G ED 1 AF-S VR 200mm f/2G ED AF-S VR 300mm f/2.8G ED AF-S 300mm f/2.8D ED II AE-S 300mm f/2.8D FD AF-I 300mm f/2.8D ED AF-S 300mm f/4D ED 2 AF-S 400mm f/2.8D ED II AF-S 400mm f/2.8D ED AF-I 400mm f/2.8D ED AF-S 500mm f/4D ED II 2 AF-S 500mm f/4D ED 2 AF-I 500mm f/4D ED 2 AF-S 600mm f/4D ED II 2 AF-S 600mm f/4D ED 2 AF-I 600mm f/4D ED 2 AF-S VR 70-200mm f/2.8G ED AF-S 80-200mm f/2.8D ED AF-S VR 200-400mm f/4G ED 2 AE-S 400mm f/2.8G ED VR AF-S 500mm f/4G ED VR 2 AF-S 600mm f/4G ED VR 2

1 Autofocus is not recommended; at close focus distances the maximum effective aperture is likely to be less than f/5.6.

2 Autofocus not supported when used with TC-17E II/TC-20 E II teleconverter, as maximum effective aperture is less than f/5.6.

The DX series Nikkor lenses were designed for use with Nikon D-SLRs. However, the D300 is usable with many older Nikkor lenses, as well. Photo © Nikon Inc.

Features of Nikkor Lenses

The designation of Nikkor lenses, particularly modern auto focus types, is peppered with initials. Here is an explanation of what some of these stand for:

- **D-type** These lenses have a conventional aperture ring and an electronic chip (CPU) that communicates information about lens aperture and focus distance between the lens and the camera body. A "D" appears on the lens barrel.
- G-type These lenses have no aperture ring and are only compatible with Nikon cameras that allow the aperture value to be set from the camera body. They contain an electronic chip (CPU) that communicates information about lens aperture and focus distance between the lens

and the camera body, similar to the D-type lenses. A "G" appears on the lens barrel.

- AF-type These lenses are the predecessors to the later D
 and G-type designs. They have a conventional aperture
 ring but do not communicate focus distance information
 to the camera.
- DX These lenses have been especially designed for use on Nikon digital SLR cameras. They project a smaller image circle than lenses designed for 35mm format cameras and the light exiting their rear element is more collimated (actually parallel) to improve the efficiency of the photo sites (pixels) on the camera's sensor. "DX" appears on the lens barrel.
- Non-CPU Nikon uses the term "non-CPU" to describe any Nikkor lens lacking the electrical connections and components that communicate information about the lens to the camera. (With the exception of the PC-Micro 85mm f/2.8D lens and Ai-P type Nikkor lenses all manual focus Nikkor lenses are non-CPU types.)
- **AF-I** The predecessor to the AF-S lens type. These lenses also have an internal focusing motor, but not a silent-wave motor (SWM).
- AF-S These lenses use a silent-wave motor (SWM) for focusing; alternating magnetic fields drive the motor, which moves lenses elements to shift focus. This system offers the fastest autofocusing of all AF Nikkor lenses. Most AF-S lenses have an additional feature that allows the photographer to switch between autofocus and manual focus, without adjusting any camera controls, by simply taking hold of the focus ring. "AF-S" appears on the lens barrel.
- ED To reduce the effect of chromatic aberration, Nikon developed a special type of glass known as Extra-low Dispersion to bring various wavelengths of light to a common point of focus.

- **IF** To speed up focusing, particularly with long focal length lenses, Nikon developed their internal focusing (IF) system. This moves a group of elements within the lens so that it does not alter the length of the lens during focusing, and prevents the front filter mount from rotating; facilitating the use of filters such as a polarizer.
- N (Nano Crystal Coat) A specialized lens coating that
 is applied to the surface of some lens elements to help
 reduce the level of light reflection, improving overall
 image quality. An "N" appears on the lens barrel.
- Micro-Nikkor The name given to specialized lenses designed specifically for close-up and macro photography; the optical formula of these lenses is optimized for close focusing
- PC-E A special type of lens that offers the ability to shift
 and tilt the lens relative to the plane of the sensor in the
 camera to control perspective and depth-of-field. "PC-E"
 appears on the lens barrel.
- VR Vibration Reduction (VR) is Nikon's name for a sophisticated technology that enables a lens to counter the effects of camera shake and other vibrations. A set of built-in motion sensors that cause micro-motors to shift a dedicated set of lens elements are used to improve the sharpness of pictures. "VR" appears on the lens barrel.

Filters

I always advocate trying to get as much as possible correct at the time of shooting; apart from anything else it means you can spend less time in front of a computer and more time using your camera. As such, optical filters are an integral part of any photographer's equipment, especially if they shoot on film. The white balance control of digital cameras such as the D300 obviates the need to carry the range of color correction, or color compensat-

ing, filters needed to control the color of light when shooting on film. Furthermore, the ability to blend two or more exposures together in digital imaging techniques, such as high-dynamic range photography, gets around the problem of how to contend with a scene that has a very high range of contrast between dark shadows and bright highlights. However, there are still a few filter effects that you simply cannot replicate during post-production computer manipulation.

The golden rule of filtration has always been to use as few filters as possible; this has become even more applicable with digital cameras. The surface of the optical lowpass filter (OLPF) located in front of the camera's sensor is highly reflective, despite the anti-reflective coating that is applied to it. As a consequence some light that falls on the OPLF is bounced back up into the lens and in turn can be reflected back to the sensor. The risk of this occurring is particularly high if this reflected light encounters a flat optical surface, such as the rear surface of a filter or lens element (the coating applied to the rear element of newer Nikkor lens has been designed to help reduce this risk). The result of internal lens reflections is lower image contrast and potential for flare effects. The good news for the digital photographer is you do not need many filters. I would recommend that you consider just these three types, using them only when necessary:

Polarizing Filters

The most useful, and probably well-known, filter is a polarizer. Often associated with their ability to deepen the color of a blue sky, a polarizer has many other uses. The unique effects of this filter make it essential for digital photography. For example, the polarizer is a favorite with landscape photographers because it can remove reflections from non-metallic surfaces, including water. Even on a dull, over cast day a polarizer can intensify the color of foliage by reducing the glare caused by the reflection of the sky.

Note: The automatic focusing and TTL metering systems of the D300 will not function properly if you use a linear-type polarizing filter; ensure you use a circular-type polarizer, such as the Nikon Circular Polarizer II (these polarizers also have the benefit of having a very slim filter mounting ring, reducing the risk of vignetting).

Neutral Density Filters

Even at the base sensitivity of the D300 (ISO200), it is often not possible to set the lens aperture or shutter speed necessary to achieve the desired results when shooting in very bright light. Continuous tone neutral density (ND) filters help reduce the overall exposure by lowering the amount of light that reaches the camera's sensor, enabling you to use longer shutter speeds and/or wider apertures under these conditions.

Note: Some manufacturers now manufacture ND filters that have a restricted transmission to eliminate IR and UV light that might otherwise adversely affect the images recorded by digital cameras.

Graduated Neutral Density Filters

Coping with high contrast is one of the most difficult aspects of digital photography. For example, the sky is often much brighter than the land, which can make shooting landscapes tricky. If you set the exposure in order to record the darker portion of the scene, the lighter portion is often too bright to be recorded properly and ends up being overexposed.

A popular way to solve this exposure problem is to make two, or more, exposures of the same scene over a range of exposure levels, then combine the series of pictures into a single image using a high-dynamic range software tool. For scenes that contain no moving elements this can be highly effective and produces a unique look. However, if an element in the scene moves between successive exposures the software is unlikely to be able to merge the separate images and the technique will fail!

The solution in such situations is to use a graduated neutral density filter. These are clear on one side and become progressively denser toward the other side, and are available in a variety of strengths and rates of change. If you use a slot-in filter system, it is easy to align these graduated filters so their dense area darkens the bright area of the scene while the clear portion leaves the darker area unaffected.

Hint: Nikon states that the 3D Color Matrix and Matrix metering of the D300 is not recommended when using any filter with a filter factor over 1x. The filter factor is the amount of exposure compensation you need to apply to compensate for the reduction in light transmission caused by the filter. For example a filter factor of 2x is equivalent to one-stop, a factor of 8x is equivalent to three-stops. This will apply to polarizing and neutral density filters, so you will want to switch to center-weighted or spot metering.

Note: Nikon does not produce continuous or graduated neutral density filters, but many independent companies do – see the listings under Resources at the end of this chapter.

General Nikon Accessories

• **BF-1A** – The body cap that will help prevent dust from entering the camera. Keep it in place at all times when a lens is not mounted on the camera.

Note: The earlier BF-1 body cap cannot be used. It may damage the lens mount of the D300.

 DG-2 – This viewfinder eyepiece magnifier provides an approximate 2x magnification of the central area of the viewfinder field.

Note: The DG-2 requires the DK-22 eyepiece adapter to be fitted.

- DK-5 This viewfinder eyepiece cover is required when using the camera remotely in auto-exposure modes. It prevents light from entering the viewfinder and affecting exposure measurement.
- DK-20C An optional viewfinder eyepiece lens available in a range of strengths to facilitate viewing without your normal wear eye-glasses.
- **DK-21M** Replaces the standard DK-23 eyecup supplied with the D300 and provides an enhanced magnification (1.2x) of the viewfinder.
- **DK-22** An eyepiece adapter that allows viewfinder accessories with a round attachment thread (i.e., the DG-2) to be mounted on the square frame of the D300's viewfinder eyepiece.
- **DK-23** The standard square profile rubber eyecup supplied with the D300.
- **DR-6** A right angle viewer that can attach directly to the square frame of the viewfinder eyepiece on the D300. It is useful when the camera is at a low shooting position.
- EH-5 / EH-5a The multi-voltage AC adapter used to power the D300.

Note: The EH-5 is no longer available but it is compatible with the D300.

- EN-EL3e (7.4V, 1500mAh) The lithium-ion rechargeable battery for the D300 (also compatible with other Nikon D-SLR cameras, such as the D40, D60, and D80).
- **EN-EL4** / **EN-EL4a** A lithium ion battery that can be used in the MB-D10 multi power battery pack for the D300 (requires the BL-3 battery chamber cover).

- MB-D10 The battery pack for the D300. It accepts one EN-EL3e battery, an EN-EL4 or EN-EL4e battery, or eight AA-size batteries.
- MC-21 A 9.75ft (3m) extension cord for 10-pin accessories that connects to the10-pin terminal on the D300.
- MC-23 A 15-inch (0.4m) cord for connecting two compatible cameras for near simultaneous shutter release. It connects to 10-pin terminal on the D300.
- MC-30 The standard remote shutter release cord (30-inch/0.8m) that connects to the10-pin terminal on the D300.
- MC-35 The connecting cord for attaching a GPS device to the D300.
- MC-36 The remote shutter release that incorporates an intervalometer to enable time-lapse photography (33inch/0.85m). It connects to the 10-pin terminal on the D300.
- MH-18a The multi-voltage AC charger for a single EN-EL3e battery.
- MH-19 This multiple battery charger can charge two EN-EL3e batteries and supports either a multi-voltage AC supply or 12V DC motor vehicle supply.
- MH-21 The multi-voltage AC charger for a single EN-EL4 / EN-EL4a battery.
- MH-22 The multi-voltage AC charger for two EN-EL4 / EN-EL4a batteries.
- ML-3 Remote Control An infrared remote release for the D300 that connects to the camera's ten-pin remote terminal. The transmitter unit requires 2, AAA-sized batteries. The receiver unit is powered from camera.

- MS-D10 A battery holder for eight AA-sized batteries that can be used as an alternative power supply for the D300 when fitted with the MB-D10 multi power battery pack.
- SB-400 An external Speedlight (flash unit) for the D300.
 It can be attached to the camera's accessory shoe or via the SC-28/SC-29 TTL flash cord.
- **SB-600** An external Speedlight (flash unit) for the D300. It can be attached to the camera's accessory shoe or via the SC-28/SC-29 TTL flash cord.
- **SB-800** An external Speedlight (flash unit) for the D300. It can be attached to the camera's accessory shoe or via the SC-28/SC-29 TTL flash cord.
- SB-R200 An external Speedlight (flash unit) for the D300 intended for close-up and macro photography. It cannot be attached to camera's accessory shoe; it requires the use of the built-in Speedlight of the D300 or optional SU-800 Speedlight Commander unit.
- **SC-28** A TTL flash cord that maintains full functionality of compatible external Speedlights with the D300.
- SC-29 A TTL flash cord that maintains full functionality
 of compatible external Speedlights with the D300. The
 terminal unit that attaches to the camera has a built-in
 AF-assist lamp.
- WT-4 This wireless transmitter enables pictures to be transferred or printed over a wireless or Ethernet network. The D300 can also be controlled from a network computer via the WT-4 by using Nikon Camera Control Pro 2 software.

Note: There are several versions of the WT-4, which support a number of different communication channels to comply with the laws and regulations of different countries pertaining to radio transmissions.

You can use specialized Nikon software programs to edit and organize your photos, or choose one of the many third-party softwares available on the market today.

Nikon Software

Nikon offers a suite of dedicated software to support the D300. I recommend you check periodically at www.nikon.com to ensure you have the most up-to-date versions.

- Nikon Transfer A standalone utility that is used to transfer images directly from the camera, via a cord connection or from a memory card inserted in a card reader. It offers features to add metadata at the time of transfer (it supports IPTC/XMP standards) and simultaneously makes a back-up copy of transferred files on a separate storage device. (A copy of Nikon Transfer is supplied with the D300.)
- Nikon View NX The successor to the venerable Nikon View application, this new application has been developed to speed up image browsing, editing, and manage-

ment. It is particularly useful if you shoot large quantities of images. (A copy of Nikon Transfer is supplied with the D300.)

- Nikon Capture NX The latest iteration of the Nikon Capture application. It is probably the most reliable and accurate raw file converter for NEF files recorded by the D300. It is a comprehensive image editing application that incorporates the unique U-point technology for making complex selections within an image area with ease.
- Nikon Camera Control Pro 2 A standalone application for photographers who wish to be able to control a D300 camera remotely from a computer and transfer images directly from the camera to a computer via a hard wire connection or the WT-4 wireless transmitter.

Resources

A number of other manufacturers and suppliers provide equipment to compliment and enhance the performance of the cameras and flash accessories produced by Nikon. The following is a list of some that you may find useful:

- Cokin Manufacturers of filters and accessories; www.cokin.com
- **Gitzo** Manufacturers of tripods, monopods, and general camera support accessories; http://www.gitzo.com
- HDRsoft Authors of the popular Photomatix highdynamic range software; http://www.hdrsoft.com
- Kirk Enterprises Manufacturers of camera and flash accessories, including flash brackets; http://www.kirkphoto.com
- Lastolite Manufacturers of lighting accessories for portable flash units and a wide range of reflectors, diffusers, and other light modifying devices; http://www.lastolite.com

- Lee Filters Manufacturers of both lens and lighting filters, including graduated filter; http://www.leefilters.com
- Lexar Media Manufacturers of flash memory cards, including high-speed UDMA CompactFlash cards compatible with the D300; http://www.lexar.com
- Lumiquest Manufacturers of flash modifiers and diffusors; www.lumiquest.com
- Manfrotto Manufacturers of tripods, lighting stands, and flash support accessories; http://www.manfrotto.com
- Really Right Stuff Manufacturers of an extensive range of camera, flash, close-up, and panoramic photography accessories; http://www.reallyrightstuff.com
- SanDisk Manufacturers of flash memory cards, including high-speed UDMA CompactFlash cards compatible with the D300; http://www.sandisk.com
- Singh-Ray Manufacturers of camera lens filters, including graduated filter types; http://www.sing-ray.com

Working Digitally

You may be surprised to learn that, apart from image data, the picture files generated by the D300 contain a wealth of other information, including the shooting parameters and instructions about printing pictures. This information is "tagged" to the image file using a number of common standards, depending on the sort of information to be saved with the image file.

Supported standards:

DCF (v 2.0): Design Rule for Camera File System (DCF) is a standard used widely in the digital imaging industry to ensure compatibility across different makes of camera.

DPOF: Digital Print Order Format (DPOF) is a standard used widely to enable pictures to be printed from print order created and saved on a memory card.

EXIF (v 2.21): The D200 support Exchangeable Image File Format for Digital Still cameras (EXIF); this standard allows information stored with image files to be read by software, and used for ensuring image quality when printed on an EXIF-compliant printer.

PictBridge: A standard that permits an image file stored on a memory card to be outputted directly to a printer without the need to connect the camera to a computer, or download the image file from a memory card to a computer first.

Images from the D300 spport a number of industry standards such as DPOF, EXIF, and PictBridge. These standards contain information about shooting parameters and printing, and are compatible with various output devices.

Metadata

Metadata is any data that helps to describe the content or characteristics of a file. You may be familiar with viewing and perhaps adding some basic metadata through the File Info or Document Properties box found in many software applications and some operating systems. You may also use a digital image management application that can search some file properties and displays them for you.

EXIF Data

The D300 uses the EXIF (Exchangeable Image File Format) 2.21 standard to tag additional information to each image file it records. Most popular digital imaging software is able to read and interpret the EXIF tags, so the information can be displayed but other software is not as capable, in which case some, or all of the EXIF data values may not be available. The information recorded includes:

- Nikon (the name of the camera manufacturer)
- D300 (the model number)
- Camera firmware version number
- Exposure information, including shutter speed, aperture, exposure mode, ISO, EV value, date/time, exposure compensation, flash mode, and focal length.
- Thumbnail of the main image

Examining EXIF data by either viewing the image information pages on the camera's monitor screen, or accessing the shooting data in appropriate software is a great teaching aid as you can see exactly what the camera settings were for each shot. By comparing pictures and the shooting data you can quickly learn about the technical aspects of exposure, focusing, metering and flash exposure control.

IPTC Data - DNPR

Other metadata that can be tagged to an image file includes the use of a standard developed by the International Press Telecommunications Council (IPTC). Known as Digital Newsphoto Parameter Record (DNPR), it can append image information to include details of the origin, authorship, copyright, caption details, and key words for searching purposes. Any application that is DNPR compliant will show this information and allow you to edit it. If you are considering submitting any pictures you shoot with the D300 for publication, you should make use of DNPR (IPTC) metadata, as most publishing organizations require it to be present before accepting a submission.

XMP

Adobe's Extensible Metadata Platform (XMP) is an open standard, digital labeling technology that allows metadata to be embedded into an image file. Any XMP-enabled software application, allows descriptions and titles, searchable keywords, plus author and copyright information to be stored in a format that is easily understood by other software applications, hardware devices, and even file formats. Since XMP is extensible, it can accommodate existing metadata schemes.

Note: Nikon Transfer, Nikon View NX and Nikon Capture NX all support the EXIF, IPTC, and XMP standards.

Camera Connections

The D300 can be connected to many different devices for the purpose of image display and image transfer. This section outlines these processes.

Video Out

The D300 can be connected to a television set, VCR, or DVD player for playback or recording of images. In many countries, the camera is supplied with the EG-D100 video cable for this purpose First, you need to select the appropriate video standard. To do this, open the Setup menu, navi-

The D300 can be connected to a variety of devices using the ports on the left side of the camera.

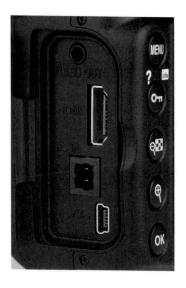

gate to the [Video Mode] item, and press

. Highlight the required option: [NTSC] or [PAL]. NTSC is the video standard used in the USA, Canada, and Japan, while PAL is used in most European countries.

Before connecting the camera to the video cord, make sure the camera power is switched off. Open the large rubber cover on the left end of the camera body to reveal the video out port (the topmost of the four ports). Connect the narrow jack-pin of the EG-D100 to the camera and the other end to the TV, VCR, or DVD player. Tune the TV to the video channel, then turn on the camera and press the button. The image that would normally be displayed on the LCD monitor will be shown on the television screen and can now be recorded to video or DVD. The LCD monitor will remain blank, but all other camera operations will function normally. This means that you can take pictures with the camera connected to a TV set and carry out review/playback functions simply by looking at the TV monitor screen. It is probably best to use the EH-5/EH-5a AC adapter to power the camera if you intend to use the camera for an extended period for image playback via a television screen.

Connecting via HDMI

The D300 can be connected to a HDMI device using a type-A HDMI cable. Check the HDMI option in the Setup menu; the [Auto] option is the default. Then, switch the camera off and connect the HDMI cable to the HDMI port (it is located immediately below the video out port under the large rubber cover on the left side of the camera body. Tune the device to the HDMI channel. Then turn the camera on and press the button. The LCD monitor will remain blank but all other camera operations will function normally.

Connecting to a Computer

The D300 can be connected directly to a computer via the supplied UC-E4 USB cable. The camera supports the high-speed USB (2.0) interface that offers a maximum transfer rate of 480Mbps. You can download images from the camera using the supplied Nikon Transfer software. Images can be viewed and organized using the supplied Nikon View NX software, while Nikon Capture NX can be used enhance images recorded by the D300. Alternatively, the D300 can be controlled from the computer using the optional Nikon Camera Control Pro 2 software.

Hint: If you use the D300 tethered to a computer for any function ensure that the EN-EL3e battery is fully charged. Preferably, use the EH-5/EH-5a mains AC adapter in conjunction with an EN-EL3e battery installed in the camera to prevent interruptions to data transfer by loss of power.

Before connecting the D300 to a computer, appropriate Nikon software must be installed and the camera must be configured for one of the two USB connection options, via the Setup menu. Open the Setup menu and navigate to the [USB] item. Press to right to display the two options: [MSC Mass Storage] and [M/P MTP/PTP]. Highlight the required option (see descriptions below) and press to select it.

 Mass storage – In this configuration, the D300 acts like a card reader and the computer sees the memory card in the camera as an external storage device; it only allows the computer to read the data on the memory card. This option can be used if computer is running Windows 2000 Professional.

• Media Transfer protocol (MTP) / Picture Transfer Protocol (PTP) — In this configuration, the D300 acts like another device on a computer network and the computer can communicate and control camera operations, as well as download and upload data from the camera. Use this option if the computer is running Windows Vista (32-bit Home basic/Home Premium/Business/Enterprise/Ultimate Edition, Windows XP (Home or Pro), or Macintosh OS X (10.3.9 – 10.4.10).

Note: You must select [MTP/PTP] to use the camera control feature in Nikon Camera Control Pro 2 software, which also supports Mac OS X (10.5)

Note: Mass storage can also be selected with Windows Vista (32-bit Home basic/Home Premium/Business/Enterprise/Ultimate Edition, or Windows XP (Home or Pro), or Macintosh OS X (10.3.9 – 10.4.10) when using Nikon Transfer.

Direct USB Connection

Make sure the correct USB option is selected in the [USB] item of the Setup menu. Turn the camera off, then turn the computer on and wait for it to start up. Connect the USB cable to the USB port of the camera (which is located under the large rubber cover on the left end of the camera body) and to the computer. If [Mass storage] is selected for the [USB] option, PC will be displayed in the control panel and viewfinder. The camera displays do not alter if [MTP/PTP] is selected. You can now use Nikon Transfer to download the images stored on the camera's memory card to the computer. If [MTP/PTP] is selected, the camera can be turned off as soon as the data transfer is complete. If you use the [Mass storage] option, ensure the camera is exited from the computer system in accordance with the correct procedure for the operating system in use before the camera is switched off and disconnected from the USB cord.

Card readers are the most popular way to transfer images to a computer. They eliminate wear-and-tear on the camera and transfers are quick and easy.

Memory Card Readers

Although the D300 can be tethered directly to a computer via a USB cord for transferring image data, there are several reasons why you should consider using a dedicated memory card reader as an alternative:

- If you use the tethered camera method, you will drain battery power and risk data being lost or corrupted if the power fails.
- Using a card reader allows you to run software to recover lost or corrupted image files as well as diagnose problems with the memory card.
- You can leave a card reader permanently attached to your computer, which further reduces the risk of losing or corrupting files as a result of a poor connection due to the wear and tear caused by constantly connecting the camera.

Wireless and Ethernet Networks

If the optional WT-4 wireless transmitter is attached to the camera, photographs can be transferred or printed over a wireless or Ethernet network. The camera can also be controlled from any network computer running Nikon Camera Control Pro 2 software. In all instances, the [USB] item in the Setup menu must be set to [MPT/PTP] before the WT-4 wireless transmitter is connected. For full information, see the instruction manual supplied with the WT-4. The WT-4 can be used in any of the following modes:

Mode	Function
Transfer mode	Upload new or existing image files to a computer or ftp server
Thumbnail select mode	Preview photographs on a computer monitor before upload
PC mode	Control the D300 from a computer using Camera Control Pro 2 software
Print mode	Print JPEG image files on a printer connected to a network computer

Direct Printing

As mentioned previously, the D300 supports a number of standards that, among other features, allow pictures to be printed directly from the camera via a USB connection without the aid of a computer. You can select to print an individual image or a group of images. Regardless, this feature is only compatible with JPEG format image files and a printer that supports the PictBridge standard (see page 371).

Note: Direct printing from the D300 is only supported for JPEG files. Nikon recommends images destined for direct printing should be recorded in the sRGB color space (using the [Color Space] item in the Shooting menu).

Linking the D300 with a Printer

The D300 can be connected to a PictBridge compatible printer to print pictures direct from the camera. First, set the [USB] option in the Setup menu to [MTP/PTP] (printing cannot be performed with at the default [USB] option of [Mass storage]), then turn the printer on and ensure that the camera is switched off. Next, connect the printer to the camera via the supplied UC-E4 USB lead; do not connect the camera and printer via a USB hub.

Note: It is essential that you make sure the camera battery is fully charged before commencing direct printing from the camera; preferably use the EH-5 / EH-5a mains AC adapter with an EN-EL3e battery installed in the camera in case the mains AC supply is interrupted.

Turn the camera on and a welcome message will be shown on the camera's monitor screen, followed by the PictBridge playback display. To scroll through the images saved on the memory card use and . To view an enlarged image, press and hold button. To view up to six images at a time, press and use to highlight individual pictures. Press to display the selected thumbnail image in full frame.

There are two options for printing pictures: one-by-one, or in multiples. To print a single image selected in the Pict-Bridge playback display, press and release the button. The PictBridge printing menu will be displayed. Use and voselect the required option:

Option	Description
Start Printing	Select to print the image highlighted in
	the PictBridge display. To cancel
	function press 🔞 button.
Page Size	Press \(\) and \(\) to select the
0	appropriate paper size from the
	[Printer Default] item: [3.5 x 5in], [5 x
	7in], or [A4]. Then press 🔞 to
	select the option and return to the
	main print menu.

Option Description Press **A** and **V** to select the Number of Copies number of copies of the highlighted image to be printed (maximum 99) Then press to select the option and return to the main print menu. Border Press A and V to select [Printer Default] (uses default setting of current printer), [Print with Border] (white border), or [No Border]. The **®** to select option and return to the main print menu. Time Stamp Press A and to select [Printer Default] (uses default setting of current printer), [Print Time Stamp] (date and time images was recorded are printed), or [No Time Stamp]. Use to select the option and return to the main print menu. Cropping Press A and V to select [Crop] (picture can be cropped in-camera), or [No Crop] (printed full frame). The press (%) to select the option. Selecting [No Crop] returns you to the main print menu. If [Crop] is selected, a dialog box will be displayed. Press ⊕ and $\mathbb{Q}^{\bullet\bullet}$ to determine the size of the crop and use to position the crop frame. to return to the main print menu.

To print multiple images, or an index print (contact sheet), connect the camera to a compatible printer as described above. Once the PictBridge display is open, press the MENU button and a menu with three options will be displayed:

Option

Print Selects
Print (DPOF)

Index Print

Description

The selected images are printed. The current DPOF print order set is printed (DPOF date and information options are not supported). Creates and index print of all images saved in the JPEG format. If the memory card contains more than 256 JPEG images, only 256 will be printed. Press button to display a sub-menu with three further options: [Page Size], [Border], and [Time Stamp]. These have the same options as described in the table above for single image printing.

Choose [Print Select] from the PictBridge menu; six thumbnail images will be displayed on the monitor screen. To scroll through the images, use , and press to see the highlighted image full frame. To select the image highlighted currently for printing, press and ; the image is marked with and the number of copies to be printed is set to one [1]. To specify the number of copies of each image selected for printing, press and hold then use and to increase or decrease the number respectively. Repeat this process for each image to be printed. Then press to display the print options and set page size, border type, and time stamp options as required according to the instructions above. To print selected images, highlight [Start Printing] and press

Note: Images saved in the NEF RAW format will be displayed in the Print Selected menu but it is not possible to select them for printing.

Creating a DPOF Print Set

The D300 supports the Digital Print Order Format (DPOF) standard that embeds an instruction set in the appropriate EXIF data fields of an image file. This allows you to insert the memory card in to any DPOF compatible home printer or

commercial mini-lab printer and automatically get a set of prints of only those images you wish to print. Apart from the fact that you do not have to tether the camera to a compatible printer as described above, this feature can be particularly useful if, for example, you are away from home, as you can still produce prints from your digital files even if you do not have access to your own printer; DPOF prints can be made by any DPOF compatible printer.

To select images for printing, highlight [Print Set (DPOF)] from the Playback menu; the [Select/Set] option will be highlighted. Press ▶ to select it, and the camera will display a thumbnail of all the images stored on the inserted memory card, in groups of up to six. Use ☺ to scroll through the images; a yellow frame indicates the currently highlighted image. To view the highlighted image full frame, press and hold the ♥ button.

To select the image highlighted currently for printing, press and

. The image will be marked with and the number of copies to be printed is set to one [1]. To specify the number of copies yourself, press and hold then use and to increase or decrease the number. Repeat this process for each image you want to print. Once all images to be printed have been selected, press the button to save the selected group of images. To imprint shooting data on the image, highlight [Data Imprint] and press . To print the date/time the image was recorded on the image, highlight [Imprint Date] and press . To finish, save the print set order, highlight [Done] and press .

To remove images from the print set, repeat steps for selecting images and when the image to be removed from the print set is highlighted, press to reduce the number of prints to [1], then press save changes to the print set by pressing save . To imprint shooting data on the image, highlight [Data Imprint] and press save . To print the date/time the image was recorded on the image, highlight [Imprint Date] and press save the print set

Note: Print set selections can only be made from JPEG format images stored on the memory card; if an image was shot using the NEF+JPEG option, only the JPEG image can be selected for printing.

Note: There are subtle differences in the functionality between the two direct printing routes. For example, direct printing with the D300 connected to a PictBridge compatible printer allows you to perform cropping of the image before printing, whereas printing from the memory card using a print set created using the DPOF standard images can only be printed full frame.

Nikon Software

It is beyond the scope of this book to describe fully the features and functions of Nikon's dedicated software, but details can easily be obtained from the technical support sections of the websites maintained by the Nikon Corporation. The D300 is supplied with copies of Nikon Transfer and Nikon View NX. The following section is intended to provide a brief overview of the four Nikon applications in their current versions at the time of this writing:

Nikon Transfer: 1.0.2 Nikon View NX: 1.0.4 Nikon Capture NX: 1.3.3

Nikon Camera Control Pro 2: 2.1.0

Note: For information about Nikon software and to download updates to existing application updates, I recommend you visit the various technical support websites maintained by Nikon, which can be accessed via:

http://www.nikon.com.

Nikon Transfer and Nikon View NX are software programs offered by Nikon, which help photographers manage their images.

Nikon Transfer

Nikon Transfer is Nikon's new utility for downloading images from camera or memory card to your computer. Nikon Transfer provides a simple intuitive workflow suitable for all users from beginners to professionals. It is included with the latest Nikon cameras, such as the D300, and can also be downloaded for free from Nikon websites. Features include:

- Automatic recognition/auto start after camera connection or inserting CF/SD card
- Transfers images from CD, external HD other removal media
- Transfers images to computer's hard drive
- Easy selection and viewing of images on up to five external devices before transfer
- Transfer image-data not only to a primary destination, but also to a backup location simultaneously

- Add metadata during transfer; both XMP/IPTC standards are supported
- Select the application the images are displayed in after transfer

Nikon View NX

View NX offers photographers a fast solution to the organization and classification of their digital images. This software uses your computer's file directory to display and browse images, and inherits the very latest features and design concept of Capture NX. Nikon View NX is included with the latest Nikon D-SLR cameras, such as the D300, and can also be downloaded for free from Nikon websites. Features include:

- · High-speed thumbnail and preview display
- A simple way to choose images, operation similar to Explorer/Finder
- Fast sorting using image rating and labeling classification system
- Includes Picture Control Utility (including sharpening, contrast, saturation, hue, brightness, black and white conversion)
- Batch processing to convert file format, resize, rename, change settings, multiple destinations
- Integration with Capture NX
- Integration with Nikon Transfer
- Printing and email transmission
- IPTC/XMP data compatible (user settings retained when image opened in other supported applications)
- Quick Adjustment features for NEF (RAW) images including white balance, exposure, and creating custom curves

Nikon Capture NX

Capture NX represents a complete rewrite by nik Software, a wholly independent software company, of the original Nikon Capture application. It incorporates their unique U-point technology that permits complex selections of an area (or areas) within an image to be made with an accuracy and speed that is far greater than can be achieved using current digital imaging software. The user has an extensive toolbox

available to enhance and modify any image file regardless of whether it was saved in the NEF RAW, TIFF, or JPEG format.

The intuitive Color Control Points system allows you quickly select an entire image, or an area within it for enhancement to modify any aspect of a selected area, including size, hue, brightness, saturation, contrast, red, green, blue, and warmth. Black, white, and neutral control points can be used to set the dynamic range and correct color casts in your images. Neutral control points can also be used to set color balance in an image. Each control point appears on the image and can be easily dragged from point to point, for precise movement and positioning to achieve the desired effect. The Control Points' sliders let you adjust their effect for the respective control point areas. Neutral control points can be used to set a targeted color to any color available within the color picker. This is useful for removing colorcasts and toning, even without a neutral object in the scene. Use of multiple neutral control points helps reduce multiple colorcasts and enhance selected colors in images. The drag, point and slider control is very easy to use, and very efficient.

Capture NX applies non-destructive image processing to NEF RAW files, which means that the original image data is never compromised. Each enhancement that is made is saved in an edit list with the original data and thumbnail. However, changes made to a JPEG or TIFF files will alter the data of the original image. To avoid this from occurring the image can be saved using a different file name, or converted into Nikon's NEF format. Parameters set on any Nikon camera-produced NEF RAW file, such as white balance, sharpening, color mode, saturation are applied to the image when it is opened in Nikon Capture NX for editing, so the camera settings are preserved. For a comprehensive set of hints and instructions on using Nikon Capture NX, together with some useful video tutorials go to: www.nikoncapturenx.com.

Other key features of Nikon Capture NX:

- Advanced white balance control with the ability to select a specific color temperature, or sample from a gray point.
- Advanced NEF file control that permits attributes such as exposure compensation, sharpening, contrast, color mode, saturation, and hue to be modified after the exposure has been made, without affecting the original image data.
- The Image Dust Off feature, which compares an NEF file with a reference image taken with the same camera to help reduce the effects of any dust particles on the lowpass filter.
- The D-Lighting tool, which emulates the dodge & burn techniques of traditional photographic printing to control highlight and shadow areas to produce a more balanced exposure.
- A Color Noise Reduction tool, which minimizes the effect of random electronic noise that can occur, especially at high sensitivity settings.
- An Edge Noise Reduction tool that accentuates the boundary between areas of the image to make them more distinct.
- The Color Moiré Reduction feature helps to remove the effects of moiré, which can occur when an image contains areas with a very fine repeating pattern.
- LCH Editor allows for control of Luminosity (overall lightness), Chroma (color saturation), and Hue in separate channels.
- Fisheye Lens tool converts images taken with the AF Fisheye-Nikkor DX 10.5mm f/2.8G lens so they appear as though they were taken using a conventional rectilinear lens with a diagonal angle-of-view equivalent to approximately 120°.

Camera Control Pro 2

Camera Control Pro 2 enables remote control of most functions of Nikon D-SLR cameras, including the D300, from a computer that is connected via USB cable, or though wired (Ethernet) or wireless LAN using a wireless transmitter (the WT-4 is required for the D300). New features and functions of the D300 such as the Live View and the Picture Control System are supported. The Viewer feature in the application enables the preview and selection of images prior to transfer to a computer. It also integrates with Nikon View NX and Nikon Capture NX software. Key features include:

- Most settings of Nikon D-SLR cameras, such as exposure mode, shutter speed and aperture can be controlled remotely.
- Images in a camera buffer can be confirmed with thumbnail, or preview display on a computer prior to transferring, enabling deletion of unwanted images.
- Support of the LiveView (Hand-held and Tripod modes) of the D300 and D3, it permits adjustment and confirmation of focus point via the image displayed on a computer monitor and control of the shutter release mode; it is also possible to control the contrast-detect AF system in the Live View Tripod mode from a computer monitor.
- Supports Picture Control System of the cameras. Picture Control parameters can be selected and adjusted on a computer, and custom curves (to modify contrast) can be created and saved.
- 51-point AF system can be controlled and displayed on a computer monitor.
- Fine-tuning of White Balance is available.

Digital Workflow

For many photographers who shoot with film, their direct involvement in the production of their pictures ends when they hand over the exposed film to be processed and printed by someone else. The digital photographer can exercise a far greater level of control over every stage of image processing, from initial capture in the camera to the output of an image as a print, or for electronic display.

It is essential to develop a routine to make sure you work in an efficient and effective manner. You may wish to consider the following 7-point workflow as a starting point for establishing one of your own, built around your specific requirements.

Preparation

- Familiarize yourself with your camera. The more intuitive you become with your equipment the more time you are able to spend concentrating on the scene/subject being photographed.
- Make sure the camera battery is charged and always carry a spare.
- Rather than saving all your pictures to a single high capacity memory card, reduce the risk of a catastrophic loss due to card failure/loss by spreading your images over several memory cards.
- Always clean the low-pass filter array in front of the sensor before you begin a shoot to reduce the level of post-processing work.
- Format the memory card in the camera each time you insert the card.

Shooting

 Adjust camera settings to match the requirements of your shoot. Choose an appropriate image quality, image size, ISO, color space, and white balance.

- Set other camera controls such as metering and autofocus according to the shooting conditions.
- Use the Image Comment feature (see Setup menu) to assign a note about the authorship/copyright of the images you shoot.
- Review images and make any adjustments you deem necessary. Use the histogram display to check the exposure level and use the magnification feature to check image sharpness. However, do not rely on this display to assess color, contrast, or hue; remember, even if you shoot NEF (RAW) you only see a JPEG version of the image displayed on the LCD monitor.
- Do not be in too much of a hurry to delete pictures unless they are obvious failures. It is often better to edit after shooting is completed, rather than "on the fly". Memory cards are relatively cheap; so do not skimp on memory capacity.

Transfer

- Before transferring images to your computer designate a specific folder, or folders, in which the images will be stored so you know where to find them.
- Rather than connecting the camera directly to the computer, use a card reader. It is much faster, more reliable, and reduces the wear and tear on the camera.
- If your browser application permits you to assign general information to the image files during transfer (e.g. XMP, or DNPR (IPTC) metadata) make sure you, at least, complete appropriate fields for image authorship and copyright.
- Consider renaming files and assigning further information and key words to facilitate searching and retrieving images at a later date.

Edit and File

- Use a browsing application to sort through your pictures. Again, do not be in too much of a hurry to edit out pictures. It is often best to take a second look at images a few days, or even weeks, after they were shot – your opinions about images will often change.
- Print a contact sheet of small thumbnail images to help you decide which images to retain.

Processing

- Make copies of RAW files and save them to a working file format such as TIFF (RGB), or PSD (Adobe Photoshop).
- Do not use the JPEG format for processing. Each time you modify file data and re-save as a JPEG, compression will be applied to the altered data. The effects of repeated compression will become cumulative.
- Make adjustments in an orderly and logical sequence starting with overall brightness, contrast, and color. Then make more local adjustments to correct problems or enhance the image.
- Save your adjusted file as a master copy to which you can then apply a crop, resizing, un-sharp mask, and any other finishing touches appropriate to your output requirements. The maxim to follow here is: process once
 - output many times.

Archive

- Data can become lost or corrupted at any time for a variety of reasons always make multiple back-up copies of your original files and the edited master copies.
- CD's have a limited capacity, so consider using DVDs or an external hard disk drive. No electronic storage media is guaranteed 100% safe, nor does it have an infinite lifespan – always check your back-up copies regularly and repeat the back-up process as required.

If you are shooting in rain make sure you protect your camera equipment from moisture. Always carry a soft microfiber cloth to dry off the camera, and keep your gear in a water-resistant bag when not in use.

Display

- We all shoot pictures to share with others. Digital technology has expanded the possibilities of image display considerably: we can e-mail pictures to family, friends, colleagues, and clients; prepare digital "slideshows;" or post images to a web site for pleasure or profit.
- Home printing in full color is now reliable, cost effective, and above all attainable. Spend some time to set up your system properly and work methodically: calibrate your monitor and printer, use an appropriate resolution for the print size you require, and choose paper type and finish accordingly.
- Once you have a high-quality print, ensure you present it
 in a manner befitting its status; make sure to frame or
 mount it securely. This will also help to protect it from
 the effects of light and atmospheric pollutants.

Caring for Your D300

Obviously, keeping your camera and lens(es) in a clean and dry environment is very important. But regardless of how scrupulous you are about doing this, dust and dirt will eventually accumulate on or inside your equipment.

Since prevention is better than a cure, always keep the body and lens caps in place when not using your equipment. Always switch the D300 off before attaching or detaching a lens to prevent particles from being attracted to the optical low-pass filter by the electrical charge of the sensor. Remember - gravity is your friend! Whenever you change lenses, get in to the habit of holding the camera body with the lens mount facing downwards. For the same reason do not carry or store your D300 on its back, as particles already inside the camera will settle on the optical low-pass filter. Periodically, vacuum-clean the interior of your camera bag/case; it is amazing how much debris can collect there! Sealing you camera body in a clear plastic bag, which you then keep within your camera case will add another valuable layer of protection in very dusty or damp conditions. In the latter situation keep some sachets of silica gel inside the bag to absorb any moisture. Putting together a basic cleaning kit is straightforward. You should consider the following:

- 1/2-inch (12mm) artist's paint brush made from soft sable hair for general cleaning.
- micro-fiber lens cloth for cleaning lens elements.
- micro-fiber towel (available from any good outdoors store) for absorbing moisture when working in damp conditions. (I find these towels invaluable in all sorts of conditions, and they are soft enough to use for cleaning lenses and filters.)
- rubber-bulb blower made for cleaning lenses and the low-pass filter.

Always brush or blow as much material off your equipment as possible before wiping it with a cloth. For lens elements and filters, use a micro-fiber cloth and wipe surfaces

in short strokes, not a sweeping circular motion. Turn the cloth frequently to prevent depositing the dirt you have just removed back onto the same surface! For any residue that cannot be removed with a dry cloth, you will need a lens cleaning fluid suitable for photographic lenses. Apply a small amount of fluid to the cloth, not directly to the lens, as it may seep inside and cause damage. Wipe the residue away and then buff the glass with a dry area of the cloth. Any lens cloth should be washed on a regular basis to keep it clean.

Cleaning the Low-Pass Filter

Unwanted material such as dust or particles of lint can accumulate inside the D300 and may settle on the surface of the low-pass filter. This is an unfortunate problem that can afflict any digital camera, especially those with interchangeable lenses, as foreign matter can enter the camera when a lens is removed or exchanged. Focusing or adjusting the zoom ring of a lens causes groups of lens elements to be shifted inside the lens barrel, creating very slight changes in air pressure. This can cause dust in the atmosphere to be drawn through the lens into the camera. Furthermore, the operation of internal camera mechanisms such as the shutter and reflex mirror can generate minute particles due to the wear and tear of the moving parts. During the manufacture of the D300 Nikon has attempted to reduce the incidence of such problems by cycling the shutter mechanism many hundreds of times before it is installed in the camera.

Any dust or other material that settles on the low-pass filter will often appear as dark spots in your pictures; they cast a shadow on the camera's sensor that is located behind this filter. The exact nature of the appearance of these shadows will depend on the size of the particle and the lens aperture you use. At very large apertures (f/1.4) it is likely that most very small dust specks will not be visible. However, at small apertures (f/22) they will probably show up with well-defined edges.

Self-Cleaning

The D300 was the first Nikon D-SLR camera to incorporate a self-cleaning function that vibrates the low-pass filter at four different frequencies using a piezo-electric oscillator. This vibration will loosen particles that have come to rest on the low-pass filter, preventing them from interfering with your images. The cleaning process can be set to activate automatically when the camera is turned on, turned off, or both. Alternatively, it can be activated at anytime the user deems it necessary.

Whenever you use the self-cleaning feature, make sure the camera is placed base down – there is a strip of high tenacious adhesive material located along the bottom edge of the low-pass filter to capture and retain any dislodged material. To configure the self-cleaning feature, open the Setup menu and navigate to the [Clean image sensor] option. Press be to display: [Clean now] and [Clean at startup/shutdown]. [Clean now] is highlighted by default and pressing will initiate the cleaning process. The message "Cleaning image sensor" is displayed on the LCD monitor during this process. Once cleaning is completed, the message "Done" is displayed. This option can be activated at anytime during camera operation.

Hint: It is worth getting into the habit of periodically viewing the images you are shooting to check for any tell tale particle shadows. Using the zoom function in image playback can help with this. I have added the [Clean image sensor] option to the My Menu listing on my D300; therefore, I can access it quickly and efficiently at anytime.

To have the cleaning process commence automatically, open the Setup menu and navigate to the [Clean image sensor] option and press ▶ . Then highlight the [Clean at startup/shutdown] option and press ▶ to display four choices:

• **©ON** Clean at startup: cleaning is only performed at start up

- OFF Clean at shutdown: cleaning is only performed at shut down
- Clean at startup & shutdown: cleaning is performed at start up and shut down
- Cleaning off (default): automatic cleaning is turned off

[Clean at startup] would appear to be the most logical selection, as it will help remove any unwanted material before you start shooting. Having the function operate at camera shutdown will bring no benefit to images that have already been recorded and will have no affect on any material that settles on the low-pass filter while the camera is dormant. Therefore, I can see little advantage in running the cleaning process at shutdown. Although it is important to consider that having the cleaning process automatically occur at startup will extend the startup time of the camera. If you need to have your camera immediately available when you turn it on, the [Clean at startup] option may not be a good idea.

Note: Any of the following functions will interrupt the sensor cleaning process: raising the built-in Speedlight; pressing the shutter release, depth-of-field preview, or AF-ON button; or using the FV lock feature.

Note: If the sensor cleaning process is repeated several times in rapid succession, the D300 may disable the function to protect the camera's electrical circuitry. If this occurs wait a few minutes before attempting to use the function again.

Note: When operating the sensor cleaning function a short sequence of high-pitched squeaks may be heard. This is normal and not an indication of a malfunction.

Manual Cleaning

The self-cleaning function available on the D300 may not always be able to dislodge unwanted material from the low-pass filter. It is often the case, particularly if the camera is

subjected to a rapid change in ambient temperature, that moisture can condense on the surface of the low pass filter and leave a solid precipitate behind as it evaporates.

If the self-cleaning process is insufficient, it will be necessary to resort to manual cleaning. Nikon expressly recommends that you should leave manual cleaning of the low-pass filter to an authorized service center. However, in recognition of the fact that this is likely to be impractical for a variety of reasons, the D300 has a feature that enables the reflex mirror to be locked up in its raised position and the shutter opened to provide access to the front surface of the low-pass filter.

Note: Nikon states that under no circumstances should you touch or wipe the low-pass filter.

Note: Any manual cleaning process you perform is done entirely at your own risk; any damage caused to the low-pass filter, or any other part of your camera, as a result of manual cleaning by the user will not be covered by warranties provided by Nikon.

To inspect and/or clean the low-pass filter you need to perform a few preparatory steps. First, ensure the camera has a fully charged battery installed or is powered by the optional EH-5a, or EH-5 battery. Second, remove the lens, or body cap, and keep the camera facing downwards. Now switch the camera ON, navigate to the [Lock mirror up for mirror cleaning] option in the Setup menu, and press to display Start - OK. Press
again and a dialog box will appear with the following instruction: When shutter button is pressed, the mirror lifts and shutter opens. To lower mirror, turn camera off. At the same time, a series of dashes will appear in the control panel and viewfinder displays; all other information will disappear. Once the shutter release is pressed all the way down the mirror will lift and remain in its raised position and the series of dashes in the control panel and viewfinder will begin to blink. Keep the camera facing down so any debris falls away from the filter; look up

in to the lens mount to inspect the low-pass filter surface (it is probably helpful to shine a light on to it).

Note: Because the photo-sites on the CMOS sensor of the D300 are just 5.49-microns square (one micron = 1/1000 of a millimeter), offending particles are often very, very small, and it is unlikely you will be able to see them by eye.

To clean the low-pass filter yourself, keep the camera facing down and use a rubber bulb blower to gently puff air towards the low-pass filter surface. Take care that you do not enter any part of the blower into the camera. Never use an ordinary blower brush with bristles, which can damage the surface of the low-pass filter, or an aerosol-type blower, which can emit condensation and leave a residue. Once you have finished cleaning, switch the camera off to return the mirror to its down-position. If the blower bulb method fails to remove any stubborn material, I recommend you have the sensor cleaned professionally.

Note: If is displayed in the control panel the [Lock mirror up for mirror cleaning] option will be grayed out in the Setup menu.

Caution: If the power supply fails during the cleaning process the shutter will close and the mirror will return to its down-position. This has potentially dire consequences if you have any cleaning utensils in the camera at that time! Therefore, always use a fully charged EN-EL3e battery. If you use an AC adapter, I recommend you also keep a fully charged battery in the camera in case the AC power supply is interrupted during inspection/cleaning of the low-pass filter.

Note: If power from the installed battery begins to run low while the mirror is locked up for cleaning, the camera will emit an audible warning and the self-timer lamp will begin to flash, indicating the mirror will be automatically lowered in approximately two minutes.

For users with plenty of confidence, there is a range of proprietary sensor cleaning materials that can be used to clean stubborn and tenacious material from the low-pass filter. These include brushes, swabs and fluids and are available from a number of manufacturers (see the list of resources on page 393). It must be stressed that if you use any such materials or implements, it is done entirely at your own risk. Remember it is essential that the camera's battery be fully charged before you attempt any manual cleaning procedure (preferably, use the EH-5 / EH-5a AC adapter with a fully charged battery installed in the camera at the same time to ensure a continuous power supply).

Caution: If you decide to clean the low pass filter of your D300 with a wet process make sure you NEVER use any alcohol based (e.g. ethanol, or methanol) cleaning fluid. The low-pass filter of the D300 has a special anti-static coating made from indium tin oxide that can be damaged by such chemical compounds.

Finally, if you have Nikon Capture NX software you can use the Dust Reference Photo feature with NEF (Raw) files shot using the D300 to help remove the effects of dust particles on the low-pass filter by masking their shadows electronically. This feature is reasonably effective, but the dust particles can be dislodged and shift between shots providing no guarantee that this technique will be completely successful if you save only one reference file. The best approach is to shoot several reference files during the course of a shoot and use the one that was made closest to the time of the exposure you need to correct (see Nikon Capture NX software for further details – page 368).

Troubleshooting

On occasion the D300 camera may not operate as you expect. This may be due to an alternative setting that has been made (often inadvertently), or for some other reason. Many of the reasons for these problems are straightforward and the solutions are set out in the table below:

Problem	Solution		
Viewfinder appears out of focus	Adjust viewfinder focusUse diopter adjustment lens		
Viewfinder display is dark	Battery not insertedBattery exhausted		
Displays turn off unexpectedly	Set longer delay for auto meter-off/ monitor-off (CS-c2/CS-c4)		
Unusual characters displayed in control panel	See information about electro-static interference below		
Displays in LCD panels appear slow to react and are dimmed	Affect of high or low temperature		
Fine lines appear in vicinity of active focus area on focusing screen	Normal – this is not a fault		
Camera takes longer than expected to turn on	Delete files / folders		
Shutter release disabled	 CPU lens aperture not set to minimum value Memory card not installed, or full BULB selected as shutter speed in S exposure mode 		
Pictures out of focus	Select S or C focus modeAF unable to operate; use manual focus		
Full range of shutter speeds is not available	Flash in use. Select flash sync speed via CS-e1		
Focus does not lock when shutter release is depressed halfway	Camera in C focus mode: use AF-L/ AE-L button to lock focus		
Image size cannot be altered	NEF (Raw) selected for image quality		
Cannot select focus point	 Unlock focus area selector Auto-area AF selected for focus mode Camera in Playback mode Camera in Menu mode Monitor is on: press shutter release halfway down 		
Camera is slow to record photos	Turn long exposure noise reduction of		

Problem	Solution		
Photo not recorded in live view mode	 Sound of mirror dropping down when shutter-release was pressed halfway in hand-held mode was mistaken for sound of shutter Shutter release is disabled if camera cannot acquire focus in hand-held mode when set to S focus mode; unless release is selected at CS-a2 		
Randomly-spaced bright	 Select lower ISO setting, or use high ISO noise reduction Shutter speed exceeds 8 seconds; use long exposure noise reduction 		
AF-assist lamp does not light	 Camera in C focus mode Center focus point is not selected for single-point AF or dynamic AF OFF selected at CS-a9 Lamp has turned off automatically to cool down 		
Photos are blotched or smeared	Clean lensClean low-pass filter		
Colors appear unnatural	Adjust white balance Adjust Set Picture Control settings		
Cannot measure preset white balance	Test target too dark, or too bright		
Image cannot be selected as source for preset white balance	Image not created with D300		
White balance bracketing unavailable	 NEF (Raw) or NEF + JPEG selected for image quality Multiple exposure mode is active 		
Results with Optimize Image vary from image to image	Avoid A (auto) for sharpening, contrast, or saturation when shooting a sequence of pictures.		
Metering cannot be changed	Auto-exposure lock is active		
Exposure compensation cannot be used	Select P, A, or S exposure modes		
Reddish areas appear in photos	May occur with long exposures. Use long exposure noise reduction when shutter speed is set to BULB		

Problem	Solution		
Only one shot taken each time shutter release is pressed in continuous shooting mode	Lower built-in flash unit		
Flashing areas appear in images	Press ▲ or ▼ to select photo information displayed		
Shooting data appears on	Change settings for Display mode		
images			
A graph appears during playback			
NEF (Raw) image is not played back	Photo taken at NEF + JPEG image quality		
Some photos not displayed in Playback mode	Select All for Playback Folder		
"Tall" (portrait) orientation photos are displayed in "Wide" (landscape) orientation	 Select ON for Rotate Tall OFF selected for Auto Image Rotation Camera orientation was altered while shooting in continuous mode Camera was pointed up/down when shooting 		
Cannot delete a photo	Photo is protected; remove protection		
No images displayed in Playback mode	Select All for Playback Folder		
Cannot change print order	Memory card is full: delete images		
Cannot select image for direct printing	Photo saved in NEF (Raw) format: transfer to computer and print using Nikon View NX or Capture NX		
Cannot print photos direct from camera via USB connection	 Set USB to MTP/PTP NEF (Raw) and TIFF photos cannot be printed by direct USB connection. Use DPOF print service (TIFF only), or transfer to computer and print using Nikon View NX or Capture NX 		
Photos not displayed on TV	Select correct video mode		
Photo is not displayed on high-definition video device	Confirm that HDMI cable is connected		
Cannot copy photos to computer	Select correct USB option		

Problem	Solution		
Photos not displayed in Capture NX	Update software to Capture NX 1.3.1 or higher		
Cannot use Camera Control Pro 2	Set USB to MPT/PTP		
Date of recording is not correct	Reset camera clock		
Menu item cannot be selected	Some options are not available at certain combinations of settings or when no memory card is inserted		

Error Messages and Displays

The D300 is a sophisticated electronic device capable of reporting a range of malfunctions and problems through indicators and error messages that appear in the displays of the viewfinder, control panel, and monitor screen. The following table will assist you in finding a solution, should one of these indicators or messages be displayed.

Control	cator View- finder	Problem	Solution
	nks)	Lens aperture ring is not set to minimum aperture.	Set ring to minimum aperture (largest f number).
	-	Low battery	Ready a fully-charged spare battery.
		Battery exhausted.	Recharge or replace battery.
		Battery can not be used.	Contact Nikon authorized service representative.
	-	An extremely exhausted rechargeable Li ion battery or a third party battery is inserted either in the camera or in the battery pack.	Replace the battery, or recharge the battery if the rechargeable Li ion battery is exhausted.

Indicator Control View- Panel finder	Problem	Solution	
CLOCK — (blinks)	Camera clock is not set.	Set camera clock.	
ΔF	No lens attached, or non CPU lens attached without specifying maximum aperture. Aperture shown in stops from maximum aperture.	Aperture value will be displayed if maximum aperture is specified.	
_ •	Camera unable to focus using autofocus.	Focus manually.	
×:	Subject too bright; photo will be overexposed.	Use a lower ISO sensitivity In exposure mode: P Use optional ND filter S Increase shutter speed R Choose a smaller aperture (larger f number)	
Lo	Subject too dark; photo will be underexposed.	Use a higher ISO sensitivit In exposure mode: P Use flash S Lower shutter speed R Choose a larger aperture (smaller f number)	
bulb (blinks)	buLb selected in exposure mode S.	Change shutter speed or select manual exposure mode.	
(blinks)	Optional flash unit that does not support flash control attached and set to TTL.	Change flash mode setting on optional flash unit.	
_ \$ (blinks)	If indicator blinks for 3s after flash fires, photo may be underexposed.	Check photo in monitor; if underexposed, adjust settings and try again.	
Full Ful (blinks) (blinks)	Memory insufficient to record further at current settings, or camera has run out of file or folder numbers.	Reduce quality or sizeDelete photographs.Insert new memory card	

Indicator Control View- Panel finder	Problem	Solution
E r r (blinks)	Camera malfunction.	Release shutter. If error persists or appears frequently, consult Nikon authorized service representative.
No [- E -] memory card	Camera cannot detect memory card.	Turn camera off and confirm that card is correctly inserted.
This memory card cannot be used. Card may be damaged. Insert another card.	Error accessing memory card. Unable to create new folder.	 Use Nikon approved card. Check that contacts are clean. If card is damaged, contact retailer or Nikon representative. Delete files or insert new memory card.
This card is not formatted Format the card.	Memory card has not been formatted for use in camera.	Format memory card or insert new memory card.
Folder contains no — Images.	No images on memory card or in folder(s) selected for playback.	Select folder containing images from [Playback folder] menu or insert different memory
All images — are hidden	All photos in current folder are hidden	No images can be played back until another folder has been selected or [Hide image] used to allow at
		least one image to be displayed
File does not — contain imahge data	File has been created or modified using a computer or different make of camera, or file is corrupt	File can not be played back on camera.

Indicator Control View- Panel finder	Problem	Solution		
Cannot select this file.	Memory card does not contain images that can be retouched	Images created with other devices can not be retouched.		
Check printer.	Printer error.	Check printer. To resume, select [Continue] (if available).		
Check Paper in printing not of selected size. Paperjam Paper is jammed printer.		Insert paper of correct size and select [Continue] Clearjam and select [Continue].		
Out Printer is out of paper paper.		Insert page of selected size and select [Continue].		
Check ink supply	Ink error. supply.	Check ink. To resumer select [Continue].		
Out of Ink	Printer is out of ink.	Replkace ink and select [Continue].		

Electrostatic Interference

Operation of the D200 is totally dependent on electrical power. Occasionally, the camera may stop functioning properly, or display unusual characters or unexpected messages in the viewfinder and LCD displays. Such behavior is generally due to the effects of a strong external electro-static charge. If this occurs try switching the camera off, disconnecting it from its power supply (remove the installed EN-EL3e battery, detach the MB-D10, or unplug the EH-5 / EH-5a AC adapter), then reconnecting the power and switching the camera back on. If the symptoms persist the camera will require inspection by an authorized technician.

A GPS unit can be connected to the D300 using a Nikon MC-35 cord. The GPS unit must conform to NMEA or NMEA0183 data format.

Using a GPS Unit

It is possible to use the D300 camera in conjunction with Global Positioning System (GPS) units to record additional data about the camera's location with each image file at the time of exposure. The GPS unit must conform to version 2.01 or 3.01 of the National Marine Electronics Association (NMEA) NMEA0183 data format. It is connected to the camera's ten-pin remote terminal using the Nikon MC-35 cord, which is available as an extra accessory.

Nikon has confirmed that the camera is compatible with GPS devices from the Garmin eTrex and Garmin Geko series (equipped with a PC interface cable connector). These devices connect to the MC-35 cord, via a cable with a D-sub 9-pin connector. Set the GPS unit to NMEA mode (4800 baud) before switching the camera on.

As soon as the camera confirms communication with a connected GPS device, GPS icon will be displayed in the control panel. The information recorded when an exposure is made with GPS icon displayed includes current latitude, longitude, altitude, time, and heading (see note below). The time provided by the GPS device uses the Universal Time Coordinated (UTC) and is independent of the camera's internal clock.

Note: To view GPS data open an image in single image playback and use ▲ or ▼ to scroll through the photo information pages until the GPS Data page is displayed.

Note: A heading is only recorded if the GPS device is equipped with a digital compass. Always keep such devices pointing in the same direction as the lens and at least 8-inches (20 cm) from the camera.

The [GPS] option in the Setup menu has two choices to determine whether or not the camera's exposure meter will turn off automatically when a GPS device is connected:

- Enable (default): If no camera operation is performed for the period selected at CS-c2 (Auto meter off delay) the exposure meter will turn off automatically. While this reduces drain on the camera's battery, it may prevent GPS data from being recorded if the meter is turned off and the shutter release is then pressed all the way down without pausing.
- **Disable:** The camera's exposure meter will not turn off automatically while a GPS device is connected; GPS data will always be recorded.

Approved Memory Cards

There are a plethora of memory cards on the market, but Nikon has only tested and approved those listed in the table below for use with the D300.

CompactFlash card and Microdrive TM technology is well established, so although Nikon will not guarantee operation with other makes of cards you should not experience any problems or have any concerns if you use an alternative brand. If in any doubt, test your memory card before using it to record any important pictures.

Nikon Approved Memory Cards For D300:

Manufacturer	Card Type / Series	Capacity
SanDisk	Extreme IV (SDCFX4) 266x	2GB, 4GB, and 8GB
SanDisk	Extreme III (SDCFX3)	1GB, 2GB, 4GB, and 8GB
SanDisk	Ultra II (SDCFH)	1GB, 2GB, 4GB, and 8GB
SanDisk	Standard (SDCFB)	1GB, 2GB, and 4GB
Lexar Media	Professional UDMA 300x	2GB, 4GB, and 8GB
Lexar Media	Platinum II 80x	512MB, 1GB, and 2GB
Lexar Media	Platinum II 60x	4GB
Lexar Media	Professional 133x with Write Accelerationy technology	512MB, 1GB, 2GB, and 4GB
Lexar Media	Professional 80x with LockTight technology	512MB and 2GB
Various	Microdrives™	1GB, 2GB, 4GB, and 6GB

Nikon states that while other brands and capacities of cards may work, operation cannot be guaranteed. If you intend to use a memory card not listed in the table above it is advisable to check with the manufacturer in relation to its compatibility with the D300. Should you experience any problems related to the memory card, use one of the approved cards for the purposes of trouble-shooting.

Memory Card Capacity

The table below provides information on the approximate number of images that can be stored on a 2GB Sandisk

Extreme III (SDCFX) memory card at the various image quality and size settings available on the D300. All memory cards use a small proportion of their memory capacity to store data required for the card to operate. Therefore, the amount of memory available for storing image files will be slightly less than the quoted maximum capacity of the card. Likewise, capacities may vary slightly if a different brand of memory card is used.

Quality	Image Size	File Size ¹	No. Images ¹	Buffer Capacity ²
NEF (Raw) Lossless compressed, 12-bit	-	13.6	98	18
NEF (Raw) Lossless compressed, 14-bit ³	-	16.7	75	21
NEF (Raw) Compressed, 12-bit		11.3	135	21
NEF (Raw) Compressed, 14-bit ³	-	14.2	112	27
NEF (Raw) Uncompressed, 12-bit	-	19.4	98	17
NEF (Raw) Uncompressed, 14-bit ³		25.3	75	16
TIFF (RGB)	L	35.5	52	16
	М	21.2	93	20
	S	10.2	208	29
JPEG Fine ⁴	L	5.8	276	43
	М	3.3	488	89
	S	1.5	1000	100
JPEG Normal 4	L	2.9	548	90
	М	1.6	946	100
	S	0.7	2000	100
JPEG Basic ⁴	L	1.5	100	100
	М	0.8	1800	100
	S	0.4	3900	100

- 1. File size will vary according to the scene photographed and the make of memory card used. Therefore, all figures are approximate.
- 2. This is the maximum number of image files that can be stored in the buffer memory. Capacity of the buffer will be reduced by the following: Optimal Quality is selected for JPEG Compression, ISO sensitivity is set to H 0.3 or higher, High ISO NR is on while auto ISO sensitivity control is on or ISO is set to 800 or higher, long exposure noise reduction is on, active D-lighting is on, or image authentication is on.
- 3. Maximum frame rate is reduced to 2.5 fps when recording 14-bit NEF Raw files. Image size applies to JPEG image files only. Size of NEF (Raw) files is fixed.
- 4. Figures are based on JPEG compression being set to Size priority. If Optimal quality is selected, file size is increased and the number of images and buffer capacity will be reduced accordingly.

Web Support

Nikon maintains product support, and provides further information on-line at the following sites:

http://www.nikon.com/ - global gateway to Nikon Corporation

http://www.nikonusa.com/ - for continental North America

http://www..europe-nikon.com/support - for most European countries

http://www.nikon-asia.com/ - for Asia, Oceania, Middle East, and Africa

Index

3D Color Matrix Metering (see Matrix metering)

A (see Aperture-Priority mode) AA (see auto aperture) Active D-Lighting 119, 219 AE-L (see autoexposure lock) 41, 70, **190-192**, AF area modes **193-194** (see also dynamic AF AF-assist illuminator 195-196, 232, **339**, 343 AF-C (see continuous-servo autofocus mode) AF Fine Tune 270-272 AF-S (see single-servo autofocus mode) Anti-aliasing filter (see Optical Low-Pass Filter) Aperture-Priority mode (A) **162-163**, 310 auto aperture (AA)169, 246, 325-326 autoexposure lock (AE-L) 165-166 autofocus lock (AF-L) (see focus autofocus (AF) system 20, **40-42**, **180-184**, 196-197

batteries 25-26, **77-84**, 57-58, 86-88, 128, 130, 232, 243-244, **266-267**, 364, 365, 366 bracketing (BKT) 132, **167-172**, 234, 244, 247, 248, 250, 253, 254 brightness 46, 53, 92, 108, 110, **114**, 138, 261, 317 buffer 47, 78, **121**, 123, 124, 284, 410-411 built-in sensor cleaning (see cleaning the sensor)

built-in Speedlight 53-55, 244-246, 307, 320-322, 327, 337, 340-341, 344-346 Bulb mode 47, 326, 400

camera care 393-399 camera connections 373-376 card reader 203, 284, 367, **377**, 390 CCD (Charged Coupled Device) (see sensor) center-weighted metering **44**, **159-161**, 165, 236 cleaning the low-pass filter 261, 389, 393, **394**, 395, 399 cleaning the sensor 393-399 clock, internal **59-60**, 86, 263 color balance 180, 272, **277-278**, 286 color space 46, 110, 119-120, **219**, 278, 378 color temperature 44, 89, **90**-**91**, 92-98, **99**, 105, 218, 338, 387 composition 35, 49, **72-74**, 123, 141, 175, 179, 353 compression (see image quality) continuous low-speed shooting 47, 123, **124**, 135 mode continuous high-speed shooting 47, 123, **124**, 135 mode continuous-servo autofocus mode (AF-C)41, 124, 184, **186**, **187**-**188**, 191, 194, 195, 227, 228 36-39 control panel Custom Picture Controls 108, 110, **117-118**, 219 Custom Settings menu 199, **223-260**, 269, 280

default settings 46, **68-69**, 150, 170, 188, 200, 212 (see also two-button reset)

148 deleting images depth of field 174-178, 187, 247, 252, 353, 360, 396 diffraction 40, 92, 158, **177-178**, 183 46, 120, **378-383** direct printing display mode 141, 144, 206 D-lighting 119, 272, **274-275**, 387 DPOF (see direct printing) Dust Off Reference Photo 265-266 DX-format sensor (see sensor) dynamic area AF 41, 122, 161,

182-184, **191**, 192, 194, 228, 254

electronic flash 307-347 EXIF (Exchangeable Image File 371, 372 Format) **Expeed Image Processing** 20, **45-46**, 288 exposure compensation 42, **166-168,** 171, 172, 235-236, 311, 312, 363 **43**, 162, 234, exposure control 235, 314, 349 exposure modes **42-43**, 67, 125, 139, 156, 158, **161-165**, 309, 326, 328, 329, 332, 344 external ports 84 external power supply

32-33, 288-304 file formats (see also JPEG; NEF) filters 28-30, 46, 98, 108, 115, 360-363 **272**, 293, 372 firmware 143, 146, flash compensation 246, 335 (see also Flash exposure compensation) flash exposure compensation 34, 345 Flash Value (FV) Lock 253, 308, 319, **335-338** flash photography 307-347 flash synchronization 244, 310, 320, **326-335** flexible program 42, 162 focus area modes 41, 189, 190-**192**, 193

focus lock**194-195**, 197, 253 focus tracking (see predictive focus tracking) formatting memory cards **66**, 148, **260**, **286-288** front-curtain sync 310, **328** FV lock (see flash value lock)

GPS 51, 60, 141, 142, **145**, **270**, **407-408**Graduated Neutral Density Filters **362-363**group dynamic AF (see also closest subject priority)

55, **262**, 375 HDMI hide image 204-206 high ISO Noise Reduction 221-222 highlight warnings 51, 143 51, 87, 141-143, histogram **149-150**, 159, 180, 206, 251, 278, 390 hue 46, 108, 111, **114-115**, 144, 279, 293, 294, 296, 385, 387 image authentication 142, 146, **268**, 411 image comment 145, 146, 263-**264**, 390 image playback 53, **141**, 204, 206, 251, 264, 279, 374, 408 image quality 20, 69, 142, 146, 151, 155, **217-218**, **274**, **288-304**, 410 image size 67, 69, 142, 146, 151, **217-218**, **274**, 294, 303, 411 image storage 20, 75, 204, 283-

Control 54, 158, 169, 307-309, **313-316**, 320-321, 323, 327, 335, 338 Interval Timer Shooting **51, 130-132**, 213, **223** IPTC Data 367, **373**, 385, 390 ISO 42-43, 54, 73, 143, 145, 146, **153-156**, 221-222, 233, 320, 323, 330-331

infrared photography

Intelligent TTL (i-TTL) Flash

286

ISO Noise 145, **155**, **221-222** ISO Sensitivity Auto Control **156**

JPEG 32, 113, 149, 217, **218**, 274, 288, **291-293**, 301, 302-303, 378

LCD Monitor 49, **51-53**, 75, 140, 239, 261 lenses **349-360** Live View 14, **49-50**, 123, **127**, **133-135**, 222-223 long exposure Noise Reduction 47, 145, **220-221**

Manual exposure mode (M) 101, 134, 156, **164-165**, 168 manual focus 20, 41, 62, 101, 136, 137, 172, 184, **186**, 192, 313, 349 matrix metering 40, **43**, 71, **157-159**, 173, 237, 253, 307, 317, 356, 363 MB-D10 Battery pack 20, **25 26**, **81-84**, 128, 232-233, 243, 20, **25-**267, 365 memory cards **64-67**, 75, 88, 118, 203-205, 241, 258, 260, 268, 283-284, 286-287, 377, 389 metering **43**, 71, **157-161**, 166, 173, 233, 236, 237, 316-318, 338, 363 Microdrives 64, 88, **284-285** Mirror Lock-Up 48, **50**, 123, 127, 134, 243, 262 monochrome 46, 108, 109, **115-116**, **276**, 298 multiple exposure 50, 128-130, 223 53, 87, **200, 280-281** My Menu

NEF 32-33, 87, 128, 149, **218**, 274, 286, 288-291, **294-301**, 302-303, **304**Neutral Density Filters 73, 179, **362**Nikon Software 17, 106, 219, **367-368**, 383

Non-CPU Lenses 161, 163, **172-173**, 256, **270**, **356-357**

Optical Low-Pass Filter 28

Picture Control System 14, 45-**46, 106-108, 219,** 388 playback (see image playback) Playback menu 142, 148, **199, 202-211,** 269, 382-383 Polarizing Filters 73, **361,** 363 predictive focus tracking 41, 186, 187, **188-189**, 194, 230 Programmed Auto exposure mode 42, 156, **161-162**, 309, 330, 332 program shift (see flexible program) protecting images 75, **147**, 204, 206

RAW (see NEF) rear-curtain sync 244, 310, **329**, 330, **332-335** red-eye reduction **275**, 310, **328**, 329 remote release **127-128**, 138, 365 reset 69, **150-151, 212-213,** 224, 280 resolution 26, 177-178, **283-294**, 392 (see also image size) 119, **200**, 201, Retouch Menu 219, **272-281** rotating images 209, 264-265

saturation 46, 108-111, **114**, 116, 140, 144, 149, 155, 293, 296, 385-387 Scene Recognition System 14, **40-42**, 92, 158, 166, 183, 191, 229, 317 self-timer **48, 124-126**, 139, 140, 238 sensitivity (see ISO) 19, 26-32, 47, 49, 126, sensor 154, 174, 176, **181-184**, 191, 220, 245, 261, 290, 294, 317, **318**, 324, 326, 338, **349-352**, 361, 395-399 Setup menu 53, 59, 199, 201, **260-272**, 280, 287, 373, 375, 378, 395

sharpening 109, 111, **112-113**, 144 Shooting Information Display **38-39**, **242**, 258 Shooting menu 47, 69, 93, 96-97, 99, 118-120, **151**, 199, **211-223**, 269, 302-304 Shooting modes 47-51, 122-127, 261 Shutter-Priority mode (S) **164,** 330, 332 single area AF 41, 70, 189 single-frame shooting mode 70, **123-124**, 135, 140, **171**, 240 single-servo autofocus mode (AF-S) 41, 71, 122, 128, **184-185**, **187-188**, 191, 194, 227 spot metering **43, 160-161**, 165, 173, 245, 314, 335, 363

TIFF 28, 32, 87, 109, 113, 217, 265, 288-291, **294**, 301, 302-303, 386, 391 trap focus **189-190**, 230 trim 272, **275-276** TTL metering 20, 43, 61, 73, 125, 139, **157-161**, 166, 172, 362 two-button reset 68-69, **150-151**, 162, 212

UDMA CompactFlash Memory Cards **283-284** USB 55, **265**, 267, 375, **376**, 378-379, 388 UV Photography **180**

Video mode Viewfinder 34-35, 49, 62-63, 67, 71, 101, 125, 126-127, 133-134, 136, 139, 156, 164, 184, 191, 195, 230-231, 240, 337, 363-364

Web support white balance 14, 44, 89-105, 132, 144, 146, 149, 218, 338-339, 360, 387-389 white balance bracketing 69, 104-106, 132, 253 wireless transmitter 49, 134, 267-268, 366, 368, 378, 388 workflow 384, 389-392 World Time 59-60, 86, 263